Art in the Age of Aquarius, 1955–1970

Smithsonian Institution Press

Washington and London

ART IN THE AGE OF

1955–

AQUARIUS

1970

William C. Seitz

Compiled and edited by Marla Price

Library of Congress Cataloging-in-Publication Data

Seitz, William Chapin
 Art in the Age of Aquarius, 1955–1970 / William C. Seitz; compiled and edited by Marla Price.
 p. cm.
 Includes bibliographical references and index.
 ISBN 0-87474-868-2.
 1. Art, American. 2. Art, Modern—20th century—United States. 3. Avant-garde (Aesthetics)—United States—History—20th century. 4. Art, Modern—20th century. 5. Avant-garde (Aesthetics)—History—20th century.
I. Price, Marla. II. Title.
N6512.S335 1991
709'.73'09046—dc20 90-26271
 CIP

British Library Cataloging-in-Publication Data available

96 95 94 93 92 5 4 3 2 1

Manufactured in the United States of America
Color plates printed in Hong Kong

⊗The paper in this book meets the requirements of the American National Standard for Permanence of Paper for Printed Materials Z39.48–1984.

Cover illustration: James Rosenquist, *Marilyn Monroe, I,* 1962, oil and spray enamel on canvas. The Museum of Modern Art, New York, Sidney and Harriet Janis Collection.

Contents

Plates

Figures

Foreword

Art in the Age of Aquarius comprises a remarkable document by a remarkable man, a time capsule of the 1960s unexpectedly retrieved for us in the 1990s. Born in 1914 and therefore of the same generation as many of the Abstract Expressionists he first championed, William Seitz was an extraordinary art historian who, with one foot always in the past of modern art, never stopped adjusting his eye, his mind, and his heart to the present and future of the youngest art around him. His commitment began with unique precocity in the early 1950s, when he was a graduate student in Princeton University's Department of Art and Archaeology, a faculty hardly known for its interest in or friendliness toward contemporary art. There, under the most alien of conditions and with the intervention of a supportive plea from none other than Alfred H. Barr, Jr., he completed what turned out to be the first doctoral thesis ever written about Abstract Expressionism, an academic tome both impassioned and objective that earned him a Ph.D. in 1955, almost before the paint on the canvases he discussed was dry.

Such alertness to the strange new breeds of art that went on to flourish in the 1950s hardly expired with the waning of Abstract Expressionism. Happily, Seitz continued to keep his eyes open while supporting fresh experiences with an understanding of historical precedents and patterns gained from his discipline in academe. He remained at Princeton as a professor of modern art until 1960, and it was there, in 1956, that I first met him in the role of friend, colleague, and fellow enthusiast for all the exciting things that were then going on in the New York art world, just a short trip away from the seclusion of campus life.

In 1960, the Museum of Modern Art wisely enlisted him into its ranks and it was there, in the span of only five years, that he put on an abundance of indispensable exhibitions, both innovative and retrospective, that deftly mixed the demands of the present with a deep knowledge of the past. Not only were there major surveys of three of the by-then venerable artists he had discussed in his thesis—Mark Tobey (1962), Arshile Gorky (1962), and Hans Hofman (1963)—but three other exhibitions that responded more directly to the changing pulse of contemporary art. The first of these, *Claude Monet: Seasons and Monet* (1960), was concerned, to be sure, with an old master and one whom Seitz had been studying intensively in the late 1950s; but his vision of Monet, focusing as it did on the serial paintings, mirrored prophetically a multitude of new issues that became important at exactly the same time in young artists as divergent as Frank Stella and Andy Warhol. More overtly rooted in current events were the other two exhibitions. The *Art of Assemblage* (1961) provided a distinguished genealogical table (all the way back to Picasso, Marinetti, Schwitters, et al.) for what Seitz had recognized as an international movement in the late 1950s that would explore, whether in the New York of Robert Rauschenberg and Louise Nevelson or the Paris of Arman and Jacques de la Villeglé, the strange new poetry that could be eked out of the palpable junk and mess of urban life. And almost as a visual and cerebral antidote to this anthology of beautiful detritus, Seitz quickly went on to organize *The Responsive Eye,* already announced in 1962, but not materialized until 1965. There, a whole other vision was proposed, consisting of the purest, most abstract and impalpable optical illusions that seemed to come not from the city streets but from the laboratories of artist-scientists, both individuals and groups, who specialized in the wonders of controlled perception. This survey of what came to be known, even before the show opened, as "Op Art," was once again historical in resonance, with ancestral figures like Josef Albers and Ad Reinhardt, and global in scope, with entries ranging from Israel (Agam), Spain (Equipo 57), and England (Bridget Riley) to Canada (Guido Molinari) and the United States (Richard Anuszkiewicz, Larry Poons, Ellsworth Kelly).

After these six spectacular exhibitions in five years at MoMA, Seitz left New York, moving on to more peripheral positions that juggled curating and teaching—at Brandeis University, at Harvard University, at the National Gallery of Art, and finally, at the University of Virginia, where he taught from 1971 until his premature death in 1974. In the frenzied epicenter of New York, it was, in fact, assumed that after he left MoMA in 1965, Seitz had more or less retired from the action that he had chronicled and generated in the first half of the 1960s; and when his path-breaking doctoral thesis on Abstract Expressionism was at last published posthumously as a book in 1983, it seemed to most of us a final tribute to the very beginnings of this vital career.

Luckily, as *Art in the Age of Aquarius* proves, we were wrong. It turned out that in his last years, nurtured by the serenity of Jefferson's ideal campus at Charlottesville, Seitz was quietly at work on a grand synthesis of what, in effect, was the broadest spectrum of the new art he had watched emerge since 1955, the year he had laid Abstract Expressionism to rest with his thesis. His embrace of the period was total, and the texts he left for posterity begin just where his thesis left off and continue into the early 1970s. Now put into publishable order by one of his own former students at the University of Virginia, Marla Price (herself now a distinguished curator of contemporary art), they compile, among other things, a living, breathing chronicle of art as experienced by a passionate observer and participant. Here one can find not only first-person accounts of the contents and reception of Seitz's own Assemblage and Op Art shows at MoMA, but keen, on-the-spot reporting of such other major-league events of the 1960s as Jean Tinguely's diabolic machine, *Hommage á New York,* which self-destructed in MoMA's garden in 1960, and Kynaston McShine's landmark exhibition, *Primary Structures* (1966). But more unexpectedly, we discover that Seitz's curiosity about and receptiveness to all the new art of the period was infinite. The predictable movements—Pop Art, Minimalism, Conceptualism, Earthworks, Performance Art—all play their parts here; but contrary to the familiar accounts of the 1960s and early 1970s written by many of his juniors, Seitz's view of the period gives equal time to many modes of art often neglected or scorned by later critics. Given his *Responsive Eye* exhibition, we may not be surprised that Op Art has a big role here; but it is more of a jolt to read an unusually sympathetic and revealing account of Photorealism, integrated into an overall vision that can involve everything from Ed Ruscha's photographs to Robert Venturi's love songs to the American highway. Indeed, one of the most tonic aspects of Seitz's text is his constant shuffling of the individual artists and their works with a kaleidoscope of 1960s culture. Abbie Hoffman, Mayor Daley, Woodstock, Herbert Marcuse, *Myra Breckenridge,* Marshall McLuhan, anti-Vietnam protests, Jerry Rubin, 1968 student revolutions, Allen Ginsberg bob in and out of these pages, mirroring a concerned spectator who stayed tuned to every channel the

1960s offered. And if the vantage point is clearly that of an American, the rest of the world is hardly excluded, as it so often was by Seitz's contemporaries and, less forgivably, by later, much younger historians of the period. A United Nations of artists and events turn up here, from Mathias Goeritz's monumental sculptures in Mexico City and Jean-Jacques Lebel's happenings in Paris to Gilbert & George's road-company performances of "Underneath the Arches" and international exhibitions as far afield as Kassel and São Paulo. Moreover, the cast of characters in Seitz's eyewitness history includes many who may be unfamiliar to the 1990s. How many of us today know the work of Sidney Goodman, Richard McLean, and Marius Boezum, to name only a few artists who have intriguing cameo roles here?

So what we now have before us is a cornucopia of fresh information, hands-on art-world experience, unexpected perceptions, and even unfamiliar art, temporarily buried in the past of the 1960s but now resurrected in Seitz's text. With these pages in hand, we are not only given enough new data and new angles of vision to oblige us to rethink the years chronicled here, but perhaps even more important, we can relive the fusion of visual excitement and informed intelligence that made William Seitz an essential part of the annals of modern art.

New York Robert Rosenblum
July 1991

Editor's Note and Acknowledgments

William C. Seitz wrote this book in the first years of
the seventies, when he was William R. Kenan Pro-
fessor of Art History at the University of Virginia.
Previously he was a respected curator at the Museum
of Modern Art and at the Rose Art Museum at Bran-
deis University and he served as the Samuel Kress
Professor at the National Gallery of Art. My first in-
volvement with the manuscript occurred at the same
time, for I was his student, as well as his research
assistant, from 1971 until his death in the fall of
1974. The text that follows was compiled from his
drafts and notes after his death, but is entirely his.
My editing of the text has been limited to the elimi-
nation of repetitive passages and grammatical incon-
sistencies. Even in the smallest alteration, such as a
change of verb tense, care has been taken to preserve
his voice.

This book therefore presents a view of the sixties
from the vantage point of the early seventies. But,
given that the viewer was not only an important
player in a number of scenes that unfolded in the
sixties but also a gifted writer and (as I can person-
ally attest) teacher, this study makes an invaluable
contribution to the literature of the period.

Seitz had planned a more ambitious text. He
hoped, for instance, to include brief commentaries
on sixty artists of the sixties, chosen as if for inclu-
sion in an exhibition of the finest work of the dec-
ade. Sadly, less than half of these insightful essays
were completed before his death. Where appro-
priate, material from the completed commentaries
has been inserted into the main text to expand dis-
cussion there of specific artists. Likewise, the com-
parative chronology of contemporary events, art
events, exhibitions, and publications was planned

by Seitz and outlined by him in a more abbreviated form than the version that appears at the back of this book. The responsibility for any errors, omissions, or biases in this section, therefore, is mine.

I would like to thank Irma S. Seitz for the honor and opportunity to work on this manuscript. Her confidence in and support of me are much cherished.

At the Smithsonian Institution Press, I would like to thank Ruth Spiegel, managing editor, and especially Amy Pastan for her enthusiastic support of this project. I would also like to thank Suzanne Winckler for her thoughtful copy-editing of the manuscript.

In Fort Worth, I am grateful to my former director, E. A. Carmean, Jr., for his support and encouragement of this project and for allowing me the when necessary, to give it my attention. A number of individuals have provided valuable assistance in preparing the final manuscript and in resolving the hundreds of problems such a task involves: Cathy Craft, Tariana Navas, Ruth Andry, Susan Colegrove, Andrea Karnes, Lindsay Joost, and Ashley Thames.

I have also benefited enormously from the generosity of a large number of individuals who have answered research questions, verified information, tracked down photographs or photographers, or otherwise provided important assistance: Richard Anuskiewicz; Kelly Bahmer, assistant to the registrar, the Cleveland Museum of Art; Sonja Bay, librarian, the Solomon R. Guggenheim Museum; Kristen Brock, assistant registrar, Norton Simon Museum; Anna Brooke, librarian, Hirshhorn Museum and Sculpture Garden; Roger Bultot, OK Harris Works of Art; Marcel Brisebois, director, Musée d'Art Contemporain de Montréal; E. Develing, curator of the Modern Art Department, Haags Gemeentemuseum, the Netherlands; Carol Corey, senior administrator, M. Knoedler and Co.; Eugenie Candau, librarian, San Francisco Museum of Modern Art; Anita Duquette, Whitney Museum of American Art; Elfie Elsenwenger, secretary, Kunsthalle Berne; Jill Hollifield, the Walker Art Center; Loretta Howard, Andre Emmerich Gallery; Milan Hughston, librarian, Amon Carter Museum; Carroll Janis, director, and Jeffrey Figley, Sidney Janis Gallery, New York; Harry Jones, senior curator, Oakland Art Museum; Brenda R. Jordan, archives assistant, the Houston Museum of Fine Arts; Penny Liebman, administrative assistant, the Jewish Museum; Elaine Lipson, curatorial assistant, the Chicago Museum of Contemporary Art; Robert McElroy; Bali Miller, New York; Ann Plumb, New York; Rachel Ranta, Curatorial Assistant, the Houston Contemporary Arts Museum; George Segal; Helene Scheffers, secretary, Stekelijk Museum, Amsterdam; Elizabeth Shepard, curator of exhibitions, Wight Art Gallery, University of California at Los Angeles; Clyde Singer, associate director, Butler Institution of American Art; Betty Vernon; William B. Walker, chief librarian, Thomas J. Watson Library, the Metropolitan Museum of Art; and Michele Wong, registrar, Grey Art Gallery, New York University.

Art in the Age of Aquarius, 1955—1970

Introduction

In the imprecise and elusive language of decennial histories, this could be said to be a book on the "sixties." As is true of the "nineties," the "twenties," or the "fifties," this inaccurate usage serves to gather together and delimit a constellation of ideas, attitudes, and events that, however contradictory they may have been, seem in retrospect to have constituted a common climate of feeling. "Turbulent," "frantic," "unbelievable," "freaked out," "swinging," and "permissive" are a few of the adjectives that have been applied to this extraordinary period. In the conservative seventies, the sixties are remembered (especially by those whose sympathies were neither with the artists nor the young) as the incubator of pornography, drugs, and dissent: indeed there is a great deal of truth in such a picture. Increasingly in this century, creative forces emerge in dichotomies and are, in part, destructive; their innate antinomies cannot be avoided in any reasoned account of these years. Yet the arts—from the acid rock concerts in San Francisco to the impeccable striped canvases of Morris Louis—were the flowers that grew from the rich, if sometimes contaminated, soil of the sixties.

To pin down the commencement of the "sixties" more accurately, one could cite the abstract paintings of Barnett Newman and Ad Reinhardt in 1950–53, Robert Rauschenberg's erasure of a drawing by Willem de Kooning in 1953, the first Jasper Johns painting of a flag in 1954, Allen Ginsberg's Dionysian reading of his long poem *Howl* in San Francisco in 1956, the exhibition *This Is Tomorrow* organized by the Independent Group at the Whitechapel Gallery in London in 1956, or the organization and European tour of the Museum of Modern Art's exhibition *The New American Painting* in 1957–

58. On the evidence of these and other events (and the recognition that most significant redirections begin underground or go unrecognized even when they are plainly visible), the "sixties" could be said to have begun in 1955, five years before the opening of the turbulent decade. In art, they could be said to have ended, perhaps, with the conceptualization and politicalization of modernism after 1968 and, historically, with the withdrawal of American ground troops from Vietnam in 1972.

Like a receiving antenna located at a single site, the viewpoint of this book reflects the situation and prospect of modernist art monitored in the United States and, more specifically, in New York. But for the sixties, as for the fifties, "New York" was as much an ideological as a geographical center. This is not, therefore, a book on American art; yet to say that it reflects every pocket of world modernism during the period surveyed would be grossly false. Such a scope is beyond both the intent and the knowledge of the author. To be exhaustively inclusive in writing about this copious period would be to assemble a catalog or dictionary. The time has arrived when choices must be made, some of which will of course seem arbitrary. It will be salutary to confess at the outset that the author's firsthand contact with activities in other world centers, though numerous, were those of an interested and concerned tourist, and that in many important instances were nonexistent. The prospect from London, Milan, Düsseldorf, Tokyo, Zagreb, or even Los Angeles would be a different, though not necessarily an unreconcilable, one.

It can nevertheless be stated without fear of serious objection that the period 1955–1970 was one of the most ebullient, diverse, protean, fragmented, and fascinating in the history of modern art, and that if there was any world center during this period it was New York City. The sixties produced a profusion of objects, images, events, and disembodied ideas, by turn beautiful and ugly, elevated and repulsive, profound and meretricious, at times challenging and at others merely absurd. It is a period in art, taste, and manner that will be researched and reevaluated long after this book has been forgotten.

As a result of the increasing speed with which historical time now evolves, by 1972 the sixties seemed already to belong to the past, not the present, whatever contributions these years may have made to current or future attitudes. Yet, when one has participated in varying degrees of intimacy with the personalities, activities, achievements, and absurdities of art during this period, when one has watched it unfold at close range month by month, it would be misleading to adapt the stance of a wholly "objec-tive" observer. One begins with inner personal dilemmas that augment the multiple contradictions that the subject itself presents.

Although I prefer to avoid the first person, in dealing with a subject as rooted in subjectivity as is modernist art, the median, "objective" stance may be a side effect of the alienating objectivity of science. This alleged objectivity was deplored in 1968 by Theodore Roszak, the least mind-blown of the champions of youth culture in the sixties, in *The Making of a Counter Culture.*[1] Approaching the disconcerting variety of rampant human creativity, no empathic writer can be wholly impersonal. And though he might wish to be both totally aware of his subject and nonprotagonistic, his view will be, to some degree, both parochial and fragmentary in observing a period that includes his own participation. To apply some "system" or "methodology" in dealing with the broad spectrum of this crucial period in modernism would be absurd; essential, however, is a faith in one's empirically based intuition—in one's radar or pattern recognition, to borrow phrases contributed to the atmosphere of the sixties by Marshall McLuhan.

Back in the distant fifties, at Princeton University, the literary critic and professor R. P. Blackmur used to sprinkle penciled dots at random on a sheet of paper and remark that the constellation of current ideas resembled a series of points around an unknown center. With certain locales of space and time, this illustration was always valid. But how much more apt it is for the sixties, in which the inclusiveness of the world of the arts was so great and its periphery so much larger—because there were so many more "points" to be plotted. It is difficult to occupy more than a few points simultaneously, much less the unknown center.

For one who is not a reactionary (and that includes anyone with an unqualified involvement in modernist art), *change* is the unavoidable condition of life. During the sixties, as Alvin Toffler in *Future Shock* (1970)[2] and many other authors demonstrated, social change accelerated exponentially, often bringing fear and trauma about the future in its wake. But to modernist art, change was a challenge, a source of joy more than of anguish. The modernist artist was always attuned to a value that the editors aptly chose for the title of the sole, but important issue of a journal that appeared late in the 1940s— *Possibilities.* Innovation, as a criterion of value, was overestimated in the sixties; *newness* and *relevance* became as central to judgment as *quality.* These first two criteria can be separated in the art of this period often only with difficulty, and toward the end of the decade the latter was declared invalid more than

once, but innovation and change were a central content in the art of the sixties.

In his chapter "The Myth of Objective Consciousness," Roszak derogates the scientific interpretation of politics.[3] What is true for political life is, a fortiori, true for the judgment of art. Any hope of establishing an objective or universally valid evaluation of the art of this or any other period is plainly false. Yet commentators on art, like those who deal with other unverifiable subjects, take for granted (or act as if) what they say is somehow "true," ignoring the glaring fact that the views of many of their peers plainly diverge from theirs. By its very nature art—especially modernist art—demands a subjective response if it is to be apprehended at all.

Indeed, in the dichotomies of our time, in the professional lies of advertising, in the absurd diatribes of evangelists, and in the abandonment of honesty by capitalist as well as communist governments, the very idea of truth may have been ground into obsolescence. Even to discover a median position—by which I mean a relatively unbiased view arrived at though both feeling and reason—is all but impossible. Yet such an open attitude is the first step in an understanding of modernist culture. But change, innovation, aesthetic subversion, ideological revolution, what Tom Wolfe called "radical chic," redirection, deviation, and a bottomless Pandora's box of provocative ideas and gestures (almost always countered from other quarters), have been the lifeblood of twentieth-century art, the stuff of masterpieces as well as messes.

To expand this intellectual predicament further, even worn and plainly outdated modes must not be utterly dismissed, for the old is repeatedly revitalized by infusions from the new: it is axiomatic in art that they coexist and interact. In trying to rise above brute documentation and reportage to a more meaningful level of examination, speculation, and evaluation, moreover, one must avoid being stampeded into insufficiently considered reactions against clichés and fashions as well as being dominated by them. There are two forms of "intellectual subservience to another mind," David Hackett Fisher wrote in *Historians' Fallacies:* "slavish imitation and obsessive refutation."[4] What is true of a response to a powerful individual is also true in reacting to the characteristic sensibility (when it can be discovered) of a month, a year, or a decade.

The Disintegration of the Postwar Synthesis

I

The Dissolution of Gestural Abstraction

In a keynote address delivered in 1957 at a conference in Houston, Texas, devoted to *The Creative Art*, the eminent art historian Meyer Schapiro spoke fervently about works of painting and sculpture as the "last handmade, personal objects within our culture. . . . The object of art is," he informed an audience that hung on every word, "the occasion of spontaneity. . . . The consciousness of the spontaneous . . . stimulates the artist to invent devices of handling, processing, surfacing, which confer to the highest degree the aspect of the freshly made. Hence the great importance of the mark, the stroke, the brush, the drip. . . .and the surface of the canvas as a texture and field of operation."[1] The kind of art to which Schapiro referred was that best (though not very precisely) known as "Abstract Expressionism," "Action Painting," and in Europe as "Tachisme," "Art Informel," and "un Art Autre."

As has been stated repeatedly since 1951, when Robert Coates used the term "Abstract Expressionism" in the *New Yorker* (the term by which Alfred H. Barr, Jr., in 1929 had characterized the early paintings of Kandinsky), it was a misleading label. More accurate, but still inadequate, might have been "Cubist Surrealism," for these were the two contradictory historical influences on one wing of the postwar New York School. But the term that caught on did, at least, point to an attempt, unpremeditated and never formulated, to merge two streams previously separate and antithetical. Radical Abstract Expressionism's break with the past (especially in rejecting most of the pictorial means of realism as well

as geometric abstract painting) was nevertheless rooted in tradition. As the artists said in public statements, they placed a high value on everything personal, and though they banded together to demand recognition, they refused to regard themselves as members of a school or movement. As the judgment of the masters and masterworks of this period became clearer, one of the period's achievements was apparent: Abstract Expressionism was a valiant attempt to inject maximal human and metaphysical content into abstract form. In both Europe and the United States, the fifties may have been the last heroic stand of traditional romanticism.

In the long history of Western dualistic responses to existence, these artists provided an essential epilogue through their synthesis of abstraction and humanism, structure and emotion, flatness and depth, planning and spontaneity. Vital ambiguity, even vagueness, became for them a cherished value. They gambled on intuition, inspiration, improvisation, and automatism and on the concepts of the unconscious, the heroic, the sublime, and the unknown. The Abstract Expressionist proceeded, as Robert Motherwell said of himself (quoting the Surrealist Max Ernst) "like a blind swimmer." Commitment to the integrity of art (nobly exemplified by their close precursor Piet Mondrian, who came to New York in 1940) animated their brushes, behind which was a dedication to serious, important painting and to revealed "truth"—subjective, existential, or transcendental—concerning the self, man, and nature. They related negatively to the commercial environment, and in their art remained aloof from the humdrum surface of life, from politics, financial success, and social status. Art was still (to borrow the title of the first book on Hans Hofmann, published in 1948) a "search for the real." [2] Until the unpremeditated international dominance of the movement—and the resultant bull market raised the value of its best works fifty times in little more than a decade—these were in every sense artists of the avant-garde.

A full-dress (though thinned and adulterated) exhibition, under the title *The New American Painting,* was in preparation during the year of Schapiro's address. [3] It toured Europe triumphantly during 1958 and 1959, generating a heady atmosphere composed, in almost equal parts, of admiration and disparagement. The results of this and other exhibitions, compounded by an unprecedented escalation of art publishing and the promotion of what was still regarded as avant-garde art by the media, was the most pervasive international style of painting the world had ever witnessed. Loosely brushed, abstract or semi-abstract, it penetrated every civilized country where it was not prohibited by decree. It could

be found in Israel, Spain, Japan, India, and, because their communist or fascist governments were not as repressive as those in the Soviet Union or East Germany, in Poland and Yugoslavia. The outcome, as the Israeli sculptor Kosso Eloul once called it, was a global "echo art."

Thus the official tour of *The New American Painting* marked not only the triumph of the postwar style, but also, ironically, its decline as a viable aesthetic and the diminution of the concept of these art works as defiantly handmade, personal objects. The free, dripping brush became an art-school commonplace; the young artists who were students in the fifties could neither maintain the previous generation's level of achievement nor extend (at least within the formal limitations they accepted) its premises. The originators of New York School painting and sculpture had been forced to devise new forms appropriate to their convictions and feelings in rejecting both the social outlook and realistic style of the thirties. The second generation unavoidably fell heir to an established procedure and "look," and to museums and libraries full of prototypes. They began, consequently, with *form* rather than *content,* at the same time breathing an ideological atmosphere vastly different from that in which Abstract Expressionism arose.

To retrace the intrinsic sequence of a period or milieu, as distinct from its surface chronology, one must attend to *evolutionary relevance:* to "entrances," viable continuities, deflections, and "exits." The public world of art is, quite demonstrably, a stage on which, experience tells us, the curtain can fall. There is consequently a "right time" for an artist or an idea to appear. If an entrance appears too early it can be stillborn; too late, it is anticlimactic for those prepared for it earlier, but, for just that reason, it may reach a larger public. To whatever degree continual change may be promoted or impeded by opposing protagonists, or its directions applauded or deplored, it is inseparable from modernist art, even though its effects often strike disastrously at the lives and beliefs of individual artists. The uniqueness of each artist arises from the matrix of his or her formative years. If the artist is able to make a favorable entrance, stand the gaff, and develop in a world of conflicting pressures and possibilities, he or she may break free from yearly change and fashion to achieve a more secure plateau and a broader historical consequence. Like Monet, Hopper, Calder, and Miró, he or she then surmounts the choppy waves in which less assured, more vulnerable, or inferior artists (and those who have suffered as much from bad breaks and the callousness of taste as from their own limitations) flounder, shift direction with every stylistic

eddy, or are finally washed up on the beach to live outside the tide of history. Some artists enter the scene too early or too late, so their most inspired efforts are ignored, tolerated, or dispensed with. Some are finally understood a generation or even a century later.

The engrossing, revelatory study of creative evolution in art can be forbiddingly impersonal. Not only can it deflect attention from the artist as an individual (for he or she is a person of soul, flesh, and blood, not a historical relay point), it can also confer value on apparently trivial phenomena. Advocates of sequential theories often assert that their observations have nothing whatever to do with "quality," which is decided by innate powers of judgment. But can this allegedly ultimate value, so difficult to isolate and determine, be separated from that placed on developmental or contextual relevance? This dilemma cannot be resolved, but it should nevertheless not be glossed over.

The emergence of an aware, original, intelligent, and courageous artist is a dramatic and effectual entrance, yet it is by no means the only kind. Combustible ideas, fresh perceptions, and truly (or apparently) seminal forms can come from any quarter: from the past or present, from scholarly journals or tabloids, from the establishment or the underground, from circles of advanced study or the media, from philosophers or publicists. Latent ideas, during this age of instant communication, can surface unexpectedly, adulterated but energized. Such entrances often subvert established values, eating away like termites at the platforms on which established achievements rest.

Such was the case with the banal image of the American flag painted by Jasper Johns in 1954, a seed work of an altered sensibility that rejected in toto the heroic, autohistorical premises of Abstract Expressionism. By accepted criteria, it was hardly a painting at all. Instantly recognizable, it was neither abstract nor representational, for its model, which exists in the memory, was conceptual—the more so because the edges of the flag were also those of the canvas on which the blue field, white stars, and stripes of white and red were painted. Unlike the soft, fluttering image one associates with the flag, but like a parody of an abstract painting, the divisions of the rectangle were rigid and would have appeared entirely mechanical had not the tremulously painted surface, applied in nuanced strokes over a collage of newspaper in the ancient medium of wax encaustic, been "handmade" and "personal" enough to identify it as a painting. The simple divisions of the surface were arbitrarily predetermined, obviating the intuitively determined asymmetrical rela-

tionships that then seemed the sine qua non of abstract art. The "subject" (if it can be so identified) plainly had no reference to either patriotism or even disrespect (though it looked different after years in which the flag became a controversial symbol).

Between 1955 and 1958 the flag motif, painted, drawn, and cast in bronze, as well as similarly common images of targets, alphabets, words, numbers, light bulbs, and flashlights in plaster and sculpt-metal (figs. 1–7, pl. 1), made Johns's reticent but

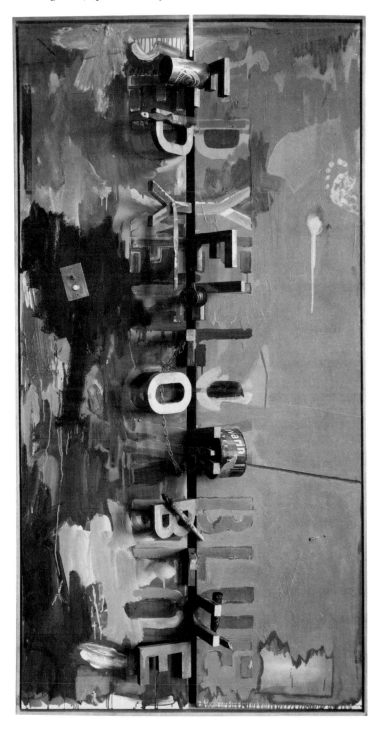

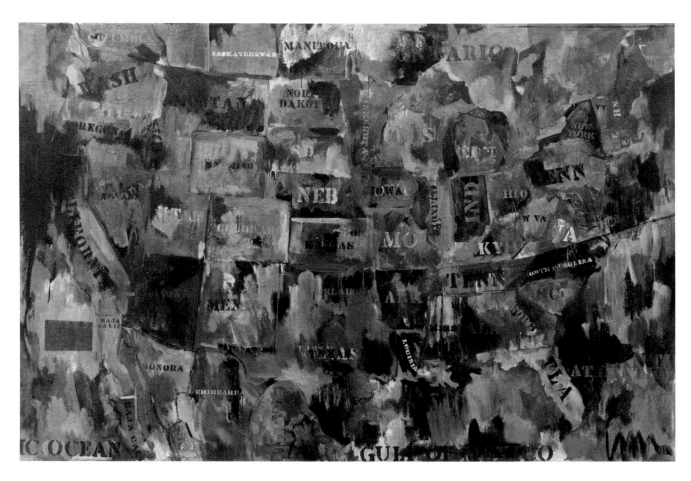

deflating comments on the art of this period more explicit. To emphasize only the aesthetic subversiveness of these early paintings and objects so admired by Alfred Barr, Robert Rosenblum, and others when they were first shown, and to ignore their inherent artistry and appeal to vision and intellect, would be to present them falsely. One of their effects, intentional or not, was to pull the plug on the pretensions of Abstract Expressionism. Such works, of course, were not the only evidences of change.

Unintentionally, writers on Abstract Expressionism such as Harold Rosenberg, who flamboyantly likened the canvas to an arena in which the artist acted out his destiny with pigment, had already undermined the vitality of the movement by journalistic overdramatization and packaged it for art-school and provincial consumption. The next year Robert Rauschenberg approached de Kooning, whose influence was then at its height, to acquire a drawing from him that, the younger artist admitted, he planned to erase.[4] In recalling the incident more than fifteen years later, de Kooning confessed, with his characteristically inverted logic, that, though the request was annoying, he nevertheless felt he should provide one of his *best* drawings for obliteration rather than a discard. Rauschenberg's ambiguous gesture, combining admiration and extirpation, recalls Marcel Duchamp's addition of a moustache to a print of the *Mona Lisa*. Signed by the obliterator, this shadow-drawing makes its own comment on tradition. Placed in the context of his later works, Rauschenberg's neo-Dada gesture can be seen as an early challenge to the authority of the movement de Kooning personified.

In 1961, when H. H. Arnason organized an exhibition called *American Abstract Expressionists and Imagists* for the Solomon R. Guggenheim Museum,[5] it was a belated realization of a division in the New York School that had existed as early as 1950. Among the primary figures, de Kooning, Hofmann, and Franz Kline maintained the psychologically expressionistic and responsive brush as a primary means. By 1947 Jackson Pollock had abandoned the direct connection of mind, feeling, brush, and pigment for poured enamel animated by movement of the entire body; Clyfford Still applied paint to his jagged-edged planes with a palette knife; Mark Rothko limited his freedom of the brush to modulation of flat color planes and the softening or fraying of their edges (pl. 2); and Newman (except for the

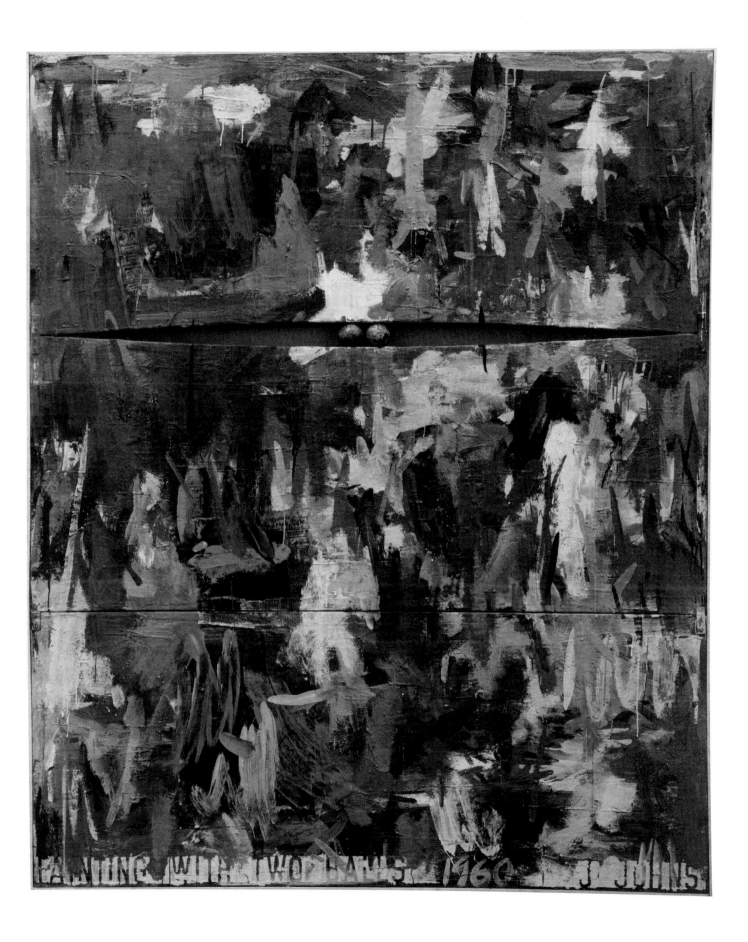

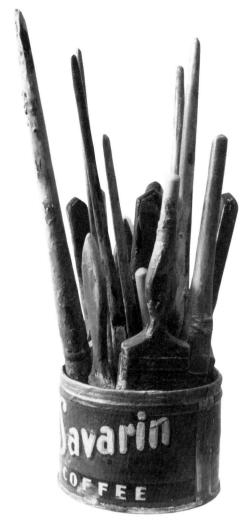

4

Jasper Johns, *Painted Bronze*, 1960, painted bronze, 13½ in. height × 8 in. diameter (34.29 × 20.32) © Jasper Johns/VAGA New York 1990. Photo by Rudolph Burckhardt.

5

Jasper Johns, *The Critic Sees*, 1961, sculpmetal on plaster with glass, 3¼ × 6¼ × 2⅛ in. (8.26 × 15.88 × 5.39 cm) © Jasper Johns/VAGA New York 1990. Photo by Rudolph Burckhardt.

6

Opposite, top: Jasper Johns, *Bronze*, 1960–61, bronze, 11½ × 6¼ × 3½ in. (29.21 × 15.88 × 8.89 cm) © Jasper Johns/VAGA New York 1990. Photo by Rudolph Burckhardt.

roughened edges of certain of his vertical lines or "zips") applied flat multiple coats to his huge color fields, all but eliminating any record of the mode of application (fig. 8). It is now clear that the rejection of gestural abstraction by these painters after 1947 was a corollary of other crucial redirections: the abandonment of the closed underlying structure of asymmetrically disposed elements along with the influence of Mondrian and the Cubist tradition, and the adoption (with the exception of Rothko) of a new, laterally expanding, and unlimited space marked, by 1950, by the enlargement of the painting surface (as in Newman's *Vir Heroicus Sublimis* or Pollock's *Autumn Rhythm*) to widths of sixteen or seventeen feet.

Open versus Closed Form

The rediscovery of the late paintings of water lilies by Claude Monet, and the subsequent reassessment of his place in the modernist tradition, was the final contribution of the Abstract Expressionist period. During 1955 Alfred Barr was negotiating the acquisition of an immense Monet canvas, almost twenty feet wide, related to Monet's water landscapes in the Orangerie of the Tuileries, for the Museum of Modern Art, where he was director of the collections.[6] As John Canaday demonstrated in his survey *Mainstreams of Modern Art* by comparing this mural panel with Pollock's *Autumn Rhythm*, which is almost as large, a real affinity existed between the two canvases.[7] Aside from the references to nature in certain

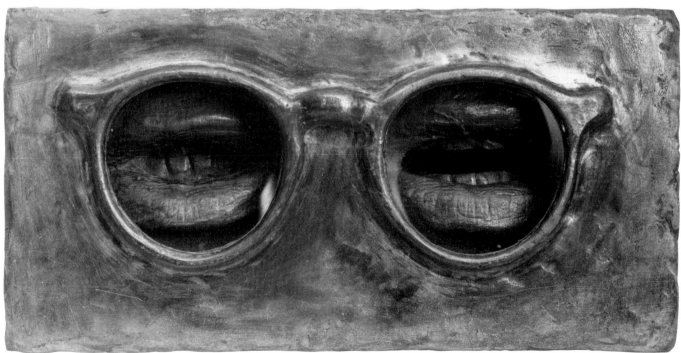

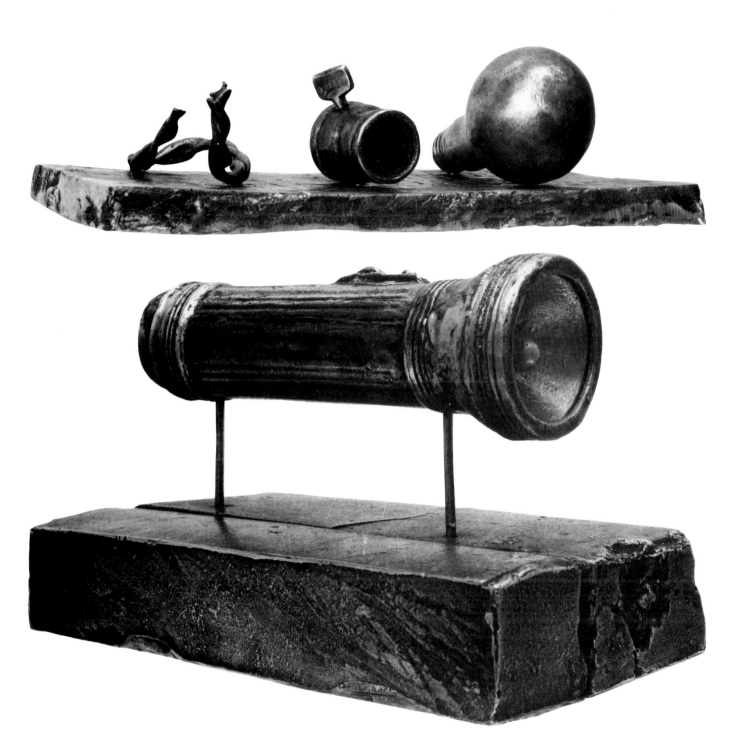

of Pollock's large dripped pictures, the three most striking parallels between Monet's water lilies and New York School painting were (1) Monet's sweeping, arm-scale brush strokes that appeared abstract when seen from close range, (2) the unprecedented size of his canvases, and (3) their expanding openness of composition. In planning the two oval rooms in the Orangerie, Monet conceived a total environment within which the sky and pond became one encircling medium. The vertical canvas and horizontal

water surface (in which cloud reflections are inverted) merge. The four lines of the frame were therefore not to be seen as a delimitation. Like one segment of a Buckminster Fuller global map seen from the inside, Monet's image postulated an encompassing perceptual experience within which the subject's location (unlike the perspectival geometry of Renaissance space representation) is indeterminate.

Post–World War II painting was a synthesis of structure with improvisation and, on the level of

7
Jasper Johns, *Flashlight*, 1960, bronze and glass, 4⅞ × 8 × 4½ in. (12.38 × 20.32 × 11.43 cm) © Jasper Johns/VAGA New York 1990. Photo by Rudolph Burckhardt.

8

Barnett Newman, *Covenant,*
1949, oil on canvas, 47¾ ×
59⅝ in. (121.29 × 151.45 cm).
Hirshhorn Museum and Sculpture Garden, Smithsonian Institution, Washington, gift of
Joseph H. Hirshhorn, 1972.

content, of *conception* with *expression.* The rediscovery
of Monet and late Impressionism in 1956 advanced
perception as an escape from this dualism. Moreover,
the acquisition of the large Monet canvas by the Museum of Modern Art followed the publication of Aldous Huxley's books *The Doors of Perception* (1954)
and *Heaven and Hell* (1955), which seemed to offer an
unprecedented means to expand consciousness, and
even a promise of salvation, through what later were
termed "psychedelic" drugs. In the second book,
Huxley recalls a conversation with Roger Fry, the
most eloquent spokesman for Cézannean structure,
about Monet's water lilies. " 'They had no right,'
Roger kept insisting, 'to be so shockingly unorganized, so totally without a proper compositional
skeleton.' 'And yet,' he had to admit, 'and yet. . . .
And yet, as I should say now, they were
transporting.' "[8]

The Monet-Pollock parallel was worried, during
the sixties, to the point where it was almost made to
seem that somehow, almost a decade before the appearance of the large water lily painting in New
York, Pollock had submitted to Monet's influence,
although there is not the slightest indication that
Pollock studied his work at any time.[9] What makes

better sense is a reversed relationship: it was Abstract Expressionism and Tachisme that occasioned
the reevaluation of Monet. The all-over, relatively
non-focal treatment, initiated by Mark Tobey in
1936 and by Pollock, Bradley, Walker, Tomlin, and
Reinhardt a decade or so later, had already begun to
undermine Cubist-derived closed space in the forties, a period in which Monet, the archetypical Impressionist, was still denigrated as a pseudoscientist
straining to copy sunlight with strokes of paint "direct from the tube." It was the inner pressure of Pollock's expulsive personality and the impact of
Surrealism, automatism, and Jungian analysis that
led him to a radical technical method that literally
exploded the dictatorship of the frame and closure of
Picassoid Cubist space. His abandonment of the
brush for mobile, fluid application, necessitating the
placement of the unstretched and unprimed duck on
the floor, brought about an immediate liberation.
These innovations, of which *Number 1, 1948* (fig.
9), and *Lavender Mist* (pl. 3) are exemplary, were
complete by 1950, a critical year for the displacement of Cubist influence. If the "aesthetic ideal" of
Abstract Expressionism, as Robert Motherwell
stated shortly afterward, was a "looser 1911 Cub-

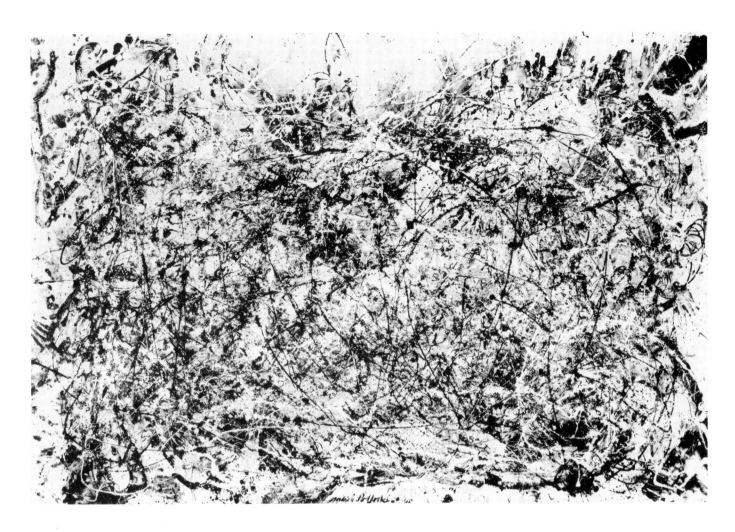

ism,"[10] the loosening process was already well advanced.

Also by 1950, the French painter Georges Mathieu had initiated his highly personal style of "autonomous liberty," in which "expressivity alone" counted. Although Pollock surely liberated him, as he did many others, Mathieu's explosive calligraphy was implicit by 1945. He programmatically renounced geometricity and still life and landscapes subjects in favor of a convulsive, abstract lyricism. Mathieu, in both his painting and flamboyant personality, provides a bridge between the quite different attitudes of the fifties and sixties. More than Hofmann, Kline, or de Kooning, he was an "action painter." Indeed, he may deserve recognition as the world's fastest executant. Squeezing pigment direct from the tube, he was able to complete a twenty-foot canvas in an hour. He preferred to work in public, dressed in pseudo-medieval costumes legitimized by his Almanach de Gotha lineage. Like the showman Yves Klein, whom he regarded as an enemy, Mathieu viewed painting as performance—an anticipation of the "happening." During a single week in

New York in 1956, using the basement of the Ritz Hotel as a studio-stage, he painted an entire exhibition for his dealer Sam Kootz before selected audiences. Early in the jet age, the exhibitionism of this showman, who spurted his "gestures in the void" at a speed comparable to the movement of ideas across oceans, has an amusing relevance.

Pollock, Mathieu, and André Masson (an influence on Pollock and one of the discoverers of late Monet) all contributed to the dissolution of closed form via their calligraphy and all-over style, while at the same time Still and Newman accomplished the same task by different means. Newman was the only one among the first-generation New York School painters to publicly identify with Monet and Impressionism and, as noted, by 1948 was painting large, flat surfaces divided by one or more tremulously ruled stripes more like jet streams across the empyrean than divisions of a rectangle (fig. 8). Still, using a rough palette knife application, ungainly shapes, and torn edges, also painted on large surfaces that, like oceans, islands, cliffs, and glaciers viewed from above, seemed to spread laterally, beyond the

9
Jackson Pollock, *Number 1, 1948*, 1948 oil and enamel on unprimed canvas, 68 × 104 in. (172.7 × 264.2 cm). The Museum of Modern Art, New York, purchase.

limitations of the canvas (fig. 10). Therefore, it was the move toward expansiveness and large size, rather than the active brush, that was redirecting their modernist art. Sharing a polemical anti-historicism that renounced Cubism, Newman, Rothko, and Still had much in common by the early fifties, although Rothko—the most original colorist of his time but concerned with content, except for a few late works, rather than form—was never to abandon lateral containment of his symmetrical images.

In addition to the encouragement of open form, the later works of Monet (exhibited in major exhibitions in 1957 at the Edinburgh International Festival and the Minneapolis Institute of Art) complement the redirections of the late fifties in other ways. During that year, the critic Clement Greenberg compared the flattened three-dimensionality of early Cubist painting (still "Impressionist" in its brush stroke) with Monet's coloristic flatness achieved by "suppressing value contrasts, or rather by narrowing their gamut."[11] Both ended up, he continued, "on the surface: only where he arrived at a shadow of the traditional picture, the Cubists arrived at a skeleton." De Kooning, Kline, Mathieu, Pierre Soulages (fig. 11), Hans Hartung, Fritz Winter, and other Abstract Expressionists and *Tachistes* emphasized contrast of light and dark tone more than color. Hans Hofmann, following his desire to embrace divergency, employed both tonal and coloristic relationships. However, it was Milton Avery, and, in his earlier close-valued landscapes, the American Impressionist John Henry Twachtman, who anticipated the concern for purely coloristic distinctions, often so subtle as to be invisible to the chance spectator and carried to an ultimate point during the sixties. The influence of Avery on Rothko and Adolph Gottlieb (an homage that later perhaps moved in the opposite direction) was profound. By 1954, moreover, Morris Louis had painted the first of his large canvases, which he produced by soaking acrylic resin colors into unprimed and unframed duck. Following the precedent of the dripped paintings of Pollock and a fluid work in oil of 1952 by Helen Frankenthaler, *Mountains and Sea* (fig. 12), Louis was able to implement what Greenberg called his "impressionist revelation" as well as his "revulsion against Cubism."[12]

As significant as the influence of Monet was the invention of acrylic resin pigment by Leonard Bocour; indeed, its gradual introduction into painting technology is comparable in importance to that of oil painting in the fifteenth century. Bocour was already supplying paint to Louis in the thirties and by 1947 was distributing his new colors, known as

Magna, to other artists for experimentation. Although acrylic resin pigment was also used later for dead-flat, hard-edge work, and even for heavy impasto, one of its first effects was to make possible, by means of soaking into raw duck, watercolorlike qualities previously unavailable, difficult, or impermanent in the oil medium.

What Greenberg called the "broad, daubed scribble in which the Water Lilies are executed"[13] also served what was often referred to as Abstract Impressionism: a utilization of freely brushed but close-valued color or tone toward less athletic ends than those of de Kooning, Kline, or Hofmann. Suffused in pale-fire luminescence, Philip Guston's pictures of 1951–54 were atmospheric and mystical in effect, with close color values and a loose plus-and-minus stroke. Guston was not, it seems clear, a follower of Monet; yet it is of interest that a pre-Cubist geometricity was present in many of Monet's paintings of the 1890s (especially the Poplars and the Rouen Cathedral series, and in the Venetian palace facades begun in 1908). Monet distilled from landscape and architectural subjects a plus-and-minus "skeleton" that may well have influenced Mondrian. Independently, in 1956, both Leo Steinberg and the author pointed out this parallel, which, it appeared, had already been observed in 1948 by Charles Biederman, a painter, theorist, and follower of Mondrian. Also in the late fifties, Richard Pousette-Dart began to granulate his images until, beginning in 1960, he arrived at a style suggesting outer space or night skies, in which all-over encrusted touches of thick pigment pulsated, as in the Monets of the 1890s, like crushed jewels. Although a few other, mostly inferior, painters borrowed directly from Monet's water lilies, only one—Milton Resnick—was able to use this stimulus for major, successful pictures. A friend of de Kooning and collaborator on his well-known backdrop of 1946 called *Labyrinth,* Resnick painted several large major works between 1959 and 1961 with an openness of form and a terse, cursive stroke that projected the implications of the water lilies into the 1960s. By the time these were shown at the Howard Wise Gallery, unfortunately, the monitors of the art scene were bored with gestural art. It was not until late in the sixties, indeed, that the importance of these works, and of Resnick as an artist, began to be recognized.

Thus what can be called Abstract Impressionism involved a use of the stroke or touch for more sublimated, less expressionistic ends than Action Painting. Such a transformation can be followed earlier in the paintings of Pollock, beginning with the disturbed, Picassoid, and surrealistic images of the late thirties and early forties (which had titles such as

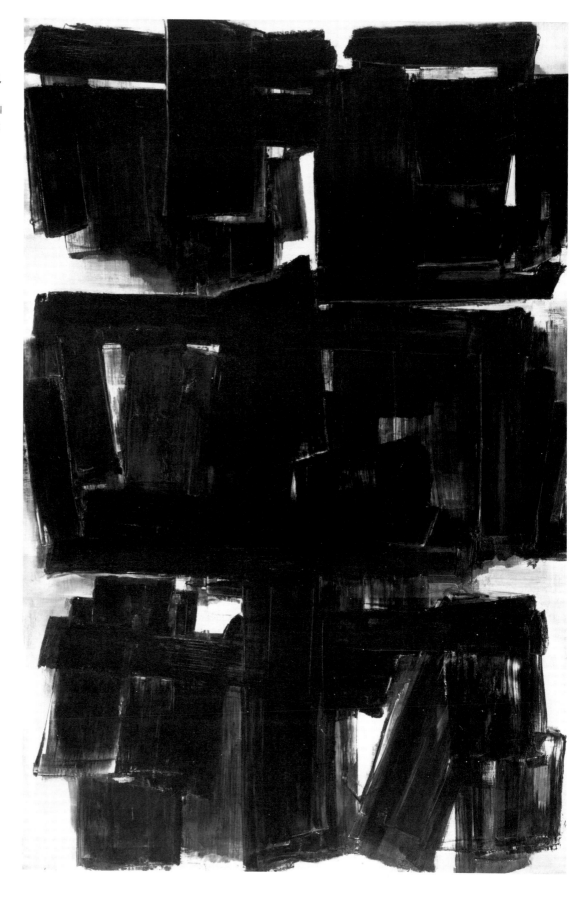

11
Pierre Soulages, *Painting,* 1957,
oil on canvas, 76¾ × 51⅛ in.
(194.95 × 129.86 cm). National
Gallery of Art, Washington, gift
of Morton G. Neumann.

The Flame, Totem, The Key, Night Ceremony, Masked Image, Pasiphaë, The She-Wolf) to the all-over, painterliness of *Shimmering Substance* (1946), and the next year, the psychically more distanced poured style.

Negatively revealing, in terms of the "Impressionist" sublimation of brush before 1960, are Johns's early encaustics. The surfaces are built up with delicate, translucent strokes, the earliest of a single tonality, but drained of every vestige of association with the stereotype of "self-expression" or the slightest identification with nature. Conceptual and detached, their references are to the hermeneutics and history of art: the issues they raise are perceptual, conceptual, and ironic. Although Still, Newman, and Rothko had initiated a sharp break with the autographic use of the brush and with painterly, improvisatory, and calligraphic means, washes and scribbles (though entirely changed in meaning) were not wholly obliterated by the sixties; they return, around 1967, in what was known as lyrical abstraction.

The biological concept of movements, styles, and periods, with its implications of cycles of birth, life, and death, is misleading, for the intertwining sequences of art constitute an ongoing transformation in which new elements continue to be added, old elements are retained or revised, while others, like worn clothes or outdated customs, are discarded. Styles and ideas overlap, exist simultaneously, blend with, and color each other. It is difficult (though perhaps not impossible) to murder them from the outside.

The conclusion of the fifties was punctuated by the arrival in New York of the antimodernist critic John Canaday, formerly a museum art-history teacher and curator of education, as "Art Editor" of the *New York Times*. Appointed by himself, if not his employers, as a knight in shining armor as well as an art critic, his inaugural article, dated September 6, 1959, was a vehement attack on Abstract Expressionism.[14] After an escape clause conceding that the "best abstract expressionists are as good as ever they

were," his blade, freshly drawn from its sheath, slashed left and right against the freaks, the charlatans, and the misled who allegedly surrounded this handful of serious and talented artists. Their existence was blamed on teachers, curators, critics, and the innate attributes of Abstract Expressionism that allowed "exceptional tolerance for incompetence and deception." In a subsequent rebuttal to one of the letters from readers offended by his onslaught, he deplored a "situation built on fraud at worst and gullibility at best."

In subsequent commentaries, Canaday revealed himself as an adversary not only of a movement in decline but also of modernism in general. "The chaotic, haphazard and bizarre nature of modern art is easily explained: the painter finally settles for whatever satisfaction may be involved in working not as a member of a society that needs him, but as a retainer for a small group of people who as a profession or a hobby are interested in the game of comparing one mutation with another." [15] "The assumption that young painters should be encouraged is absurd and in the end vicious," he wrote at just the time when artists of thirty or under were beginning to look like good investments. "They should be cut down in battalions, on the principles of weeding and pruning to allow the ones with vigor to rise again." [16] In the long line of denigrators of the modern movement that began with the critics of the Impressionists, Canaday occupied his prestigious post, something of an anachronism, throughout the sixties—the Spiro Agnew of art criticism.

The Crisis of Idealism

Like the European *Tachistes,* the artists of the New York School of the forties and fifties maintained a heroic and metaphysical view of art, still rooted in Romanticism. Hans Hofmann's wholly idealistic theory, which he had deeply internalized, fused northern European nature philosophy with the structural principles of Cubism and the freedom of color of the Fauves. In this sense, his art is an extension, pressed forward until his death in 1966, of a belief in art as a revelation of natural forces and of man as a part (or protagonist) of nature. Still, Rothko, and Newman, as Robert Rosenblum demonstrated, [17] translated into abstract terms the lofty, essentially tragic idea of the "Sublime," which the eighteenth-century statesman, philosopher, and aesthetician Edmund Burke held to be a value superior to beauty as an aim of art. For example, as Brian O'Doherty has shown in *American Masters: The Voice and the Myth in Modern Art,* [18] the lone figure por-

trayed in Caspar David Friedrich's tragic paintings of sea and mountains is actualized by the live observer of Rothko's soft-edged rectangles. In all of their statements, private as well as public, Still, Rothko, and Newman expressed their immersion in tragic human and natural content rather than form—an unwavering involvement minimized by the formalist criticism of the sixties. Their rejection of European influences notwithstanding, the expressionistic and transcendental aims of these artists share a common tradition with the views of Mathieu, Soulages, and other European *Tachistes.* They are separated from these artists, most evidently perhaps, by the last-ditch intensity of their beliefs and the radical new pictorial means they employed.

These values, which many still see as inseparable from art in its fullest meanings, and which began in the Romantic landscapes of Friedrich and Turner, may have come to an end with the careers of these painters. The idea of abstract art as a revelation of a "higher" or "inner" reality was forgotten, or dismissed as metaphysical cant, by the artists and critics that best typify the sixties, and who read Wittgenstein, Merleau-Ponty, Robbe-Grillet, and Lévi-Strauss, rather than Sartre, Kierkegaard, Whitehead, or the Romantics. In this striking, almost universal rejection of the lofty beliefs, aims, and intuitions that still animated the fifties, the new artists surely exemplified a more widespread decline of belief. The detached, nominalistic skepticism of the sixties permeated the entire intellectual establishment. What used to be called "philosophy" was taught only in departments of religion. It was the Youth Culture that, in defiance of the operational pragmatism and moral relativism of an entire society, initiated after 1965 an upsurge of nonrational and idealistic involvement so instinctual and unconformable that it ended in its own destruction.

The Absorption of the Avant-Garde

It was 1962, the year in which Pop art became the prevailing mode, before anyone among the hundreds of salaried "avant-gardists" in the universities, museums, and other institutions that support the arts, gave voice to a realization that the century-long period properly known as that of the avant-garde, during which the work of vital artists was either ignored or met with hostility, had been ended for at least a decade. It was during the spring of that year, in preparing for a symposium held at Brandeis University on *The Role of the Avant-Garde,* that this observer, then a curator at the Museum of Modern Art, faced the fact that it is impossible to have a greater

demand than supply for what was still seen as a re-
jected commodity: innovative modernism. These
views were enlarged in an article in September
1963, "The Rise and Dissolution of the Avant-
Garde," [19] that spelled out the stages in the accept-
ance and patronage—curatorial, academic, and
financial—of art forms and activities often far more
unacceptable than the disdained paintings of the
nineteenth-century Realists and the Impressionists
with which the bourgeois rejection of modern art
began.

"The modern art we most admire today," this ar-
ticle commented, ". . . was the outcome of aliena-
tion from society, and an absence of patronage. . . .
Today . . . rupture seems to be healing: *we are wit-
nessing the absorption of avant-garde into 'The American
Way of Life.'* Why should we be surprised that some
of the less attractive marks of our society—a craving
for kicks, exaggeration of the profit motive, the
preference of publicity to truth, the scramble for sta-
tus, a continual search for divertissement—are adul-
terating the product in the process of absorption?" [20]
Belated though this realization seems today, the idea
that so-called avant-garde art was no longer a radi-
cal, beleaguered venture bereft of public, patrons,
and financial support still had the ring of a fresh
insight.

The following summer the austerely British *Times
Literary Supplement,* emphasizing literature, devoted
a large supplementary issue to the "Changing
Guard." It is rather surprising that the recognition
in print of the changed situation did not become
more widespread in the following five years, during
which the clamor for innovation, redirection, and
neo-avant-garde shocks began to subside only when
certain artists, increasingly unwilling to collaborate,
tried desperately to evolve objects, events, and situa-
tions that would be unacceptable. It was at issue,
however, in Irving Howe's *Literary Modernism* in
1967. Renato Poggioli's useful book, *The Theory of
the Avant-Garde,* appeared in English in 1968, a
posthumous translation of the Italian original edi-
tion of 1962. Poggioli saw avant-gardism as a situa-
tion still operative, probably because he died in
1963, unfamiliar with what had happened in the
United States by the year of his first English publi-
cation. Other articles followed, among them Harold
Rosenberg's *New Yorker* piece "D M Z Vanguard-
ism" [21] (1968). The cycle was completed, if only
temporarily, by Hilton Kramer's *The Age of the Avant
Garde* (1973). [22]

So universally accepted, indeed, did the ideas of
the end of the century begun by Courbet's Pavilion
of Realism in 1855 and the exhibition of Manet's *Le
Déjeuner sur l'herbe* at the Salon des Refusés in 1863

become, that one began to wonder if such was in fact
the case, or whether the extreme modernist, always
alert for strategems that would project his gestures
beyond what was accepted as art, had simply
changed the terms of the game: now it was the gal-
lery, the collector, the museum, and the curator who
were spurned rather than the artist. It was in 1969
that, following the social theories of Herbert Mar-
cuse, Gregory Battcock argued that the only truly
radical art was hard-core pornography or materials so
boring as to discourage extended attention. [23]

In an editorial in *Art in America* in 1971, "What
Is Post-Modernism," Brian O'Doherty used the term
"post-modernism"—"a word that came into com-
mon usage in the late sixties," accepting as a histori-
cal fact the idea that "the modernist era (1848–
1969?) is over." The tradition of modernism,
whether seen from a formalist viewpoint—as a re-
flective sequence of reductions from the figurative
avant-gardism of Manet—or as a self-conscious and
polemical anti-bourgeois stance becomes, in this
reading, all but inseparable from the idea of the
avant-garde. "Modernist art," O'Doherty wrote, "re-
sulted from the exploitation of contradictions, or
from an escape into an absolutism which such con-
tradictions simultaneously promised and revoked."
Modernism ended when the unexpected no longer
arose from the expected territory; in post-modernism
"all the strategies of modernism have become highly
conscious." [24]

The pressures of the early sixties were never more
evident than in their power to devalue previously
crucial ideas and commitments. The outcome, once
the contradictions of modernism were reduced to
calculated procedures, was a dumb anger and a "dis-
taste for the habits of mind that could bring art to
such a pass." Yet, in a post-avant-garde period, the
history of art is not necessarily made by what ap-
pears to be the cutting edge of change at any mo-
ment, and the state of art, if not modernism, is not
necessarily that melancholy. A great deal can be
found on the following pages that will lighten such
a judgment, as well as much that will support it.
O'Doherty's diagnosis as of 1971 does serve at the
least to punctuate the rapid cycle of changes in the
social and philosophical orientation of innovative art
during the sixties, placing a full stop (until the line-
aments of a new historical period take shape) to the
beliefs, principles, and forms that energized the art
of the fifties. The masters whose works and thoughts
initiated a synthesis of traditional and avant-garde
values may well have been the last Romantics, the
last idealists, and, until an appropriate word is
found for the alienation of the seventies, the last
avant-gardists.

The Inchoate Threshold

2

The years 1959–1961 were an auspicious (or for some perhaps calamitous) introduction to a wild, bizarre, and feverishly animated decade in the arts, a period during which innovation thrust outward in every direction that can be imagined or was even hinted at in the works and papers of the avant-garde movements of the past.

Sixteen Americans—second to the last of a perennially controversial series of exhibitions organized for the Museum of Modern Art by Dorothy C. Miller—bridged the beginning of the decade and can serve as a point of departure (figs. 13–16). Among the artists included were Jasper Johns, Frank Stella, Jack Youngerman, Ellsworth Kelly, Robert Rauschenberg, Richard Stankiewicz, and Robert Mallary. The group ranged from those in some way new to the scene, whether as young as Stella (23) or as old as Landes Lewitin (67), to Louise Nevelson, already internationally known. Of the nine artists whose work had a prospective relevance, Rauschenberg, Mallary, Stankiewicz, and Nevelson, then working within an assembled, environment-oriented, or "junk culture" tendency, moved toward pluralistic openness. Youngerman, Kelly, and Stella, on the other hand, were reductive abstractionists whose paintings seemed to verify Greenberg's "law of modernism," propounded in 1955, that the "conventions not essential to the viability of a medium be discarded as soon as they are recognized."[1] In terms of the division of New York School painting between "gestural" and "field" abstraction, these three projected into the sixties the formal principles of Still, Rothko, and Newman, and, in the case of Youngerman, the replacement of Picasso by late Matisse as a dominant influence.

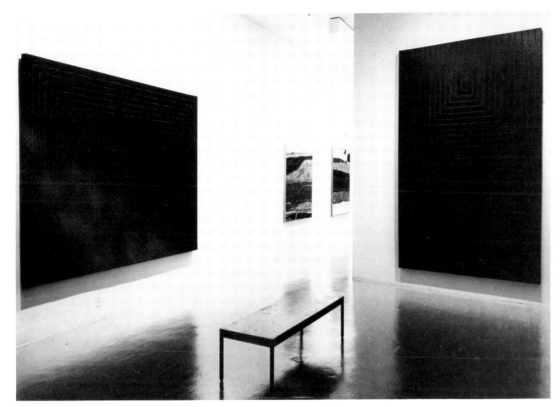

13

Installation view of the exhibition *Sixteen Americans.* December 16, 1959, through February 17, 1960. The Museum of Modern Art, New York. Works by Frank Stella (foreground) and James Jarvaise (background).

14

Installation view of the exhibition *Sixteen Americans.* December 16, 1959, through February 17, 1960. The Museum of Modern Art, New York. Works by Ellsworth Kelly.

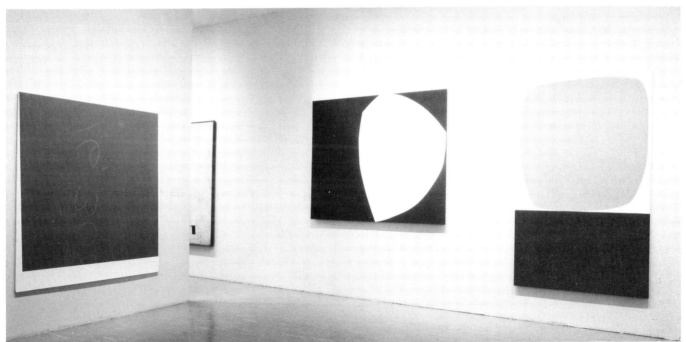

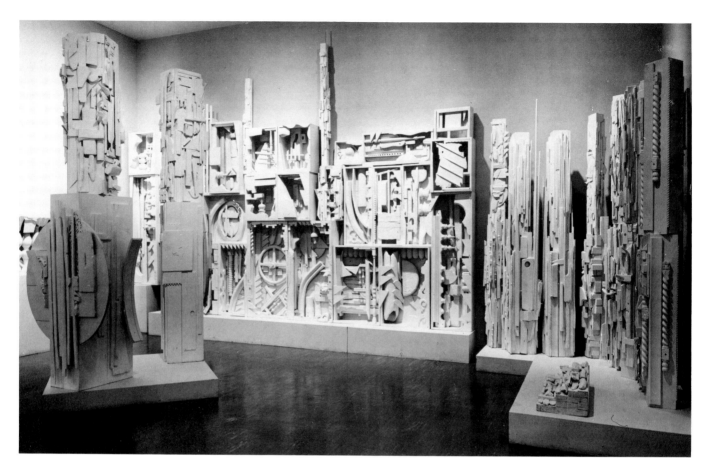

Johns was represented by Flags, Targets, Numbers, Alphabets (figs. 17–19), and an enigmatic but lovingly painted gray encaustic inscribed, like a tomb, with the inscription TENNYSON (fig. 20). A link between both New York Schools—Abstract Expressionists and Abstract Imagists—his work straddled them while rejecting both. "The situation must be a Yes-and-No not either-or," John Cage was to write of his friend's art, adding a Johns memo: *avoid a polar situation.*[2]

More startling, in their proclamation of the encroachment by the megalopolitan environment into the hallowed precinct of Art, were Rauschenberg's "combine paintings" that included, besides the traditional materials of collage, such objects as neckties, Coca-Cola bottles, and a stuffed pheasant. Aggressively assertive and executed with fluent virtuosity, these "combines" merged the anti-art stance and materials of the Dadaists with the unbridled painterliness and large size of Abstract Expressionism (pl. 4). "A pair of socks is no less suitable to make a painting with than wood, nails, turpentine, oil and fabric," Rauschenberg asserted in the catalog, which also included a statement to become famous and be repeated and parodied, with differing emphases, all through the sixties: "Painting relates to

both art and life. Neither can be made. I try to act in that gap between the two."[3] Rauschenberg's disruptive yet extroverted talent, unorthodox development, and volatile career dramatically realized the environmental pluralism espoused early in this century. In 1912, for example, Umberto Boccioni projected the use of metal, fur, glass, wire, wood, cardboard, cement, horsehair, cloth, mirrors, and electric light as art media in the *Technical Manifesto of Futurist Sculpture;* during the same year, Guillaume Apollinaire found "a new source of inspiration" in "catalogues, posters and advertisements" that for him contained the "poetry of our epoch."[4] The dragons' teeth for the fragmentation of traditional media were bared, and by 1918, in Hanover, Kurt Schwitters had inaugurated the anti-art of found material called *Merz,* a syllable left after excising parts of the word *kommerziell* (see fig. 34). "It is my ultimate object," Schwitters said, "to combine art and non-art in a world-embracing Merz picture."[5]

Positive and negative, creative and destructive impulses continually interact in the sequence of modernism. Just as Pollock's radical style was in some part generated by rebellion against the chauvinistic regionalism of his teacher Thomas Hart Benton, Rauschenberg's philosophy may have been

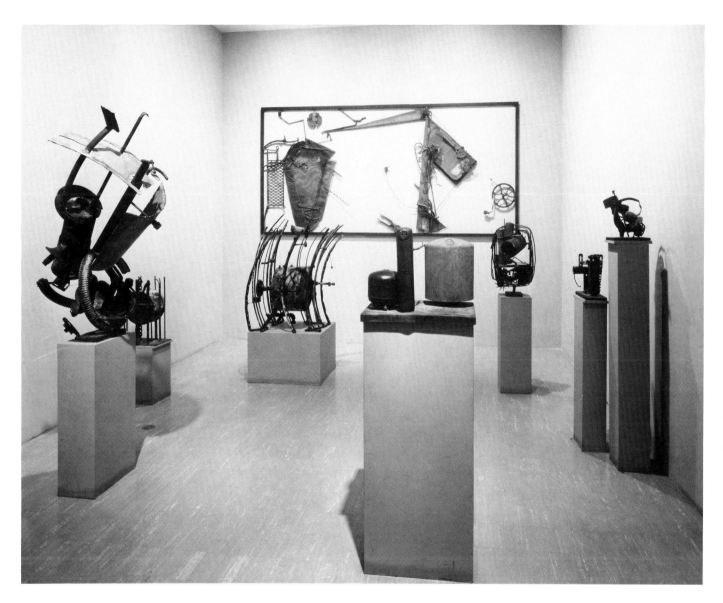

in some part generated by his rejection of the authoritarian pedagogy of Josef Albers, the teacher for whom he traveled from Paris to Black Mountain College in North Carolina to study with in 1948. (Albers, that most rigorous and reductive of masters, was chairman of the Art Department there.) During that same year, de Kooning, Buckminster Fuller, and John Cage were also in residence; Rauschenberg and Cage, the most dispersive influence of the sixties, became close friends. Long before 1948 Cage advocated accident and the collage style (which has little, if anything, to do with pasting) and was, as Calvin Tomkins wrote, "an intellectual if ever there was one, [who] not only had worked his way through the theories of Arnold Schönberg, Edgard Varèse, Anton Webern, and the other pioneers of modern music, but had also steeped himself in Hindu and Buddhist philosophy, including Zen." [6]

Cage surely, therefore, knew of Luigi Russolo's Manifesto of 1913, which advocated the "art of noises" produced by his *Intonarumori* (Noise Organs), was familiar with Erik Satie, and with Varèse's *Ionization,* composed in 1931, which had "parts for forty-one percussion instruments and two sirens." [7] Encouraged by a radical composer friend, Henry Cowell, Cage first used, at the Cornish School in Seattle in 1938, a piano "prepared" by placing newspapers, ash trays, and pie plates on the strings and subsequently nails, screws, rubber, wood, glass, and other materials between them. [8]

Rauschenberg unquestionably admired de Kooning. The 1953 gesture of erasure was an inverted homage, and he had surely studied carefully the brush styles of Abstract Expressionism, but its content, "all about suffering and self-expression and the State of Things," was not appealing to an artist who,

16

Installation view of the exhibition *Sixteen Americans.* December 16, 1959, through February 17, 1960. The Museum of Modern Art, New York. Works by Richard Stankiewicz.

17

Jasper Johns, *Target with Four Faces,* 1955, encaustic on newspaper and cloth over canvas, surmounted by four tinted plaster faces in wood box with hinged front, 33⅝ × 26 × 3 in. (85.3 × 66 × 7.6 cm). The Museum of Modern Art, New York, gift of Mr. and Mrs. Robert C. Scull.

18

Jasper Johns, *White Numbers,* 1957, encaustic on canvas, 34 × 28⅛ in. (86.5 × 71.3 cm). The Museum of Modern Art, New York, Elizabeth Bliss Parkinson Fund.

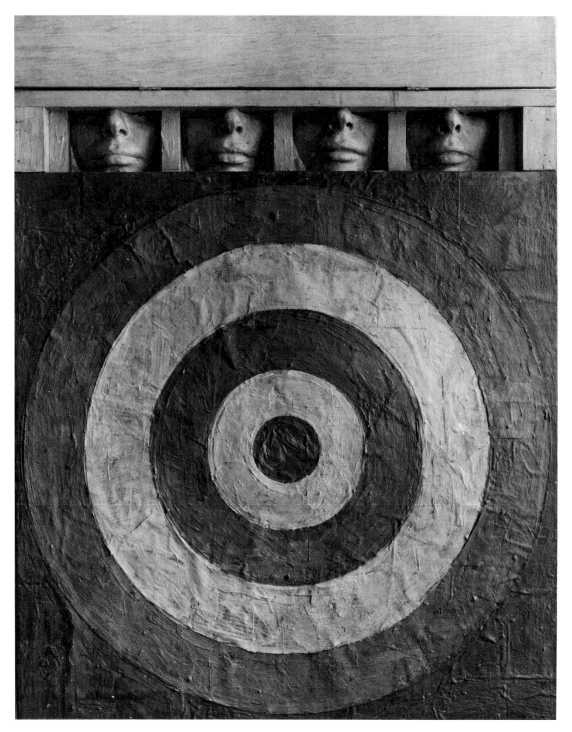

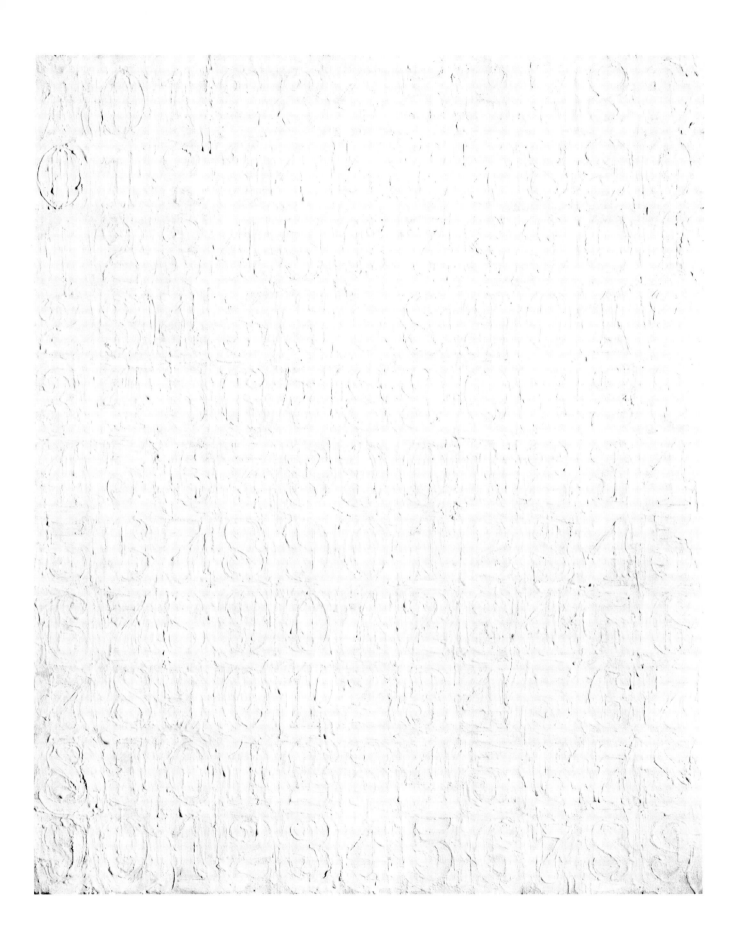

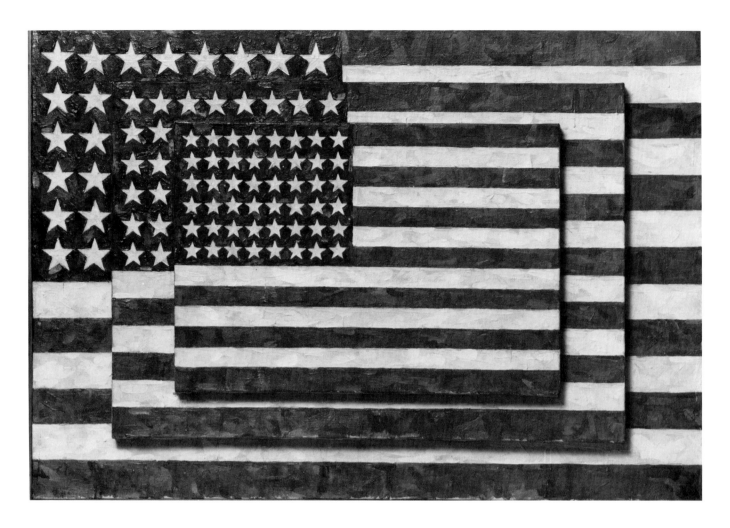

as he said, "didn't have any interest in trying to im-
prove the world through painting."[9] In 1957—in
another gesture subversive of "first generation"
preoccupations—Rauschenberg painted *Factum I*
and *Factum II*, canvases identical in size, in their col-
lage elements, and virtually even in their drips,
stains, and "accidental" irregularities. The joke of
this duplication was on Dada as well as Abstract
Expressionism. Later, in a reversed demonstration,
he painted a set of four pictures, each called *Summer
Rental*, using the same colors in identical amounts,
and the same collage elements, to produce four en-
tirely *dissimilar* compositions: "I don't believe in
chance any more than I believe in anything else.
With me, it's much more a matter of just accepting
all these elements from the outside and then trying
to work with them in a sort of free collaboration."[10]

Unlike the other New York School painters and
sculptors who viewed the idea of movements with
distaste, de Kooning himself contributed to the end
of Abstract Expressionism. Always plagued with in-
ner contradictions, such as that between figuration
and abstraction, he wrote in 1951 that "art never

makes me feel peaceful or pure. . . . I always seem
to be wrapped in the melodrama of vulgarity."[11] His
was a personality that welcomed the adulteration of
purist ideas. Indeed, his use of cut-out patterns of
the female body to rearrange its parts into disjunct
rather than organic relationships, his obsession with
florid women, and his affection for Marilyn Monroe,
the subject of a figure painting of 1954, make him
the only source, within the Abstract Expressionist
group, for the merchandising motifs of the sixties.
The dirtied pinks of his Women (fig. 21), charcoal
dust ground into the nacreous tints, were like dis-
carded ladies' slips found in the gutter. In the case of
a now famous little study in the Woman series
(1950), the smiling, toothy female mouth from a
Camel "T-Zone" advertisement provided the focus of
the composition. Like the foreign elements intro-
duced into painted compositions by the Cubists, it
was a seed of adulteration—a provocative, iconic
fragment from the common world that would pro-
vide, with the addition of a drooping cigarette, suf-
ficient material for entire, blatant canvases by Tom
Wesselmann some fifteen years later.

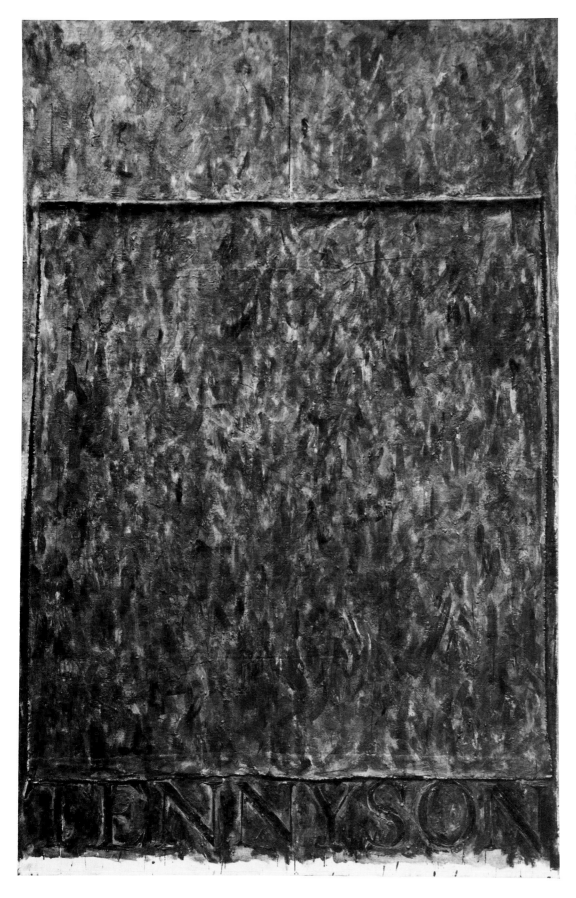

20
Jasper Johns, *Tennyson,* 1958,
encaustic and canvas collage
on canvas, 73½ × 48¼ in.
(186.69 × 122.56 cm) © Jasper
Johns/VAGA New York 1990.
Photo by Rudolph Burckhardt.

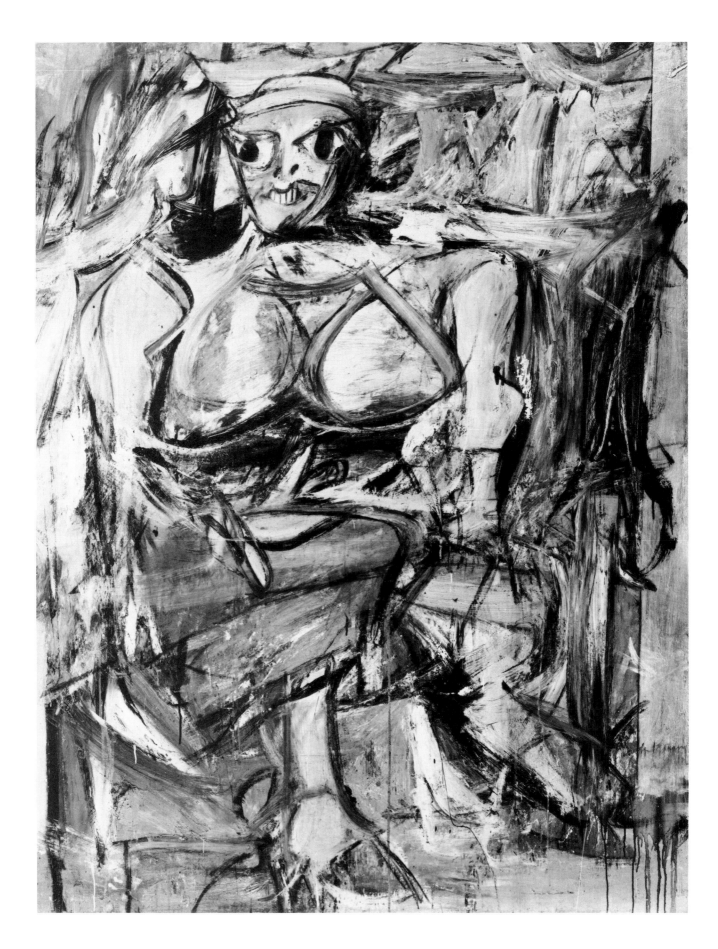

The Inchoate Threshold

By the time *Sixteen Americans* was organized, Stankiewicz, following precedents in the work of Picasso, Julio Gonzalez, and David Smith, was the master of junk sculpture welded from tanks, chains, pipes, screens, automobile parts, and other metal scrap. Witty and ideographically figurative, Stankiewicz worked in the Cubist tradition and that of the welded sculptors of the New York School. Mallary showed semi-sculptural works in an original polyester resin medium that, although still Abstract Expressionist in reference, resembled the scarred, vermin-ridden walls of abandoned tenements. One, in wood, was split and frayed like the brushstrokes of Franz Kline. Mallary was concerned, he stated in the catalog, "with that bastard area where the painted and sculptured object is uncertain of its parentage." [12] These artists demonstrated that by 1960 the implosion of commercial and refuse culture, in both spirit and materials, and the hybridization of media that it accelerated were already established.

At the opposite pole, the inclusion along with Youngerman and Kelly of Frank Stella (just graduated from Princeton University) not only marked the start of the most rapid rise of a young artist to fashionable and financial success in history, but also an abrupt break with the former "New American Painting." One of Stella's black-striped paintings was shown at the Tibor de Nagy Gallery in April 1959; in December, four more—one with the smashing

title *The Marriage of Reason and Squalor II* (fig. 22)— were included in *Sixteen Americans*. All were similar, composed of freely brushed but nevertheless straight-edged black bands separated by narrow strips of unprimed duck. From a distance the stripes and whitish lines formed symmetrical geometric patterns offering the eye, in addition to their factual flat patterns, optical illusions of projection forward or recession into a dark architectural space. At one stroke, they dispensed with Action Painting and relationally asymmetrical composition. The catalog statement by Stella's friend Carl Andre pressed what amounted to only one point: Stella paints black stripes because he finds it necessary to do so: "Art excludes the unnecessary. Frank Stella has found it necessary to paint stripes. There is nothing else in his painting. Frank Stella is not interested in expression or sensitivity. He is interested in the necessities of painting." [13]

Stella continued this direction in 1960 and 1961 by using first aluminum and then copper pigments that, by their reflective tendency, blocked recession behind the picture surface. The edge of the stretcher was deepened to more than two and a half inches, emphasizing the picture as object rather than illusion, and the canvas was shaped by notching its edges or cutting out its center in accordance with the strip patterns, thus eliminating background and making image and picture synonymous. In bright, color-wheel hues, metallic pigments, and less pri-

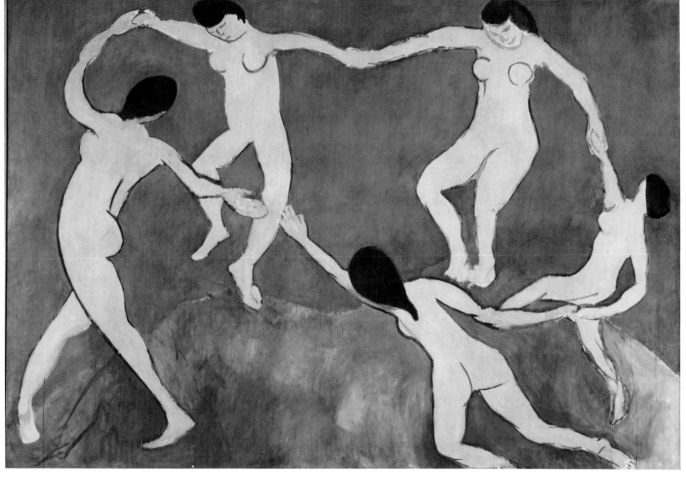

mary reds and browns, Stella extended his first statements in a variety of geometric shapes determined, by the necessity of his method, in advance (pl. 5).

De la Nada Vida a la Nada Muerte (fig. 23), in a metallic earth green, was the culmination not only of the Notched V series of 1964–65, but also of the striped pictures. An authoritative canvas, it superbly demonstrates the paradoxical flatness and new illusionism of the entire stringent first period of Stella's painting. It is impossible to see this picture as either flat (though there is no space behind its surface) or homogenous in color: at each juncture, the stripes seem to change planes, so that the four short runs initiate reversible diagonal recessions, and optically alter the single color tone of the picture. After 1965 Stella's painting became more sensuous. In the now familiar mural-sized canvases in fluorescent colors and protractor curves, he sought a frankly decorative, but unequivocally abstract kind of painting that would combine the "abandon and indulgence of Matisse's *Dance* with the overall strength and formal inspiration of a picture like his *Moroccans* [figs. 24 and 25]." [14]

Stella's thoroughgoing formalism was preceded by the close-valued, symmetrical, flatly painted, and hard-edged canvases of Ad Reinhardt. Combining innovations made by the Russians Kasimir Malevich and Alexander Rodchenko between 1915 and 1918, Reinhardt in 1954 painted a seventy-eight-inch-square canvas divided into nine smaller squares of almost identical tones of black. After 1960 he repeated the same non-composition, with infinitely slight (but crucial) differences in surface and color, until his death in 1967 (fig. 26). Following is his intentionally overextended description of this ultimate purism, which may have been, as Barbara Rose wrote, his "statement regarding the finite possibilities of painting." [15]

A square (neutral, shapeless) canvas, five feet wide, as high as a man, as wide as a man's outstretched arms (not large, not small, sizeless), trisected (no composition), one horizontal form negating one vertical form (formless, no top, no bottom, directionless) three (more or less) dark (lightless) noncontrasting (colorless) colors, brushwork brushed out to remove brushwork, a mat, flat, freehand painted surface (glossless, textureless, non-linear, no hard edge, no soft edge) which does not reflect its surroundings—a pure, abstract, nonobjective, timeless, spaceless, changeless, relationless, disinterested painting— an object that is self-conscious (no unconsciousness) idea, transcendent, aware of no thing but Art (absolutely no anti-art). [16]

The exhibition of Reinhardt's black paintings at the Marlborough-Gerson Gallery in 1970, a decade after they became his only form, brackets the minimalism of the sixties, though his view of art as finite, timeless, academic, and separated from every other sector of existence had been maintained without deviation for the decade before 1960 as well. Dubbed "Mr. Pure" by Elaine de Kooning in 1957, Reinhardt served as the motionless center around which Abstract Expressionism revolved. In discussions at "The Club" he was the obstinate devil's advocate, occupying a ground precisely opposed to de Kooning's self-contradictions. His "Twelve Rules for a New Academy," extended beyond its assigned numeration, was characteristically stated as a list of pitfalls to avoid: no texture, no brushwork or calligraphy, no drawing or sketching, no forms, no design, no colors, no light, no space, no time, no size or scale, no movement, no object, no subject, no matter, no symbols, images, visions, or readymades. [17] His redundantly stated position, ethical as well as aesthetic, was opposed to the concepts of expression, realism, geometry, and neo-humanism, and to museums, critics, dealers, and, it is fair to say, almost everything in the art scene around him. He was stubbornly positive only in his defense of art, which (like God in the mysticism of Meister Eckehart) can only be described negatively.

Geometric abstraction has a long history, beginning with Cubism, Russian Constructivism and Suprematism, and the De Stijl movement in Holland, but the term "hard-edge" arose only in the fifties, in a discussion at the home of the art historian Peter Selz, then chairman of the Department of Art at Pomona College. It was first used in print in 1959 by the critic Jules Langsner in the catalog of an exhibition of four California painters: Karl Benjamin, Lorser Feitelson, Frederick Hammersley, and John McLaughlin. Lacking the ideological associations of the term "geometric," it is somewhat less distasteful to artists and useful, in its neutral descriptiveness, to denote all kinds of painting employing ruled, compass-drawn, or smoothly curved shapes of uniform color or tone.

Before the mid-thirties, American artists who had not lived abroad had little understanding of European hard-edge abstract art, but by then it had begun to develop in the United States as a subcurrent, in opposition to realism. The pioneers of abstraction, most of whom joined the American Abstract Artists group when it was formed in 1936, fought for the recognition of any kind of abstract art. However, two Europeans, Ilya Bolotowsky and Fritz Glarner, immigrated to America in 1933 and 1936;

23

Frank Stella, *De la Nada Vida a la Nada Muerte*, 1965, metallic paint on canvas, 62½ × 225½ in. (205.7 × 744.2 cm). The Art Institute of Chicago, Ada S. Garrett Prize Fund. © 1990 The Art Institute of Chicago.

24

Henri Matisse, *Dance (first version)*, 1909, oil on canvas, 102½ × 153½ in. (259.7 × 390.1 cm). The Museum of Modern Art, New York, gift of Nelson A. Rockefeller in honor of Alfred H. Barr, Jr.

25

Henri Matisse, *The Moroccans,*
1915–16, oil on canvas,
71⅜ × 110 in. (181.3 × 279.4
cm). The Museum of Modern
Art, New York, gift of Mr. and
Mrs. Samuel A. Marx.

26

Ad Reinhardt, *Black Painting
No. 34,* 1964 oil on canvas,
60¼ × 60⅛ in. (153.04 ×
152.72 cm). National Gallery of
Art, Washington, gift of Mr. and
Mrs. Burton Tremaine.

and Burgoyne Diller, a New Yorker and a friend of Harry Holtzman, who traveled to Paris expressly to visit Mondrian, became a committed but original Mondrianist in 1934. The painter and collector A. E. Gallatin, who worked part of each year in Paris between 1921 and 1928, also worked in a more or less rigorous hard-edge style, as did a large group of American painters, among them Charles Shaw, Balcomb and Gertrude Greene, John Ferren, Giorgio Cavalon, and George L. K. Morris, who had studied with Léger and had met Jean Arp and Mondrian.

In September 1940 Holtzman assisted Mondrian (whose studio windows in London were smashed when the house next door was bombed to rubble in the Blitz) to immigrate. Here was an "entrance" that gave both the expressionist and geometric wings of modernism in New York an infusion of life—markedly so in that the influx of eminent war refugees and visitors who represented other schools, especially Surrealism, had already begun. Glarner, Diller, and Charmion von Wiegand met Mondrian the year he arrived, and between then and his death in 1944, when Abstract Expressionism was in formation, Mondrian exerted a powerful influence, felt even by his Expressionist countryman de Kooning, who had shipped to New York in 1926.

Reinhardt was also among the pioneers of abstract painting during the thirties but, like Stuart Davis and most other members of the American Abstract Artists, his hard-edge painting was not ideologically rigorous before the forties. It evolved between 1940 and 1949 into an all-over, free-brush abstract manner akin to that of Tobey, Tomlin, and even de Kooning. However, beginning in 1953—and now the need for this excursion backward from 1960 should become clear—Reinhardt not only tightened his brush, hardened his edges, and flattened his tones but also, more importantly, began to dispose his rectangles of close-valued color in *exact symmetry.* Except for a few prime works by Balla, Delaunay, and Malevich painted before 1920, almost all abstract art had been *asymmetrical and relational.* The work of art was conceived as a unity of "dynamic self-distribution" (to purloin a phrase from the Gestalt psychologist Wolfgang Koehler).[18] This organizational principle, which is both perceptual and conceptual, determined in part the "distortions" in Cézanne's still-life paintings and was carried forward by the Cubists. Once Cubism, Constructivism, collage, and (although it was not yet so labeled) assemblage had been invented by Picasso and his brilliant friends and applied in several media, the asymmetrically disposed structure (or anti-structure in the more disjunct works of the Dadaists) became the

dominant premise of abstract and semi-abstract art. It was opposed only by conservative realists and the "photographic" wing of Surrealism. From de Chirico in 1913 to Magritte in 1967, however, even they often applied the structural aesthetic in their juxtaposition of images; the "automatic" Surrealists such as Miró, Masson, and Matta—not to mention Arshile Gorky—drew, as did Schwitters, on the Cubist tradition to provide a structural framework. It also gave order to Abstract Expressionism and the open sculpture of the fifties, but it was almost totally abandoned by the abstract painters of the sixties.

The asymmetrical disposition of diverse elements, seen as a psychological process rather than as mere arrangement, is intuitive and improvisatory, but the uniform divisions of Reinhardt's black paintings, as well as their color, were *predetermined.* The division of a square into nine smaller ones, and the virtually unchanging repetition of a single, stringently minimal image, were perhaps initiated partially for the enjoyment of a polemical stance, but were also the outcome of a long-standing interest in Eastern art and philosophy. With the addition of the black paintings to the anti-Cubist position and the painting of Still, Newman, and Rothko, a numbing blow was dealt to relational asymmetry to which Stella responded in 1958 (though he was to return partially to it later). While Stella was working through Abstract Expressionism as a student, desperately trying to balance unequal shapes, lines, spots, colors, and textures in the manner codified by Hofmann's teachings, he was drawn into a state of anxiety: the integrating process never seemed finished. With a predetermined system, and with everything the same on both sides, he recalled later, less than half in jest, painting became tranquilizing for him rather than disquieting. Of those he regarded as "relational" painters, Stella commented in 1964: "The basis of their whole idea is balance. You do something in one corner and you balance it with something in the other corner. Now the new painting is being characterized as symmetrical. Ken Noland has put things in the center and I'll use a symmetrical pattern, but we use symmetry in a different way. It's nonrelational."[19]

The radical, subversive, and creative reduction that Reinhardt initiated in 1952 foreshadowed the reductionism of the sixties. The black pictures after 1960, while retaining a tremor of relativity, leapt in one stroke further toward minimalization than any artists but those, such as Yves Klein and Ralph Humphrey, who simply covered the canvas with a single unbroken color, or artists of the *Nouvelle Tendence* movement, such as François Morellet, who covered their panels with a uniform grid pattern.

Color-Field Painting and the Washington School

3

During the season of 1959–1960, Clement Green-berg, who had championed the Abstract Expression-ists in the forties but was to trumpet their decline in his article "After Abstract Expressionism" [1] in 1962, served as adviser to the sumptuous and large New York gallery sponsored by French and Company. As is true of most of his activities, the exhibitions he organized were devoted primarily to those few artists to whose work he was totally committed. (An im-portant exception to that principle was the 1964 ex-hibition *Post-Painterly Abstraction,* which included more than thirty painters working in a variety of ab-stract styles.) The first exhibition, in March 1959, was a major showing of the paintings of Barnett Newman, and followed a similar show Greenberg had organized the year before at Bennington Col-lege, which became a center of the critic's influence during the sixties. In showing Newman, he was in-troducing the master who, in his judgment, pro-vided the crucial bridge from the painting of the fifties to that of the sixties. (Had his judgment been more open, he might have shown Rothko and Rein-hardt in the same context, but Rothko turns up only peripherally in Greenberg's writings, and the pres-ence of Reinhardt on the scene was ignored.) He was surely right, nevertheless, in recognizing that New-man's expanses of color, along which vertical stripes of varying color tones were placed, pointed toward a new abstraction, and that this exhibition was a his-toric occasion.

"Seeing the same and new pictures of his over the years since [1953]," he wrote in the catalog, "I be-came increasingly aware of how complex they were in their exploration of the tensions between different light values of the same color and between different

colors of the same light value. Such tensions form an almost entirely new area of interest for our tradition of painting, and it is part of Newman's originality that he led our sensibility toward it."[2]

Newman's one-man show was followed by similarly revealing exhibitions of paintings by Morris Louis and Kenneth Noland.[3] Close friends, Louis and Noland were from Washington, D.C. Louis showed the sumptuous Veils; Noland, paintings of concentric rings separated by rings of bare duck, and others in which freely edged color areas exploded outward from a central point. Louis's Veils were freely symmetrical, as if they had been folded like a Rorschach blot down the center. Both artists, that is to say, had broken with the closed asymmetry of the Cubist tradition, and both had adopted the method of staining or soaking raw duck with thin acrylic pigment. It was thus that the school of Washington Color painters and the more general category of what was to be called color-field painting made its entrance. The other painters associated with this school, foremost among them Gene Davis and Tom Downing, never received the Greenberg imprimatur; and Jules Olitski, whose painting still reflected European *Tachisms,* was a New Yorker. David Smith, also shown in the series, occupied the position of Newman in sculpture. Later Greenberg was to add to his small list the painted columns of the Washington minimal sculptor Anne Truitt and, on a higher level of support, Anthony Caro, the English sculptor influenced by Smith. Nevertheless, Greenberg's name continued to be associated with references to Washington Color painting, and the presence, lack of, and degree of support he offered Washington artists continued to be an issue of controversy throughout the sixties.

The often retold account of Louis and Noland's visit to the New York studio of Helen Frankenthaler in 1953 gained an almost sacerdotal significance in formalist criticism of the sixties, and in the history of the Washington Color School, of which Louis must surely be regarded as the founder.[4] The painters were accompanied by Greenberg, among others, and were profoundly impressed and later influenced by her picture *Mountains and Sea.* Painted in 1952, it was produced by pouring thin paint onto unstretched duck disposed in a more or less horizontal position: the "soak-stain" technique. "She was a bridge between Pollock and what was possible,"[5] Louis stated later. He had been introduced to acrylic resin pigment, the medium that made such painting practical, much earlier, however. Louis had been a friend of Leonard Bocour, the originator of Magna acrylic colors, since the thirties; he had used the paint, in one form or another, since 1953 (pl. 6).

Louis's exact methods of painting remain a mystery,[6] for no one observed him at work and provided an eyewitness account of his procedures. It is fairly certain, however, that he allowed acrylic washes to flow over and into unstretched duck placed in various positions, in some cases arranging it in ridges and channels, and even folding it back on itself, allowing one surface to print on another. The same methods, as Michael Fried has noted, provided "the means to a kind of figuration capable of sustaining a wide gamut of internal articulations."[7] Especially in the Veils, balanced around a central fold, and the Florals, the diaphanous multiple translucencies and the organic character of the primary and secondary shapes could not have been produced in another medium or by another process. The woven texture of the fabric remained as visible in the stained as in the unpainted areas, and the image, like colored mist, flame, or flowing liquid, was itself a superimposition of transparencies. In Louis's hands this process and medium almost dissolved the traditional opposition of figure and background, solid and void—a redirection already initiated, in various ways, in the paintings of Still, Rothko, Newman, and Pollock, and the late works of Monet. By staining, furthermore, color was accorded a more dominant function than it had been given since the Fauves, Robert Delaunay, the Orphists, the Synchromists, and Matisse.

In 1960, beginning with such pictures as *While,* Louis stopped the merging, scrubbing, and superimposition of colors (which often resulted in passages that resembled mud puddles) for flowing plumes or columns of color with a minimum of overlapping or mixture that glow like rainbows. However, because many of his canvases were unstretched when Louis died in 1962, it is difficult to be certain as to what sizes and positions he intended. In the Stripe pictures, one end of the run usually concludes within the picture space. In the wide Unfurleds, which Louis is said to have considered his finest works, the sharp-edged chromatic rivulets that flank the central area begin and end at some point outside the canvas. In devoting the major expanse of his painting surfaces to what, being untouched cloth, reads as open, neutral, and almost void, Louis reversed a principle never violated in Western art before the late water lilies of Monet. Moving beyond the lateral surface-void of such canvases as Newman's *Vir Heroicus Sublimis,* the inverse symmetry of the Unfurleds introduced a new kind of spatial relativism.

Like Louis, Noland worked in acrylic on unprimed, unsized duck. The works shown in his one-man exhibition at French and Company in 1959 were of two types: the first, concentric bands of color separated by untouched canvas, leaving the rings

free to position themselves in depth; the second, amorphous spurts of color that were most effective when centered, like the circles, on square canvases, thus exploding outward.

Unlike Louis's early soaked pictures, however, Noland's color fields from this period are unmodulated and clearly edged, though some are surrounded by a splashed, spinning halo. Unlike the works of Frankenthaler or Pollock, in these pictures Noland made a sharp break with asymmetrical relational composition in favor of a holistic, instantly apprehended image. In contrast with Johns's Targets, in which an object-image served to emphasize thematic emptiness and the materiality of the panels in contradiction to the disintegrating effect of the brushwork, Noland's chromatic rings are liberated from the surfaces on which they exist.

Certain of these principles continue throughout Noland's later work, but after 1962 his divisions became more sharply edged, carefully controlled, and integrated with the support. The paintings of 1964 are composed of Vs, or chevrons, symmetrically or asymmetrically disposed on rectangular, diamond- or lozenge-shaped canvases. He entirely obviates the ground dilemma, for both direction and position are determined by the outer shape, in what Fried described as "a deductive mode of pictorial organization."[8] Like the striped painting of fellow Washingtonian Gene Davis, these are stained, geometric works, though their geometry has nothing in common with that of Cubist-influenced geometric painting. The chevrons are climaxed by the eighteen-foot-wide *Tropical Zone,* an expansive panorama comprised of six chevrons in brilliant colors separated by bands of unpainted canvas, shown in Noland's exhibition at the Venice Biennale in 1964.

Beginning in 1967, Noland painted almost exclusively on horizontal canvases, in bands of varying widths, colors, brightness, and saturation. Some pictures are so pale and delicate that the canvas separations take on a positive identity; others are sonorous and brilliant. Some include a whole spectrum of hues; others are tonal and almost monochromatic. The bands, all horizontal, alter each other optically to produce strikingly original, and sometimes sumptuous, combinations. Some are less than two feet in height but eighteen in width; the proportions of others are less idiosyncratic. That is to say, within rigorous limitations, the diversity is great, and the best have an exhilarating lateral sweep.

Noland's determinations of color, position, and size—the pictorial elements can hardly be described as "shapes"—are masterfully controlled but seem entirely intuitive and sensuous. They implement a purely aesthetic vocabulary—"optical," surely, but entirely unsystemic—of contrasts and analogies of flatness and suggestions of recession, aggressive and calm colors, warmth and coolness. Occasionally, a thin stripe seems to tilt into recession, or vibrate like a plucked string, yet there is not a hint of methodological color interactivity. For more than a decade, Noland has been an artist for whom color, field, and extension have been synonymous. His failed pictures can fall entirely flat, but at his best he produced the most finely tuned, erudite color relationships of this period.

Because the works of Noland and Louis were shown in New York before those of Gene Davis, it used to be wrongly assumed that his characteristic method of disposing equally wide stripes of color from one edge of a canvas to the other was somehow derived from these artists. Davis began using vertical striations as early as 1952, however. Like other venturesome young painters in the fifties, he was trying to escape the domination of de Kooning, Resnick, Guston, and the clichés of Action Painting; for him the way was always, as he said in an interview with Barbara Rose in 1971, "to do the outrageous thing, the thing which is seemingly ridiculous."[9]

Davis tried the anti-Cubist device of placing a square at the center of the canvas, later adopted stripes (a form that carried with it a proto-Pop irreverence as the trite "subject matter" of wallpaper and dress goods), and even used the comic strip. His first stripes appeared in Abstract Expressionist pictures that resembled Kline's or Motherwell's vertical bands of the forties; between 1958 and 1960 (concurrently with Stella's first striped works but independently and quite differently), Davis began to harden his edges and work out his uniformly striped system, established more than a year before Louis's striped but centralized pictures. Rather than his Washington friends Louis and Noland, it was Paul Klee, Newman, Albers, and the sheer effrontery of Johns's *Target* of 1958 that led Davis to his own solution.

Perhaps more important, Davis studied music before art. Although he never set out to make musical paintings, his use of a uniform beat of vertical lines on which he projects coloristic diversity reflects his early musical training. As he said, "Music is an art of interval, and my work is an art of interval."[10] By no means have all his canvases since 1960 conformed to the same module: the stripes vary widely in width from work to work, and the even beat is interrupted in certain pictures, but division into equally spaced vertical bands has continued as an organizing principle. "The very monotony of the stripes," Davis said in 1966, "operates in favor of the color."[11]

Exploring the infinite possibilities of differing hues and tones, pure or mixed, and from neutral gray to black to white, Davis produced an impressive body of work in which continuity and variety

interact. The uniform parallel lines provided him with a means of control, but he was not a conceptual or systemic painter. Freed by the underlying structure of redundancy, he began with a random scattering of quite arbitrary color stripes, adding others spontaneously but with increasing control, until a relational direction emerged. Ultimately the composition establishes its own rules of tone and interval (pl. 7). After that, Davis says, "I go along for the ride." The sequence is seldom uniform. Grouped in families and related color chords, the resonance of a work swells and recedes, its impact rhythmic rather than spatial. These are processional and temporal rather than symmetrical or asymmetrical pictures.

When Sam Gilliam arrived in Washington in 1962 after completing a graduate program in painting at the University of Louisville, he was unfamiliar with the work of Louis, Noland, and Davis, but rapidly absorbed the soaked method and other principles on which their commonality was based and adapted them to his own ends. Beginning in 1965, he showed pictures produced by folding the duck after soaking it in color, adding additional color after folding, and finally stretching the dry canvas. The outcome of this process was not only a fluid mottling of watercolorlike splashes, lines, shapes, textures, and effects, but also a sequence of radiating or parallel divisions yielding overlapped, modeled, and spatial illusions that stabilized the amorphous images. It was not until the spring of 1968, however, that Gilliam put his original stamp on this method by suspending unstretched canvases from the ceiling in fully environmental configurations, breaking entirely with flat, rectangular surfaces and fulfilling a spatial potential of Louis's Veils and Florals.

This improvisatory form has affinities with the environments of "process" and "distribution" artists such as Alan Saret and Keith Sonnier—in its volatility and the freedom of its facture as well as in its dependence on placement, which must change from setting to setting. Yet by not abandoning canvas and paint, Gilliam successfully demonstrated that a flat, rectangular, or geometrically shaped support is not essential to that medium (pl. 8).

Like the Washington Color painters, Jules Olitski worked on unprimed duck in fluid but uniform areas of strong color, but no major painter since Rothko has staked so much on the sheer seductiveness of color as he. This proclivity was not yet fully evident in the heavily pigmented, quasi-figurative pictures (with such proto-Pop titles as *Nude of the Gas Station*) shown in his exhibition at French and Company in 1959. Perhaps carryovers from a period spent in Paris in the early fifties, the surfaces were heavy, recalling the works of European artists like the

Frenchman Jean Fautrier. By 1962, however, Olitski had adopted the "soak-stain" method. His unprimed canvases were fields on which he placed large organic shapes—globules, irregular circles and rings, relaxed ovals, organismic groupings—arranged concentrically, in some cases, like waves made in water by a fallen stone. In 1964 these color globes decreased almost to dots; he began to abandon shapes until all but an occasional patch of border near the edge was stained or rubbed with mutations and unexpected combinations of color.

Olitski's most important and original period began with a new application of the soaked method, described in 1965 by Michael Fried: "He draws a length of unprimed and unsized canvas through a trough containing acrylic paint . . . places it on the floor . . . and to record his most intuitive, evanescent coloristic impulses, he sprays into the still wet canvas . . . new color, from one, two or three spray guns powered by an electric compressor." [12]

Using a mechanical tool that had previously resulted only in vulgar commercial effects (the compressor), Olitski after 1965 achieved an unprecedented evanescent beauty and vaporous spatiality that consisted entirely of color (pl. 9). From that time onward, changing from picture to picture and series to series, demonstrating amazing variety within a narrow range, Olitski gave free rein to his voluptuous and exceptional color sensibility—a Delacroix in the language of the sixties. Choosing the shapes of his rectangles with evident care, he accented the edges, here and there, with lines and strokes of contrasting tones. By 1968 the fields began to build up in a physical relief of sprayed color and, in paintings after 1970, to a heavy tactile surface contradicting the opticality of the particulated colors. Fried has quoted Olitski as wishing he could "make paintings that would consist of nothing but some color sprayed into the air and remaining there." [13]

Short though its existence was, Greenberg's French and Company Gallery must be accorded an important position in establishing what has been called, inadequately, the elitist or formalist trend of the sixties. The arbitrariness of Greenberg's use of his wide influence in support of his chosen artists led to charges of partiality and even of conflict of interest. In his favor it must be said that he placed the highest premium on quality, and that he was surely the most powerful modernist to defend serious or "ambitious" art against the inroads of imitation, gimmickry, and the media. The French and Company exhibitions, at the very least, introduced three of the major artists identified with painting in the sixties—Louis, Noland, and Olitski—even though one of them, Louis, died in 1962.

Assemblages, Environments, Happenings

4

The exhibition *The Art of Assemblage* opened at the Museum of Modern Art in October 1961 (figs. 27–30), one year and four months after *New Forms–New Media* at the Martha Jackson Gallery and about a year before *The New Realists* shown by the Sidney Janis Gallery in two locations on West 57th Street. These exhibitions all demonstrated (as did *Bewogen Beweging,* devoted to various kinds of kineticism, at the Stedelijk Museum in Amsterdam in 1961) the inchoate, surcharged neo-avant-garde climate of these years.

The *Assemblage* exhibition was not devoted to newness: it was a historical survey of a heretofore un-named medium, but the pressures of the time were hard to circumvent. Its working title was "Collage and the Object," but the term "assemblage," first used by Jean Dubuffet to characterize prints made from spattered papers, was finally adopted as the necessary and only term that would embrace both papier collé and the method of three-dimensional agglomeration that constitutes a considerable part of the inventory of modernist objects. An assemblage, the exhibition publication explained, is a work "pre-dominantly assembled rather than painted, drawn, modeled, or carved," of which the constituent ele-ments "are performed with natural or manufactured materials, objects, or fragments not intended as art materials." [1] In an attempt to be comprehensive, the exhibition presented not only more than 140 artists from some ten countries, but also examples of col-lage and three-dimensional assemblage by every important artist of the century, beginning with Pi-casso, Braque, and Gris. Included were fourteen works by Joseph Cornell (fig. 31), thirty-four by Schwitters and nineteen by Duchamp, and among

the many artists shown for the first time in a major American exhibition were Arman, George Brecht, Austin Cooper, Jean Follett, George Herms, John Latham, Niki de Saint Phalle, Martial Raysse, Daniel Spoerri, Yigael Tumarkin, and the *afficheurs* (the group who preserved specimens of accidental bill-poster collage and décollage—Raymond Hains, Jacques de la Villeglé, and Mimmo Rotella).

Because of the large number of young, innovative artists working in a medium that was still regarded as controversial, this survey was received, by both supporters and detractors, as a "new directions" exhibition. John Canaday denounced the carefully installed presentation as "viciously prostituted," a "highly perfumed affair," a "show afflicted by fashionable bloat."[2] Before he had seen it, he described the related book (in a telephone conversation) as the "silliest crap I ever read." Characteristically, *Art News*, still fighting a last-ditch battle to extend the Abstract Expressionist movement, also panned *Assemblage*.[3]

Among those artists included who made significant contributions to the art of the sixties (aside from already established reputations such as Motherwell, Rauschenberg, John Chamberlain (pl. 10), and Eduardo Paolozzi) were Bruce Conner, Lee Bontecou, Edward Kienholz, Marisol, Jason Seley, and Richard Stankiewicz. Conner was a true avant-gardist of extraordinary ability, whose drawings, sculpture, collages, and assemblages, like the lesser known works of George Herms and Wallace Berman, arose from the intense disenchantment with established values that typified the Beat Generation

colony in the North Beach section of San Francisco. Conner's works between 1957 and 1965, some free-standing and others assembled in boxes, were combines of photographs, beads, bicycle wheels, fur, underclothing, the paraphernalia of the emerging drug culture, and other San Francisco rummage, usually shadowed or wrapped in nylon stockings. These fetishes of nonconformity emanated, with trenchant power, the mood, at once stoned, anarchistic, and erotic, exemplified by the literature of Jack Kerouac and Allen Ginsberg, to whom Conner dedicated one work of 1961, *The Snore*. Conner's friend George Herms, as assembler who drew his materials from a dump near San Francisco where he lived, sent checks for "Love" instead of money to those who supported his work. On leaving San Francisco (to which he later returned), Conner stenciled the word LOVE across the street in front of his flat. Distaste for the establishment and affection for the people of the counterculture underlay all of Conner's work and activity. It announced, years before the love-ins, be-ins, and demonstrations of flower power that spread eastward from California in 1965, the Love theme adapted by Robert Indiana, which he made into a United States postage stamp in the early seventies. By the late sixties, at least as far as the art scene in the East knew, this brilliant artist disappeared from view. As an artist and as a personality, he exemplifies, again ahead of time, the apathy that followed the peak years of the counterculture.

Bontecou, after a period as a sculptor of animals and birds, became known for her constructions of metal, wire, and canvas. They built outward from

27

Installation view of the exhibition *The Art of Assemblage*. October 4, 1961, through November 12, 1961. The Museum of Modern Art, New York. Works by Kurt Schwitters.

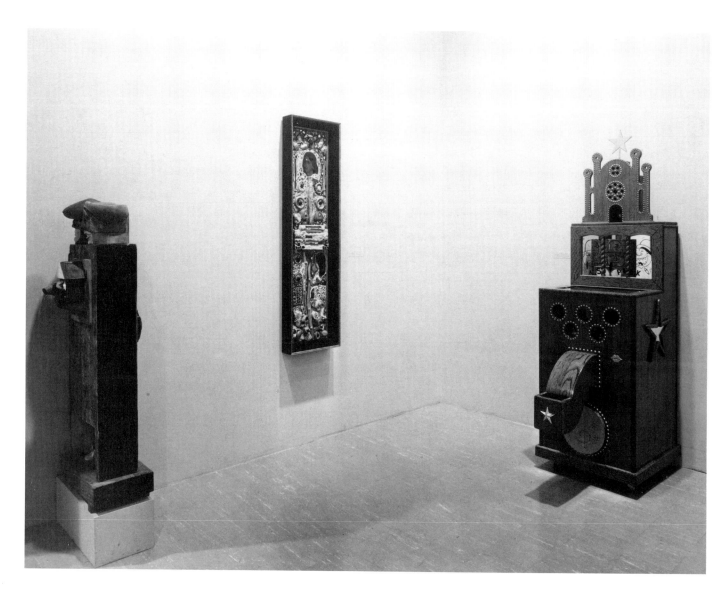

Installation view of the exhibition *The Art of Assemblage.* October 4, 1961, through November 12, 1961. The Museum of Modern Art, New York. Works by (left to right) Marisol, Ossorio, Westermann.

the wall like inactive volcanoes seen from above, threatening the spectator with sharp points even as they seduced him to look into the stygian black of the opening (fig. 32). Kienholz, now a figure of international reputation, was represented in *Assemblage* by his *Jane Doe* and *John Doe* and became the most scathing social commentator among the artists of the sixties. (For a further discussion of Kienholz's work, see pp. 171–77.) Seley continued to work as a serious and accomplished sculptor, welding automobile bumpers into assertive works that, like the assemblages of Chamberlain, remained essentially abstract in spite of their unprecedented materials. Stankiewicz—solidifying the "junk culture" eulogized by the English critic Lawrence Alloway and the art historian and artist Allan Kaprow—became the master of Junk Sculpture until he retired from the exhibition scene. The wit and humor of his quasi-figurative agglomerations of gears, tanks, chains,

and other steel scrap, however, was only a surface attraction. Stankiewicz was a brilliant exemplar of an essentially Cubist relational abstraction (fig. 33). Fortunately, he refused to sink into oblivion when the euphoria of the early sixties subsided and resumed his public career in the early seventies, still using preformed steel as his material, but in an austerely reduced and monumental style.

The career of the mysterious, noncommunicative Venezuelan, Marisol, seems (at least to this observer) to be a casualty of the sixties, despite the fact that in the early seventies she was still exhibited in a major gallery, getting commissions, and receiving impressive allotments of space in the press.[4] Born in Paris, she came to the United States in 1950 and not only generated a myth in New York but also came to be recognized as an artist of immense talent, intelligence, and ironically narcissistic wit by those who knew her early sculpture. After *The Art of Assem-*

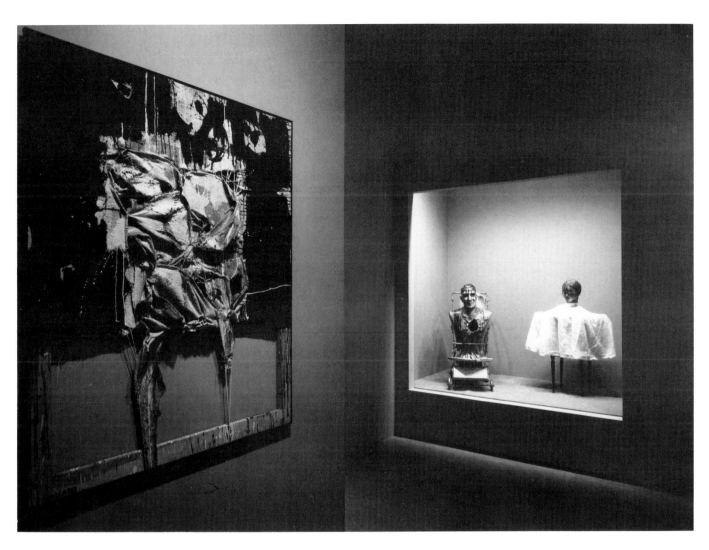

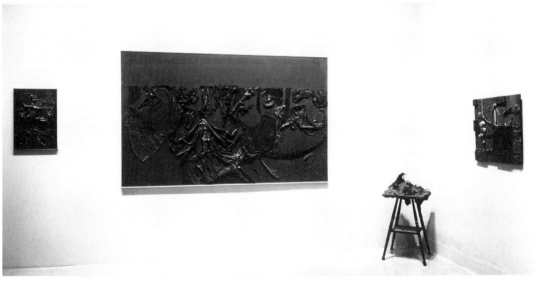

29

Installation view of the exhibition *The Art of Assemblage*. October 4, 1961, through November 12, 1961. The Museum of Modern Art, New York. Works by Millares (left) and Kienholz (right).

30

Installation view of the exhibition *The Art of Assemblage*. October 4, 1961, through November 12, 1961. The Museum of Modern Art, New York. Works by (left to right) Coetzee, Burri, Conner.

31

Joseph Cornell, *Untitled (Medici Boy)*, 1953, wood, glass, oil, and paper, 18¼ × 11½ × 5¾ in. (46.36 × 29.21 × 14.61 cm). The Modern Art Museum of Fort Worth, Benjamin J. Tillar Memorial Trust.

32

Lee Bontecou, *Untitled,* 1960, welded steel with canvas, 72 × 59 × 20 in. (182.88 × 149.86 × 50.8 cm). Collection of Frances and Sidney Lewis. Photo by Rudolph Burckhardt. Courtesy of Leo Castelli Gallery.

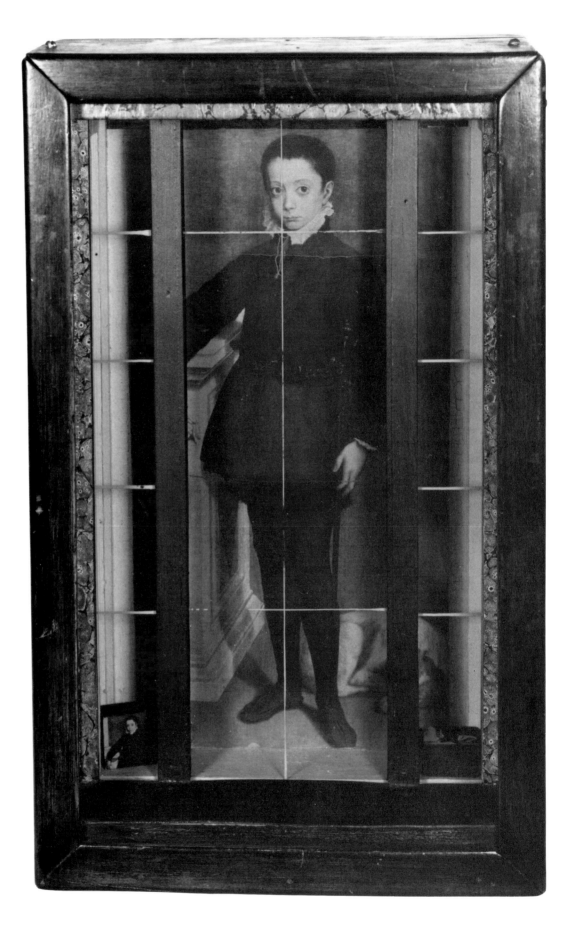

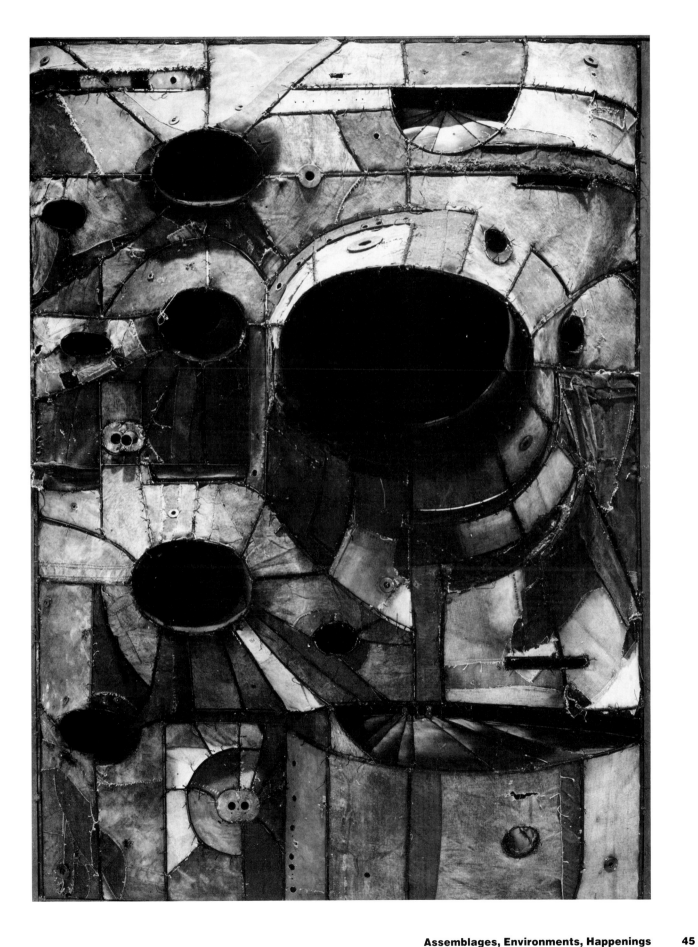

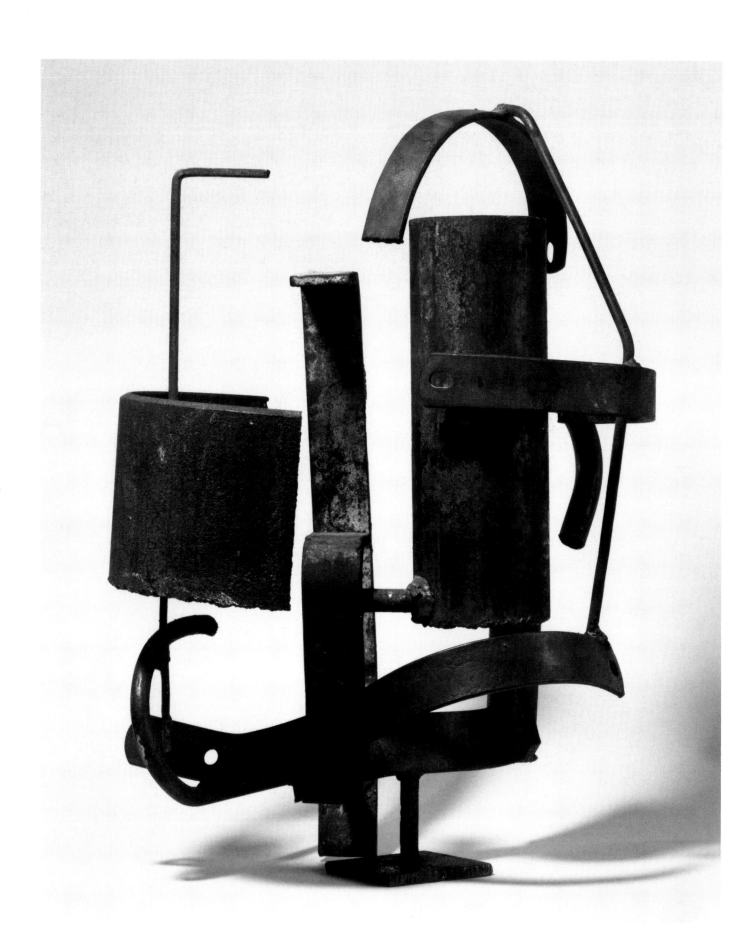

blage, and her first show at the Stable Gallery, she was bombarded by collectors, museums, and the media with opportunities difficult for any artist to refuse. *The Family* (1960), in the Museum of Modern Art, is an almost naive portrayal of a poor mother and four children before a painted door, assembled of actual and fabricated elements, drawing, and painting (pl. 11). Much of her later and far more sophisticated work, in a wide range of skillfully worked materials, represents families, political figures, sunbathers, people then conspicuous on the art scene (among them Andy Warhol and Henry Geldzahler), and, most often, Marisol herself. One very small work—a Coca-Cola bottle shoved downward into the wide-open mouth of a mask of the artist, titled *Love* (1962)—could be cited as an icon of the pluralistic sixties, in which the objects and viewpoint of the media and marketplace were, so to speak, shoved down the throats of everyone associated with the arts. However finely wrought, however expensive the materials, the later, highly successful work of this artist was flawed by fashionableness, by meretricious implications of everything that, for a time, was chic. The swinging sixties was the climate in which Marisol's talent emerged; had it developed in another, she might have been one of the major sculptors of her time. Yet she may still realize such an achievement. Her rapid "rise" is of interest, in addition, in documenting the connection of assemblage to the appearance of Pop in 1962. Marisol's assembled works, drawings, and prints were most commonly seen in the context of Pop. Certain other artists in *Assemblage* shared the Pop spirit, but the Janis exhibition of so-called new realists, though it included collagists and assemblers like Yves Klein and Jean Tinguely, also included Peter Blake, Oyvind Fahlström, Claes Oldenburg, Roy Lichtenstein, James Rosenquist, George Segal, Wayne Thiebaud, Andy Warhol, Robert Indiana, and Tom Wesselmann. Although the school was as yet unlabeled, *The New Realists* was surely the New York premiere of Pop art.

The appearance of the happening—a mixed form combining painting, collage, sound, theater, aspects of the dance, and group interaction—epitomizes the outward thrust of a decade of ceaseless innovation. In an essay that appeared in an early 1959 issue of a literary review published by Rutgers University, Allan Kaprow voiced a wish recurrent in the sequence of modernism for a "new art, a really new art." [5] He also included a script for "Something to take place: a happening." [6] The word was used in an intentionally offhand way, to indicate an event as unexceptional as a "little dog relieving himself at a hydrant." [7] "I had no intention of naming an art form," [8] he said later,

and for a while he tried, unsuccessfully, to prevent its use. However, he did use it the next October as the banner for a presentation at the Reuben Gallery (then a loft on Fourth Avenue in New York) called "18 Happenings in 6 Parts," thereby adding a new term to the technical glossary of the arts.

Working in 1957 and 1958 with friends (among them George Segal, Robert Whitman, and Lucas Samaras) from the Hansa Gallery in New York and Rutgers University, where he taught, Kaprow had found the first appropriate designation for a long history of loosely structured artists' events that began (in spirit if not in their subsequent specific forms) with the first performance of Alfred Jarry's *Ubu Roi* in 1896. A student of Meyer Schapiro, Hans Hofmann, and John Cage, Kaprow belonged to a new generation whose training spanned the gap between conventional art history and the practice of unconventional art and anti-art. Moreover, university-based knowledge of the history of modernism was a gold mine of disruptive ideas. It was Kaprow's aim, it would appear, to obliterate just that "gap between art and life" in which Rauschenberg chose to act. Beginning in the early fifties with collages of found materials, and stimulated by Pollock's radical method of painting rather than by the works that were its outcome, Kaprow evolved a "kind of action-collage technique" using tinfoil, canvas, photos, newspaper, and other random materials until, in an exhibition at the Hansa Gallery in 1956, his collage—like Schwitters's more disciplined *Merzbau* of 1924 (fig. 34)—surrounded the spectator entirely. "The Environment," Kaprow explained, "came out of collage which is the prime mover in a kind of thinking which is 'impure,' that is unclassical and antitraditional—and which hinges upon accepting not only the accidental but whatever is there. Collage inflames the imagination: I began wanting to collage the impossible—to paste-up action, to make collages of people and things in motion." [9] (See figs. 35 and 36.)

In its narrower meaning, collage was of course not the only source of happenings. The many kinds of activities to which the term has been applied drew ideas from the entire history of international modernism in art and paralleled the theatrical innovations of Antonin Artaud, Jean Genet, Samuel Beckett, Eugene Ionesco, and Julian Beck's "Living Theater," as well as the Dada-Zen performances of Tudor and Cage and the deliberately disjunctive choreography of Merce Cunningham, Paul Taylor, and other dance groups. Yet in the expanded meaning of collage, aglomerates, environments, and happenings also belong to the entangled chains of influence and counterinfluence through which the

33
Richard Stankiewicz, *Untitled 1962 #5*, 1962, iron and steel, 27 × 14 × 19 in. (68.58 × 35.56 × 48.26 cm). Walker Art Center, Minneapolis, Art Center Acquisition Fund, 1963.

mode of juxtaposition and simultaneity, and which could be called the "McLuhan phenomenon," evolved. Happenings have been defined by the historian Michael Kirby as *a purposefully composed form of theater in which diverse alogical elements, including non-matrixed performing, are organized into compartmented structures.*[10] The actions of the participants, never theatrical professionals but an in-group of friends, students, and a participating and/or observing audience, were schematically structured by the script (when there was one) but unplanned in detail and subject to unexpected deviations. They transpired in lofts, stores, galleries, streets, parks, fields, or woods, often demanding careful prearrangement and extensive and even massive props—large constructions, quantities of papers, oil drums, barrels, automobile tires, dummies, ladders, eggs, bicycles, smoke and fire makers, lawn mowers, plastic sheets, rope and wire, automobiles and trucks, and, at least in one case, a bulldozer.

Beginning in 1957—before the movement (for it was surely that) was christened and started to attract media attention and until its innovations were disseminated—a concentrated series took place at the Reuben Gallery and other locations in New York, New Jersey, East Hampton, and Provincetown. Among the American originators who were later to be successful as object artists were Red Grooms, Jim Dine, Claes Oldenburg, and Lucas Samaras. Only Kaprow and Robert Whitman, of the initial nucleus, continued and modified this medium after 1962. The quality of these events varied from group entertainment resembling high school theatricals or old-fashioned fraternity house horseplay to striking participatory spectacles that remain imprinted on the memories of those who attended or took part in them. Among the best witnessed by this author was Dine's *Car Crash* (figs. 37 and 38), performed in November 1960, within a white environment at the Reuben Gallery. Combining poetry, tape-recorded

34
Kurt Schwitters, *Merzbau*, ca. 1933, Hannover, Germany (destroyed 1943). Photo by Landesgalerie Hannover.

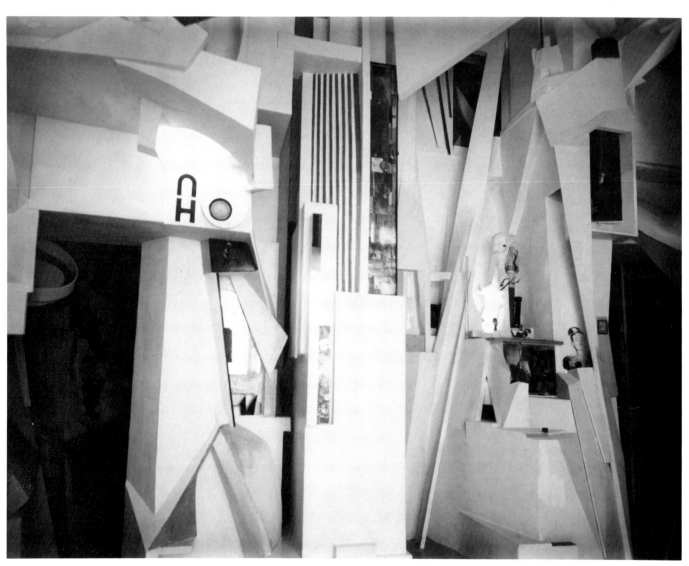

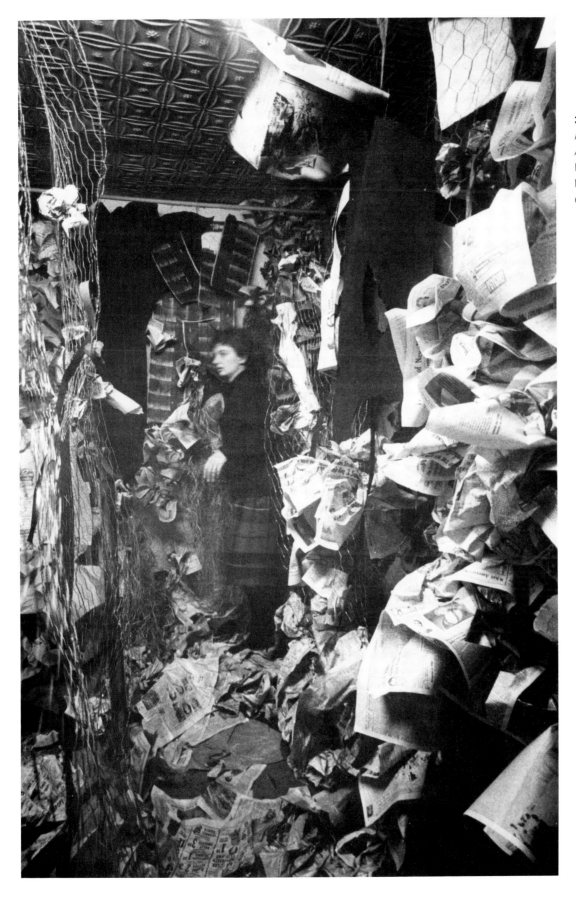

Allan Kaprow's environment *An Apple Shrine* at the Judson Gallery, Judson Memorial Church, New York, 1960. Photo by Robert R. McElroy.

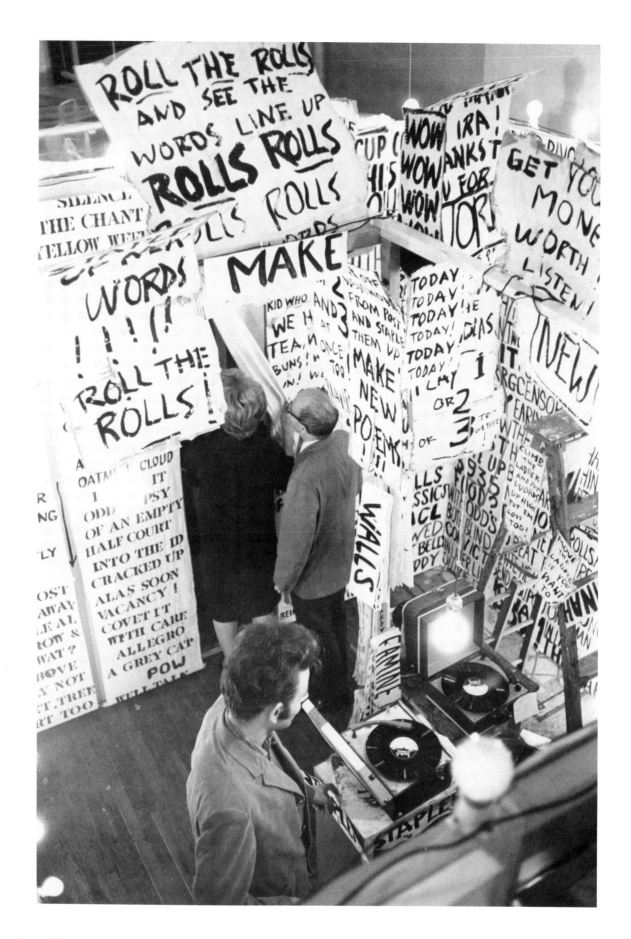

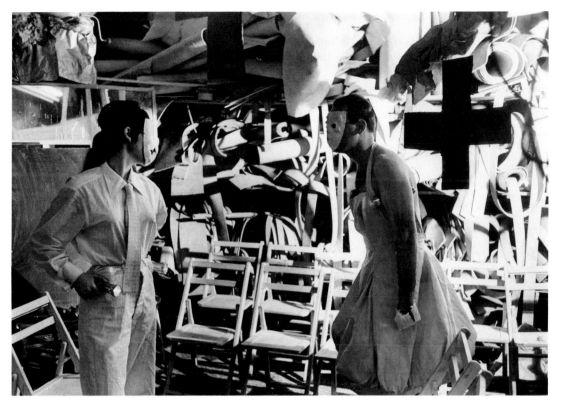

36
Opposite: Allan Kaprow's environment *Words* at the Smolin Gallery, New York, 1962. Photo by Robert R. McElroy.

37
Jim Dine's happening *The Car Crash,* 1960. Photo by William C. Seitz.

38
Jim Dine and Judy Tersch in Dine's happening *The Car Crash* at the Reuben Gallery, New York, 1960. Photo by Robert R. McElroy.

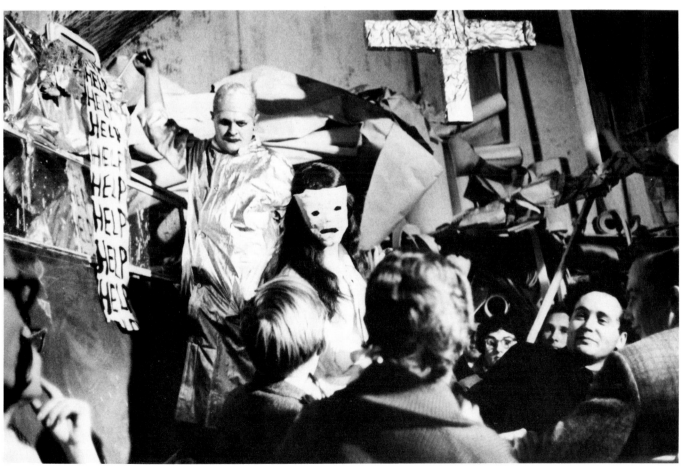

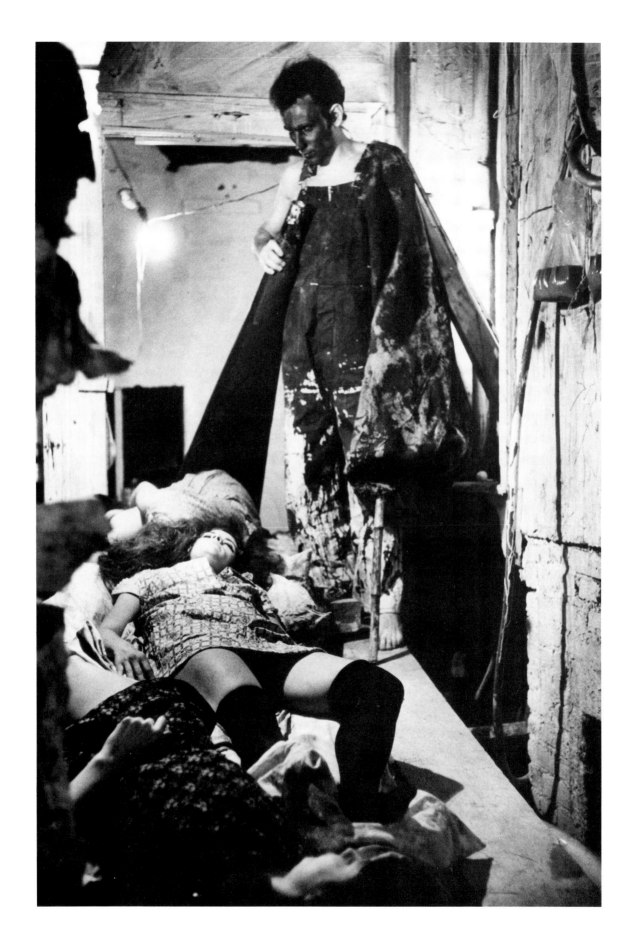

traffic sounds, and a choreographic interplay of performers in stark costumes of white or metallic gray—among them Dine, who uttered inarticulate sounds as he drew tortured images on a blackboard—this presentation dramatized, with traumatic intensity, the automobile as a sexual vessel and instrument of death. That the happening medium could also be a means of Dionysian catharsis was demonstrated in Dine's *Shining Bed,* presented just before Christmas of 1960, in which only the author acted out the birth of a golden Christ child from the symbolic onanism of Santa Claus. (See also pl. 12.)

Claes Oldenburg's happenings were a means of putting "objects in motion"—living collages, either intermixed or compartmented by blackouts, of ordinary but somehow enhanced objects and actions—and his performances came closer to professional film and theater techniques than did those of his friends (figs. 39 and 40). In a large New York loft or outside the city, complex interactions of cast and props surged within one space or even from indoors to outdoors. In 1962, however, Oldenburg, absorbed with his "Store," returned to static objects.

Kaprow's *Yard* (fig. 41), staged that year in the superbly dramatic covered central court of Stanford White's Mills Hotel on Bleeker Street, was performed around a huge tar-paper-covered "mountain" in the center. The quiet movement of figures walking, climbing, perched on the peak, or appearing in windows, while bright materials fluttered down from above, generated an unforgettable poetry of ample but limited space.

Whitman was concerned more with time and the sequence of occurrences than with objects or forms. Beginning with *The American Moon* (figs. 42 and 43), which ran for ten performances at the Reuben Gallery in 1960 and continued there and at other locations, his happenings employed figures on the ground or suspended, participant audiences moving through enclosed spaces or grouped in separate compartments, soft, hard, dry, or dripping materials, and multiple film projection.

Between 1960 and 1962, when happenings were the new, controversial, and fashionable novelty, curators, dealers, art historians, artists, critics, and "beautiful people" crowded the Reuben Gallery. After its period in the New York spotlight and in the media, the new form spread—following the gal-

39
Lucas Samaras in Claes Oldenburg's happening *Injun, I,* at the Ray Gun Manufacturing Company, New York, 1961. Photo by Robert R. McElroy.

40
Claes Oldenburg as the Prop Man and Pat Oldenburg as the Performer in Claes Oldenburg's happening *Store Days, II,* at the Ray Gun Manufacturing Company, New York, 1962. Photo by Robert R. McElroy.

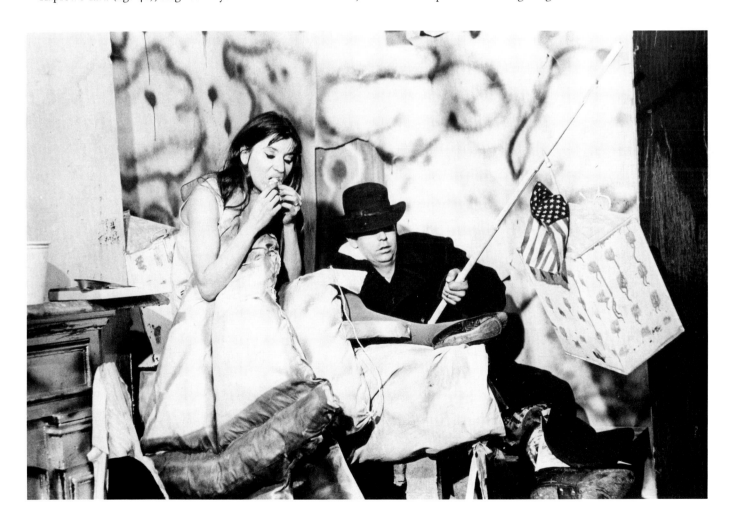

41

Allan Kaprow's environment
Yard in the courtyard of the
Martha Jackson Gallery during
*Environments, Situations,
Spaces,* New York, 1961. Photo
by Robert R. McElroy.

42
Robert Whitman with his the-
ater piece *The American Moon*
under construction at the Reu-
ben Gallery, New York, 1960.
Photo by Robert R. McElroy.

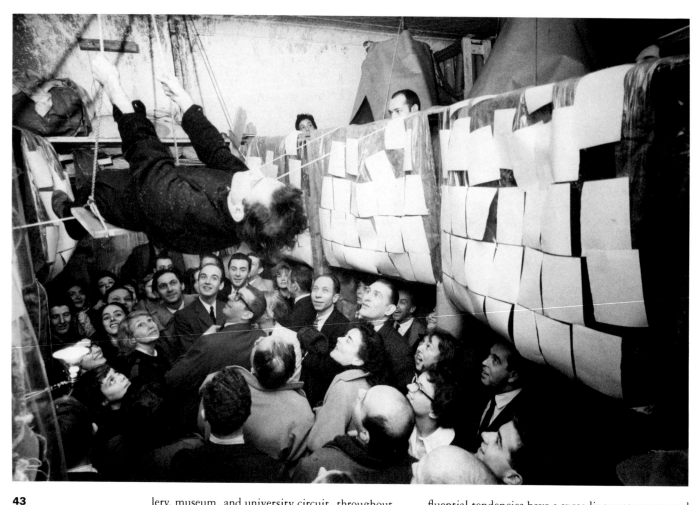

43
Lucas Samaras in Robert Whitman's theater piece *The American Moon* at the Reuben Gallery, New York, 1960. Photo by Robert R. McElroy.

lery, museum, and university circuit, throughout the country, meshing with an international network of innovationalism, to Europe and South America. The rapid expansion of the happening movement (and its subsequent popularization and dissolution in planned community recreation in city parks, ghettoes, and shopping centers) emphasized what, outside of modernist art circles, may have been its most timely contribution: the opportunity for *group interaction,* which was to develop like prairie fire in the youth, psychedelic, and rock movements as popular art forms in the love-in, the be-in, and even the riot, with hippies, "heads," cops, and protestors as the performers. "We are theater in the streets," Abbie Hoffman wrote in 1967, "total and committed." [11] The happening initiated an experience of togetherness and human contact for the young that was reassuring in a time of increasing disillusion, insecurity, and alienation. Indeed, the Woodstock Rock Festival of 1969—a final peak in the nonviolent youth movement—could be seen as the greatest happening of them all.

New York's conviction of its self-sufficiency in the early sixties tended to obscure the fact that most in-

fluential tendencies have a spreading root system and often emerge in different centers simultaneously. A good case could indeed be made—quite independent of early sources in Futurism, Dada, and Surrealism—for Japan as the place of origin for the happening, as in the following account by Japanese critic Yoshiaki Tono:

In the first half of the 1950's, another movement was started in Osaka. Some twenty young artists gathered around the prewar vanguard painter Jiro Yoshihara and formed the Gutai Group. During the first years, they staged happenings, outdoors or on a stage, to demonstrate that art can spring from chaos and chance. They had not lost their sense of innocent "fun." Atsuko Tanaka draped innumerable pieces of pink and yellow cloth in a pine forest near the sea and let them flutter in the wind like big banners. Sadamasa Motonaga hung vinyl bags filled with liquids in many bright colors from a ceiling so that they shone like a cluster of giant drops suspended in midair. Kazuo Shiraga mixed clay with water, then jumped into it, leaving traces of his action in the mud. Saburo

Murakami used a large piece of gold foil as a wall and hurled himself through it, leaving the jagged mark of a man's figure. Another example was a white vinyl cloth spread out in a forest for about a hundred years to collect footprints. These experiments, which at first seemed Dadaist, liberated Japanese art from the narrow conventions of two-dimensional painting. Dramatizing spontaneous encounters between human actions and objects in simple settings, they were symbolic of growth and death in nature. Needless to say, this anti-art-like movement did not last long. But when Michel Tapie, the originator of the term "Art Informel," came to Japan in 1957, he praised the group highly. When he undertook to support them in the international market, the artists in the group began to return to two-dimensional painting, an ironical development. [12]

Japanese avant-garde painting of the fifties and early sixties was a mélange of Abstract Expressionism and *Tachisme* with traditional calligraphic art and the spirit of Zen, which had always delighted in improvisation, paradox, and antirationalistic gestures. But the Gutai happenings were a quite indigenous manifestation. Contradiction, as Tore Haga wrote in 1962, is in Zen practice a "therapeutic treatment" that aims at leading us to the impasse of analytic deceptions and at keeping us bewildered until we awaken from our "logical somnabulism." [13] Dada and Zen have always made a blend like a good hollandaise sauce, in Japan as well as in the West. "You talk of Zen in New York," Yoshiaki Tono once remarked, "in Tokyo we talk about Tinguely." [14] In the wake of the sympathy felt by Japanese artists for Pollock, Tobey, Kline, and Wols in the fifties, the Swiss sculptor Jean Tinguely was the artist to whom the younger generation of Japanese artists responded most enthusiastically (fig. 44).

Art as play, anti-art, art as destruction, art as happening, art as protest, art as junk, art as subversion, and art as movement were far from unknown in 1960 or, for that matter, in 1916; but the destruction of Tinguely's preposterous work of kinetic junk sculpture, *Homage to New York* (fig. 45), in the sculpture garden of the Museum of Modern Art on the dank, slushy evening of March 17, 1960, combined all of these concepts before television cameras and a select audience that included Governor Nelson Rockefeller and his wife, Happy. All accounts of that evening now seem fanciful, but it is beyond question at least that, as the chilled and impatient guests waited long beyond the appointed hour of 7:30—the time the twenty-seven-foot-high "self-constructing and self-destroying work of art" was

supposed to have performed the peak of its life cycle ". . . out of the chaos of the dump and back again. . . ." [15]—they had ample time to observe its fragile but majestic beauty. Painted dead white, it stood outlined against the snow, the garden wall, and dark evergreens, surmounted by an orange weather balloon that was finally inflated, and its pregnant minutes of immobile existence were triumphant. The self-destroying machine had been frantically assembled under a Bucky Fuller dome in the garden during the previous two weeks, from scrap materials scavenged by Tinguely and his technical adviser and assistant Billy Kluver from the dumps, surplus outlets, and junkyards of the metropolitan area. A crazily beautiful contraption defying verbal description, a jet-age Rube Goldberg, it was composed of diverse materials: bicycle and baby-carriage wheels interconnected by belts, spindles, and axles; sticks, wires, tubes, saws, electric motors, and a piano designed to be played by a rebuilt Addressograph machine.

Had *Homage to New York* been preserved, it might well stand today as the key monument of mixed-genre sculpture or (by contrast with the calculated humor and studied relationships of Stankiewicz's junk constructions) anti-sculpture. Incorporated were two "metamatic" painting machines that, in a parody of *Tachiste* art, produced jerky calligraphic marks on rolls of paper. Although Tinguely had assured museum officials that fire would take no part in the destruction, the piano had been carefully prepared to die by precisely that means. The entire structure was designed not only to saw off its own members, but also, with joints already weakened, to collapse and melt on receiving an electric charge. Everything was at last ready and, with creaks and rattles, the insane maze of wheels and belts started and broke down immediately. After some attention, it began to function again and played out its role to the end. One metamatic machine failed to operate properly, its disconnected paper flapping in the breeze of an electric fan that was planned to waft the machine's creations toward the audience. The other, designed to store its work on a take-up roll, worked well. The piano, its inner anatomy exposed, repeated three mournful notes over and over and, breaking into flame, continued to accompany its own suicide.

Those familiar with Tinguely's art knew that breakdowns, failures, and unpredictability were its innate and essential qualities. Indeed, Tinguely always professed complete happiness at such eventualities, as he did when his machines were proclaimed not to be art at all. As the fire in the piano increased, an infant suicidal machine in its own wheels

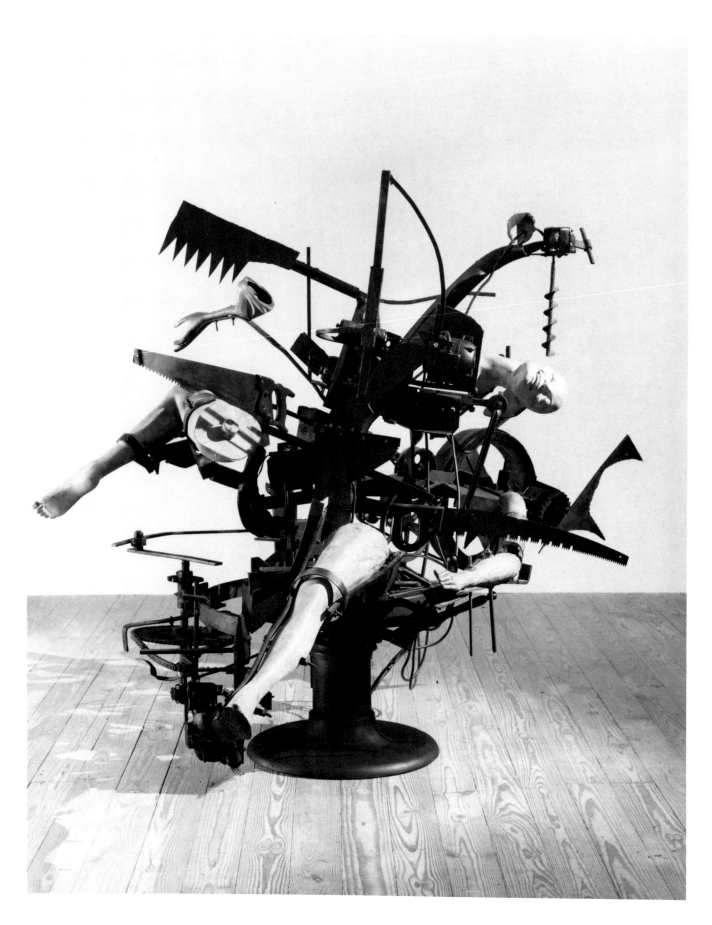

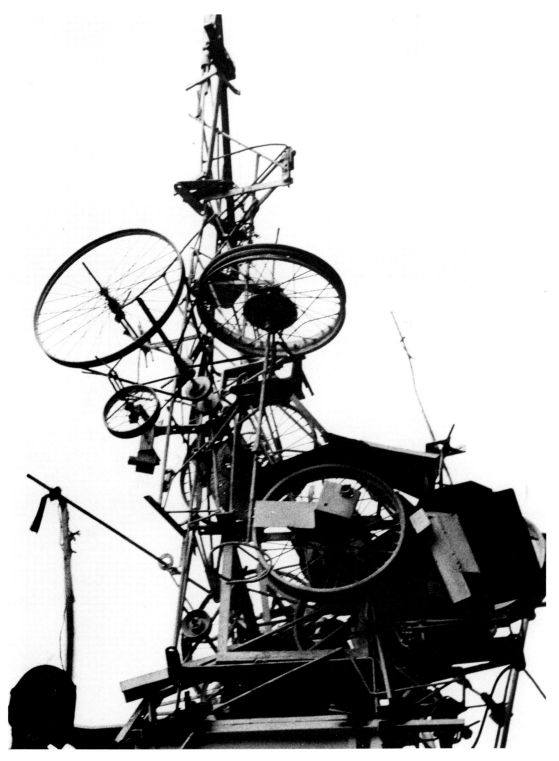

broke away from the parent, faltered, and then, "its Klaxon shrieking, and smoke and flame pouring from its rear end,"[16] faced into the crowd of spectators and journalists where it was captured. As the moment for self-destruction approached, the fire in the piano threatened to get out of control, and the specially prepared self-destruct joints failed. Finally, accompanied by boos from the crowd and relief on the part of the museum staff, the fire was extinguished by New York City firemen, and the spent remains of the structure were chopped into pieces to be carted away.

Tinguely was well known in Europe before his appearance in New York. All his life he had been ob-

sessed (as a leaflet he dropped from an airplane over Düsseldorf in 1959 made clear) with movement. He entitled this manifesto "Für Statik" (For Statics):

Everything moves continuously. Immobility does not exist. Don't be subject to the influence of out-of-date concepts. Forget hours, seconds, and minutes. Accept instability. Live in time. Be static—with movement. For a static of the present moment. Resist the anxious wish to fix the instantaneous, to kill that which is living.

Stop insisting on "values" which can only break down. Be free, live. Stop painting time. Stop evoking movement and gesture. You are movement and gesture. Stop building cathedrals and pyramids which are doomed to fall into ruin. Live in the present; live once more in Time and by Time—for a wonderful and absolute reality. [17]

By 1959 his work had been seen in some ten one-man exhibitions in Paris, Milan, Düsseldorf, and London, where, at the Institute of Contemporary Art, which was the hub of British avant-garde activity, he delivered a "lecture" assisted by friends that recalled the confrontations calculated to enrage audiences during the Dada period (except that, in 1959, neo-Dada was received with delight). Tinguely extended the Düsseldorf Manifesto with an apparent paradox in which most scientists and sociologists would now concur: "Movement is static because it is the only immutable thing—the only certainty, the only unchangeable." [18] Both his detestation of everything static and established and his infatuation with movement were asserted, like the inception of the Dada movement, against a background of Swiss orderliness. He was twelve when he devised his first work of kinetic art: a row of sound-and-motion machines activated by the flow of a fast-running stream near his home in Basel. Later, an exceptional young teacher, Julia Ris, introduced him to modern art, collage, and Schwitters, in a course called Material Studies. In 1955 he participated, along with Yaacov Agam, Pol Bury, Duchamp, Robert Jacobsen, Jesús Raphael Soto, and Victor Vasarely, in the pioneer exhibition Le Mouvement at the Galerie Denise René in Paris, where he showed slowly moving Arp-like shapes, Klee-like ratchet-and-belt-driven constructions in wire that were caricatures of Swiss clockwork, and a metamatic robot that, as Calvin Tomkins wrote in his fine New Yorker profile of Tinguely, "walked about, drew pictures, and jostled neighboring exhibits in a manner that some of the other artists found anything but amusing." [19]

Tinguely's appearance on the New York scene, under official auspices and with critical acclaim sufficiently seasoned by derogation to maintain an aura of controversy, was a fitting inauguration of the modernist sixties. An auspicious confluence of an original mercurial personality with the right time and place, it was a textbook "good entrance."

Among the many other redirections that accompanied the advent of the sixties, far too numerous to catalog in one account, was an attack—which gained momentum toward the end of the decade—on works of art as solid, exchangeable, and salable commodities. This impatience with gallery and museum art had separate and apparently spontaneous origins in France, England, Italy, Germany, Japan, and the United States. In London, for example, Gustave Metzger, one of whose "art forms" was the collection of rubbish in transparent plastic bags, also produced "expendable art" by brushing acid on disintegrated nylon. Those patches that the acid touched disintegrated, curling the edges of the remaining material and forming a pattern of voids. He also proposed metal sculpture that would slowly disintegrate "by undergoing a continual destructive process such as the action of acid or some other erosive [sic]," [20] or simply from normal atmospheric conditions that "will almost certainly corrode completely a thin piece of iron or mild steel within a decade at the outside." [21] Such apparently foolish ideas, regarded as bids for publicity by most "serious" critics, must at the very least be recognized for their symptomatic importance, especially in the light of later and similar manifestations as process art.

In France, Yves Klein's affront to the art object was both disruptive and reductive. Reminiscent in his exhibitionism of Georges Mathieu, this volatile Niçois had an impact in Europe comparable to that of Tinguely, although he entirely failed to achieve the succès fou that he sought in New York and Los Angeles in 1961. Of Dutch Malaysian and French parentage, Klein studied Oriental languages, attended the French Merchant Marine Academy, became a jazz musician during the forties, and studied Rosicrucianism and judo.

On the beach at Nice in 1946 with his friends Claude Pascal and Arman Fernandez, he magisterially appropriated the cloudless blue sky as his domain, and, it is said, signed it "on the underside," in the art of "le vide" and "le monochrome." His first monochrome paintings were exhibited privately in London in 1950 and, after a period in Japan where he achieved a black belt in judo, he became director of the National Judo Federation in Spain in 1954, and subsequently published a basic text on judo in Paris. Among the repertoire of vanguardist gestures by which Klein attracted attention throughout Europe between 1957 and 1959 were monochromes painted in a deep ultramarine that he proclaimed to

be "International Klein Blue";[22] a joint exhibition with Tinguely (*Pure Speed and Monochrome Stability*) in which blue panels were whirled and "dematerialized"; a theory, advanced from his studio in Gelsenkirchen, Germany, of "air architecture" and climate control; fountains of fire, water, and steam; the floating of 1,001 balloons ("immaterials") over Paris; the exhibition at the tiny Iris Clert Gallery of an empty white room called "*le vide*"; "Fire painting" produced by burning and scorching composition board with a torch; reliefs (one a mural in the opera of Gelsenkirchen) and a "sculpture" of "Klein blue" dipped sponges and "moongold" painting in gold leaf. (See fig. 46, pl. 13.) In what came close to being a true happening, Klein in 1960 performed his *Monotone Symphony*, first conducted in 1949, and made up of one long continuous tone followed by one long continuous silence. Klein also initiated "cosmogonies," for which rain, wind, and other atmospheric conditions served as the media. Revealing an extroverted egotism comparable only to that of Salvador Dalí, he believed that these and other manifestations were means rather than ends—that "the painter only has to paint one masterpiece, himself, constantly." [23]

Klein had met the French critic Pierre Restany in 1955, and was included by the Milan dealer Arturo Schwartz in a 1957 exhibition of *Nuclear Art,* held to be the only fitting movement to follow Futurism, Dada, and Surrealism. Restany and Schwartz, critic and dealer, were continually goading the already frenetic pace of centrifugal modernism and were fervent and self-proclaimed avant-gardists. Under the leadership of Restany and Klein, the Nouveaux Réalistes group was formed in October 1960. Besides Klein, it included Tinguely, Arman (the initiator of "accumulations" and "garbage manifestations"), François Dufrêne, Raymond Hains, Jacques de la Villeglé, Daniel Spoerri (who glued found arrangements of objects to their supports and declared them to be "snare pictures"), and Martial Raysse (who at that time made constructions of plastic objects). It has never been explained how the umbrella "new realism" could shelter so diverse a group, especially in that it was later enlarged to embrace other quite different artists. According to the poet and critic John Ashbery, it was the "European term for art today which in one way or another makes use of the qualities of manufactured objects," [24] and to Restany it was "art dealing with a new nature," a nature changed because "nature is mechanical, industrial, and flooded with advertisements." [25] In spirit, perhaps, Schwartz's term "nuclear" had some minimal validity to Klein's and Restany's bids for attention in that they ventured dazzling and disconcerting innovations calculated to burst like rockets and explode

in every direction. Associated with the New Realists in 1960 were also Niki de Saint Phalle, who completed her constructions of small plastic bags of paint by firing into them with a rifle until they bled color, and Christo Javacheff, who had just initiated his "packages," which would climax in 1969 with the wrapping of one mile of the rocky coastline at Little Bay, New South Wales, Australia.

Surely the key word of 1960, as in 1913 when Apollinaire spoke of "the new spirit," was *new, new, new*—the perennial in the modernist lexicon. Within the stringent limits of gallery space and static objects, the exhibition *New Forms—New Media,* held at the Martha Jackson Gallery in June, could be said to have concluded the year in New York. The catalog, with a cover by Oldenburg, included an explanation of "junk culture" by Alloway, which traced its origins to Schwitters and the Futurists, and another commentary by Kaprow, which today appears amazingly prophetic. He observed that "the categories of the plastic arts were becoming increasingly indistinguishable, involving a shift in general from a concern for the work of art as a thing to be possessed . . . and upon which highly specialized care has been lavished, to the work of art as a situation, an action, an environment or an event." [26] In documenting the expansion from agglomerates to environments and happenings, he notes a new emphasis on impermanence, change and extension, and the challenge presented to the definition and limitation of art. There is no reason, Kaprow argued, "why a work of art should be a fixed object to be placed in a locked case"; he predicted that "in the long run, whatever drawbacks exist now will disappear and it will all seem perfectly credible and will be praised as a note of freedom in a trying period." [27]

We speak, admiringly, of our society as pluralistic. To the degree that this designation remains valid, it defies convergent summarization in modernist art as in other open sectors. But it is clear that the year of the changing decade began a chain reaction from premise to premise, work to work, event to event, and artist to artist, and transformed (in a truly new way) the interaction between artist, dealer, critic, curator, gallery, and museum—each link and contact enhanced, opposed, and defined by the art journals and publicized by the media. The elevated commitment of the fifties and the isolation of the isolated loft were supplanted by an unprecedented interplay between the individual artist and the kaleidoscopic and portentous setting of the megalopolitan environment: one can understand and sympathize with the elitism, renunciation, and even total rejection of those for whom art was a sacred and ancient commission.

Assemblages, Environments, Happenings

46

Yves Klein, *Requiem (RE20) blue,* 1960, sponges, pebbles, dried pigment in synthetic resin on board, 78⅜ × 64⅞ × 5⅞ in. (199.07 × 164.78 × 14.92 cm). The Menil Collection, Houston. Photo by Hickey-Robertson.

Pop: Its Variations and Mutations

5

In 1970 the *New York Times* published an anthology of essays by its staff writers dealing with television, radio, newspapers, magazines, film, theater, pop and rock music, art, and other media of information and entertainment. It was called *Pop Culture in America,* [1] a title that conferred immense social and historical significance on that rather foolish little word—*pop.* An unprepossessing designation for such an embracing concept, it nevertheless has a venerable history. Once a common but affectionate form of filial address, memorialized in Charlie Chan movies, *pop* has its origins not just in baby talk, but in the Latin *papa* and the Greek *papas,* meaning priest, or father. And whatever happened to the unfortunate weasel in the old jingle when he was chased around a cobbler's bench, it emitted a "sharp, quick, explosive sound," like the removal of a champagne cork, a *pop gun,* pistol, and a *pop-pop,* or machine gun. The unlucky gang leader gets *popped off.* Audible sharpness and quickness being extended to movements and gestures, heads are said to *pop* out of windows, and eyes to *pop* out of their sockets. Encouraged by television commercials, peanuts, chocolates, and pills are *popped* into mouths. Heroin, bought with money received from stolen goods *popped* into pawnshops or *pops,* is *popped* into veins. Americans consume innumerable gallons of bottled *pop* each year, some of it frozen into *Popsicles.* However, dictionaries published before 1965 make no mention whatever of *pop* as defining a tendency of fine art. Until 1962, in fact, the terms *popular* and *fine* as applied to art were contradictory. *Pop,* of course, was recognized as a contraction of *popular,* a many-faceted concept rooted in the Latin *populus* that, although it originally referred to Roman patricians, came to imply the whole

people or nation—the Italian *popolo,* the French *peuple,* and the German *Volk.*

It was once more common than it is now to refer to *folk art,* and even today that term is useful in referring to the vestiges of indigenous communal art not yet obliterated or degraded by modern technology, communication, and colonial domination. *Popular art* and *folk art* were once all but synonymous, though their meanings were invaded by the loose application of the now discredited term *primitive,* applied alike to early Italian paintings, sculpture from the Congo, New Guinea, or Baffin Land, and untaught painters from the American limners to Henri Rousseau and Grandma Moses. The flood of images that poured from advertising agencies, sign shops, and printing presses was known as *commercial art*—a curriculum of study in trade-oriented schools. But the contraction *pop,* as it was used before the sixties, provided a convenient catchall for everything believed to be acceptable to, though seldom originated by, what used to be called the "masses." Prices are *popular* when they are low. A *populist* is an advocate of social justice or a member of a people's party. On this basis such artists as Ben Shahn objected to the common distinction between commercial and fine art, and, taking the opposite viewpoint, the De Stijl, Bauhaus, and *Nouvelle Tendence* movements were founded on the principle that the images and objects of everyday life, and ultimately the entire environment, could be transformed and unified by a creative and informed elite. In his essay of 1939, "Avant-Garde and Kitsch,"[2] Clement Greenberg drew the sharpest possible line between authentic or ambitious modernism and vulgar attempts to imitate high art, which marked the beginning of his thirty-year defense of elitist modernism against adulteration by an increasingly pluralistic society. Pop, in its many varieties and mutations, is the name for these erosive forces.

Before the sixties, a relatively clear stratification had also been established in music: classical and avant-garde music were, allegedly, the forms of an elite, or those who aspired to belong to it; Negro jazz, originally a true folk-art form, was the music of the black subculture and the white avant-garde; the Boston Pops were concerts that ranged from easy classical music to the most banal kitsch; and the term *pop* covered the commercial music that, from Cole Porter and George Gershwin to Irving Berlin, originated on Tin Pan Alley, or in London on Denmark Street. It was still possible in the fifties to discern four divisions of taste: traditional elite, avant-garde elite, alienated underground, and the mass of the press, radio, and television. But even then, the Museum of Modern Art exhibited Matisse on one

floor and Fred Astaire on another, pop tunes provided the melodic line for jazz improvisation, *hot pop* was a jazz version of a commercial "number," and a bebop fragmentation of it was *pop bop.* Gradually, moreover, commercial pop began to be supplanted by the psychically eruptive sound of Bill Haley and Elvis Presley, who initiated rock-and-roll, the music of the nascent counterculture. At key junctures, the terms pop and rock were all but interchangeable. "Modern Pop," historian Nik Cohn wrote in 1969, "began with rock 'n' roll in the middle fifties."[3]

In 1956, just at the moment when Presley and rock-and-roll were beginning to subvert the old pop in London, Richard Hamilton exhibited the collage *Just What Is It That Makes Today's Homes So Different, So Appealing?* in an exhibition at the Whitechapel Art Gallery called, with some prescience, *This Is Tomorrow.*[4] The Independent Group, which included Hamilton, the sculptor Eduardo Paolozzi, and the critics Lawrence Alloway and Reyner Banham, had been meeting at the Institute of Contemporary Art to discuss the merger of popular culture with the fine arts, an idea that they favored. (For a later example of British Pop, see pl. 14.)

Indeed, if any one nonartist is to be either credited or held accountable for the initiation of what was to be called Pop art, it is surely Alloway, who wrote in 1960 that "it is noticeable that no significant differences have yet emerged in the definitions of Pop Art's role in the environment between the early and the later 1950's."[5] His reference, it is important to emphasize, was to an expanded application of *pop* in the sense then accepted. The phrase to which Alloway objected, as he said later, was Greenberg's "reduction of the mass media 'ersatz' culture . . . destined for those who are insensible to the value of *genuine* culture."[6] A committed pluralist, Alloway saw the fine arts as "one of the possible forms of communication in an expanding framework that also includes the mass arts." These views were expressed in 1958, in an article on "The Arts and the Mass Media," and the term *pop* was used as a friendly way of saying "mass media."[7]

The exhibition, *Six Painters and the Object,* organized by Alloway in 1963 for the Guggenheim Museum after the term Pop art had been adopted, still reflected the inchoate modernism of the beginning of the sixties when assemblage, new realism, and neo-Dada were seen as aspects of the same phenomenon. Of the six painters in the exhibition, three— Johns, Rauschenberg, and Dine—were not Pop artists in the intentionally narrow definition adopted for this chapter, but artists who incorporated certain Pop elements, as well as common objects, into their art (fig. 47, pl. 15). The other three—Lichtenstein,

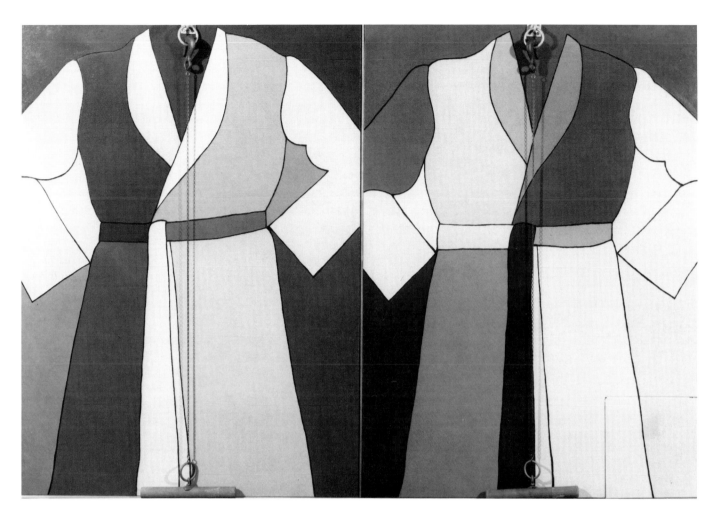

Warhol, and Rosenquist—are perhaps the purest exemplars of Pop. (For examples of other Pop exhibitions, see figs. 48–54.) "What these six artists have in common," Alloway wrote in the catalog, "is the use of objects drawn from the communications network and the physical environment of the city. Some of these objects are: flags, magazines and newspaper photographs, mass-produced objects, comic strips, advertisements." [8] In showing painters who were also object makers, Alloway avoided the controversial term Pop art, and it does not appear in the catalog. Nevertheless, his statement drives home the essential point: *Pop art was media art.* To make this connection is to recognize that the inception of Pop art was a direct outcome of the incursion, which McLuhan and others began to document in the fifties, of the commercial and technological environment into an area of culture previously set apart. As urban refuse was the raw material of collage, assemblage, and junk sculpture, that of Pop art was the artificial, souped-up image of life fabricated by the media. On this basis alone, the sculptor George Segal, who came to prominence by association with Pop, must

be separated entirely from his friend Lichtenstein. No artist whose working process made a transformation directly from actual figures, objects, landscapes, or cityscapes can be characterized as hardcore Pop. To make this distinction is not only to trim off the fat from the term as it was used during the heyday of the movement, but also to improve it as a sharper denotation of its origins, processes, forms, and intentions.

The issue of the relation of art to the environment was raised in 1963 in an article by the painter Erle Loran, who in the thirties had photographed Cézanne's landscape motifs in and around Aix-en-Provence and written a book in which heavily drawn diagrams purported to explain Cézanne's composition. One of Loran's diagrams, of a portrait of Mme. Cézanne, became the first of Roy Lichtenstein's parodies of works by modern masters. This article by Loran, "Cézanne and Lichtenstein: Problems of 'Transformation,'" [9] focused the charges of plagiarism from debased sources, capitulation to commercialism, and lack of sincerity that were directed against Lichtenstein and the other Pop artists at that time.

47

Jim Dine, *Double Isometric Self Portrait (Serape)*, 1964, oil with objects on canvas, 56⅞ × 84½ in. (144.5 × 214.6 cm). The Whitney Museum of American Art, gift of Helen W. Benjamin in memory of her husband, Robert M. Benjamin. Photo by Geoffrey Clements.

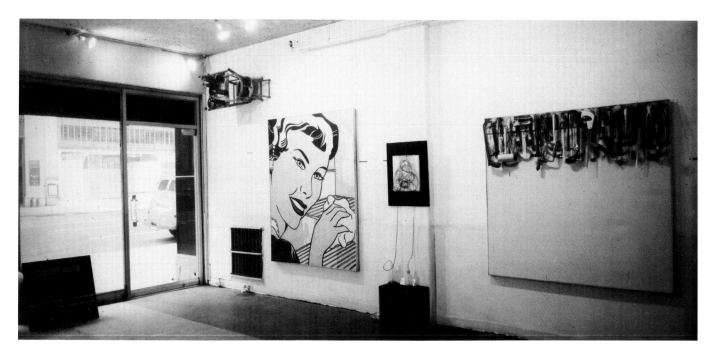

48

Installation view of the exhibition *New Realists.* October 31 through December 1, 1962. Sidney Janis Gallery, New York. Works by (left to right) Daniel Spoerri, Roy Lichtenstein, Martial Raysse, Jim Dine. Photo by Jim Strong. Courtesy of Sidney Janis Gallery.

49

Installation view of the exhibition *New Realists.* October 31 through December 1, 1962. Sidney Janis Gallery, New York. Works by (left to right) Peter Agostini, Tom Wesselmann, Mimmo Rotella, George Segal, Andy Warhol, Robert Indiana, Claes Oldenburg. Photo by Jim Strong. Courtesy of Sidney Janis Gallery.

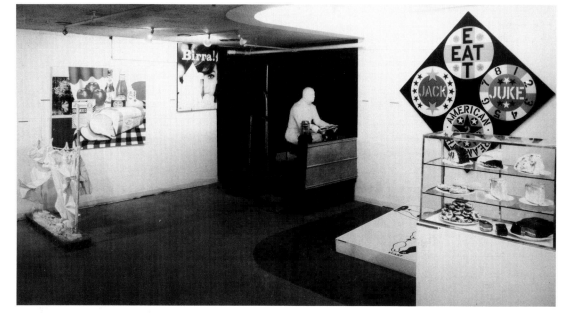

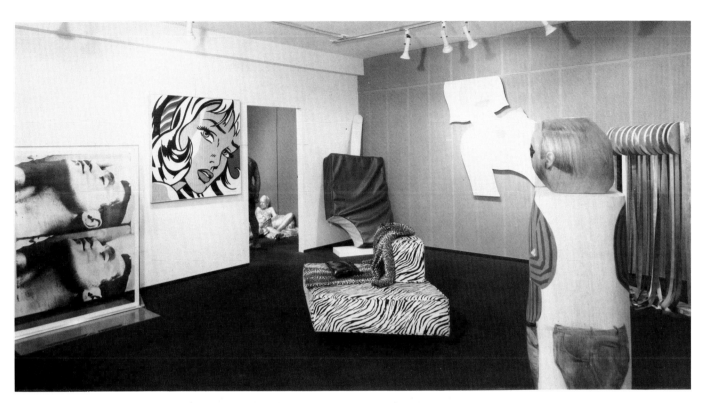

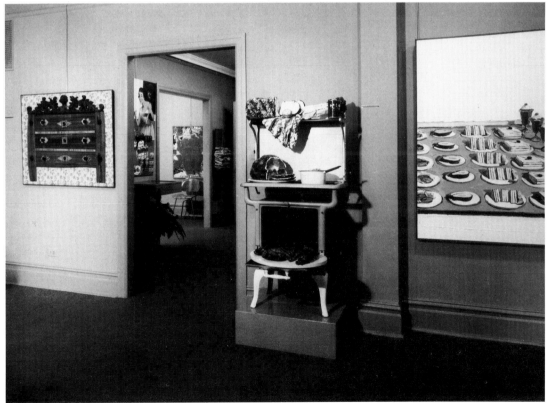

50

Installation view of the exhibition *Pop and Op*. December 1 through 31, 1965. Sidney Janis Gallery, New York. Works by (left to right) Andy Warhol, Roy Lichtenstein, George Segal, Claes Oldenburg, Tom Wesselmann, Jim Dine, Marisol. Photo by Geoffrey Clements. Courtesy of Sidney Janis Gallery.

51

Installation view of the exhibition *New Realists*. October 31 through December 1, 1962. Sidney Janis Gallery, New York. Works by (left to right) Enrico Baj, Tom Wesselmann, Raymond Hains, Tano Festa, Claes Oldenburg, Wayne Thiebaud. Photo by Jim Strong. Courtesy of Sidney Janis Gallery.

52

Installation view of the exhibition *New Realists.* October 31 through December 1, 1962. Sidney Janis Gallery, New York. Works by (left to right) Andy Warhol, Arman, Claes Oldenburg. Photo by Jim Strong. Courtesy of Sidney Janis Gallery.

53

Installation view of the exhibition *New Realists.* October 31 through December 1, 1962. Sidney Janis Gallery, New York. Works by (left to right) Roy Lichtenstein, Arman, Yves Klein, Giacometti, Jim Dine. Photo by Jim Strong. Courtesy of Sidney Janis Gallery.

54

Opposite, top: Installation view of the exhibition *Homage to Marilyn Monroe.* December 6–30, 1967. Sidney Janis Gallery, New York. Works by (left to right) James Rosenquist, George Segal, Andy Warhol, Dali, Chryssa. Photo by Geoffrey Clements. Courtesy of Sidney Janis Gallery.

55

Opposite, bottom: Roy Lichtenstein, *Yellow and Green Brushstrokes,* 1966, oil and Magna on canvas, 87¾ × 187¾ in. (215 × 460 cm). Museum für Moderne Kunst, Frankfurt am Main. Photo by Robert Hausser.

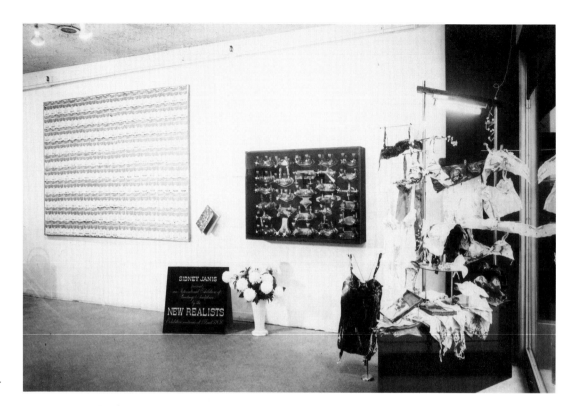

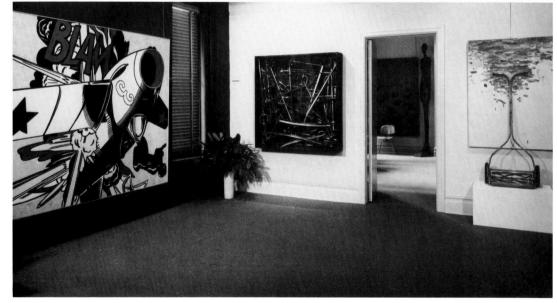

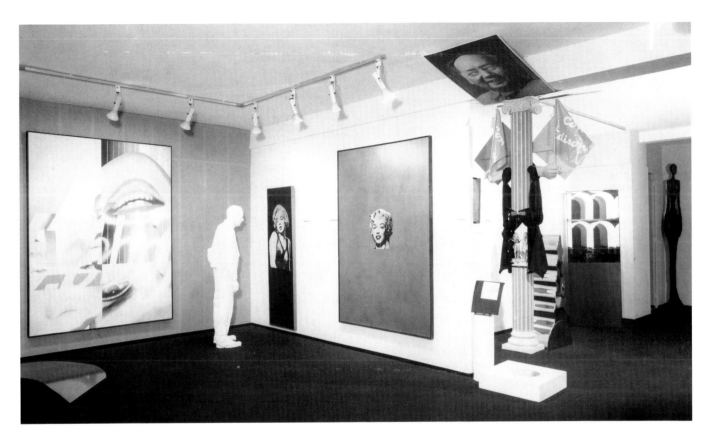

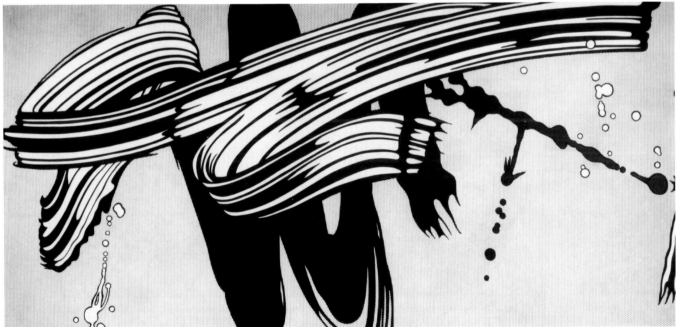

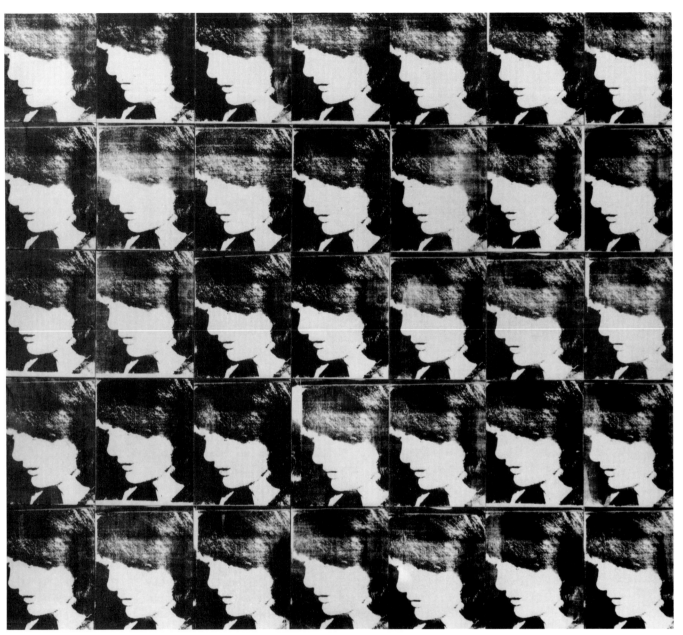

58

Andy Warhol, *Multiplied Jackies* (35 panels), 1964, acrylic and liquitex on canvas, 104 × 117 in. (255.5 × 286.5 cm). Museum für Moderne Kunst, Frankfurt am Main. Photo by Werner Kumpf.

59

Andy Warhol, *100 Cans*, 1962, oil on canvas, 72 × 52 in. (182.88 × 132.08 cm). Albright-Knox Art Gallery, Buffalo, New York, gift of Seymour H. Knox, 1963.

ages, conceived to sell Fords, depilatories, spaghetti, and Pepsi-Cola, and juxtaposed them, at different scales, with magnified images of other common objects (fig. 60). Certain of these fragments of the schematized morphology of hardware, household gadgets, packaged foods, and human anatomy were barely decipherable and were therefore perceived as semi-abstract forms. Unlike Warhol, Rosenquist presented his art as serious social commentary rather than provocative gesture, and, like Rauschenberg and Larry Rivers, he was a relationist working within collage tradition. His work, therefore, in every way epitomizes the environmental collage and monumentalizes the Surrealism mode of juxtaposed images.

To the roster of innovators of hard-core Pop the name of Tom Wesselmann must be added, although he surely does not emerge in retrospect as one of the major artists of the sixties. Nevertheless, his paintings and constructions are of interest in their initiation (in the wake of the early Chrysler/toaster/breast collages of Richard Hamilton) of Americanized, commercialized eroticism as a theme. Wesselmann combined the collage image (often physically, using large sections from billboard-sized paper advertisements) with single-image compositions. The first of his Great American Nudes came uptown from Tenth Street to the Member's Rental Gallery of the Museum of Modern Art in 1961; by 1964 the works in this extended series had enlarged to big-picture pro-

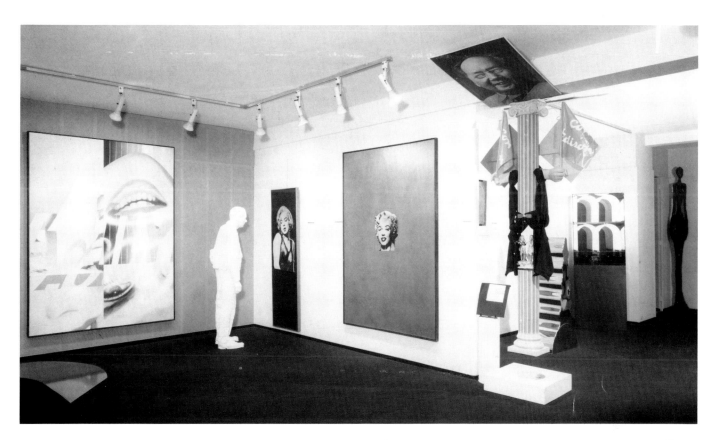

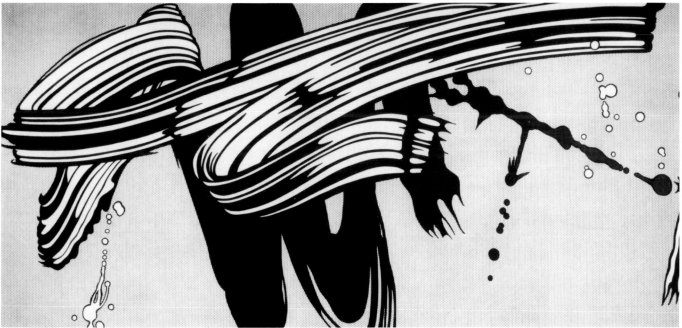

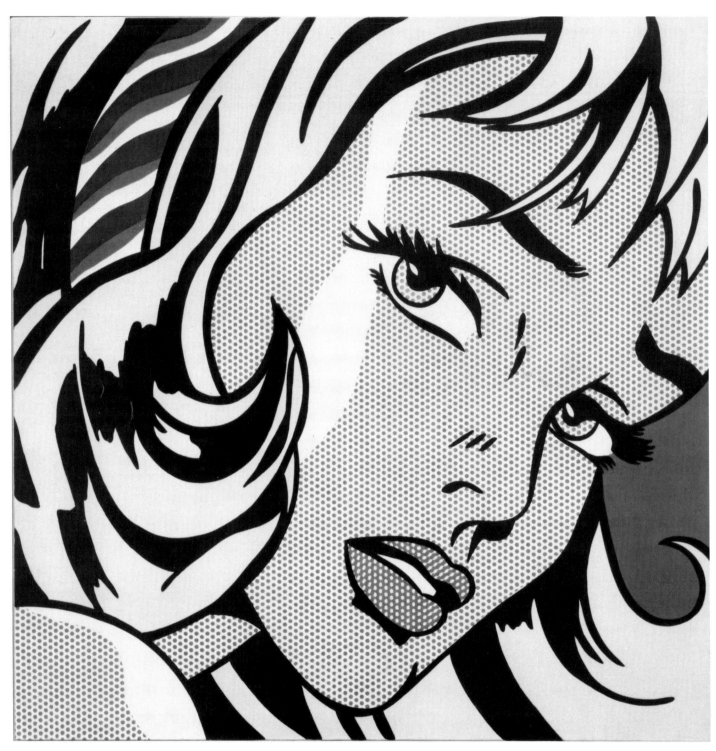

56
Roy Lichtenstein, *Girl with Hair Ribbon.* 1965, oil and Magna on canvas, 48 × 48 in. (117.6 × 117.6 cm). Private collection, on loan to the National Gallery of Art, Washington.

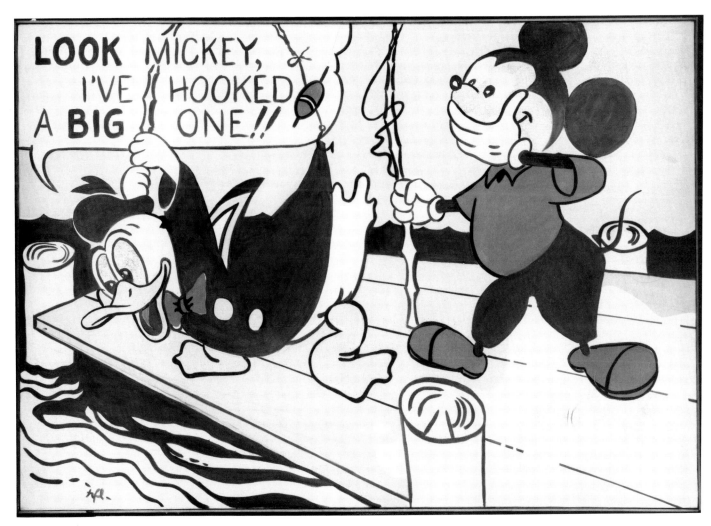

From the time of Courbet, as art historians have repeatedly demonstrated, popular art, like so-called primitive art, has repeatedly been used by modern artists as a point of reference—to set the key, as it were, for their observations of actuality. The critics of Pop art claimed, however, that the new utilization of the most common forms of commercial illustration was little more than copying.

It is true that Lichtenstein, following conversations with his friends Segal and Kaprow, flipped the coin of taste, and of his previous Abstract Expressionist style, by choosing to enlarge, with a bit of what Greenberg once called "trueing and fairing," the most vapid subjects and coarse techniques of outdated comic strips and the cheapest and least sophisticated forms of advertising (figs. 55–57). In 1961, by this aggressively anti-art device (used in reverse when works by Monet, Picasso, or Mondrian were mimicked in a pulp-paper style), he nullified the elitism, the relational aesthetic, and the creative process of his predecessors. It was a blow, for its period, quite as effectively iconoclastic as the mous-

tache placed on *Mona Lisa*'s upper lip in 1919 by Duchamp.

Because he had made his living until 1960 as a modish and fine-art-influenced commercial illustrator, Andy Warhol's "ascent" into the galleries, which began in 1952, and his "descent" from sophisticated drawings of shoes, figures, and flowers to Dick Tracy in 1960, seems less of a premeditated crime than does that of Lichtenstein. (See figs. 58 and 59, pl. 16.)

During that same year, James Rosenquist, a university-trained artist who was also a dues-paying member of the Painters, Decorators, and Paper Hangers Union, and who painted immense billboards on Times Square for the Art Kraft Strauss Sign Company, transferred the gaudy but monumental images and techniques of the billboard painter from the street to the art gallery. Here again, in every sense, is an invasion of a sacred precinct by a profane form. Rosenquist's mode of transformation resembled that of the collagist de Chirico or (more closely) Magritte. He dissected the elephantine im-

57
Roy Lichtenstein, *Look Mickey*, 1961, oil on canvas, 48 × 69 in. (121.92 × 175.26 cm). Dorothy and Roy Lichtenstein, partial and promised gift of the artist in honor of the 50th anniversary of the National Gallery of Art, Washington.

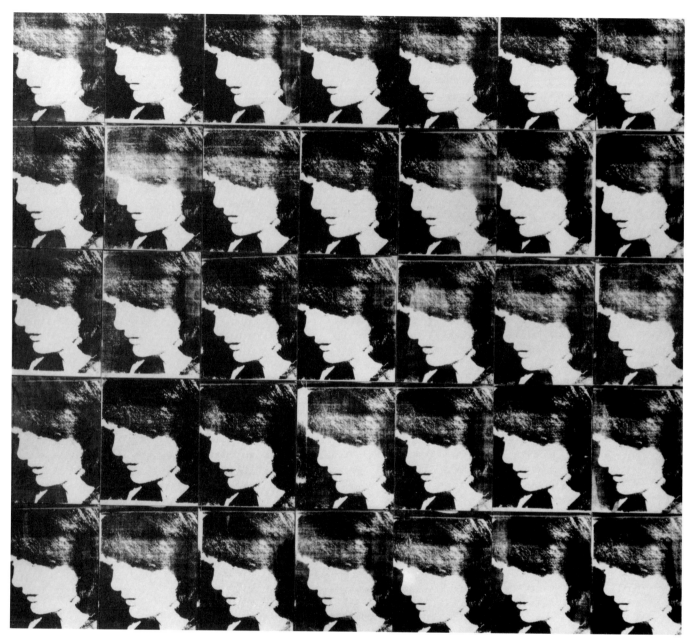

58
Andy Warhol, *Multiplied Jackies* (35 panels), 1964, acrylic and liquitex on canvas, 104 × 117 in. (255.5 × 286.5 cm). Museum für Moderne Kunst, Frankfurt am Main. Photo by Werner Kumpf.

59
Andy Warhol, *100 Cans*, 1962, oil on canvas, 72 × 52 in. (182.88 × 132.08 cm). Albright-Knox Art Gallery, Buffalo, New York, gift of Seymour H. Knox, 1963.

ages, conceived to sell Fords, depilatories, spaghetti, and Pepsi-Cola, and juxtaposed them, at different scales, with magnified images of other common objects (fig. 60). Certain of these fragments of the schematized morphology of hardware, household gadgets, packaged foods, and human anatomy were barely decipherable and were therefore perceived as semi-abstract forms. Unlike Warhol, Rosenquist presented his art as serious social commentary rather than provocative gesture, and, like Rauschenberg and Larry Rivers, he was a relationist working within collage tradition. His work, therefore, in every way epitomizes the environmental collage and monumentalizes the Surrealism mode of juxtaposed images.

To the roster of innovators of hard-core Pop the name of Tom Wesselmann must be added, although he surely does not emerge in retrospect as one of the major artists of the sixties. Nevertheless, his paintings and constructions are of interest in their initiation (in the wake of the early Chrysler/toaster/breast collages of Richard Hamilton) of Americanized, commercialized eroticism as a theme. Wesselmann combined the collage image (often physically, using large sections from billboard-sized paper advertisements) with single-image compositions. The first of his Great American Nudes came uptown from Tenth Street to the Member's Rental Gallery of the Museum of Modern Art in 1961; by 1964 the works in this extended series had enlarged to big-picture pro-

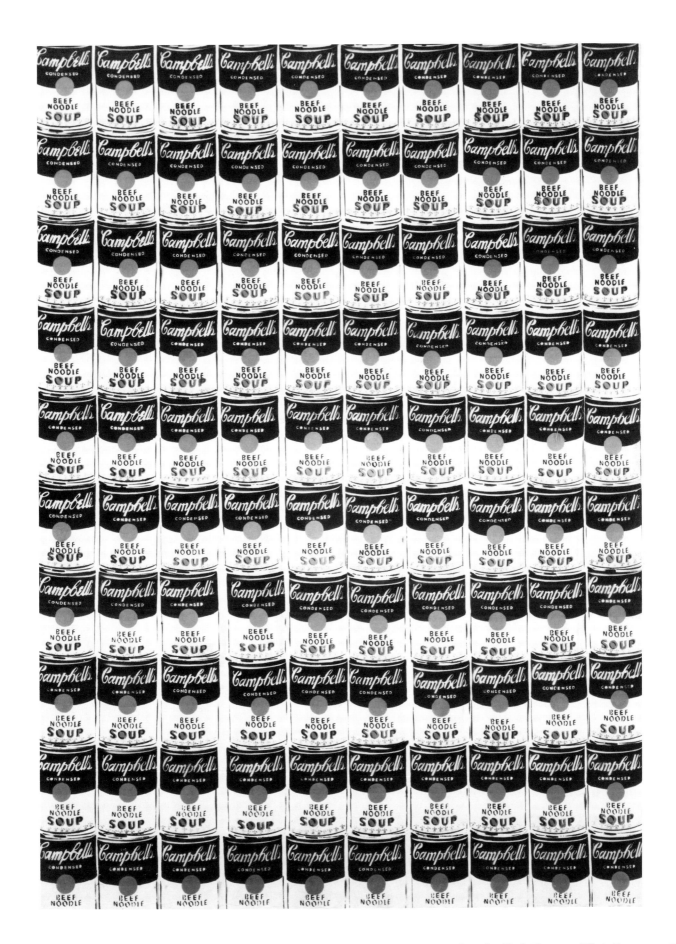

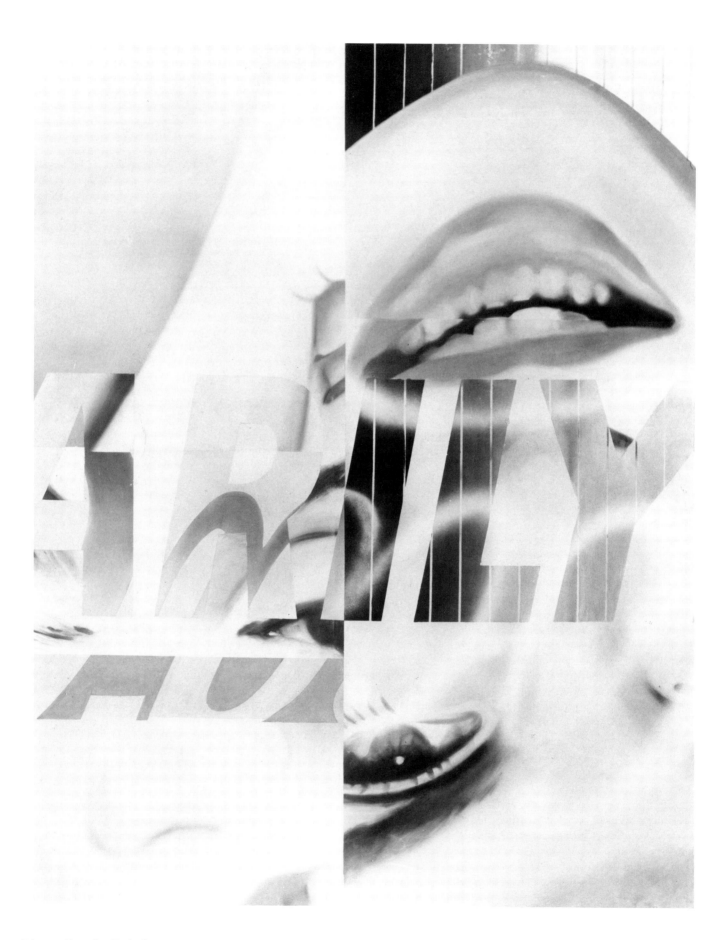

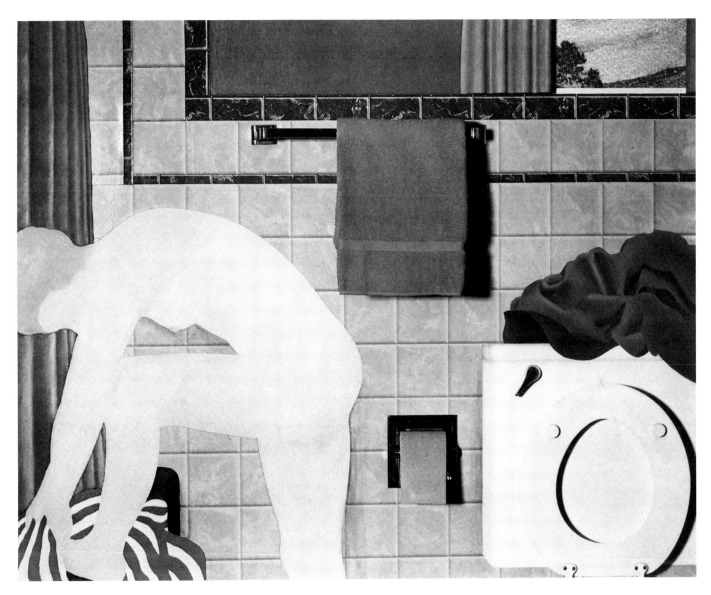

portions. The intentionally blatant colors, phony
flesh tones, self-consciously salacious poses, the en-
vironment of the bedroom and bathroom (fig. 61),
the call-girl iconography of cigarettes, ash trays,
pillows, fruit, flowers, and fuzzy pubic hair were
rendered acceptable—at least to the collectors of
Pop—by a considerable degree of taste in arrange-
ment and relationship combined with a hip, clean
style that, like the works of Lichtenstein, Indiana,
and Allan D'Arcangelo, offered a stylistic parallel to
the flat colors and hard edges of the leading abstract
painters (pl. 17). Lipsticked mouths (a projection of
de Kooning's Women) became the entire shape of
canvases; oranges were surrogate breasts. Wessel-
mann's Pop eroticism could be said to have peaked
in 1970, when a model was hired by the Janis Gal-
lery to insert her breast downward from behind a
wall into a three-dimensional "still life," a caricature
of male sexism (fig. 62). The advent of the women's
liberation movement may have dampened the mar-
ket for this genre—a "school" of slick eroticists
within which must be included Allen Jones, Mel
Ramos, and other Pop and post-Pop practitioners.

The most eminent of the alleged precursors of Pop
art cited in the extensive literature of defense that
accompanied the style's inception and establishment
was Fernand Léger. His central theme, toward
which his attitude was participatory and acquies-
cent, was the impact of technology on the urban en-
vironment. Mechanical form was imposed on human
and natural form. With the city as his habitat,
Léger, however, fully performed the artist's tradi-
tional function of transposing reality into art. He
incorporated, interpreted, and transformed commer-
cial images rather than merely appropriating them,
as did the greatest follower of his urbanist Cubism,

60
James Rosenquist, *Marilyn
Monroe, I*, 1962, oil and spray
enamel on canvas, 93 × 72¼
in. (236.2 × 183.3 cm). The
Museum of Modern Art, New
York, Sidney and Harriet Janis
Collection.

61
Tom Wesselmann, *Bathtub Col-
lage*, 1963, combine painting,
50 × 62¼ in. (122.5 × 152.5
cm). Museum für Moderne
Kunst, Frankfurt am Main. Photo
by Robert Hausser.

62

Tom Wesselmann, *Bedroom Tit Box*, 1968–70, oil, acrylic, collage, woman's breast, 6 × 12 × 8½ in. (15.24 × 30.48 × 21.59 cm). Photo by Jim Strong. Courtesy of Sidney Janis Gallery, New York.

Stuart Davis, as early as 1921, in *Lucky Strike*, and subsequently in *Bull Durham*, *Sweet Caporal*, and *Odol*—a literalistic representation of a box of disinfectant that prefigures Warhol's Brillo boxes. The dilettante artist Gerald Murphy, best known by F. Scott Fitzgerald's fictional portrayal of him in *Tender Is the Night*, also ranked for a moment in 1924, with Léger and Davis, as a precursor of Pop, in *Razor*, a hard-edge representation of a safety razor, a fountain pen, and a box of safety matches.

The term Pop art, as it is being used in this chapter, thus denotes a varied class of works that, in the most unequivocal instances, take theme, motif, and style from stereotypes already flattened by the camera, printing press, television screen, and sign painter's brush. The archetypical Pop artist appeared to accept the falseness to life of such iconic representations, thus celebrating, however ironically, their very meretriciousness and vapidity. The apparent capitulation of the Pop artists to merchandising and their sellout of high-art prerogatives (which in Warhol's photo-silk-screen duplications of Coca-Cola bottles and Campbell soup cans included the abandonment of personal execution) were their boldest innovations, and were direct thrusts at the ethics and aesthetics of previous modern art. The "purest" Pop artist, judged from the position of a defender of either conservatism or elitist avant-gardism, was the one most wholly contaminated. Yet the attempt to

isolate pure, hard-core Pop demonstrates that the accusation of plagiarism was false and calls attention to the great variety of forms made possible by these acts of creative negation.

The attempt to schematize Pop, moreover, is also blocked by the distinction between artists like Lichtenstein (following Johns's Targets and Flags), who isolated out one image, and those like Rauschenberg, Rosenquist, Wesselmann, and Peter Phillips, who made an art form from the confrontations of the environment. In his early work, Richard Hamilton—prime subverter, Duchamp scholar, and pioneer of Pop—was an assembler of clips from the media jungle. If one can countenance the canonization of the vulgar that accompanied the pluralism of the sixties, the question of derivation from the media is not at all that of plagiarism but of the impact of a new, artificial environment; and evidence of the many modes by which the words, images, objects, and even sounds inundate all of us every day was simply utilized by intelligent and responsive, if sometimes disenchanted, artists.

When Pop is seen as an aspect of a larger, broadly activated, and almost inevitable social and technological phenomenon—i.e., the violation of the elitist precinct of art by the commercial and artificial environment—its various manifestations, directions, and mutations demand less explanation. Such was the theme of this author's exhibition *Environment*

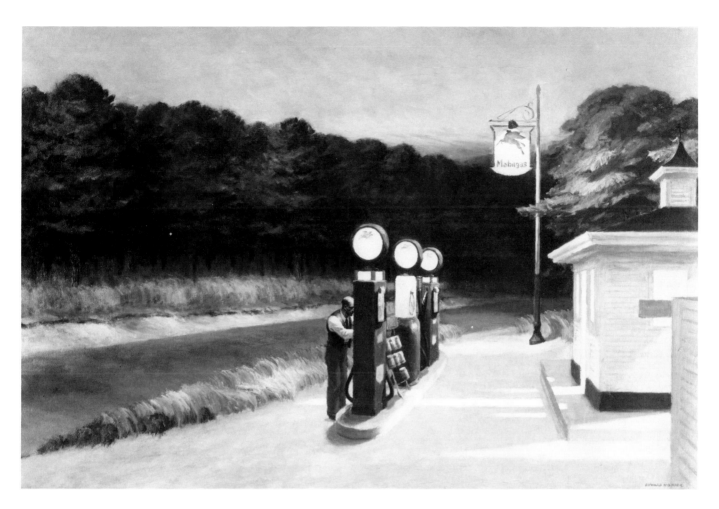

63

Edward Hopper, *Gas*, 1940,
26¼ × 40¼ in. (66.7 × 102.2
cm). The Museum of Modern
Art, New York, Mrs. Simon Gug-
genheim Fund.

U.S.A. 1957–1967, presented in the latter year at
the São Paulo *Bienal*. An important part of that ex-
hibition, including the concurrent one-man show of
the works of Edward Hopper (fig. 63), was devoted
to what Lawrence Alloway called "Highway Cul-
ture." Implicit in this most American of nostalgias is
that alternating current of attraction and detesta-
tion, wanderlust and quite justified fear of the high-
way, the paradoxical mystique of the automobile and
the motorcycle, and the cinematized conquest (as it
used to be called) of the West. The cult of the high-
way and gasoline-powered vehicles has a long and
fascinating tradition that can be found in Steinbeck,
Nabokov, and Kerouac as well as Hopper, D'Arcan-
gelo, and Indiana, and has its origin in the art and
manifestos of the Italian Futurists. However, by the
late 1960s and early 1970s, the biggest franchise
and gasoline companies, responding to the objec-
tions of urban planning boards, were being asked to
remove or lower the profiles of their electric signs
and more garish constructions: perhaps this decision
was an omen of the end of what we call the sixties.
But at their peak, the affection felt for these outra-
geous slashes through the American landscaped was

documented with iridescent verve in Tom Wolfe's
essay on Las Vegas in *The Kandy-Kolored Tangerine-
Flake Streamline Baby* (1965) and *The Electric Kool-
Aid Acid Test* (1968). In 1968 the documentation
was extended by Robert Venturi and Denise Scott
Brown's "A Significance for A&P Parking Lots or
Learning from Las Vegas," which appeared in *Archi-
tectural Forum* followed by a book on the subject in
1972.[10] Brian O'Doherty's "Highway to Las Vegas"
in *Art in America* appeared that same year.[11] Looked
at from a viewpoint opposite to Lady Bird Johnson's
American Beautification Program or the environ-
mental movement, these flamboyant, nationally re-
dundant stretches of concrete, bulldozed terrain,
monstrous electric signs, and other diverse environ-
mental atrocities can be seen as the most resplendent
works of kinetic art in history. In an awful, futuristic
way, they are dazzlingly beautiful.

It is in the context of this long American tradi-
tion, rather than under the worn Pop art label, that
the work of such painters as Robert Indiana can best
be viewed. Indiana, who chose as his precursors
Hart Crane and the Charles Demuth of *I Saw the Fig-
ure 5 in Gold* (1928) (fig. 64), evolved his heraldic

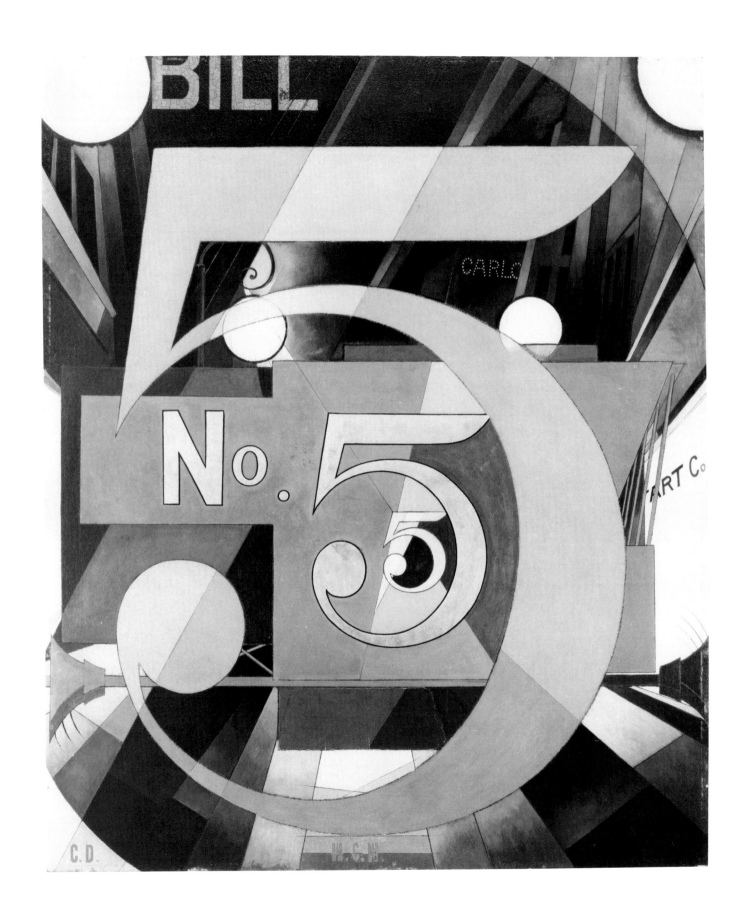

style from billboards, pinball-machine embellishment, airplane markings, and highway signs, but his outlook was retrospective and almost sentimental. The litany of his highway pictures—EAT/HUG/ERR/DIE—epitomizes the dichotomy of the highway and the automobile (fig. 65). A comparable involvement in the mystique of the highway permeated the works by which Allan D'Arcangelo became known after 1962. Typical of these is a series of five canvases dedicated to U.S. Highway 1 (fig. 66). The viewpoint is that of a driver moving, one might assume, at fifty miles an hour or more. Attention is directed toward the central dividing strip, which moves up the canvas surface like the "zip" of a Barnett Newman painting, but in perspective. The sharp-cut stripe, the edges of the highway, and the dark silhouette of distant trees all focus at a high, distant vanishing point. The only other elements in the pictures aside from the flat, dark road, its shoulders, trees, and sky are the signs—US 1, SUNOCO, TEXACO—that from picture to picture appear first in the distance, approach rapidly, slap the observer-driver in the eye, and, from left or right after a flashing glimpse in the rearview mirror, disappear behind. After these early romantic evocations of the road, D'Arcangelo began to explore the formal, "abstract" potential of the central stripe, the arrows of directional or warning signs, barriers, and other highway symbols until, by the late sixties, his initial involvement in the highway was gradually absorbed by an abstract, sixties style that, in the early works, was little more than an influence—a mode of implementing a felt content.

Needless to say, Indiana and D'Arcangelo were not the only artists concerned with the automobile. In popular music and literature from F. Scott Fitzgerald to Jack Kerouac's *On the Road,* and beginning with the paintings of Hopper and Davis, the automobile and the highway have long been a prime subject of the arts in America. More than at any time since the Futurists' obsession with mechanical speed, the road and the car were a dual theme of the sixties found in the works of such artists as Stankiewicz, Warhol, Chamberlain, Marisol, Wesselmann, Trova, Kienholz, and Edward Ruscha. After 1967, in the work of Ralph Goings, Robert Bechtle, Don Eddy, and other photorealists (pages 185–200), the automobile and motorcycle were to become even more central sources—for form as well as subject.

It is worth reemphasizing that the first manifestations of Pop—a movement that more than any other demolished the barrier between modernism and the surrounding world of artifacts, commercialism, and kitsch—were outside the United States in Great Britain. Something of the appeal these London artists felt for the American environment, the automobile, and everything that pertained to the standardized, synthetic American way of life is implicit in a comment of the English artist Gerald Laing, who painted racing cars early in the sixties and later turned to sculpture in an abstract, but intentionally slick, "streamlined" manner:

> . . . that Utopian dream of USA which I held, in common with most of my contemporaries in London, made it inevitable that I should eventually choose to depict these gleaming exotic images and extravagant attitudes which were so heavily propagandized in Europe and which, for us, implied not only an optimistic and classless society, but also that every American had his hot-rod and his surfboard. [12]

Seen in a broader historical perspective, it should now be evident that the phenomenon that surfaced in art as Pop, with origins that predate World War I, was the worldwide change from life among natural things to a world of artifacts. In considering the rampant urbanization of the capitalist world after World War II, it should not be surprising that the figurative artists brought up within it responded, with increasing specificity, to their natural habitat—that, for example, Wayne Thiebaud painted ice-cream sodas and display racks of neckties as still life, or that his figures emanate the clean, minimal, everyday look of secretaries or computer salesmen. Pop was the first major wave of art that depicted a new, artificial, but insistently real world.

The new megalopolitan habitat, of which Pop was but one outcome in art, produced two masters of unquestioned stature: George Segal and Claes Oldenburg. Although Segal performed something of the function of a midwife in the innovation of happenings and American Pop, his persona, like his sculpture, radiates human warmth and empathy to the predicament of the inhabitant of what Henry Miller called the "air conditioned nightmare." Segal's environments and white plaster figures, at one-to-one scale, perfectly contain and implement his continued concern for the individual human being and his speculations on universals and particulars.

Previously a chicken farmer, art teacher, and expressionistic figure painter, Segal began to rise to prominence in 1961, when he initiated a new approach to figurative sculpture that combined casting from the model with direct modeling in plaster. In retrospect, Segal's work of the sixties appears both innovative and traditional: innovative in its radical, veristic method and the placement of starkly white plaster figures in settings of actual objects and archi-

64
Charles Demuth, *I Saw the Figure 5 in Gold,* 1928, oil on composition board, 36 × 29¾ in. (91.44 × 75.56 cm). The Metropolitan Museum of Art, New York, Alfred Stieglitz Collection, 1949.

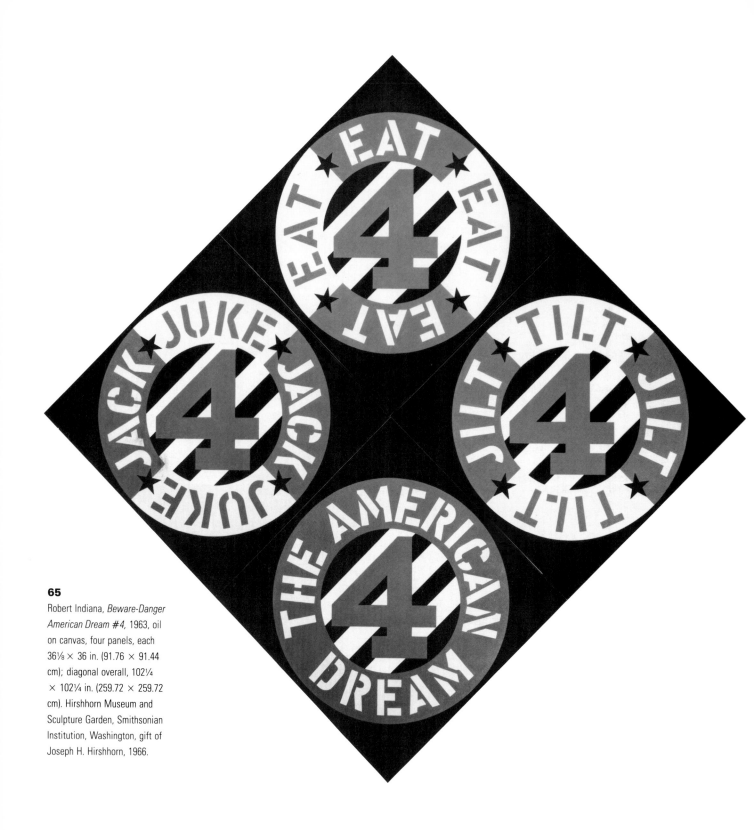

65

Robert Indiana, *Beware-Danger American Dream #4*, 1963, oil on canvas, four panels, each 36⅛ × 36 in. (91.76 × 91.44 cm); diagonal overall, 102¼ × 102¼ in. (259.72 × 259.72 cm). Hirshhorn Museum and Sculpture Garden, Smithsonian Institution, Washington, gift of Joseph H. Hirshhorn, 1966.

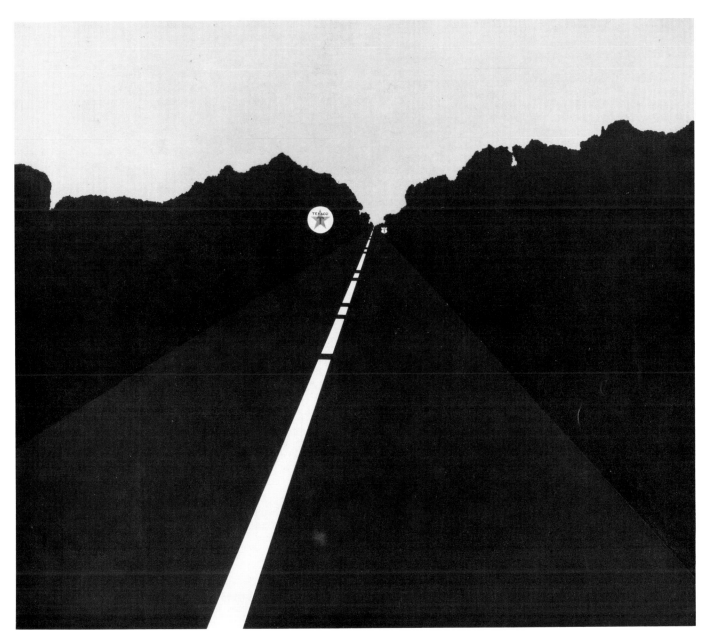

tectural settings; traditional in its blunt naturalism, which recalls the works of Degas and Hopper. In the fifties, Kaprow, Lichtenstein, and Lucas Samaras were among Segal's friends, and his art took form in the circle of the Hansa and Reuben galleries, in which happenings and Pop art originated between 1959 and 1961. Surely Segal benefited by the fluidity and diversity of this milieu, yet his own work remained stubbornly individual and independent and, though environmental, had little to do with Pop.

Segal incorporated many techniques and mediums into his situational sculpture, yet the initial premises have remained constant. Except for portrait commissions, he has dealt with ordinary people in intimate vocational situations—mainly those who live in the megalopolitan sprawl of New York and New Jersey and perform routine activities of work, relaxation, and necessity. Concerned from the beginning with existential content, Segal scrupulously structured the relationships between figures and objects in his environments; veracity is never achieved at the expense of abstract form. Because he uses his family, friends, and neighbors for models rather than professionals, the actuality of the poses, the painterly freedom of the plaster surfaces, and the intimate physical and psychological involvement of artist and subject that the casting phase entails, Segal's figures have an immediacy new to the history of serious sculpture (fig. 67). But sharply countering this kinesthetic life, the stark whiteness of what Kaprow

66
Allan D'Arcangelo, *Highway U.S. 1, Number 5*, 1962, synthetic polymer paint on canvas, 70 × 81½ in. (177.6 × 207 cm). The Museum of Modern Art, New York, gift of Mr. and Mrs. Herbert Fischbach.

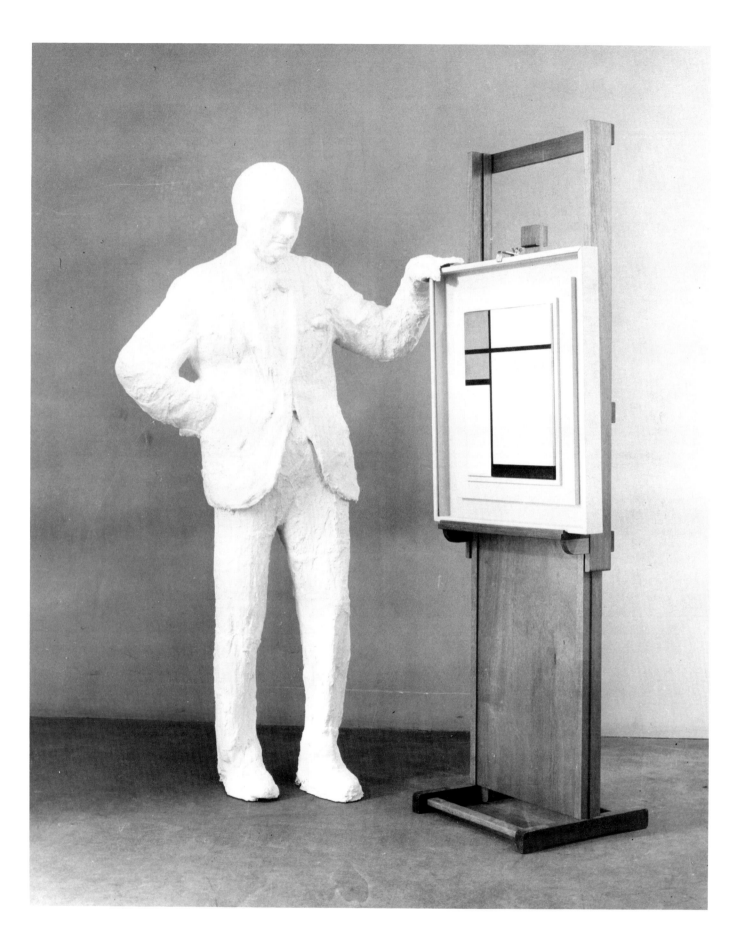

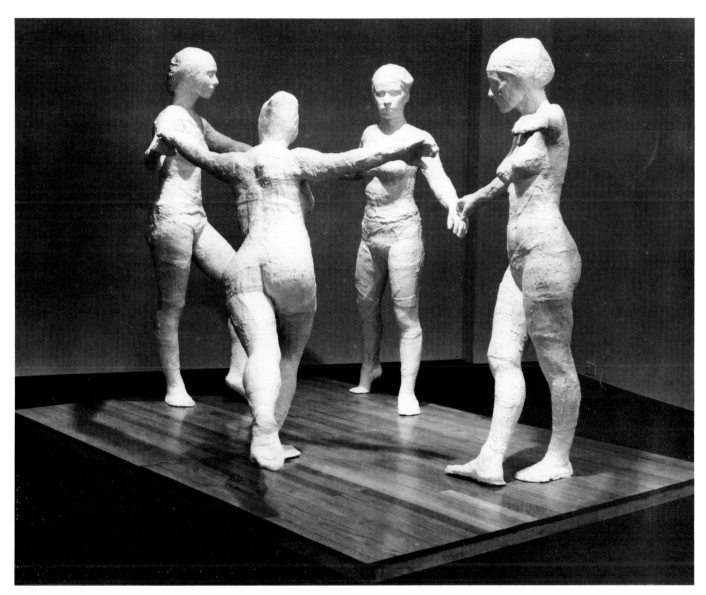

called "Segal's vital mummies"[13] imparts a life-in-death immobility that has been compared with Egyptian funerary sculpture and the casts of Romans who were trapped by flowing lava in Pompeii and Herculaneum.

Among his single figures, the female nudes washing, dressing, or caring for their bodies have a warmth also typical of the lovers' groups. The larger environmental pieces, set in a laundromat, gasoline station, lunchroom (pl. 18), or some other characteristic American urban habitat, are among the most ambitious and successful representational works of the sixties and early seventies.

The Dancers (fig. 68) of 1971 perhaps signals a new period in Segal's work. It is plainly a homage to Matisse, who influenced Segal's early painting and sculpture, but in a literal style opposite from both

Matisse's sculpture and his two great Fauve canvases of the same subject. Segal has always been moved not only by the total figure but also (as his drawings, pastels, and prints attest) by isolated movements and portions of the body. In 1970 he began to exhibit unassembled fragments, small but beautiful epitomizations of his art that focus his powers as a sculptor and show his ability to capture concentrated as well as diverse forms. No artist could be further from the cool stance of the Pop virtuoso than Segal. These purely sculptural works reaffirm continuity with the millennial tradition of figure sculpture—with Degas, Rodin, and, ultimately, with the pediments and stelae of ancient Greece (fig. 69).

As Barbara Rose has shown,[14] Oldenburg also used Pop materials in different ways, and on a multiplicity of levels, to project his intensely felt and

67

George Segal, *Portrait of Sidney Janis with Mondrian Painting*, 1967, plaster figure with Mondrian's *Composition*, 1933, on an easel, 69⅞ × 56¼ × 27¼ in. (177.3 × 142.8 × 69.1 cm). The Museum of Modern Art, New York, Sidney and Harriet Janis Collection.

68

George Segal, *The Dancers*, 1971, plaster and wood, 72 × 144 × 96 in. (182.88 × 365.76 × 243.84 cm). Courtesy of Sidney Janis Gallery, New York.

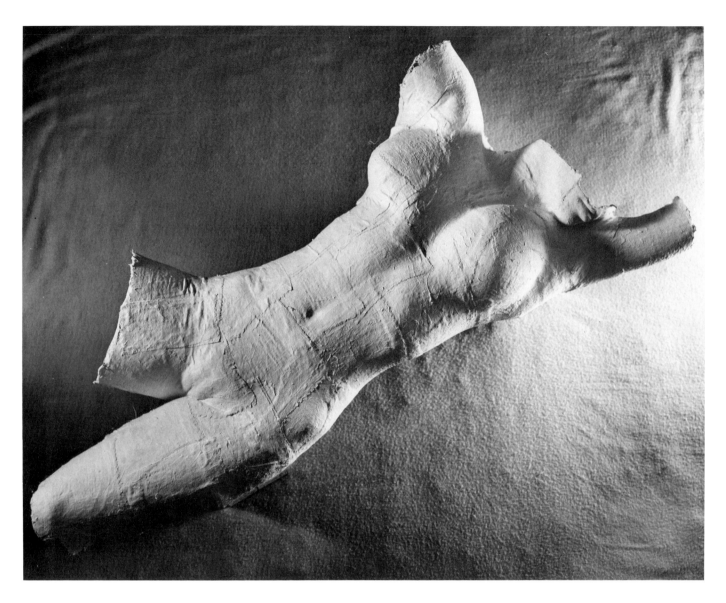

69

George Segal, *Fragment: Wall Relief,* 1971, plaster, 44 × 23 × 8 in. (108 × 56.4 × 19.6 cm). Collection of Mrs. William C. Seitz. Photo by Ed Roseberry.

profoundly human responses to the facts of contemporary living. Rabelaisian, Freudian, ironist, humorist, expressionist, by his skill and ruthless perspective, he forced us to confront the realities of the world we live in even as he willfully distorted it to the image of his own private fantasies.

The sad-sack figures and other bedraggled objects that Oldenburg showed in 1959 and 1960 at the Judson Gallery and the Martha Jackson Gallery gave little indication that he was to gain international prominence—one can say eminence—by the end of the decade. Assembled from newspapers, burlap, corrugated cardboard, string, wire, and other rubbish, their torn, disreputable silhouettes were in fact the culmination of a long period of concentrated thought, deep self-analysis, and exploratory drawing. The works of 1959–60 had their roots, perhaps, in Oldenburg's childhood fantasies, and their

intentionally childlike but mordant scrawl recalls the primitivist *art brut* of Dubuffet. Influenced by Celine's novel *Death on the Installment Plan,* Oldenburg's disconsolate theme was the street—the degradation, material and human, of his neighborhood on the Lower East Side of New York.

Yet even by 1962, when he showed harshly enameled plaster replicas of sundaes, pie wedges, American flags, hamburgers, shirts, and other free simulations of food and merchandise, both in his "Store" and in uptown galleries (figs. 70 and 71), his still incipient genius for seriocomic castigation of society by the transformation of its artifacts was not fully recognized. Oldenburg's utterly personal art, often expressionist and surrealist in effect (though not in origin) was (and still is) related to the Pop explosion in that the vast majority of his subject matter is drawn from the inexhaustible glut of commercial

objects and detritus. His belligerent but Rabelaisian antielitism and fully conceptualized nonconformity took form within the ambience of "junk culture," assemblage, environments, and happenings.

A Yale graduate conversant with art history and Western literature and the son of a Swedish diplomat, Oldenburg from the beginning launched an assault on established verities, high art, and formalist limitations. From his base in the slums, he cultivated ribald vulgarity, aggressive eroticism, and common verbal and visual language with a ruthless directness and intellectual precision. Because of his unique powers of mind and personality, intense convictions, natural virtuosity, and other innately creative attributes, he is, as Barbara Rose has fully demonstrated, a "true innovator within the tradition of modernism, rather than a neo-Dada experimenter with novelty."[15]

Neither an expressionist nor a Surrealist, he nevertheless had studied Freud, surely knew Dalí's limp watches and pendulous images of sleep, was familiar with Joycean free association, and continually employed what he called his "metamorphic capacities." In the Marcusean sense post-Freudian and post-Marxist, he implemented his alternative view

of life and society by the transformation of commercial objects into organic forms (usually suggesting those of the male or female body) and in 1960 conjured up a rude double, Ray Gun, to act out outrageous arrogances and taboo gestures. His (or its) various incarnations were those of a cartoon-strip disintegrator ray gun, a phallic surrogate which later evolved into a gutter and chainpipe.

Following his street theme, the objects in Oldenburg's "Store" celebrated, with participatory exuberance, the gaudy affluence of American life (pls. 19 and 20). When this "merchandise" was moved to Uptown galleries, its scale was enlarged. *Floor Burger,* composed of three heaped canvas bags filled with foam rubber and paper cartons and measuring seven feet in diameter, was among the early magnifications. The absurd enlargement of common objects was the first of Oldenburg's primary metamorphoses; softening hard objects was the second.

Beginning in 1964, most of his projects were translated (at first by his wife's skill as a seamstress) into soft, stuffed versions made of cloth and later, after a stay in Los Angeles that resulted in the *Bedroom,* in vinyl (figs. 72–74). These pendulous, drooping, or flaccidly slouching telephones, type-

70
Claes Oldenburg, *The Store,* September 18 through October 20, 1962, at the Green Gallery, New York. Photo by Robert R. McElroy.

writers, kitchen mixers, New York maps, scissors, bathtubs, toilets, and drum sets are among the most significant innovations of the sixties. Unlike expressionist distortions, the forms of which project the artist's own inner tensions, the comical, disturbing, and carnal dispositions and postures assumed by Oldenburg's soft works are brought about by their outlandish size, materials, and qualities, and from the fall of gravity, which he described as "my favorite form of creator." Though conceived by the artist, these deformations occur in the real world; every new installation changes their aspect.

In 1965, Oldenburg began his satirical conceptions of public monuments. They include a mammoth baked potato to be placed in front of the Plaza Hotel in New York, a Good Humor bar (parodying the Pan Am Building) for Park Avenue, a clothespin to be installed in Chicago, and a giant copper toilet tank float to rise and fall with the tide in the

Thames. The implicitly political content of the anti-monuments was made explicit in 1969, when Yale University art and architectural students, motivated by Herbert Marcuse's observation that once a Good Humor bar was erected on Park Avenue, "the society has come to an end," [16] commissioned and helped to erect a full-scale anti-monument that filled the space between the Beineke Rare Book Library and a war memorial building. It was a huge lipstick mounted on a military half-track. The projecting lipstick— soft and drooping in some of the studies—became a monument to both aggressiveness and impotence.

Can Pop be separated from the massive intrusions into art from a world that the formalists ignored? The work of these two superb artists of the sixties answers that question, as does the continuation of common subjects and media-influenced art after the decline of the Pop movement, which by 1964 had all but run its course in the cycle of art fashions.

71
Claes Oldenburg, *Two Cheeseburgers with Everything (Dual Hamburgers),* 1962, burlap soaked in plaster, painted with enamel, 7 × 14⅗ × 8⅝ in. (17.8 × 37.5 × 21.8 cm). The Museum of Modern Art, New York, Philip Johnson Fund.

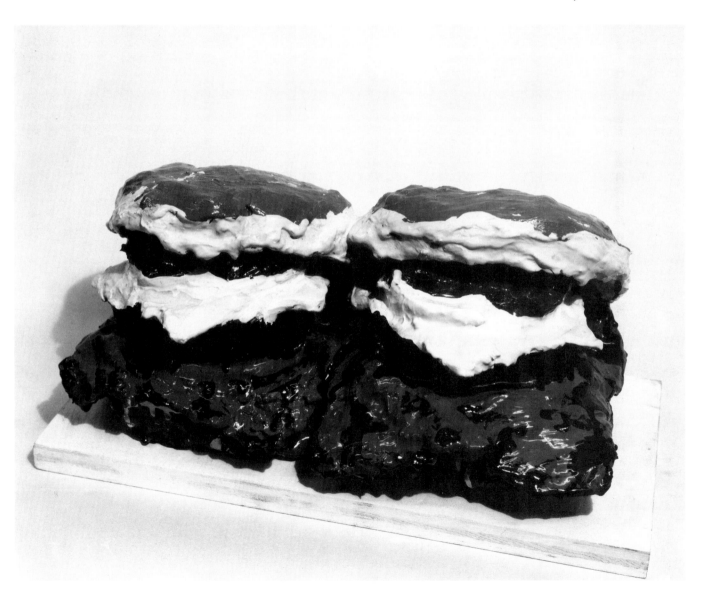

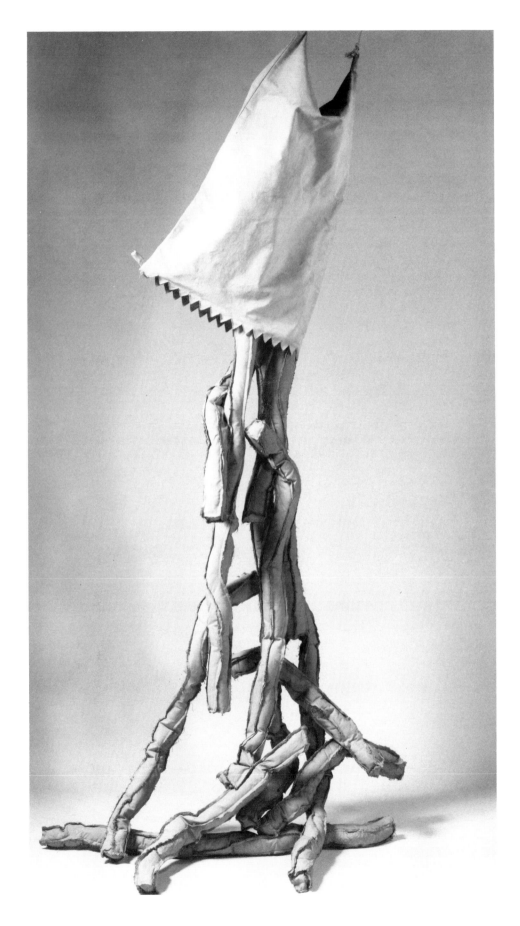

72
Claes Oldenburg, *Falling Shoestring Potatoes,* 1965, painted canvas, kapok, 108 × 46 × 42 in. (274.32 × 116.84 × 106.68 cm). The Walker Art Center, Minneapolis, gift of T. B. Walker Foundation, 1966.

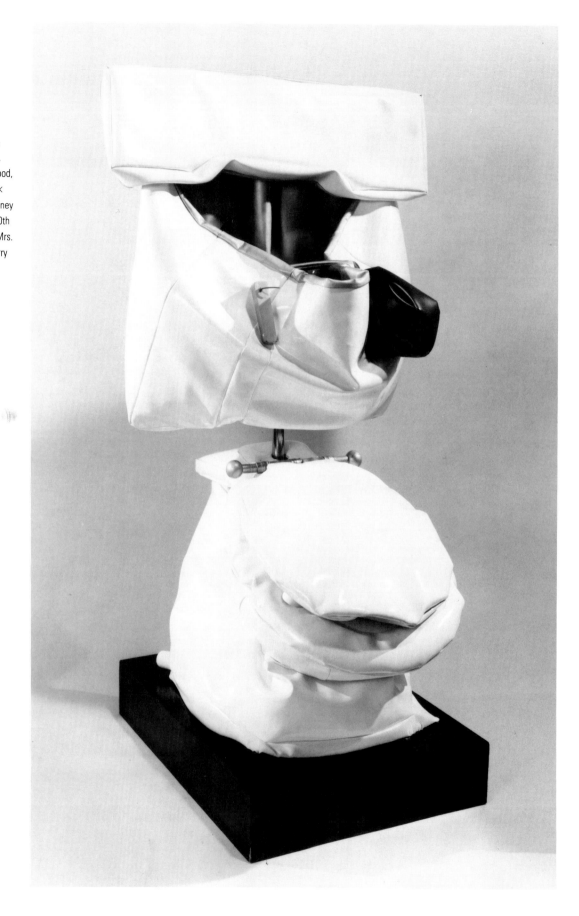

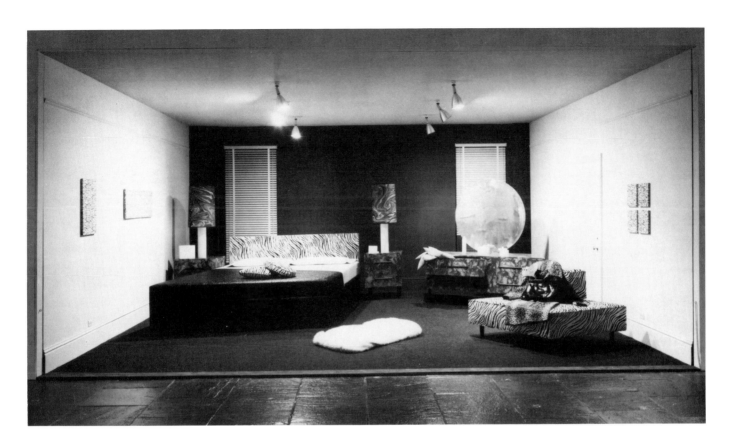

74
Claes Oldenburg, *Bedroom Ensemble,* 1963, wood, vinyl, metal, artificial fur, cloth, paper, 9.9 × 21.45 × 17.325 ft. (3 × 6.5 × 5.25 m). The National Gallery of Canada, Ottawa.

Optical Art

6

By 1965, with the war in Vietnam growing in intensity, war protests beginning in Berkeley, and riots in Watts, ominous signs pointed from the ebullient toward the "explosive" years of the sixties. The hyperanimated art scene, however, intoxicated by its own exuberance and audacity, failed to apprehend the constraints it was to feel a few years later. Following the 1964 Venice Biennale, 1965 was a year in which brushless edges, flat tones, new materials, and impersonal fabrication gained favor, and Op art was the rage. The Pop artists' cool subversion of high art by calculated vulgarity, and the transformation of kitsch into camp had already been absorbed. The museum scene was still effervescent; see-through plastic dresses and metallic miniskirts were in vogue; the art market was on the rise; vanguard collectors, dealers, and the media were all awaiting some unexpected and dazzling innovation. Gestural abstract painting and the aesthetics of commitment and unveiled subjectivity, cooling for five years, were passé with the new generation, supplanted by a more cerebral stance, clean surfaces, and an unprecedented proliferation of new forms and materials. Irving Sandler, a scholar and defender of Abstract Expressionism, recognized a change in sensibility and saw its embodiment in the work of five artists—the sculptors Ronald Bladen, George Sugarman, and David Weinrib and the painters Al Held and Agnes Martin—whom he designated as Concrete Expressionists; their clean-edged work as "Expressionism with corners." [1]

The year 1965 also witnessed an extraordinary historical sequence: a reversal of the usual order of cause and effect tagged by Harold Rosenberg as the "Premature Echo." In this case, the year's craze, Op

art, occasioned by *The Responsive Eye* at the Museum of Modern Art, was launched long *before* the exhibition's opening date. Large museums move slowly, and try to clear their plans with each other in advance, so plans to organize an international exhibition of abstract art directed primarily toward vision were announced in 1962.

To launch or label a new style was not at all the museum's intention. This survey, like *The Art of Assemblage* in 1961, aimed to present diverse but related currents in many world centers. Interest in perception was keen in both America and Europe in the early sixties, but the intensive study of visual dynamics, outside of design schools and the classes of Josef Albers at Yale (climaxed in 1963 by his book *Interaction of Color*), was still more a concern of Gestalt and experimental psychologists than of painters and sculptors. *The Responsive Eye,* which included work by ninety-nine artists from some twenty countries, presented most varieties of more or less pointedly perceptual abstract art and forms of visual illusionism, systematically separating color images from black-and-white and transparent works.

Although it was in the United States that it became a fad, optical art was not American in origin. Gestural abstract painting in Europe, which had pre-World War I roots in Kandinsky's early Abstract Expressionism, Surrealist automatism, and the early calligraphic painting of Hans Hartung, was of a different order than its American counterpart. Except for Mathieu's large autographic canvases influenced by Pollock and other New York School artists, *Tachisme* was smaller in scale, more elegant, and its freight of ideas more mystical and Orientalist than the explosive emotion of Pollock, de Kooning, Kline, or Hofmann.

The contrast of cultures is revealed by comparing the smooth knife swaths of umber in the canvases of Soulages with the raw, scraggly enamel jabs of Kline. European brush and line, as seen in the works of such painters as Wols, Henri Michaux, and Mathieu, charged with a self-consciously metaphysical spirit, were thinner in impasto, more concerned with finesse, and weaker in impact than New York painting; the criticism supporting it—by Michel Tapié, Marcel Brion, Pierre Restany, and others—was more philosophically pretentious than the existential New York writing. The small-scale, spiritually elevated "white writing" of Mark Tobey and the brightly hued but washed canvases of Sam Francis, for example—further evidence of this difference in ambience—were better received, initially, in Paris by eyes trained on Alfred Manessier, Jean Bazaine, Roger Bissière, and Jean Fautrier than they were in New York.

Because of the traumatic disruption of Nazism and the war, and also because for the first time European painting became subject to influence from across the ocean (markedly so in the case of the Cobra group in the Low Countries and Alan Davie in England, who adopted the aggressive attack of New York painting), general boredom with gestural abstraction set in later in Europe than in the United States. When the ultimate disenchantment came about, however, there was a more established opposition style to benefit by the swing of the pendulum: a deeply rooted and stubborn constructivist/geometric tradition that had been suppressed but never supplanted by *Tachisme* and Art Informel. Indefatigable supporters of geometric art were prepared for the change: the painter-critic Michel Seuphor, the dealer Denise René, a score of artists whose hard surfaces were never dissolved by the expressionist wave, and a new generation who were never attracted to it. As *Tachisme* was different from Abstract Expressionism, the new "classicism" in Europe was vastly different from the art of Newman, Reinhardt, Louis, Noland, and Stella, and the gulf was widened by the caustically anti-European bias of the Young Turk artists and critics of the "Pepsi Generation." Indeed, it was never bridged, even after young Europeans were seen in New York after 1963—introduced by the Howard Wise Gallery and Contemporary Gallery, the painter-educator Gyorgy Kepes, and the sculptor George Rickey.

With this profound divergence once noted, one can go on to say that committed young artists in France, Holland, Germany, Italy, Spain, and Yugoslavia, entirely independent of American influence, made parallel moves toward a cool, impersonal abstract art that was similar both in certain of the things it discarded and in its formal principles to American art, but entirely unrelated in motivation and spirit. Anti-individualistic, technologically aware, and programmatically opposed to accepted conceptions of art and the artist, the works of these artists—most of it at first the product of anonymous groups—were industrial in their forms, materials, and methods and socialistic in their aspirations and devotion to duplicative fabrication.

Equipo 57 (Madrid) was formed in 1957, Gruppo N (Padua) in 1959, the Groupe de Recherche d'Art Visuel (Paris) in 1960, and Gruppo T (Milan) and Zero (Düsseldorf) in 1961. In that year, these and other groups, as well as individual artists, banded together for the first of a series of large exhibitions in Zagreb, Yugoslavia, and other cities under the signification of the New Tendency, a term that was, according to George Rickey, "a cry of mutual recognition rather than a definition of style."[2] Yet, though

a style was never enforced by fiat and its thresholds were freely crossed, the New Tendency showed a higher degree of conformity than most movements, in attitude, forms, and materials, that broke sharply with the earlier Constructivism, De Stijl, or even the German Bauhaus, whose principles they approached most closely.

Between 1920 and 1950, most hard-abstract styles, whether in two or three dimensions, manifested four principles, with varying emphasis:

1. A technological utopianism, implicit or programmatic, that saw machine forms and techniques as the means and ultimate environment of a more just, aesthetically beautiful, and smoothly operating society.
2. A vocabulary of simplified abstract forms held to partake of a more absolute beauty, purity, clarity, and rationality than representational or free forms.
3. The idea (advanced by Mondrian) of the opposed horizontal and vertical as the ultimate reduction of natural principle to its essence.
4. Asymmetrical, Cubist-influenced organization of similar but diverse elements.

Only the first and, with an altered emphasis, perhaps the second of these principles can be found in the New Tendency and programmatic art that originated in the late fifties. As more attention was given to kineticism, opticality, and technology, asymmetrical *composition* gave way to unitary, redundant, or random *arrangement.*

Among the most important of the works that prefigure this redirection are surely Giacomo Balla's two *Iridescent Interpenetrations* of 1912—systemic arrangements of pale but interacting colored wedges, one within a rectangle and the other within a circle. These radical paintings seem to be the first entirely nonrepresentational works plainly perceptual and luministic in intent. Mondrian was influenced by Impressionism and neo-Impressionism as well as Cubism, and his "plus-and-minus" pictures of 1914–1917, in which Cubist asymmetry is all but obliterated, are precursors of systemic and cybernetic as well as optical painting. (One of the last of these, *Composition with Lines,* was used by Michael Noll of the Bell Laboratories in 1964 as an archetype for one of the first experiments in computer-generated art.) Malevich's *White on White,* and other works painted by him and by Rodchenko around 1918, also imply opticality by close value relationships, but less specifically. Kandinsky in 1927 painted a spatially ambiguous nest of checkered forms. Also in the twenties, the Polish painter Henryk Berlewi, using a method he called "mechanofak-

tur," began to replace relational composition with additive arrangements. Following a system known as "unism," two other Polish artists, Wladyslaw Strzeminsky and Henryk Stazewsky, sought "to secure an optical integrity by uniform, all-over painting, which not only had no subject, but went beyond Malevich in having no image either."[3]

Another prototype can be found in the early work of Victor Vasarely, who trained at the Mugely, the Budapest Bauhaus of Alexander Bortnyik in Hungary, and who, in 1935, represented a spatially ambiguous chessboard. In 1939, this ideological progenitor of the New Tendency depicted a fishing bobber floating on a sea of waving lines—a work with which Bridget Riley must have consulted. Yet because the kinetic/optical/technological art of these groups falls solidly in the Bauhaus tradition, it is a surprise to discover that so little prefiguration of optical art can be found in the Bauhaus archives, though the Gestalt school of Max Wertheimer, Wolfgang Koehler, and Kurt Koffka, which pioneered the study of abstract optical illusions, was contemporary with the original German Bauhaus in Weimar and Dessau. These limited examples demonstrate the pedagogy of the Weimar Bauhaus, the most advanced academy of technologically oriented art of our century.

Lectures on psychology were begun there in 1928 based on the Gestalt psychologists Wundt and Kreuger, as well as on the analysts Freud and Adler, but with primary emphasis on "broadening the approach of individual psychology into aspects of social psychology."[4] A definition of a gestalt was included in these lectures, with "optical illusions" as one of its manifestations. Yet only passing reference was made to the leading German Gestalt psychologists and Koehler, and there was none whatsoever of Koffka, or of Ernst Mach, on whose premises the Gestalt school was based. Nor was there any mention, to go back further, of such early pioneers of optical psychology as Chevreul, Herring, and Rook. In spite of the repeated utilization of dynamic visual devices by both Klee and Kandinsky (who taught at the Bauhaus), little evidence of optically aware teaching was revealed by the records of student work.

In conversation with the author, Josef Albers (who taught the basic design course beginning in 1923 and remained on the faculty until 1933 when the school was closed under Nazi pressure) stated that his teaching of the interaction of color began after his appointment at Black Mountain College in 1933. Indeed, a book on color theory published in 1958 by Johannes Itten, the first teacher of design who was responsible for bringing Klee, Kandinsky, and other avant-garde artists to Weimar, shows little

sense for color interaction. Further evidence of this omission is demonstrated in the work of László Moholy-Nagy, whose concept of abstract space as represented on a flat surface remained tied to linear perspective and size diminution. Moholy-Nagy's insensitivity to the moiré effect is evident in his entirely conceptual use of crossing diagonals—an amazing lack in an artist devoted to "vision in motion!" Moreover, his book of that name, published in 1947 when he was director of the Institute of Design in Chicago, demonstrated the same paucity of references to perceptual psychology as the Bauhaus records, and the same visual insensitivity. Moholy-Nagy, the first to order a work of art by telephone, was therefore more the precursor of conceptual than of optical art.

Following this excursus from the sixties, it should be apparent that awareness of the optical potential of colors, lines, and shapes followed far behind its investigation by scientists and was surprisingly slow to develop in twentieth-century art—suggested in the early years, sporadic in the twenties and thirties, but never pursued in a concentrated way by painters and sculptors until the late fifties.

The art of the New Tendency retained no traces of the metaphysics of Mondrian, the mysticism of Malevich, or more than a passing thought for the pure beauty of ruler-and-compass forms. As the commentaries that appear in the catalog of the third Zagreb exhibition (1965) make clear, the thrust of the movement was environmental and perceptual, emphasizing visual action over static form, shared goals over individualism, and replicative, impersonal fabrication over traditional studio materials and procedures. The New Tendency artists sought also to detach themselves from commercial distribution, fashion, and what they regarded as the vulgarity of public taste. Although their aesthetic was far from the subversiveness of "artists" in the Dada tradition, they distrusted the term "art" for its romantic and individualistic connotations, worked together on cooperative projects, and willingly applied the term "research" to their experiments in visual perception and search for an "industrial esthetic." Cubist asymmetrical composition was abandoned for unitary, repetitive, systemic, or random arrangement, and the traditional divisions between painting, sculpture, and drawing were replaced by flat images, transparency, spatial and kinetic optical illusions, and actual movement, light, electronic effects, and three-dimensional construction used interchangeably or in combination.

The New Tendency, as Frank Stella was honest enough to admit with some distaste in 1964, anticipated the reduction introduced by American artists:

I think the obvious comparison with my work would be Vasarely, and I can't think of anything I like less. . . . Mine has less illusionism than Vasarely's, but the Groupe de Recherche Visuel actually painted all the patterns before I did—all the basic designs that are in my painting—not the way I did it, but you can find the schemes of the sketches I made for my own paintings in work by Vasarely and that group in France over the last seven or eight years. I didn't know about it, and in spite of the fact that they used those ideas, those basic schemes, it still doesn't have anything to do with my painting. I find all that European geometric painting—sort of post-Max Bill's school—a kind of curiosity—very dreary.[5]

Paintings and transparent constructions of Vasarely, the ideological progenitor of the groups, began to be widely seen in New York by 1960, and that of the younger artists, especially the Groupe de Recherche d'Art Visuel, was shown in group exhibitions—in the Carnegie International Exhibition in 1961 in Pittsburgh, and in New York after 1963 at the Howard Wise and the Contemporary galleries. Others were shown for the first time in *The Responsive Eye,* in which Vasarely and Albers were given more extensive presentation as the most important and influential precursors. (Jesús Raphael Soto, a Venezuelan working in Paris who was the first to make extensive use of the moiré principle, refused to exhibit because he was not granted the same recognition.) Yaakov Agam, another pioneer of visual kineticism, was represented by a thirteen-foot serrated mural, *Double Metamorphosis II* (pl. 21).

Agam, who became the best-known Israeli artist of the sixties, was born Jacob Gipstein, the son of a Palestinian rabbi. In 1952 he began to create reliefs whose elements could be moved at will by the spectator, and in 1955 he participated in the groundbreaking exhibition *Le Mouvement* at the Galerie Denise René in Paris. Agam's operational approach to art, which he relates to Hebrew religious philosophy, embraces many kinds of kinetic and technological painting and sculpture as well as music, light, theater, and writing. Like many of his smaller panels, *Double Metamorphosis II* is divided into right-angled serrations, each face painted with components of two quite different schemes, allowing for four different compositions. When approached from the right (which is only one possibility), no color is visible, but the spectator sees a complete, crisp composition based on thirty-three alternating horizontal bands of black and white. As one moves closer, the bands open up, circles form and split, diagonals are broken. Then comes a delicate anticipatory sequence in which body colors still hidden from view exist as

ephemeral reflections on white. Bit by bit the ghostly geometry materializes, despite the optical ambiguity in which the shapes swim. As in music, it is often impossible to isolate the various themes when they appear in full polyphonic superimposition. The Venezuelan painter Carlos Cruz-Diez showed work employing a similar device, used figuratively long before this century, and abstractly by the Russian artist El Lissitzky in 1928.

Bridget Riley was the first English artist to utilize the power of black-and-white patterns and images to activate perception and, of all the painters identified with the hard-core Op Art movement during the mid-sixties, she remains preeminent. Unlike Vasarely and the artists of the New Tendency, she avoided metal, plastic, and other constructivist materials as well as kinetic art. Within the traditional mediums of painting, drawing, and printmaking, however, the impact of her images on vision, overtaxing the muscles and nerves of the eye and brain, has been more potent than that of any other optical artist. What separates Riley's painting so evidently from routine productions in this mode is not only their greater aggressiveness, but also their emotional depth, historical reference, and accomplished intellectual control.

Often the explanation of an artist's power lies in the nature of his or her development. Riley did not adopt an already established style or method but, like Mondrian and Kandinsky, arrived at her way of painting by slow maturation. Beginning with a feeling for Monet, she distilled the optical essentials from Impressionism and neo-Impressionism, the early canvases of Mondrian, and Vasarely's work of the fifties. In such pictures as *Current* (fig. 75) and *Crest,* one can also feel the rhythmic emotionality of Van Gogh's *The Starry Night* or his paintings of cypresses. Properly programmed, a computer could take over the production of many eye-shattering Op art configurations; not so the work of Riley. Whether disturbingly electric or, as is often the case, quietly assertive, the swirling lines, circles and ovals, ambiguous geometric figures, or systemic progressions of grays in her canvases or prints are personal, subtle, and intelligently varied. In 1967, Riley returned to color, using pale pinks, blues, and greens; less overtly, these paintings in color are as imperative in impact as those in black and white. Like no other contemporary painter, Riley has been able to control and channel the kinesthetic potential of lines, shapes, and optical color tones.

Among the American innovators in *The Responsive Eye* were Ad Reinhardt, represented by a large close-valued work of 1952, and Alexander Liberman, whose stringently reductive, nonrelational excur-

sions into opticality in the fifties and early sixties were unique, and surely would have had greater influence had they been better known. Another pioneer was the West Coast painter Lorser Feitelson (pl. 22), who showed an arrangement of four colored lines that established a mystifying quality of space and openness.

Of the younger artists whose opticality well antedated the Op bandwagon were Richard Anuszkiewicz (pl. 23), an Albers student, who by 1961 had accomplished a perceptual alteration of hues in striped and radiating images, and Larry Poons, whose overall patterns of colored circles or ovals, coordinated with an underlying grid structure, generated kinetic complementary afterimages more brilliant than the painted elements that were their stimulant. Poons had studied music at the New England Conservatory of Music, and his approach to abstract painting was influenced by Bach's counterpoint and Mondrian's interest in the rhythms of boogie-woogie. In his paintings of the mid-sixties (pl. 24), Poons elongated some of the dots into ovals, enriched the colors of his fields into saturated reds, lavender, bright yellow, and other rich colors, and intensified and varied the hues of the dots. Some were complements of the field and other were closely analogous to it, so that painted and optically induced images were confounded. Yet Poons paintings of this period, though perceptually functional, resist categorization as Op Art, a tendency for which he, like Stella, expressed distaste.

The Washington Color painters—Louis, Noland, and Gene Davis—were included in *The Responsive Eye,* as well as Ellsworth Kelly, then working at a peak of power and quality (pl. 25). Also on view were works by Frank Stella and Leon Polk Smith—the latter one of the first American artists to move from Mondrian-influenced asymmetry to a purely coloristic and spatially ambiguous image. The circle image, widely employed after Johns's first Targets, was represented by the Polish painter Wojciech Fangor, the Japanese Tadasky (Tadasuke Kuwayama) (fig. 76), and the complementary bands of Claude Tousignant who, like Guido Molinari, worked in Montreal where the change from gestural painting occurred at least five years before it did in New York. (See figs. 77–80.)

The Responsive Eye was a comprehensive survey of sensory concentration in the art of the sixties rather than an Op Art exhibition. In retrospect, however, it does not seem surprising that those works that administered the most vertiginous visual shock attracted the most attention, or that exhibitors to whom the term was unwelcome were tarred by the "Op" publicity brush.

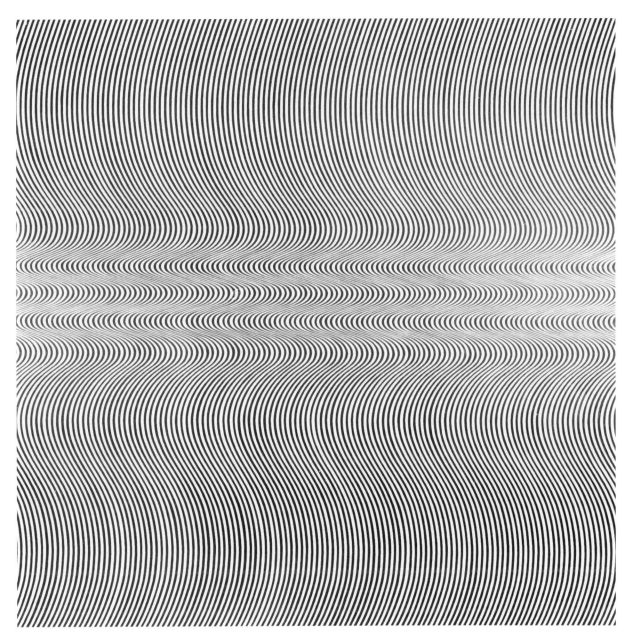

Months before the opening on February 23, 1965, scouts from *Time, Life,* and other mass publications were haunting the museum's Department of Public Relations. It was a *Time* reporter who concocted the journalistically ingenious but artistically unfortunate rhyming of "Op" with "Pop" to launch the swingers' style of 1965. In October, *Time*'s scoop, "Op Art: Pictures that Attack the Eye,"[6] appeared. *Life* followed in December,[7] carefully explaining that their title was not a misspelling of "Pop Art," annexing an explanation by the science editor, but failing to give any indication that their advance research had begun at the Museum of Modern Art. More than a year before the exhibition, a representative of the fashion industry observed that women would never accept eye-shattering fabrics. Yet before the vernissage, the media, fashion, and advertising had fully absorbed, adulterated, and processed a movement that they, rather than the museum or the director of the exhibition, had inaugurated, and to which the general public, children, artist, teachers, psychologists, and scientists flocked.

As Lawrence Alloway, the most open and pluralistic of the accepted art critics, observed, "'The Responsive Eye' was put down by critics writing in art journals, but was an instant success in fashion magazines, humor magazines, teenage magazines, *Time* magazine, and so on."[8] His observations, made during a debate on the role of museums, were not

75
Bridget Riley, *Current,* 1964, synthetic polymer paint on composition board, 58⅜ × 58⅞ in. (148.1 × 149.3 cm). The Museum of Modern Art, New York, Philip Johnson Fund.

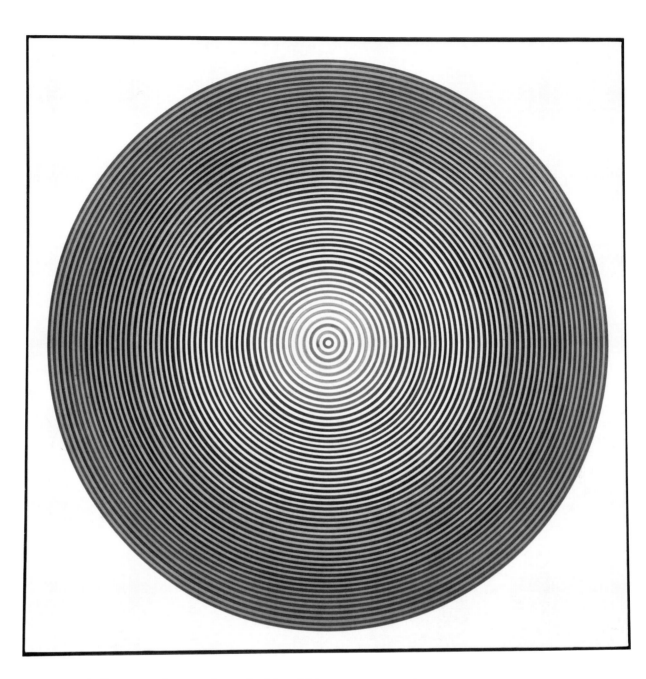

76

Tadasky, *A-101*, 1964, synthetic
polymer paint on canvas,
52 × 52 in. (132.1 × 132.1
cm). The Museum of Modern
Art, New York, Larry Aldrich
Foundation Fund.

wholly accurate, however, for much of the criticism
was positive or mixed. He was quite right in calling
attention to the new power of the media to dissemi-
nate, in adulterated form, the ideas of the arts. As a
final ironic twist—perhaps it was a kiss of death—
John Canaday of the *New York Times* was transported
by what he saw and extolled the mechanical neatness
of many of the works as the ideal antidote to Ab-
stract Expressionism and the "sloppiness, the shod-
diness, the amateurism posing as esthetic sensibility,
that has marked avant-garde art for so long." [9] In Op
he found a "display of craftsmanship in the service of
a new idea as to what art we should be about in this
century." [10]

Perhaps because they were most effective in black
and white, and thus easily reproducible on TV and
by cheap printing methods, moiré patterns became
the most ubiquitous manifestations of Op. When
used solely as a means of visual stimulation, moiré
art came dangerously close to optical science. In the
early sixties, the most advanced technical researcher
into this branch of optics was Gerald Oster, a profes-
sor at the Brooklyn Polytechnic Institute, and a con-
sultant to the Groupe de Recherche d'Art Visuel. In
1963, an article by Oster in *Scientific American* ex-
plained that the term moiré (which means "watered"
in French) was derived from the shimmering silk
made by pressing one surface of a corded fabric

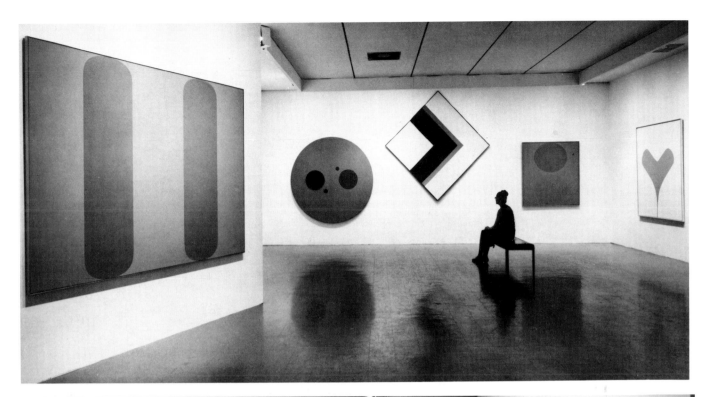

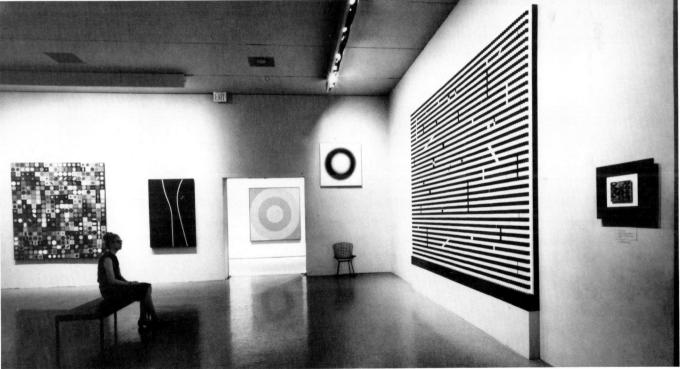

77–80
Above and overleaf: Installation views of the exhibition *The Responsive Eye.* February 25, 1965, through April 25, 1965. The Museum of Modern Art, New York. Photos courtesy of Museum of Modern Art.

Optical Art 97

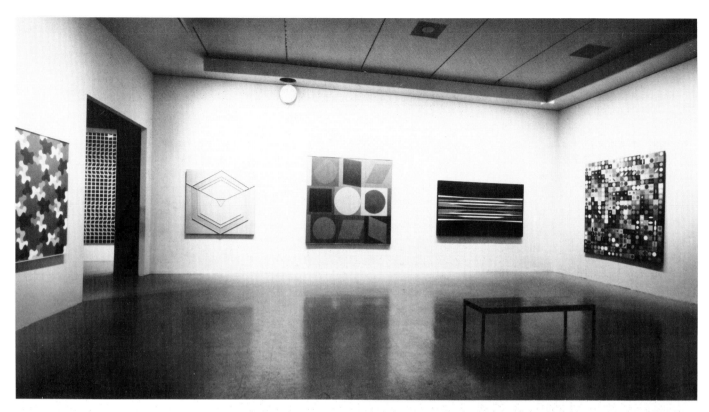

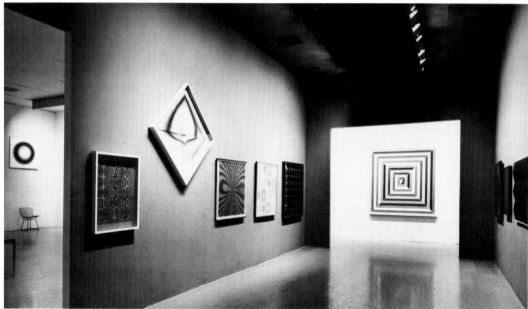

against another, and that such patterns are produced whenever two periodic structures are overlapped.[11]

Difficult though the moiré effect may be to account for physiologically, the unitary phenomenon underlying it is simple to describe. It is an optical illusion that occurs whenever a line crosses another at an angle of less than thirty degrees. To the eye the angles seem to widen, breaking the continuity of both lines. If the angle is small enough, the crossing "clogs" with black, much as if two wet ink lines had bled together. When such crossings, whether straight or curved, are multiplied, they produce soft-edge bands like those in Tony Costa's *Visual Dynamics*. When patterns on superimposed transparent surfaces such as glass or plastic are shifted in relation to each other, the kinetic effect is compounded as the darkened intersections move and appear to magnify, resulting in dizzying curvilinear effects. Crossings, however, are not essential for a wide range of related visual illusions, among them "beats" of superimposed verticals, radiating patterns, or the oscillating waves in the paintings of Riley. Such black-and-white patterns can even induce illusions of color—usually of a transparent reddish or bluish hue.

Intrigued by the approaching exhibition, Oster channeled a part of his activity into art. Two of his moiré works were included in *The Responsive Eye;* and during its run he was ready with a one-man exhibition at the Howard Wise Gallery. Thanks to his promotional zeal, Oster got more space in the media than the best-known artists in the exhibition. Yet compared with the works by Riley, Costa, Yvaral, Mon Levinson, and other artists who had arrived at moiré through steady development and trial and error, Oster's works—a deductive application—resembled scientific demonstrations. Unprepared for the ego-trap that artists learn either to evade or master, Oster moved quickly to consolidate his beachhead on the art scene, writing and lecturing about his moiré interpretation of the gaps and distortions in the painting of Cézanne, about his own paintings based on phosphenes (radial images seen with closed eyes), and on Op Art in general. His most interesting contribution, therefore, was as a publicist rather than a scientist or artist. Worthy of record in a book of "entrances," however, was his conclusion, arrived at after experimenting with LSD, that moiré images can induce experiences like those induced by drugs.

The "fine art" painting that was later called "psychedelic" was, in the main, a vulgarized mélange of images, usually figurative, drawn from almost every style from Surrealism and Expressionism to orientalizing and academic painting. Far more relevant to the sixties was popular and commercial psychedelic art and related perceptual devices developed within the youth, rock, and drug cultures: the posters, designed by Wes Wilson and others, for the Fillmore and Avalon ballrooms in San Francisco, in which Pop and Op were incorporated into the erotic, swirling rhythms of Art Nouveau; posters and wall decorations combining Scotch and black light, moiré patterns, photographs, and inscriptions. It was in San Francisco, as Tom Wolfe has recorded in a brilliantly psychedelic literary style in *The Electric Kool-Aid Acid Test,* that the development of electronic multimedia evolved out of the "Trips Festival" and "Acid Tests" held by the hippie guru Ken Kesey and his Pranksters in 1966. "The Acid Tests were the *epoch* of the psychedelic style and practically everything that has gone into it."[12] "Even details like psychedelic poster art, the quasi art nouveau swirls of lettering, design and vibrating colors, electropastels and spectral Day-Glo, came out of the Acid Tests."[13] Thus, in the decade of violated thresholds, the Museum of Modern Art's *Art Nouveau* exhibition in 1960, the publications that followed in its wake, and Op Art coalesced in the rebellious underground with extemporaneous innovations of life style that produced a creative efflorescence.

Quite unintentionally, *The Responsive Eye* marked a peak, as far as the public and the media were concerned, of "trend-setting" exhibitions. The number of related showings, before and after, large and small, in galleries, museums, and art centers across the country, would be difficult to estimate. In what was surely a milestone in the history of ironic hyperbole, Thomas Hess wrote that the exhibition had been preceded by "some forty or fifty thousand Op Art groups in 1963–65."[14] One of the most notable of these, in its incongruity, was that organized by the American Bible Society in New York. Its publicity release proclaimed that "just as the artists of today are seeking new dimensions and a new outlook in their field, so the American Bible Society is constantly seeking bold, creative, colorful and imaginative new formats and translations to lead more and more people to . . . search for God's word for this new age."[15]

Save in the hands of its best representatives, hardcore Op was a limited art form addressed primarily not to the mind, emotions, or even the aesthetic sense, but to that anatomical area subject to direct stimulation by visual images, which lies somewhere between the cortex and the sight center at the rear of the brain. But its emphasis on the perceptual potential of color and form—a lesson passed artist to artist in the grammar and syntax fundamental to their media—was an irrevocable contribution to the means of art.

Primary Structures and Minimal Art

7

When the spotlight of public attention fell in succession on one new wave and then another, previous waves, ground swells, or ripples seemed to break into foam and disappear. And when New York pointed a direction, London, Milan, and the German centers followed. These entrances and apparent exits resulted from a different set of conditions: happenings gained attention from series of activities that transpired entirely outside galleries and museums. In retrospect, the first Pop artists arrived at their absorption in the common environment simultaneously, but their entrance was stage-managed by gallery operators: Richard Bellamy at the Green; Eleanor Ward at the Stable; and Leo Castelli at the Castelli. The story might have been somewhat different had the Guggenheim Museum, the Museum of Modern Art, or even the Whitney responded with an instant canonization of Pop, but Lawrence Alloway's exhibition *Six Painters and the Object* (1963) at the Guggenheim evaded the word, and arguments within the staff of the Modern over a full-scale Pop exhibition were won by those who did not wish to see the museum programmed by a combine of galleries, collectors, and promoters. Op Art, of which the various forms were sharpening their concentrations in many countries after 1959, exploded into a fad because of media publicity that preceded one exhibition. Color-field painting, Op, and what was called "primary structures" in the Jewish Museum's influential 1966 sculpture exhibition of that same name had in common their total abandonment of asymmetrical relationalism and referential metaphysics, the use of geometricity in varying degrees, flat tones (or in sculpture, actual spatial planes), an unprecedented concern for optical qualities, and,

perhaps most important, an extreme reduction of means to what seemed to be the minimum possible elements. Despite great differences in national origin and philosophical positions, and the disdain expressed by the color painters and formalist critics for both Op and European *art kinetique,* they all conformed to an international trend that can best be described as reductive.

The *Primary Structures* exhibition was organized by Kynaston McShine, a young curator who had recently left a post at the Museum of Modern Art to become curator of painting and sculpture at the Jewish Museum. It was surely one of the least mercantile, most relevant, and best-timed entrances of the decade. The concentration of conceptions that this exhibition presented is evident in these paragraphs from McShine's introduction to the catalog:

> These structures are conceived as "objects," abstract, directly experienced, highly simplified and self-contained. There is no overt surrealistic content in the sculpture, and the anthropomorphic is rejected. The structures are generally not "compositions." Shape, color and material have a physical concreteness and unity that is both elegant and monumental, expressive or restrained, but always challenging.
>
> The sculpture has benefited from modern technology and industry. The sculptor can now conceive his work, and entrust its execution to a manufacturer whose precision and skill convey the standardized "impersonality" that the artist may seek. Plastics, fibreglass, aluminum, fluorescent light have allowed the sculptor to formulate ideas and create dramatic visual effects that at any other time would have been impossible: as one artist has put it, "We are about to redesign the world." [1]

At first reading, the sweeping aim quoted by McShine has a juvenile ring: the world (if measured only by architectural structures from Mies van der Rohe to I. M. Pei) had, in part, been programming the artists. Yet the boast was not entirely idle. Primary structures were not just "ABC ART," as Barbara Rose labeled them in 1965,[2] but an entirely new kind of sculpture, a prime contribution of the sixties (though recognition must be made, as with any innovation, of cues and archetypes from earlier periods).

Geometric abstract painting and sculpture had its origins before World War I, as did the replacement of construction for carving or modeling. The immense importance of the combination of those forms Plato regarded as the most beautiful—"Straight lines and circles, and the plane and solid figures which are formed out of them by turning-lathes and ruler and measurers of angles"—and the new method of construction, with its potential for industrial fabrication, will be indicated in the following chapter. The entrance of "primary structures" into sculptural tradition during the sixties, whatever precedents existed, was a prime event that has surely redesigned the world at significant focal sites. In addition to concentrating and spotlighting the reductive three-dimensional art of the United States and Great Britain, *Primary Structures* gave the first major attention (and this was not so fortunate, at least for the environmental potential of geometric, industrially produced sculpture) to those artists who were soon to direct their efforts to the subsequent radical manifestations by which the decade is marked after 1966.

Keeping in mind the point in time under observation, it should be worth squandering a page or two to consider certain participants in this important exhibition. Anthony Caro was surely the best-known and most successful sculptor in the exhibition, and the most prominent English sculptor since Henry Moore, whose part-time assistant he was from 1951 to 1953. Yet because his work, intuitively assembled from prefabricated painted steel elements, retained an open relational and intuitive asymmetry, and thus did not lend itself to industrial fabrication or enlargement, he also was the most conservative (an art historical observation entirely irrelevant to the value of his work). Until 1959 Caro was a figurative sculptor who worked in clay, plaster, and bronze in a tortured manner resembling work of the same period by Reg Butler, Kenneth Armitage, and Eduardo Paolozzi.

Caro met Clement Greenberg in England in 1959, and in 1960 spent two months in the first of many visits to the United States, where he met Morris Louis, Kenneth Noland, and David Smith. The trip was decisive for his career, for he abruptly abandoned figuration for abstract, welded steel sculpture. Almost immediately, however, he consolidated Smith's influence and asserted his own formal criteria. Utilizing clean-cut sections of stock I-beams, composed in blunt relationships and long horizontal thrusts countered by short, tilted verticals, Caro placed his works directly on the ground or gallery floor, thus entirely eliminating the disturbing plinths, pedestals, and boxes that for centuries had intervened in the apprehension of sculptural form. Beginning in 1963, Caro's prefabricated elements became more diverse or reduced to two or three long, crisply opposed spatial lines—geometric drawings in three dimensions. Few pieces were left unpainted—red, green, orange, violet, or whatever—with the important effect of destroying the

weight, tactility, and structural associations of the steel members, lightening, and, as it were, abstracting them into purely aesthetic and optical relationships. In 1965, Greenberg had advocated Caro as the "only new sculptor whose sustained quality can bear comparison with David Smith."[3] Surely a major and truly innovative sculptor, Caro, as Greenberg says, changed and expanded art and taste (fig. 81).

Much of David von Schlegell's work at the time of *Primary Structures* was still in wood; his *Wave* (fig. 82), purified but almost naturalistic in form, revealed his New England training in boat building. The asymmetry of this, and his later sculpture in steel and aluminum (usually completed by the artist), is more reduced in number of elements than that of Caro. Von Schlegell's sculpture is wholly of the sixties—in its inception (he was a painter until 1960), in its conceptions, and in its stringently minimalized form, yet at the same time it is entirely personal. The most influence-mongering art historian would find it difficult to provide him with a stylistic genealogy. His originality can be explained partially by his biography: familiarity with boat-building techniques and materials, training in engi-

neering (1940–42), employment with Douglas Aircraft as an engineer (1942–43) and with the U.S. Air Force as a pilot (1943–44), and instruction in art (1945–50) first at the Art Students League and then with his father, who was a painter. His first mature sculpture, done in 1961, was in oak and laminated airplane plywood, which he formed by steaming it into freshly conceived forms that, though entirely nonfigurative, somehow bridged the gap between nature and mechanics, with the resonance of sails, boats, aircraft, birds, waves, sea, and even sky. In 1962, he began to use metal as reinforcement; after 1965 it became his primary medium—first aluminum and then a combination of aluminum and stainless steel, necessary for large pieces to survive in the outdoors.

Mies van der Rohe's credo "less is more" is corroborated by von Schlegell's sculpture. Unlike Tony Smith, Donald Judd, or other sculptors whose works have been industrially fabricated, each of von Schlegell's pieces is entirely finished by him or his assistants. Each is unique, yet they share essential qualities that give his work an impressive cohesiveness. From the first wood pieces to more recent con-

81

Anthony Caro, *Prairie*. 1967, painted steel, 38 × 229 × 126 in. (96.5 × 582 × 320 cm). Collection of Lois and Georges de Menil, on loan to the National Gallery of Art, Washington.

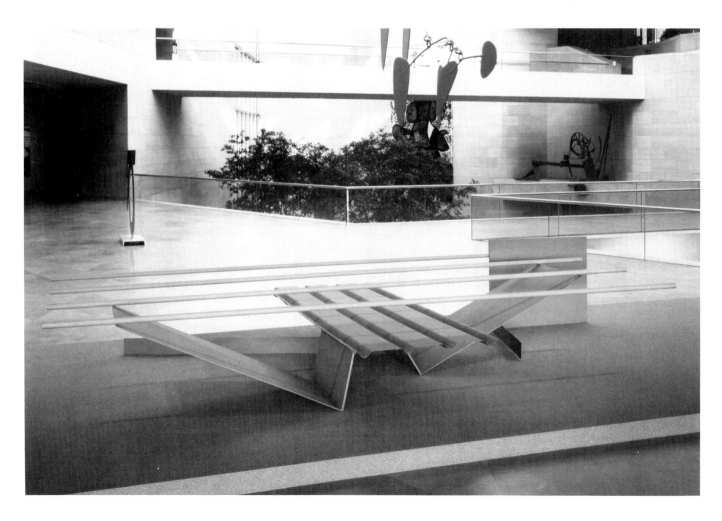

structions, materials are used both to exploit and reveal their innate properties; joints, whether in metal or wood, and fastenings, such as rivets, nuts, and bolts, are not hidden, but pointedly revealed as inherent parts, in their economy and precision, of a highly distilled aesthetic. The works comprise a few, carefully pondered elements, and their configurations are neither neo-Cubist nor anti-Cubist, systemic nor either symmetrical or nonsymmetrical. Like the modes of joinery, every element and quality has a purpose. If a surface is polished, it has been done to provide a reflection, not simply for elegance or display of craftsmanship.

Lyman Kipp's rigorous arrangement of two or three rectilinear volumes (a manner that evolved from less impersonal work in bronze, a medium which for advanced sculptors was all but obsolete by 1966) was painted, usually in primary colors. As is the case with Caro, color tends to dispel an effect of mass. Robert Grosvenor's work, both in 1966 and later, was usually also painted in a single color, but the apparently precarious and threatening suspensions of immense volumes within a limited space, environmentally calling into play the spectator's em-pathy and kinesthetic insecurity, overpower the opti-calizing effect of color (fig. 83). Ronald Bladen's *Untitled*—three identical, ominously tilted slabs, each approaching ten feet in height—reiterated the exploitation of insecure juxtaposition to galvanize the spectator (pl. 26). This work, here shown in an aluminum and wood model, can now be seen, finished in steel, in the collection of the Museum of Modern Art.

Although Tony Smith had a one-man show the same year at the Wadsworth Atheneum in Hartford, *Primary Structures* was one of the first showings of the work of this previously all but unknown architect, painter, teacher, and friend of the Abstract Expressionist painters. A member of their generation, Smith is nevertheless a sculptor of the sixties. Surely he is one of the masters of this decade. His *Free Ride* (1962)—resembling, in three dimensions, certain of Stella's early shaped canvases—fits three movements of a square-sectioned tube into an eighty-inch cube of space. In this piece, as well as in later, more complex works, Smith combined preplanned arrangements of elements with a wry, theatrical, and almost surrealistic intuition.

82

Installation view of the exhibition *Primary Structures.* April 27 through June 12, 1966, at the Jewish Museum, New York. Works by (left to right) Peter Forakis *JFK,* 1963; Salvatore Romano *Zeno II,* 1965; Forrest Myers *Zigarat,* 1966; David von Schlegell *Wave,* 1964; Ellsworth Kelly *Blue Disk,* 1963; William Tucker *Meru I,* 1964, and *Meru III,* 1965. Photo, Jewish Museum/Art Resource.

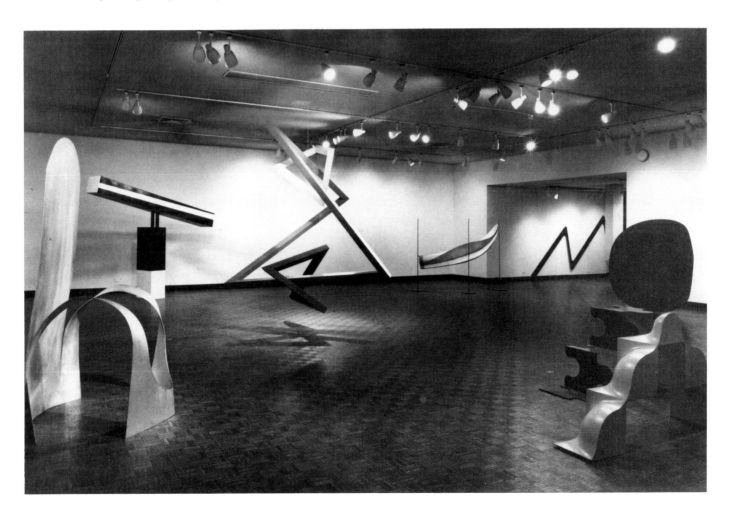

In Germany between 1953 and 1955 Smith had made some abstract wood constructions and had conceived a work assembled from triangular prisms in 1956, but his public emergence as a sculptor began in 1962 with *The Black Box*—a steel enlargement of a three-by-five-inch card file—and *Die*, ordered by telephone from the Industrial Welding Company in Newark: "Build me a six-foot cube of quarter-inch hot rolled steel, with diagonal, internal corner bracing."[4] By 1962, however, he had also evolved far less elemental works, using right-angled volumes, the tetrahedron and octahedron, for which dimensioned drawings, models, and the know-how of Smith's assistants were necessary to build both plywood mockups and steel finished works. They are usually black, and Smith prefers to see them placed outside against trees, at dawn or dusk, when they become organic rather than geometric presences.

Smith's sculpture is not conceptual. It has a different aspect from every viewpoint and is openly asymmetrical, organic, or even random. That this effect is his intent is evident from his pointedly nonformalistic and evocative titles: *Night, The Snake Is Out,* *Smoke, Smog, Grasshopper, Cigarette* (fig. 84). His archetypes are not found in previous modernist sculpture but in the mysterious forms of cairns, menhirs, Indian mounds, and Stonehenge, or the entirely nonartistic environments of the industrial landscape: smokestacks, storage tanks, water towers, "artificial landscape without cultural precedent."[5]

Wandering Rocks is not one of Smith's large works, but one of the most complex, compelling, and original. The five units are titled *Smohawk, Crocus, Slide, Dud,* and *Shaft,* and are all variations of his characteristic tetrahedral and octahedral forms. We have become familiar with two-dimensional optical art that appears spatially ambiguous, but in this moving group, in which the odd, crystalline volumes of dull gray steel have a mysterious affinity, an optically induced animism both invalidates physical mass and creates a magical sense of life and nature.

By 1965, Donald Judd's commercially fabricated geometric metal works had broken totally (and, it then seemed, polemically) with the old relationalism. His thin metal boxes, very evidently hollow, repeat in a tautology of identical rectangles. Although

83
Robert Grosvenor, *Untitled,* 1967, wood and steel, 11 × 40 × 20 ft. (3.66 × 12.12 × 6.06 m). The Walker Art Center, Minneapolis, gift of M. A. Lipschultz, 1976.

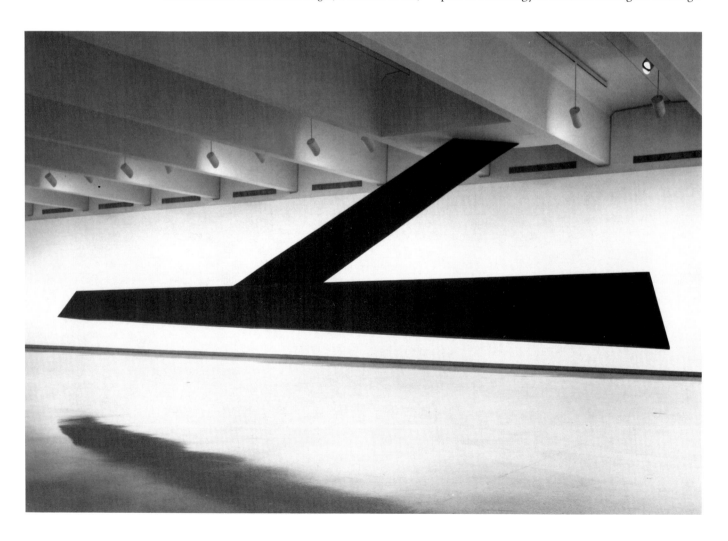

he disdained *Primary Structures* as a stupid name and a stupid exhibition, the appearance of his work after 1962 was instrumental, even crucial, in promoting the minimalism that was documented in this influential show. Judd's austerely Euclidean sculpture originated more as a criticism of past and current art than as an inner directed concept and arose from two thoroughgoing exclusions. First, like Stella, but with even more explicit purposefulness, he sought to drain his art of content. He dismissed as spurious and "unbelievable" self-expression, metaphor, symbolism, or idealism, as qualities outside the physical and perceptual art object itself. Second, he discarded composition (a term for which he professes hatred) in favor of holistic units, symmetry or neutral asymmetry, repetitive spacing of identical units in rows or stacks, and their spacing by arithmetical or free progressions (pl. 27). Scarcely less important was his abandonment of free forms and hand craftsmanship

for geometric volumes describable in orthographic and isometric drawings, and for industrial materials fabrication, and finish. Yet new materials and technology were merely a *means* to Judd.

He dispensed entirely with the base or pedestal and avoided kinesthetic elicitations of movement and gesture. Seen in the light of his renunciations, which include all of European art, Judd is a textbook exemplar of the Greenberg hypothesis of progressive elimination of inessentials as the prime evolutionary principle of modernist art. But what is surprising is the positiveness, intelligence, clarity, sensuous beauty, and nuanced complexity that have been the outcome of such polemical repudiations.

Judd preferred the term "specific objects" rather than "sculpture" for his work. It epitomized not only the "fewness" and antirelationality of the sixties, but also the high degree of *conceptualization* implicit in any disposition of elementary forms for

84
Tony Smith, *Cigarette,* 1961, painted steel, 15 ft. 1 in. × 25 ft. 6 in. × 18 ft. 7 in. (459.2 × 777.2 × 566.3 cm). The Museum of Modern Art, New York, Mrs. Simon Guggenheim Fund.

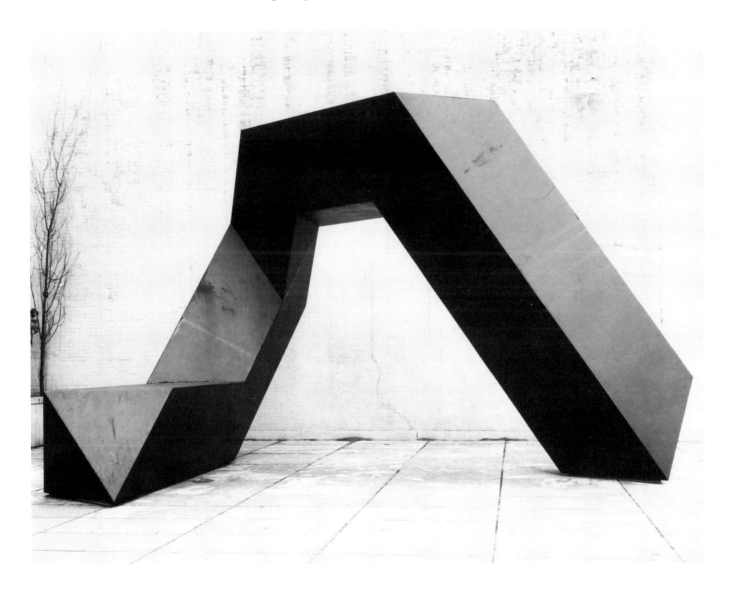

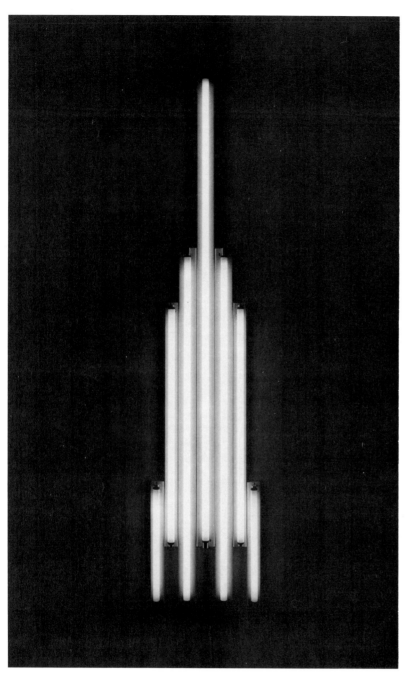

Dan Flavin, *Monument for V. Tatlin*, 1966–69, fluorescent light, 108 × 23 in. (274.32 × 58.42 cm). The Menil Collection, Houston. Photo by Hickey-Robertson.

tends to be countered by its antithesis. Among the English sculptors in the exhibition, for example, Philip King, like David Annesley, Michael Bolus, and Peter Phillips, injected purist geometricity with an antigeometric (surrealist?) ingredient, intentionally using odd forms and insecure balances. Such formal irony, or wit, also demonstrated in this exhibition by Isaac Witkin, is to be expected after the influence of Dada and Duchamp in a period of multifarious stimuli in which commitment to any one position demanded real grit. Tony De Lap's metal and steel sculpture—in this case a splayed, inverted "U", within which steps move inward to a hollow center—was clean, well fabricated, and decorative in a sparse way. It is characteristic of much holistic work of the mid-decade in painting as well as sculpture.

Ellsworth Kelly was in his early forties by 1965. A pioneer of "nonrelational" painting, he was already an established figure. The inclusion of his *Blue Disk* (fig. 82) calls attention to the dissolving borderline between painting and sculpture that accompanied the reductive trend. A single element, it is one of the suavely faired shapes from his canvases of the late fifties and early sixties removed from its white background and replicated in painted aluminum. Dan Flavin's medium, by 1966, could be said to be neither painting nor sculpture—or both: the placement of standard fluorescent lighting fixtures. Perhaps it more closely resembled painting—an environmental form in which light, often differing in color as the result of different gases, provides the palette (fig. 85). Also at the threshold between sculpture and painting was the work of Anne Truitt. Although the piece in Primary Structures was more complex, it was her painted columns that gained critical attention (fig. 86). "The surprise of the box-like pieces in her first show early in 1963, in New York," as Clement Greenberg wrote in 1967, "was much like that which Minimal art aims at. Despite their being covered with rectilinear zones of color, I was stopped by their deadpan 'primariness,' and had to look again and again, and I had to return again, to discover the power of these boxes to move and affect."[6]

All of the just mentioned artists shared a commitment, however rarified their means may have become, to the materiality of the art object. Indeed (Dada and happenings notwithstanding), its essentiality had not been seriously challenged by 1966. Even Flavin's light painting—for which the hardware-store fixtures, though hidden or altered, were tools of the phenomena, and the fading and merging light was hardly material—nevertheless retained a unified gestalt that (as in poetry or music)

which the artist, like an architect or engineer, contributes an idea and a working drawing, but no longer is concerned with fabricating his own products. Such objects could be (and are in the work of lesser artists) merely props for phenomenological demonstration. But Judd's critical intelligence, theoretical rigor, polemical factuality, and sensuous, even exquisite, use of new materials and processes resulted in a unique and aesthetically radical art form.

So sophisticated were the form combinations of the sixties that, even in minimalist work, a tendency

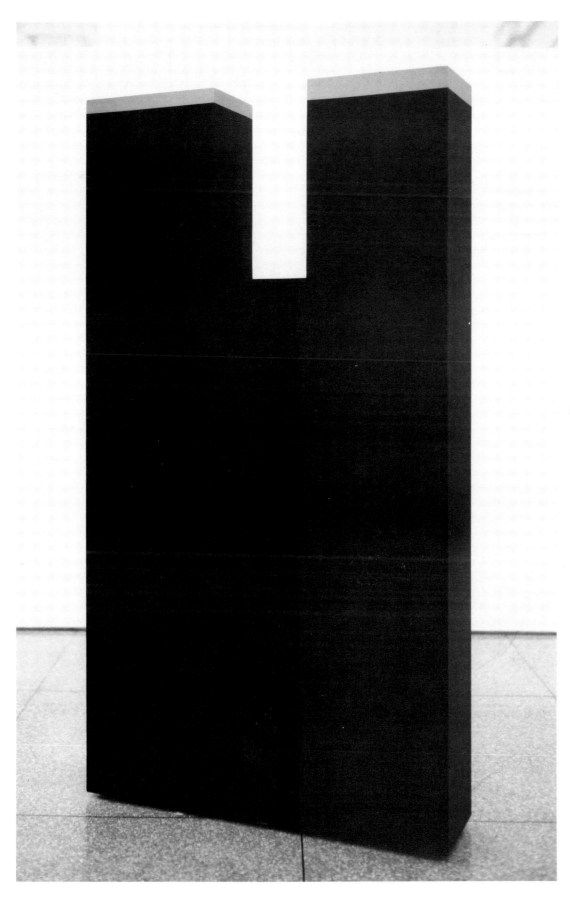

86
Anne Truitt, *Keep,* 1963, acrylic
on wood, 72⅝ × 39 × 10 in.
(184.47 × 99.06 × 25.4 cm).
National Collection of Fine Arts,
Washington.

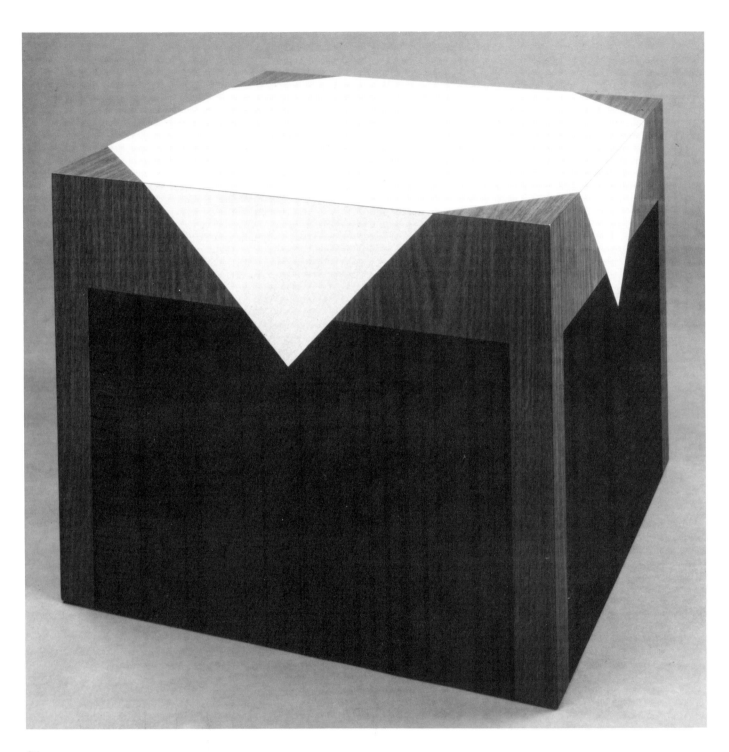

87
Richard Artschwager, *Descrip-
tion of a Table,* 1964, Formica,
26¼ × 32 × 32 in. (66.88 ×
81.28 × 81.28 cm). The Whit-
ney Museum of American Art,
gift of the Howard and Jean
Lipman Foundation, Inc.

separates the formal relations of the work into a contained aesthetic unit—a nonphysical "object." At that time, the object's inviolability was also maintained by the Los Angeles artist Larry Bell, who was known for his untitled, perfectly fabricated cubes of coated, sometimes iridescent, glass held in position by the thinnest possible frame of polished steel. By comparison, Richard Artschwager's rectangular volume of Formica six inches high and resting on the floor, was divided by color tones into descriptive areas of light and dark, and was titled *Table with Tablecloth*. Artschwager, a crafter of usable modern furniture, was making a Pop joke, albeit on a rather high level and at the expense of the new, minimal "specific objects," on the current reduction in the relational complexity that formerly marked art objects. It somehow says: "This is not sculpture, but furniture." (See fig. 87.) John McCracken's submission was typically minimal—reduced to simple forms, few elements—but personal in its lustrous lacquered surfaces and carefully finished surfaces, edges, and corners. The next year, however, McCracken reduced a work to a single board, perfectly fabricated in warp-resistant polyester resin, lovingly smoothed and lacquered in many polished coats. A typical work, ten-feet high, was titled *There's No Reason Not To* and was exhibited leaning against the gallery wall. Here, as in Lichtenstein's parodies of avant-garde art, the sometimes pretentiously serious

stance of Minimalism is ridiculed. The object, without physical autonomy, leans against the wall appearing, whether the artist meant it to or not, as a tongue-in-cheek comment on the reductio ad absurdum that Minimalism could and did, in some cases, become.

The abstract sculptural art object as it existed until the sixties was a free-standing entity, around which an observer could move, responding to the quality and level of relationships established by the sculptor. To decrease the number and diversity of its elements—its relational potential to a minimum— or (though not a relief) to lean it against the wall, was to deprive the medium totally of both spatial integrity and of what used to be thought of as essential sculptural qualities. *Rainbow Picket* (fig. 88), by Judy Gerowitz (later Judy Chicago), was in its way more complex than McCracken's lacquered planks, if only by multiplication of number of elements. It consisted of six hollow rectangular beams of canvas-covered plywood, painted in a succession of "decorator" color tones that formed diagonal bridges between floor and wall. Starting from the left, each tinted beam was progressively shorter than the other. The smallest at the right, therefore, postulated the disappearance of the series into the corner, whereas the large left side of the arrangement seemed capable of infinite additive expansion according to a prearranged increment. The containment of

88

Installation view of the exhibition *Primary Structures.* April 27 through June 12, 1966. The Jewish Museum, New York. Works by (left to right) Judy Gerowitz *Rainbow Picket,* 1966; Robert Smithson *The Cryosphere,* 1966. Photo, Jewish Museum/Art Resource.

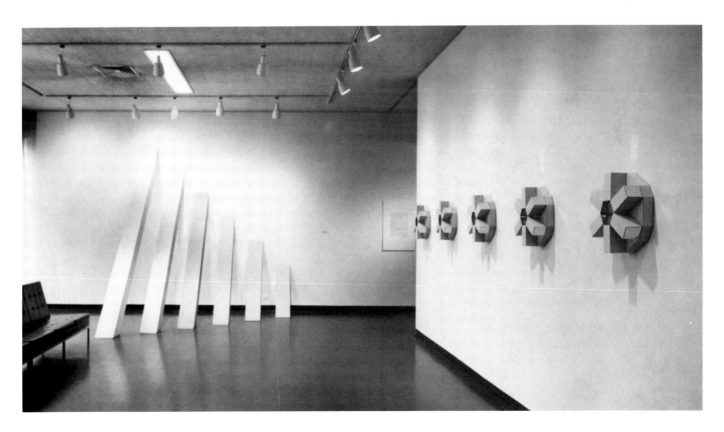

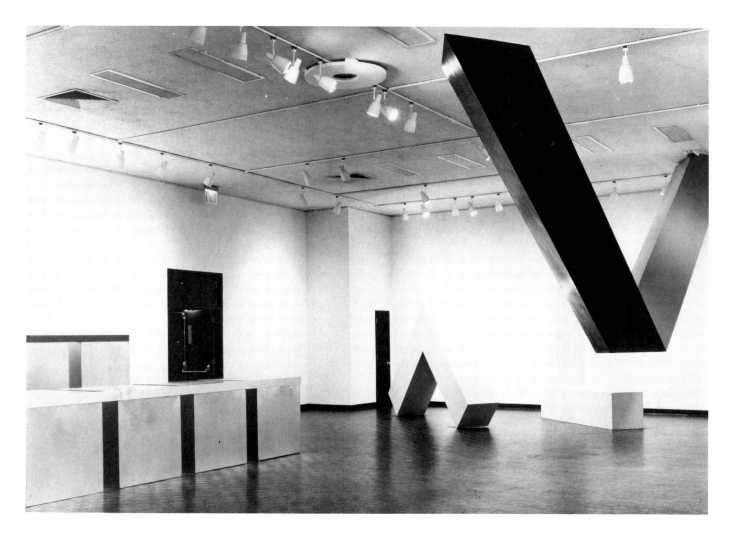

the work was therefore threatened by its potential for infinite conceptual extension. It is to work such as this that the useful term "systemic," applied to painting somewhat too loosely in an exhibition at the Guggenheim Museum in this same year, 1966, is relevant. Here, however, the "system" is not just modular redundancy, as in Judd's repeated boxes, but a successive, ordered enlargement from element to element with no change of form.

Were the precedents of Tony Smith and Don Judd not existent, Robert Morris's *Floor Piece*—a square, twenty-four-foot-long geometric log painted light gray, with one corner rounded—would have been a radical gesture in 1966 (fig. 89). Morris himself had made a standing rectangular column in 1961, to be used in a performance by La Monte Young at the Living Theatre, and two other painted boxes, *Slab* and (hanging) *Cloud* in 1962. An important difference must be pointed out between Morris's Minimalism and that of Smith and Judd: these latter artists subsequently continued their devotion to the sculptural form to which their thinking had led them. In

both cases, the rudimentary box was an ultimate statement of position, a tabula rasa from which new kinds of sculptural relationships originated.

Quite differently, the changes in Morris's work and activities indicate that his identification was not with medium or form, autonomous or environmental, but with implementing a chain of phenomenological speculations, or with occupying successive neo-avant-garde positions. The first boxes were followed by a series of witty, ironic figurative objects, influenced by Duchamp in attitude and Johns in form, among them a "brain" covered with dollar bills and a hinged, padlocked box on which the impossible instructions LEAVE KEY ON HOOK INSIDE CABINET appeared in raised letters. Morris performed one of the first nude dance events in 1965 (*Waterman Switch*, in collaboration with Yvonne Rainer), was involved with other dance/happening activity, and moved to random scatter pieces, environments, earthworks, and other changes in direction that the diversity of the decade suggested. The introduction of Duchampian jokes into the percep-

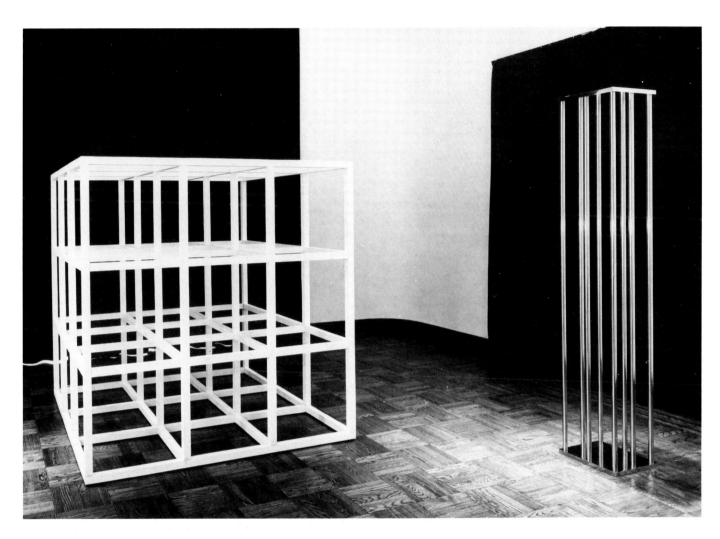

tual postulates of Minimalism was a contradiction and an intentional adulteration of its essentially phenomenological premises. Further, it was typical of Morris, as well as several others who were working in this mode in 1966, that their conception of art (or anti-art) was unwilling to settle for long on *any* formal or aesthetic solution. Immediate neo-avant-garde art history, real or synthetic, but ultimately leading toward the dissolution of the art object, seems to have motivated them.

In various ways and for various reasons, these rapid deviations were all surely influenced by the compulsion toward innovation and aesthetic subversion characteristic of the sixties. Douglas Huebler showed a delicately colored, characteristically primary piece in Formica. Color was used, he said, "to float the weight and the parallel lines to move the form from volume towards flatness (or illusion)"[7]—a good statement of the play between tactile and optical implicitly in highly reduced geometric volumes. By 1969, however, Huebler was practicing geographical conceptual art involving the mails: the art

object had been abandoned. Such can also be said of Robert Smithson, who showed a radial modular piece in painted steel with chrome inserts in 1966, but came to be best known for color photographs and a film of his impressive *Spiral Jetty* in the Great Salt Lake and for his placements of mirrors at various sites in Mexico, published in *Artforum* in 1969.[8] Sol LeWitt showed one of the first of his multiple spatial cubes, in this case a framework of twenty-seven open cubes comprising a larger six-foot cube. (For further discussion of Smithson's work, see pp. 145–49.) More consistent, LeWitt's later handsome prints and wall drawings (these executed by others) demonstrated a continued concern with precisely thought-out conceptual, systemic variations of line schemes.

Walter de Maria's *Cage* was just that: a cage of stainless-steel rods and plates, some seven feet high (figs. 90 and 91). By 1970 de Maria was to try a grab bag of options: a stainless-steel *High Energy Bar* qualifying as a work of art because of a mock-serious signed and stamped certificate that accompanied it; a metal column engraved with an homage to Greta

90

Installation view of the exhibition *Primary Structures.* April 27 through June 12, 1966. The Jewish Museum, New York. Works by (left to right) Walter de Maria *Cage,* 1961–65; Sol LeWitt *No Title,* 1966. Photo, Jewish Museum/Art Resource.

91

Walter de Maria, *Cage,* 1965, steel, 88 × 15 × 15 in. (216.5 × 37 × 37 cm). Museum für Moderne Kunst, Frankfurt am Main. Photo by Eric Pollitzer.

92

Constantin Brancusi, *Endless Column,* version I, 1918, oak, 80 × 108⅞ × 9⅝ in. (203.2 × 25.1 × 24.5 cm). The Museum of Modern Art, New York, gift of Mary Sisler.

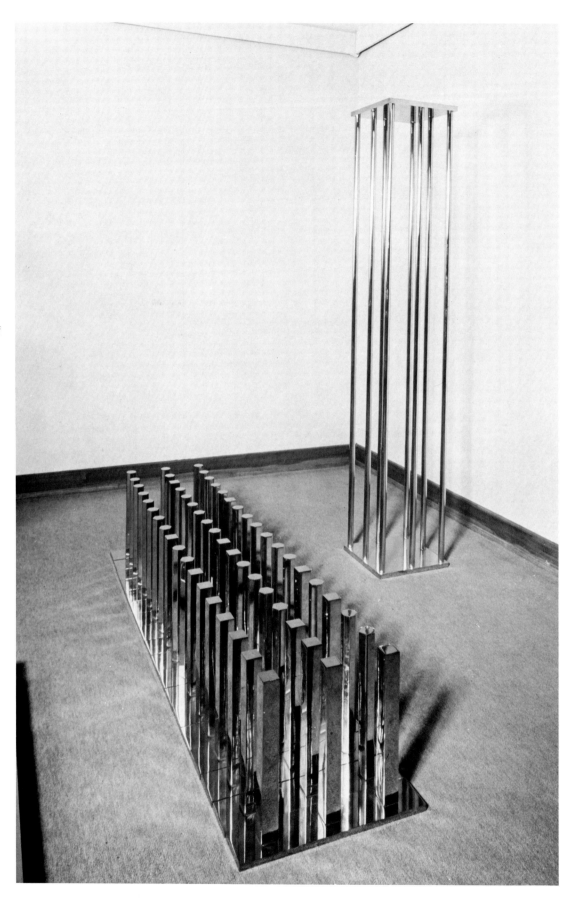

Garbo; a gallery floor covered with dirt; a bed of sharpened steel spikes; and a mural-sized photocopy of a *Time* article on Walter de Maria.

Carl Andre was something of a special case in this exhibition. His submission, called *Lever,* consisted of a line of 137 Firebricks laid side by side on the gallery floor flush to a wall at one end but free at the other. The piece projected "in such a way that the viewer could approach it from either of two directions. From one position, it was possible to view the entire length of the work receding in perspective. From another doorway, only the terminal portion was visible." [10] Influenced by Brancusi's *Endless Column* (fig. 92), and in 1959 a self-proclaimed protégé of Frank Stella, Andre at that time was making handsome intricate stacked works, since destroyed, of rough lumber that resembled the lost sculptural projects of Alexander Rodchenko. By 1969, seeking flatness and horizontal extension rather than unterminated vertical extensions of the Endless Columns, his sculpture (if such it can still be called) was laid on the floor, like squares of linoleum, in rectangular modules. *37 Pieces of Work,* 36 units of 36 squares each, 1,296 elements, 216 each of aluminum, copper, steel, lead magnesium, and zinc, plus the square of the entire work, 432 inches by 432 inches, was his most ambitious flat work and the feature of his one-man exhibition at the Guggenheim Museum in 1970. However unsatisfying Andre's flat works or other floor pieces may have been to one accustomed to more familiar abstract sculpture, the sequence of his development is *internally* consistent, one premise following from another. As a visual, concrete word poet, Andre was surely a precursor of Conceptual Art by several years; yet, however reduced, his sculpture retained serious systemic structure, without adulteration from Duchampian irony or Pop jocosity.

With the compulsion to innovation of the sixties as the "scene," any mode, viewpoint, or conviction was subject to diversion or adulteration from the moment of its dissemination. Surely this was true of the kind of work shown in the *Primary Structures* exhibition. Nevertheless, it documented what may be a historic stage in the evolution of sculpture: the final elimination of the base, or plinth, as a sculptural prop and the potential, and in some cases the power and dominance, of highly simplified three-dimensional forms. Ultimately, the real impact of a style does not depend on its aberrations but on the viability of its ground premises. Already established in major earlier works, these premises became after 1964 the vocabulary of contemporary abstract sculpture, at least for those who did not find sculpture to be an obsolescent form.

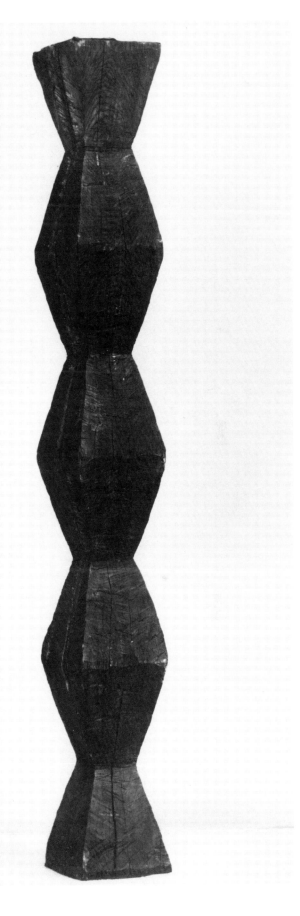

Big Sculpture

8

Both nonrepresentational sculpture and the technique of construction are innovations of the early twentieth century. Certain of the conditions for the proliferation of large, freestanding outdoor structures that occurred in the sixties were thus established a half-century earlier. Picasso's first experiments with assemblage and construction, and their application to abstract sculpture by Vladimir Tatlin after his visit to Picasso in 1912, constitute one of the crucial transmissions of a concept in modern art history. But even without this epochal meeting, the Russians might well have drawn from Cubism what they needed for the foundation of Constructivism. Moreover, if one is willing to regard symbolistic engineering as sculpture, the "proud tower" designed by Alexandre-Gustave Eiffel and erected for the Paris Exposition of 1889, was the archetype of the Constructivist idea. Standing 984 feet high, it was the tallest structure in the world at the time, and its form and mode of construction, foretokens of a new world to Apollinaire and Delaunay, are echoed in Naum Gabo's *Project for a Radio Station*—a conceptual projection of an immense construction of lines and planes overshadowing a small, rectangular building—and Tatlin's *Model for the Monument to the Third International* (both 1919–20). Yet in the Constructivist tradition, despite the ambitious concepts of Naum Gabo and his brother, Antoine Pevsner, it was not until the time of Max Bill's large sculptural experiments in Switzerland during the thirties and forties, or (to consider works of a size appropriate to contemporary architecture and engineering) Gabo's *Construction for the Bijenkorf Department Store, Rotterdam,* finished in 1957, that the environmental potential of Constructivism began to be realized.

Although it flowed directly into optical and technological art and influenced, for example, the kinetic art of George Rickey and Nicolas Schöffer, Constructivism does not provide a formal precedent for the big sculpture of the sixties. Far closer to these spare geometrical volumes are the pyramids and—as Barnett Newman's *Broken Obelisk,* a work of the sixties, emphasizes (fig. 93)—the obelisks of ancient Egypt. These were surely the first major "minimal" sculptures. In other early precedents, from the Assyrians and Mayans to the conceptions of the eighteenth-century French architect Claude Ledoux, large abstract sculpture of simple geometrical masses can be found, but Egypt offers the most direct, best-known examples.

Why was work resembling that of, let us say, Tony Smith or James Rosati not done in the twenties or earlier? There are surely several reasons. Large sculpture was usually official sculpture, effigies of heroes, statesmen, and politicians standing stiffly or seated on horseback. Since the time of the emperor Constantine, elephantine figures have seemed absurd, so a semblance of monumentality was achieved by elevating the figure or group on a massive stone base. (It is amusing to observe that these often resemble the boxes of the sixties.) Most Cubist sculpture was figurative and was modeled or carved. In its potential, however, as the Constructivists sensed, Cubist form moved toward open structure; only Brancusi, before 1920, worked in solid, essentially abstract volumes. Forms that were both volumetric and geometric were not, with very few exceptions, part of the vocabulary of the early abstract artists. Of the exceptions, perhaps the most striking are Alexander Rodchenko's *Construction of Distance* (1920), a stack of eight or nine rectangular wooden members, and Georges Vantongerloo's little concrete *Composition* (1924).

To combine an inner metal structure with an outer metal skin to produce large, volumetric abstract art demanded engineering processes not applied to sculpture until after World War II, when a great and prophetic work was produced by the architect Eero Saarinen: the Jefferson National Expansion Memorial, a 630-foot arch that stands beside the Mississippi River in St. Louis. The commission was given, as the result of a competition, in 1948. From that time until his death in 1961, Allan Temko wrote, Saarinen worked on the design in search of a "faultless arch form, contemplating the monumental arches of the past, and the vaults and buttresses of Gothic Cathedrals, reflecting on the energy that a curved line develops in space, and on the paradox of its downward direction." [1]

When one encounters a segmental view of the arch [I wrote in 1969] cutting across the blue sky between the office buildings of downtown St. Louis like the trajectory of a rocket, with sunlight dazzling from its stainless sheath, its thrust induces a kinesthetic and spiritual elation that is as physical in its effect as rapid acceleration in a plane or roller coaster. Totally lacking a sense of mass, linear rather than volumetric, optical rather than tactile, its materiality dissolved or flattened by changing light and weather, its perfectly tapered triangular shaft soaring into space "in a single aspiring moment," the sublime power of this matchless work arises from attributes precisely opposed to those so often held indispensable to great sculpture. [2]

The concluding reference, in the last sentence above, was to the bronze and stone sculpture of the past, as well as to recent commissions of such works—exceptionally large for the medium of cast bronze—as that by Henry Moore placed above a reflecting pool on the plaza of the Vivian Beaumont Theatre at Lincoln Center in New York in 1965. Such work recalls the large bronzes of the fifties. The new sculpture of the sixties, however, in its reduced, industrially controllable, geometric form and its emphasis on volume and opticality rather than mass follows naturally after Saarinen's arch, for which the Washington Monument—itself optical and reversible in apparent volume against the late afternoon sky—is a masculine counterpart.

If one considers only simplification of form and potential for large-size fabrication, indeed, that forgotten landmark, the Trylon and Perisphere, constructed for the New York World's Fair of 1939, is surely among the prototypes for the sixties. More notable, in style as well as size, are the concrete *Square of the Five Towers in Mexico City* (1958), the highest soaring to 185 feet, by the architects and sculptors Mathias Goeritz, Luis Barragan, and Mario Pani, and Goeritz's earlier, horizontally spreading *Steel Structure,* about 15 feet in height, in the patio of an experimental museum in Mexico City (1953): this is surely the most prophetic work of the fifties for the primary structures of the sixties.

The enlargements of Alexander Calder's stabiles provide a technical (but only technical) parallel to the new work. Most notable of these are the commissions completed for the Massachusetts Institute of Technology, Cambridge, Massachusetts (1965), for Expo, held in Montreal, Canada (1967), and the stabile called *La Grande Vitesse,* for the city of Grand Rapids, Michigan (1969). Calder's stabiles lend themselves easily to enlargement, because they are

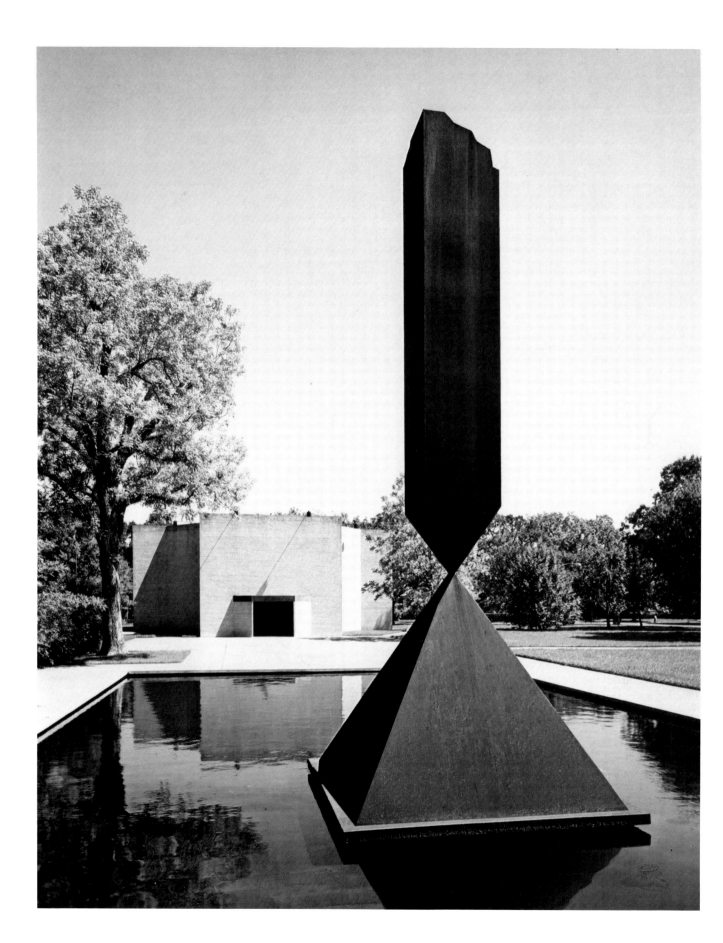

relational arrangements of profiles—steel plates—rather than volumes. Like the enlarged, ponderous interior stabiles, moreover, they are prime examples of what Barbara Rose in 1968 called the "blow up":[3] mechanical enlargement of small models to almost any size, a situation in which the new visual problems raised by expanded size—problems, precisely, of *scale*—are ignored or not fully comprehended. The works cited above, and others that could be added to them, are of historical interest here as key monuments of large, abstract sculptural construction (fig. 94). Yet, it would be false to see them as precursors in a line that leads to sixties Minimalism. Other European sculptors who worked between the thirties and the fifties, in addition to Max Bill, might be singled out for the elemental abstractedness of their forms and for their large-scale thinking. But their connections are, in the main, with Constructivism, and their relationships are, until the threshold of the sixties, essentially Cubist.

There was almost no equivalent, in sculpture, of the geometric painting of the thirties and forties, and among the sculptors who came into prominence in New York with Abstract Expressionism—Peter Grippe, David Hare, Herbert Ferber, Ibram Lassaw, Seymour Lipton, Theodore Roszak, David Smith—only Smith, most evidently in his influence on Anthony Caro, had anything that modernism of the sixties wanted. Smith's art, like that of Arshile Gorky, began with an unstable merger of Cubism and Surrealism—that most antisculptural of styles. Only the Cubi Series (which began in 1963) links him closely with the sixties (fig. 95, pl. 28), and few of these, most notably the horizontal additive *Cubi XXIII,* break with closed Cubist syntax. One work of 1956, *Five Units Equal,* must however be separated out (fig. 96). It is a stack of five equal-sized steel boxes, uniformly spaced from one to the other and suspended on a central vertical support.

Because there was little nonexpressionistic abstract sculpture during the fifties in the United States, it is essential to call attention to the isolated presence, within the context of the New York School, of Richard Lippold. One might describe him as a "mystical constructivist." In 1951 he participated in the symposium *What Abstract Art Means to Me* at the Museum of Modern Art. Rather than explaining his work, he projected a film of the earth made from a camera affixed to a rocket, at that time a surprising technological and Futuristic gesture. Unlike the improvisatory Abstract Expressionists, Lippold's environmental constructions were planned entirely in advance and made primarily of tautly stretched wire that reflected light. He was seldom successful in small gallery pieces but was known for large installations, beginning with his ten-foot suspension *Variation Number 7: Full Moon* (1949–50) and going on to larger commissioned projects. Although at one time Lippold shared a studio with John Cage, who continued to support his art, he had little status among the young sculptors and critics of the sixties who, if they thought about it at all, saw his work as overly decorative, or even as kitsch.

A closer connection with sixties sculpture could be made with the polished steel calligraphy of José de Rivera. According to the artist, technology was not available, even in the sixties to produce the varying thicknesses, in circular cross-section and in World's Fair dimensions, for which he is known, although *Infinity* (1966), with an angular cross-section, rises to eighteen feet atop a base on which the work turns slowly (one revolution every eight minutes). But both Lippold and de Rivera existed (as do many artists) outside the primary chain of directions and redirections, and the generation that matured in the sixties gave them little heed.

From what, then, in the absence of source—a solid position in a sculptural tradition—do sixties primary structures arise? The solution to this mystery is not difficult. As discussed earlier, the assault on neo-Cubist asymmetry was carried out by Rothko, Still, Newman, Reinhardt, and (though his early work in Paris was not known in New York and therefore not influential) Ellsworth Kelly. Nonrelational, hard-edge images were projected into the sixties by Stella, Kenneth Noland (the softening effect of the technique of soaking notwithstanding), and other color-field painters. The adoption of the unframed, shaped, thickened, and/or sculptured canvas by Stella, Sven Lukin, Charles Hinman, Richard Smith, and James Huntington answers this question, which is further emphasized by the bronze replicas Newman made in the sixties of his painted "zips." Although there were surely some sculptural sources, the ground rules of Minimalism (which lies at the core, as an extreme postulate of the new large sculpture) were established by painters or arose in the context of a dialogue set up by painters. But, in addition to the painterly origins of specific objects, and the influences of Constructivism, other social and technological forces stimulated a movement toward large three-dimensional abstraction.

The demands imposed by the buildings of the fifties and sixties, with their simplified volumes and large open plazas, could not be properly filled in bronze or stone, or by the old figurative monuments. At the same time, more money for art became available (in many cases by the requirement that a small percentage of building costs be spent for sculpture), which lessened the hostility toward ab-

93
Barnett Newman, *Broken Obelisk,* 1963–67, Cor-ten steel, 312 × 125 × 125 in. (792.48 × 317.5 × 317.5 cm). The Menil Collection, Houston. Photo by Hickey-Robertson.

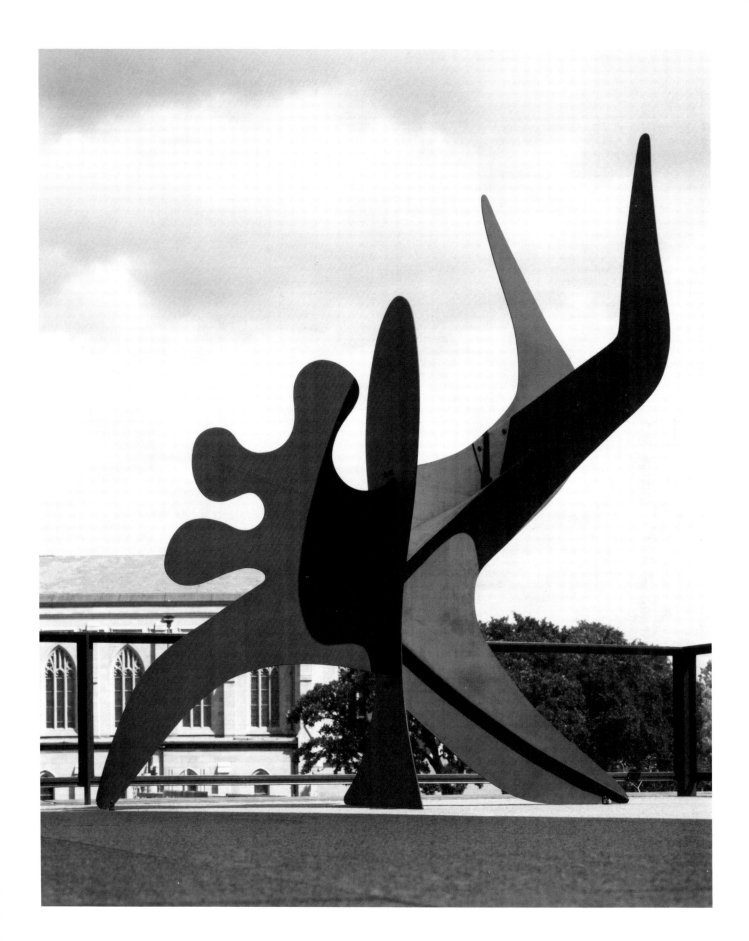

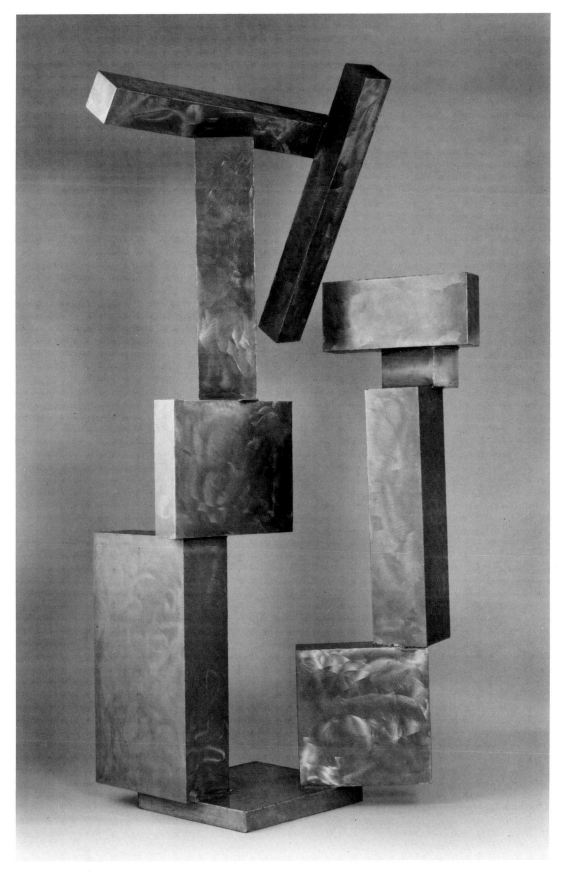

94
Alexander Calder, *Octopus*, 1964, steel plate, 120 × 108 × 66 in. (304.8 × 274.32 × 167.64 cm). The Walker Art Center, Minneapolis, gift of the T. B. Walker Foundation, 1968.

95
David Smith, *Cubi IX*, 1961, stainless steel, 105¾ × 58⅝ × 43⅞ in. (268.61 × 148.91 × 111.44 cm). The Walker Art Center, Minneapolis, gift of the T. B. Walker Foundation, 1966.

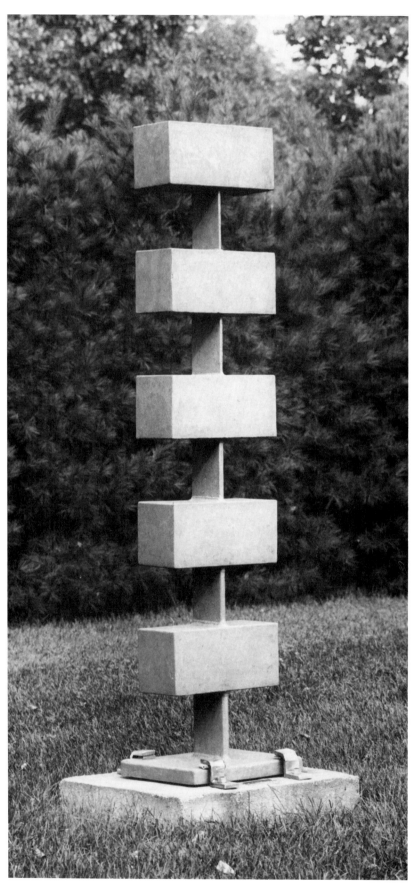

stract art, even in smaller cities far from the cosmopolitan centers. The inclination of sculptors to work in large sizes, with or without a demand for their work, was documented by the International Symposium Movement. At more than twenty working convocations between 1959 and 1967, each lasting from three to twelve months, in Austria, Yugoslavia, Israel, Japan, Italy, the United States, and Canada, sculptors from several countries met to produce major large, personally fabricated works in stone, wood, metal, and other mediums. Usually only materials and lodging were provided by the sponsors. The work, whether good or bad, remained on the site, a gift of the sculptors. One proposal, a "Voie des Arts" in France, was finally fulfilled in Mexico during the 1968 Olympics. Mathias Goeritz, himself a pioneer of both large and minimal sculpture, induced the government to commission nineteen immense abstract works to line the eight-lane Route of Friendship that led to the Olympic Village. Sculptors from Mexico, Switzerland, Czechoslovakia, Japan, Hungary, Uruguay, Italy, Belgium, Poland, Spain, Australia, the Netherlands, Israel, and Morocco were represented. From the United States, Todd Williams, Constantino Nivola, Herbert Bayer, and Clement Meadmore (officially representing Australia, where he was born) were included.

Large figurative sculpture—from the colossal statues of the Egyptian Pharaoh at the Abu Simbel and the immense stone heads of Easter Island, to the monuments of the nineteenth century that fill the world's parks and public squares, the Lincoln Memorial, and Mount Rushmore—depends in large part on subject matter for their impact—on the relation of the human effigy to the spectator. The inherent absurdity of such outsized monuments for our time was brilliantly revealed by critics among the artists of the sixties, Oldenburg's proposals for a drainpipe to be placed beside Lake Erie near Toronto (as a late entry to the Chicago Tribune Building competition), a wing nut for Stockholm, a toilet tank float to bob in the Thames, and a solid concrete block to fill the intersection of Broadway and Canal Street in New York. Even before his controversial lipstick/war machine at Yale, the thrust of these propositions for anti-monuments was implicitly political, if only because they clothed the antiestablishmentarianism of the modernist artist in the idiom of monumental sculpture—for centuries the symbols of dominant power elites.

The attention given above to works of gargantuan proportions might suggest that, beside abstractness, size is the prime criterion for adequate environmental sculpture. Although essential for the Saarinen arch, in inappropriate instances sheer size can be ab-

surd, as the blowup of a Picasso sketch for New York University's apartment complex or the 280-foot-high inflated sausage made by Christo for the *Documenta 4* exhibition in Kassel, Germany, in 1969 demonstrate. Indeed, much of the finest work conceived in the late sixties, in response to the new environmental situation, emphasizes visual accessibility rather than commemoration and is disposed horizontally rather than vertically. Therefore the height range most important to consider, both for its relationship to human observers and the disposition of modern buildings and their related open spaces, lies between ten feet, or even less in the case of widely extending works, and, at the most, one hundred feet.

Thus, the large sculpture of the sixties faced new problems of size, vision, and pure form previously faced by architects, but never by sculptors. Their solution demands that the sharpest possible distinction be drawn between *size* and *scale:* between a blowup of a sketch or gallery piece and the application of the full artistry of the creator, in collaboration with the fabricator, in establishing a situation in which not only the relative size of the work to the size of a human being is at issue, but also the effect of forms of a prescribed size and character to human perception *in motion,* as seen from five feet or five hundred feet or, if the work permits environmental entry, even from below or within it.

It has always been customary for sculptors of monuments to have the final stone carving done by craftsmen and, of course, to turn over bronze casting to a foundry. Often they did not carry personal execution beyond a small clay or plaster model. Factory-made sculpture was therefore not a radical break with tradition. But fabricated artworks from raw steel, using, to quote the sculptor Robert Murray, "brakes for bending and forming plate, flame-cutting torches, metal saws, gas or electric welding equipment, grinders, sand blasting tanks,"[4] and other industrial equipment, was nevertheless a new situation that posed both new problems and new possibilities. David Smith, however, had already transformed the atmosphere of the atelier into that of the sculpture factory. From 1934 until 1940 he had rented space to do welding in the Terminal Iron Works in Brooklyn, and later gave that name to his private "factory" in Bolton Landing, New York, around which his works were placed in the fields. But Smith was a Paul Bunyan of sculpture, a mountain of a man who carried personal fabrication of large, but still human-sized works further than anyone else of his generation could. In 1962, the town of Spoleto in Italy sponsored a citywide sculpture exhibition in connection with the fourth Festival of Two Worlds for which the ancient, closed-in spaces of the city provided an effective containment for sculptural enrichment. The climax of the festival was the creation of twenty-six works in one month by Smith, using several empty factories in Voltri. Dramatically shown in the ancient Roman amphitheater, these works—the Voltri Series—are now distributed among the world's museums and private collections. His performance was a last, extraordinary feat of the expressionistic individualism of the fifties.

The next step was the replacement of the foundry by the factory. In New York, Brooklyn, and other cities during the sixties, metal-fabrication plants were drawn into the manufacture of large steel sculpture, often of Cor-Ten steel, which became fashionable for its deep brown rusted patina, of painted steel, or of stainless—the latter being the most difficult to work, the most expensive, but the most beautiful and permanent material. The first factory entirely devoted to the production of large sculpture started operations on a ten-acre site in North Haven, Connecticut, the brainchild of Don Lippincott, the idealistic son of a commercial steel fabricator. Lippincott Environmental Arts soon became famous, producing works by Rosati, Nevelson, Morris, Murray, Meadmore, Oldenburg, and other artists of both the older and younger generation. Perhaps its best-known commission was for two versions of Barnett Newman's *Broken Obelisk* (1963–67), one of which is now permanently installed near the Rothko Chapel in Houston, Texas (fig. 93).

Donald Judd's article "Specific Objects" appeared in *Arts Yearbook* in 1965.[5] The Lippincott Sculpture Factory in New Haven was founded that summer. Thus the year before the *Primary Structures* exhibition was also the year in which both reductive form and the impulse toward large outdoor sculpture came to a focus. One might expect, in these circumstances, that the major practitioners of the new approach to monumentality would be primarily of the generation born in the twenties or thirties. It is therefore germane to recognize how much of the best that was produced was the work of artists from the older generation. As demonstrated above, monumental abstract sculpture was not an invention of the sixties. In 1951–52 Herbert Ferber, under the auspices of the Sam Kootz Gallery, executed a large welded sculpture of the burning bust for a synagogue facade in Millburn, New Jersey. David Smith's Cubi belong to the ambience of the sixties in their geometricity and use of prefabricated elements, though they remain limited to a large, but anthropomorphic "gallery" size and scale that did not lend itself to magnification. Also of the older generation, George

96
David Smith, *Five Units Equal,* 1956, steel, 73¼ × 16¼ × 14¼ in. (186.05 × 41.28 × 36.2 cm). Storm King Art Center, Mountainville, New York, gift of the Ralph E. Ogden Foundation. Photo by Derek St. John.

Rickey, became one of the leading kinetic sculptors of the sixties along Jean Tinguely and Nicolas Schöffer. Rickey's work, much sought after by collectors and museums in America and Germany, evolved from an admiration for Calder, a feeling for nature, and immersion in the Constructivist tradition, and is therefore outside the present discussion. The greater affinity of other sculptors of the previous generation for volumetric form can be explained as a natural development of principles inherent in earlier work, the environmental and economic go-ahead for major outdoor work, the natural desire (anything but new) that an artist feels to have his or her creations executed in a most imposing way, and the development of a technology capable of producing more ambitious projects than had previously been possible. Of great importance also (and this consideration subsumes all of the previous three), was the absorption, not always conscious, of the ambience of the period. An exception perhaps is offered by Isamu Noguchi's brilliant work, whatever its size, and including his environmental complexes in Israel, at the Unesco Building in Paris, the Chase National Bank in New York, his great marble garden at the Beineke Rare Book Library at Yale University (1960–64), and even his superb fountains for the Tokyo World's Fair of 1970. All of these are a part of the boldness and radicality of his entire life work.

Alexander Liberman, the versatile painter, sculptor, photographer, and then art director of *Vogue,* was one of the most prolific artists of the sixties. During the previous decade, he produced a series of ruthlessly antirelational, sparse, optical paintings that are unique. His sculpture of the sixties continued this taste for economy and reflected, in various phases, a sympathy for Newman, Smith, and perhaps Caro. Liberman had the means, and space, in the fields around the home of the painter Cleve Gray in Connecticut, to execute by command a copious series of welded assemblages of sections cut from storage tanks, huge tubes, and other preformed steel members. Once Liberman made the decisions, cutting and welding were accomplished by an assistant. Large relational works could by this means be completed impulsively, without preliminary sketches, and entirely under the artist's control. Liberman's sculpture was painted a single color, emphasizing the openness and opticality of his forms. Although he belonged to an older generation, his familiar constructions of frames, heavy rods, wide-stretching planes, and yawning hollows became a hallmark of the sixties.

Like Newman and Reinhardt, Tony Smith was both a precursor and initiator. The sense of organic life he projected into a few tetrahedral forms in *Cig-arette,* his immense mock-up *Smoke,* built for an exhibition at the Corcoran Gallery in Washington in 1967, or his entirely systemic *Smog,* a 78-foot-wide plywood mock-up for steel of 1969, are all intensely personal. They are the work of a master, whose unique art surfaced at the proper time for its full reception. Born the same year as Smith, 1912, James Rosati emerged by 1967 as a figure of comparable stature, though his powerful yet nuanced volume constructions were never the favorites of the young modernists. Although he gained a solid reputation as a carver and modeler during the fifties, and was a close friend of such artists as de Kooning and David Smith, Rosati rejected the open, welded style that accompanied Abstract Expressionism, preferring the abstract solids of Brancusi. After 1967, however, his monumental works in steel, now seen in major installations across the United States and in Canada, established him as a major sculptor. One of the first artists to work with Don Lippincott in 1965, he emerged as a master by the end of the decade.

In addition to the patronage of private collectors and business organizations, the most important support for the sculptural enrichment of the modern urban environment, both in individual awards and major commissions, has come from the enlightened program of the National Endowment for the Arts. Directed for the fine arts, first by Henry Geldzahler and next by Brian O'Doherty, it granted, in equal sponsorship with local fund-raisers, major commissions to Calder, Noguchi, and Rosati, and numerous smaller commissions to lesser-known sculptors. In considering younger, and often aesthetically anarchistic, modernists, the professional jurors for these commissions have faced real difficulties in reconciling the conservatism of middle-American communities with the artists' congenital distrust of public authority. City fathers who would relish bronze replicas of Indians, buffalos, or pioneers seldom wish to collect $50,000 for what may appear to them as a fifteen-foot steel shipping crate. Moreover, a conscientious juror, whatever his or her own tastes, does not wish to be a conduit by which an aesthetic time bomb is placed at the City Center.

In their most extreme, and at the time polemical, manifestations, primary structures did not fill the need for permanently placed environmental art. Robert Morris's slabs, boxes, cages and frames, as the artist himself recognized, were props for the refinement of perception. These—and such works as Ronald Bladen's large wedge balanced precariously on its inverted apex and compressed within a small gallery—provided a fascinating series of object lessons to the gallery visitor in the phenomenology of environmentally conceived forms. The issues they

raised were perceptual and empathic, not decorative, but their fascination was temporary. Nevertheless, it is conceivable that a large, dominating form with a minimum of inner relationships—a concrete enlargement, let us say, of a Morris box—could dominate a public situation with imperious power, and one can imagine a memorial situation in which such an Oldenburgian application of Minimalism could be effective. But in a democracy, community sculpture is placed by the consent and through the interest of its members, and among the leaders of most urban communities such objects remain truly avant-garde, and are instinctively, and sometimes justly, rejected.

Although many talented modernist sculptors were working across America often teaching in universities (or in Israel, Germany, and other European countries), a survey of those younger sculptors of the sixties who were noticed in New York, Boston, Los Angeles, or Chicago is surprisingly small. Many of the artists shown in *Primary Structures* in 1966 were also included in Maurice Tuchman's ambitious survey at the Los Angeles County Museum, *American Sculpture of the Sixties,* in 1967. Of these, Bladen and especially Grosvenor demonstrated the immense potential of volumetric projections that, because of their apparently precarious placement, read as mass rather than hollow volume. Judd showed a row of four-foot-square painted metal cubes: a gesture, a potential confrontation between nature and artifact, perhaps, but unsatisfactory as public sculpture. Smithson's systemic sequence units, each progressively smaller (or larger) and constructed entirely of cubical units, showed the possibilities of modular thinking for what could have been major work. Among the older sculptors was Peter Voulkos who, though here working in cast bronze and aluminum, had earlier pioneered large sculpture in ceramics. The Canadian-born Robert Murray, one of the strongest sculptors of the sixties, was represented by a minimal work in steel and painted aluminum. Several of the younger artists in this exhibition showed work which, though the individual pieces were not necessarily their best, demonstrated a potential for real contributions to the quality of life in cities, suburbs, and on campuses. To be singled out, for their achievements, are Robert Murray, Forrest Myers, Silvia Stone (who was to continue to work in large panes of glass and Plexiglass), Tom Doyle, Peter Forakis, David Gray, Gary Kuehn, Lloyd Hamrol, Duane Hatchett, Robert Howard, and Richard Randall.

From this exhibition, two artists must be further separated out, one who projected ideas from the recent past, and the other whose work may have been a portent of the future. Mark di Suvero transformed the gestures of Abstract Expressionism into three dimensions, at the same time amplifying and formalizing the detritus of "junk culture" into an ordered, monumental art of juxtaposition and balance. In 1960 when he was twenty-seven, an age at which most American artists are still students, his bold constructions of found materials burst suddenly into public view in a one-man exhibition, his second, at the Green Gallery. Seeking words to convey his admiration, Sidney Geist (himself an accomplished sculptor and Brancusi scholar) wrote that the exhibition stepped "beyond immediate experience into history," adding, "I myself have not been so moved by a show of sculpture since the Brancusi exhibition in 1933."[6]

Di Suvero's art is a concentration of "old" rather than "new" principles: its core structure is linear, angular, irregular, oppositional, asymmetrically relational rather than minimal, systemic, conceptual, or process-oriented. A work by di Suvero is a distribution of real physical forces that defines a central volume. Its elemental but secure joinery and worn, splintered, and rusted surfaces combine the gesture of a Franz Kline, amplified and brought into real space, with a probing Constructivism and a passion at the opposite pole from the cerebral, dispassionate stance identified with the sixties. Acutely aware of social injustice, di Suvero named a major work of 1960 *For Sabater,* in homage to a Spanish loyalist killed by Franco during the fifties. These energies, radical, moral, and personal, surcharge his works with an immediacy of emotion absent in art of the Constructivist tradition.

Di Suvero's monumental scale and juxtapositional method began with a chance discovery of some discarded wooden beams. The materials of his works of the sixties—immense timbers, boards, barrels, sections of tree trunks, and other wooden elements, steel beams, rods, angles, plates, chains, and cables—carried with them the industrial scale, atmosphere of demolition, dust and alienation of deteriorating lofts of lower New York, the debris, docks, and filthy streets from which the mediums of assemblage and happenings arose (fig. 97). But the sine qua non of his sculpture is not the roughness or social reference of his materials but the establishment of a precariously maintained equilibrium: a ponderous steel beam is suspended on a pivot; a structure like a primitive weapon, held by thin cables, seems to hang suspended in thin air; a worn truck tire at the end of a hinged beam, supported on a coil spring, distorts against the ground when it is forced downward. By 1968, di Suvero's formal and kinesthetic purity became strikingly apparent in im-

mense, bolted constructions of clean steel girders that command outdoor space in dimensions of thirty to fifty feet. In such a work as *Are Years What? (For Marianne Moore)*, painted a bright red, a massive V of steel is suspended from one of its prongs by a cable and a hook in a beautiful but precarious balance. By introducing real risk into a stripped geometric art of counterpoised diagonals and verticals, di Suvero gives monumental abstract sculpture an added dimension, muscular, existential, and still moral.

Kenneth Snelson, whose original constructions of tension and compression evolved out of his study with Buckminster Fuller, showed a breathtaking thirty-foot projection of steel and aluminum, *Cantilever*, in the Los Angeles exhibition. It is Snelson's contention that his method of placing solid compression members in space by a network of taut wires, though inspired by Fuller's ideas, is original and was in fact an influence on Fuller's later geodesic domes. Until the *Primary Structures* exhibition of 1966, he was regarded more as an engineer than as a sculptor, although his first one-man show of tensegrity sculpture occurred in the same year, at the Dwan Gallery.

Snelson's art of open spaces and countered forces looks toward the future, for the basis of its cohesiveness is entirely internal and independent of gravity. Quite different from almost all previous sculpture, however modernist in form, Snelson's constructions could exist, and would be aesthetically appropriate, in outer space (pl. 29).

The Australian sculptor, Clement Meadmore, did not show extensively in New York until after the Tuchman and McShine exhibitions. Since then, working in this country, he has exhibited two kinds of work, both worthy of attention: unitary disks, presented either singly or in groups, as mock-ups for major execution in steel; and gallery-sized pieces, some fabricated as multiples in editions of two to four pieces, in which a rectangular cross-section appears to have been twisted like a cigarette butt or a nail puzzle. It is as if the organismic potential of Tony Smith's *Cigarette*, in which a crawling movement is implied by ruled edges, were made actual: the "geometry" contradictorily bends and twists as if it were alive.

Is an enlargement of such a post-minimal form simply a blowup? Is a huge work by Oldenburg—removed from a base, magnified, and placed in the open (as has been the case in several instances)—a durable sculptural experience? The answer must address itself to the innate relationships one calls "scale," the relation of the proposed object to its observers, and the kind of space and surrounding forms

within which it appears. A purification of impurity—a contradiction of premises—lies at the core of Meadmore's impact. Is it merely an eccentric fillip like so many objects of the sixties? How big a situation can it command? Such are the fascinating problems presented by the permutations of reductive form, but the insecurity and volatility of the late sixties hardly offered a climate within which such aesthetic and phenomenological issues could be adequately worked out. There is no doubt but that, during the sixties, a new kind of open-air sculpture was born, using new principles of form, new materials, and a new technology. The decade ended with many important placements of works in stainless, painted, or Cor-Ten steel that will remain as part of the environment for many years. Surely certain of these are vacuous and may some day appear as absurd as the worst of the world's national capital and park sculpture (for which, if only as a human embellishment of natural setting, we should be grateful). They do not look as bad as they once did. Sculpture fills the grounds of art museums and sculpture parks. Not planned for their sites, these, like small gallery pieces, have a more transient connection with their environment. From the Israel Museum to Pepsico's sculpture park at Purchase, New York, the Princeton University campus, and the Hirshhorn Museum and Sculpture Garden in Washington, D.C., the sixties evolved outdoor art museums containing works that proliferated and increased in size as the sixties became the seventies. Whether or not the sculpture garden or park will remain a fixture of the future or will be seen as a curiosity that resulted from the public and corporate acceptance of modernism, to be looked back on like the extravagant vanity gardens of baroque kings, will be answered by future artists, critics, and art historians of taste. More important than the fate of outdoor sculpture collections, however, would be a vital solution to the demands the new environment makes for an appropriate formal enrichment in which the interaction of utilitarian form, human interaction, and pure form will meet on the common ground of perception.

By 1968 (as the comprehensive fourth *Documenta* in Kassel, and the tenth Venice Biennale documented) abstract sculpture that was large in size, geometric, and sparse in its vocabulary of forms, with little overt symbolistic connotation beyond its environmental aesthetic and phenomenological presence, was an established international language. Artists from Germany, Holland, and England—Eduardo Paolozzi, Philip King, and William Tucker—were working with abstract forms of reduced complexity. The urge to monumental sizes, however, was strongest in Israel. Here Kosso Eloul and Me-

nasche Kadishman, both working in close contact with New York, and Yehiel Shemi, who in 1971 completed a memorial for the Lud Airport in Tel Aviv (fig. 98), continued a monumental impulsion born of Israeli national assertiveness, but in a more reductive, volumetric manner than earlier. For the neo-avant-gardists, however, concern for an environmental sculpture to complement the environment of the modern world was already a dead issue. Such work, to them, was egocentric or chauvinistic in its pretensions and empty of significance to sensibilities by then concerned with the dissolution of the art object, the superiority of conception to perception, or the disruption of the art establishment. The history of big primary sculpture, for them, ran from 1965 to 1968.

The first abstract monumental sculpture originated three thousand years before the Christian era. The figurative tradition that replaced it, from the Great Sphinx to its nadir in the elephantine Iwo Jima Memorial (fig. 99) in Washington, D.C., occupied almost 5,000 years. The need for a perceptually conceived, human-scaled environmental art has as yet not fully begun to be filled. Are we to assume that the potential of an entirely new mode was exhausted in three years?

Jack Burnham's data-packed and thought-provoking book *Beyond Modern Sculpture,* published in 1968, assigns the kinds of sculpture examined in this chapter and the related commentaries to the "weary vocabulary" of formalism or, in the case of more reduced primary structures, to the exhaustion of relationality by inert "object sculpture."[7] Imbued with enthusiasm for a "sculpture" of cybernetic and electronic interacting systems, he saw "formalism"—which would include nearly all the sculptural works examined here—as a "brief interlude." By the twenty-first century, Burnham prophesies,

97

Mark di Suvero, *Hankchampion,* 1960, wood and chains, 77½ × 149 × 105 in. (196.9 × 378.5 × 266.7 cm). The Whitney Museum of American Art, New York, gift of Mr. and Mrs. Robert C. Scull. Photo by Jerry L. Thompson.

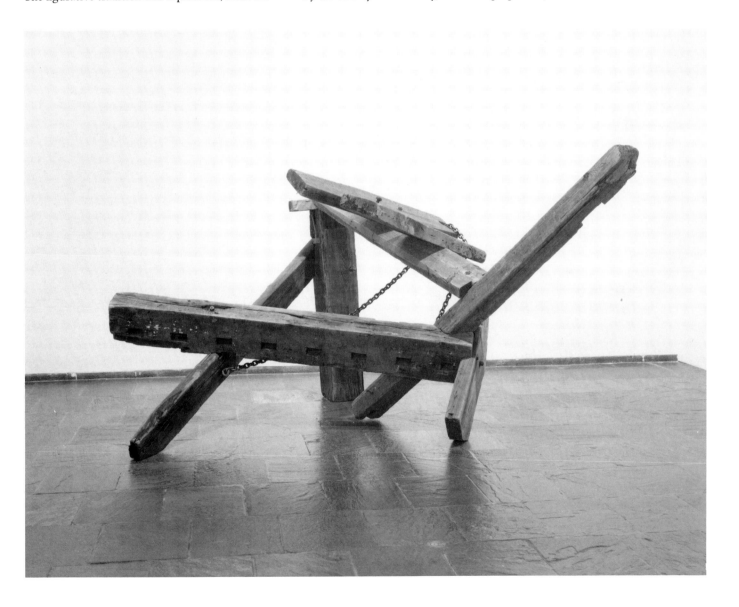

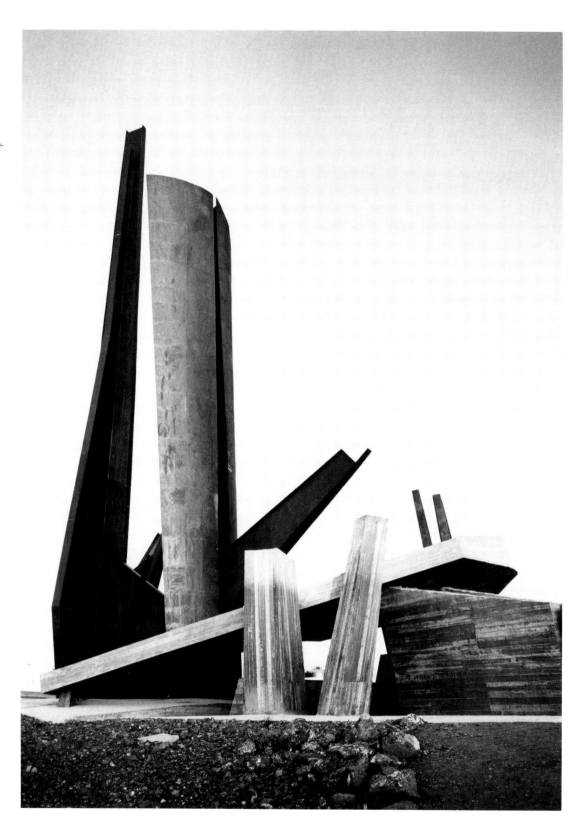

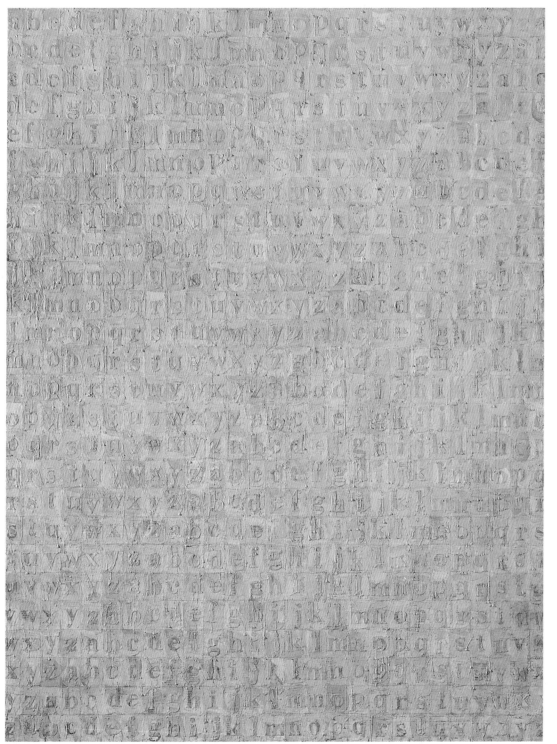

Pl. 1.
Jasper Johns, *Grey Alphabets,*
1956, beeswax and oil on news-
paper and paper on canvas,
66⅛ × 48¾ in. (167.96 ×
123.83 cm). The Menil Collec-
tion, Houston. Photo by Hickey-
Robertson.

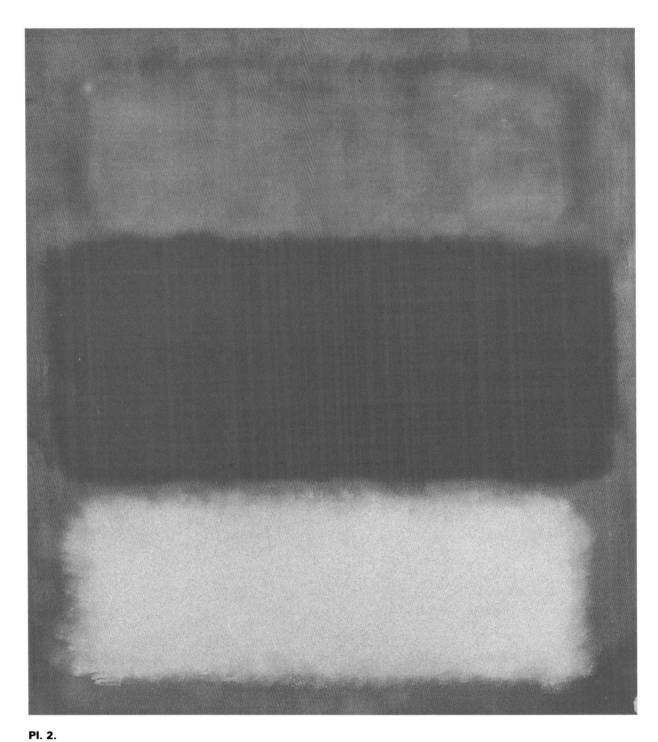

Pl. 2.

Mark Rothko, *Light Cloud, Dark Cloud*, 1957, oil on canvas, 66¾ × 62½ in. (169.6 × 158.8 cm). The Modern Art Museum of Fort Worth, Benjamin J. Tillar Memorial Trust.

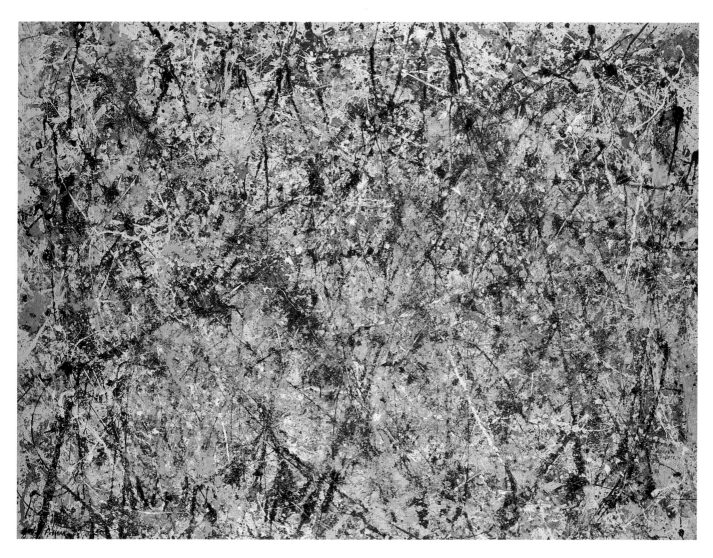

Pl. 3.
Jackson Pollock, *Number 1, 1950 (Lavender Mist)*, 1950, oil, enamel, aluminum on canvas, 87 × 118 in. (220.98 × 299.72 cm). National Gallery of Art, Washington, Ailsa Mellon Bruce Fund.

Pl. 4.
Robert Rauschenberg, *Bed*, 1955, combine painting, 75¼ × 31½ × 8 in. (191.1 × 80 × 20.3 cm). The Museum of Modern Art, New York, fractional gift of Leo Castelli in honor of Alfred H. Barr, Jr.

Pl. 5.
Frank Stella, *Gur I*, 1968, polymer and fluorescent paint on canvas, 10 × 15 ft. (304.8 × 457.2 cm). The Modern Art Museum of Fort Worth, museum purchase, Benjamin J. Tillar Memorial Trust.

Pl. 6.
Morris Louis, *Dalet Kaf*, 1959, acrylic resin (Magna) on canvas, 100½ × 142½ in. (154.6 × 362 cm). The Modern Art Museum of Fort Worth, purchased through a grant from the Anne Burnett and Charles Tandy Foundation.

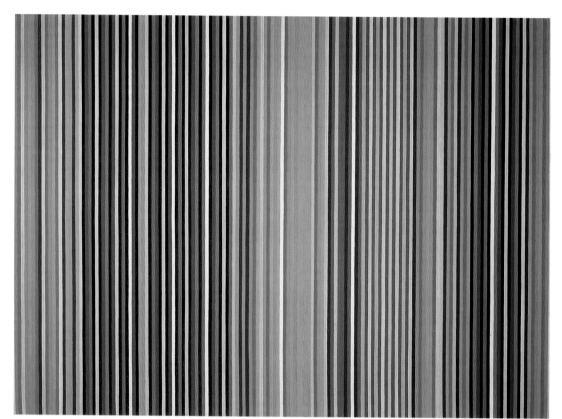

Pl. 7.
Gene Davis, *Moondog,* 1965, acrylic on canvas, 116 × 161¼ in. (294.64 × 409.58 cm). Rose Art Museum, Brandeis University, Waltham, Massachusetts, anonymous gift.

Pl. 8.
Sam Gilliam, *Light Depth,* Venice Biennale, 1972. Photo by William C. Seitz. In the collection of the Corcoran Gallery of Art, Washington, D.C.

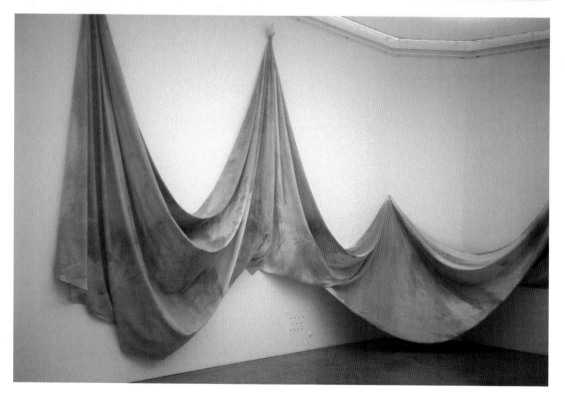

Pl. 9.
Jules Olitski, *High A Yellow,*
1967, acrylic on canvas, 89½
× 150 in. (227.3 × 381 cm).
The Whitney Museum of Ameri-
can Art, New York, purchased
with funds from the Friends of
the Whitney Museum of Ameri-
can Art. Photo by Geoffrey
Clements.

Pl. 10.
John Chamberlain, *Essex,* 1960, automobile body parts and other metal, relief, 108 × 80 × 43 in. (274.3 × 204.2 × 109.2 cm). The Museum of Modern Art, New York, gift of Mr. and Mrs. Robert C. Scull and Purchase.

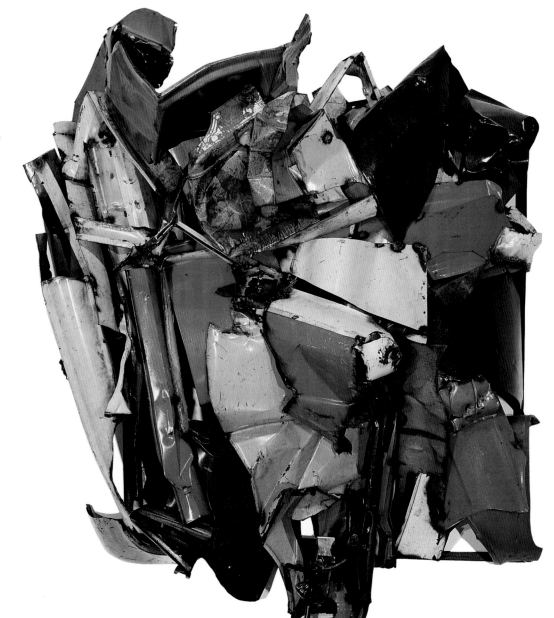

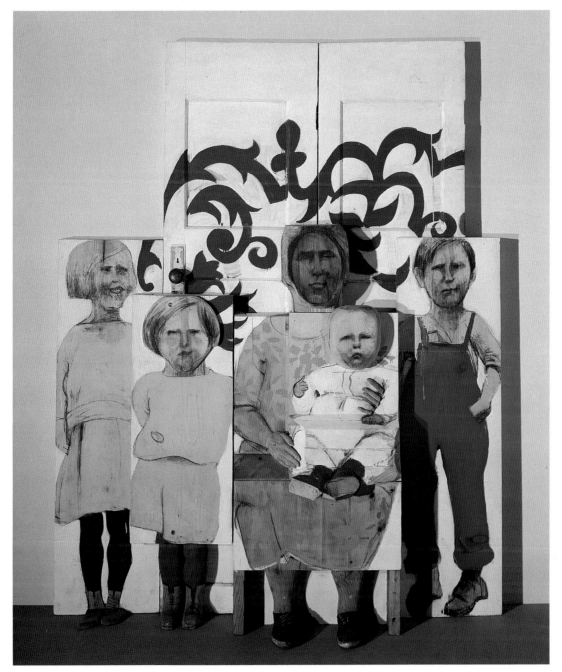

Pl. 11.

Marisol (Marisol Escobar), *The Family,* 1962, painted wood and other materials in three sections, overall, 6 ft. 10⅝ in. × 65½ × 15½ in. (209.8 × 166.3 × 39.37 cm). The Museum of Modern Art, New York, Advisory Committee Fund.

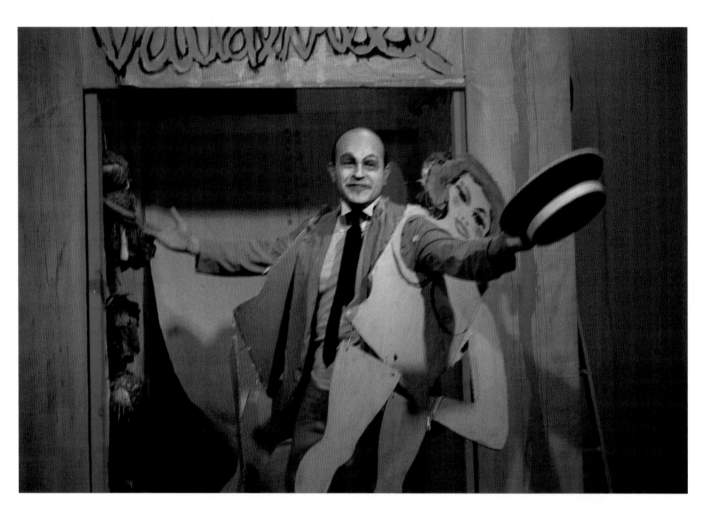

Pl. 12.
Jim Dine in his happening *The Vaudeville Show* at the Reuben Gallery, New York, 1960. Photo by Robert R. McElroy.

Pl. 13.
Yves Klein, *Blue Monochrome*, 1961, dry pigment in synthetic polymer medium on cotton over plywood, 64⅞ × 55⅛ in. (195.1 × 140 cm). The Museum of Modern Art, New York, Sidney and Harriet Janis Collection.

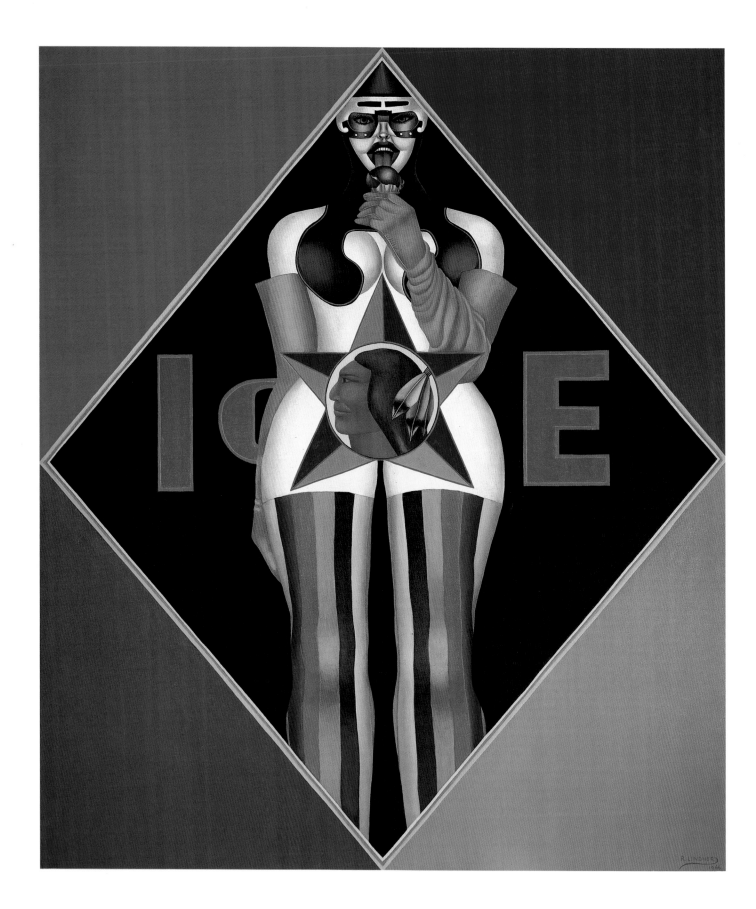

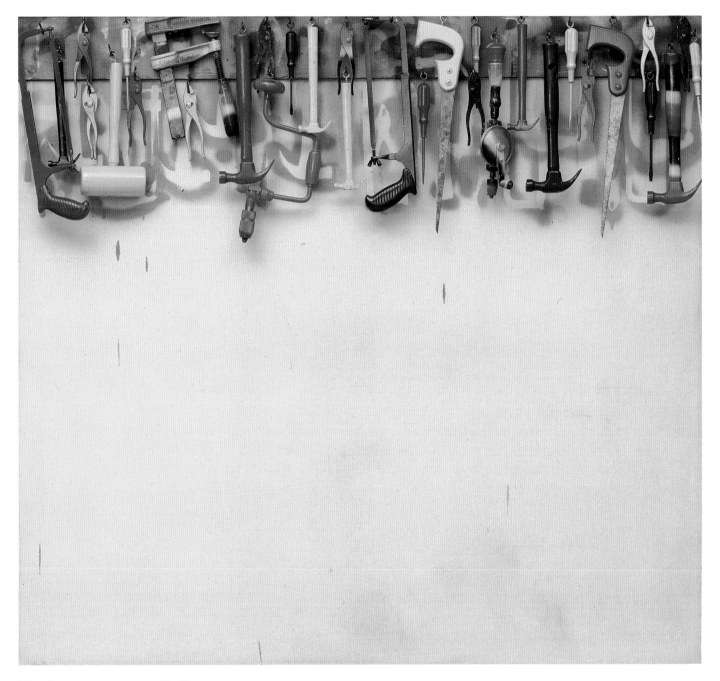

Pl. 14.

Richard Lindner, *Ice,* 1966, oil on canvas, 70 × 60 in. (177.8 × 152.4 cm). The Whitney Museum of American Art, New York, purchased with funds from the Friends of the Whitney Museum of American Art. Photo by Roy Elkind.

Pl. 15.

Jim Dine, *Five Feet of Colorful Tools,* 1962, oil on unprimed canvas surmounted by board on which 32 painted tools hang from hooks, 55⅝ × 60¼ × 4⅜ in. (141.2 × 152.9 × 11.1 cm). The Museum of Modern Art, New York, Sidney and Harriet Janis Collection.

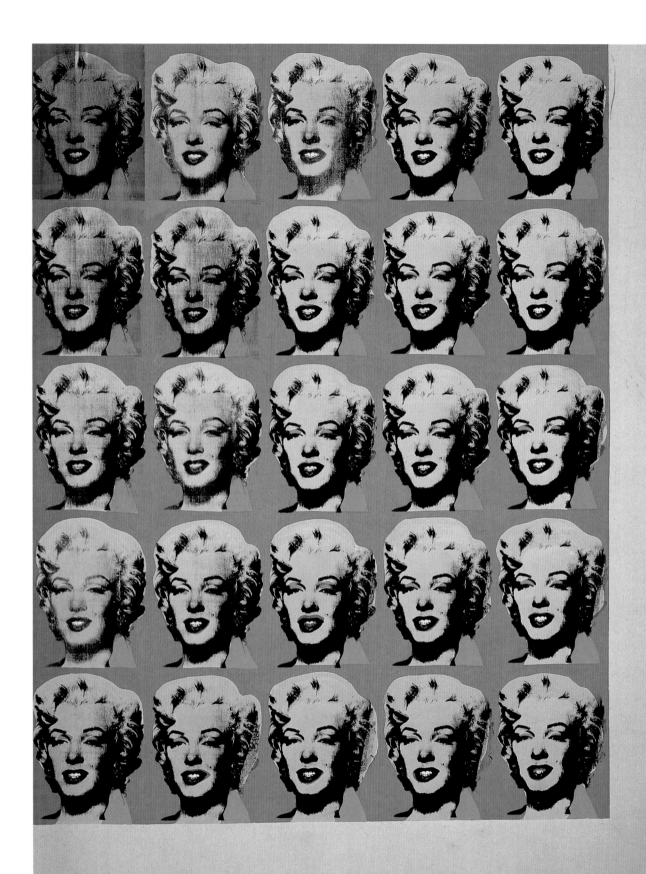

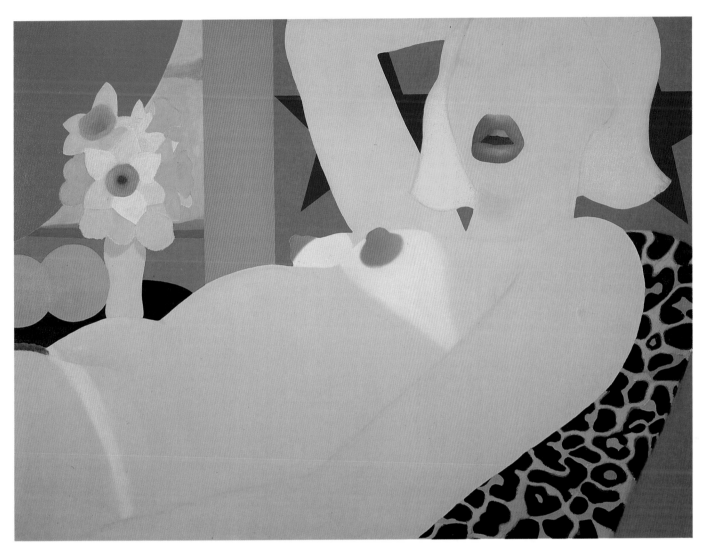

Pl. 16.
Andy Warhol, *Twenty-Five Colored Marilyns,* 1968, acrylic on canvas, 89 × 69 in. (226.06 × 175.26 cm). The Modern Art Museum of Fort Worth, museum purchase, Benjamin J. Tillar Memorial Trust.

Pl. 17.
Tom Wesselmann, *Great American Nude Number 57,* 1964, synthetic polymer paint on composition board, 48 × 65 in. (121.9 × 165.1 cm). The Whitney Museum of American Art, New York, purchased with funds from the Friends of the Whitney Museum of American Art. Photo by Geoffrey Clements.

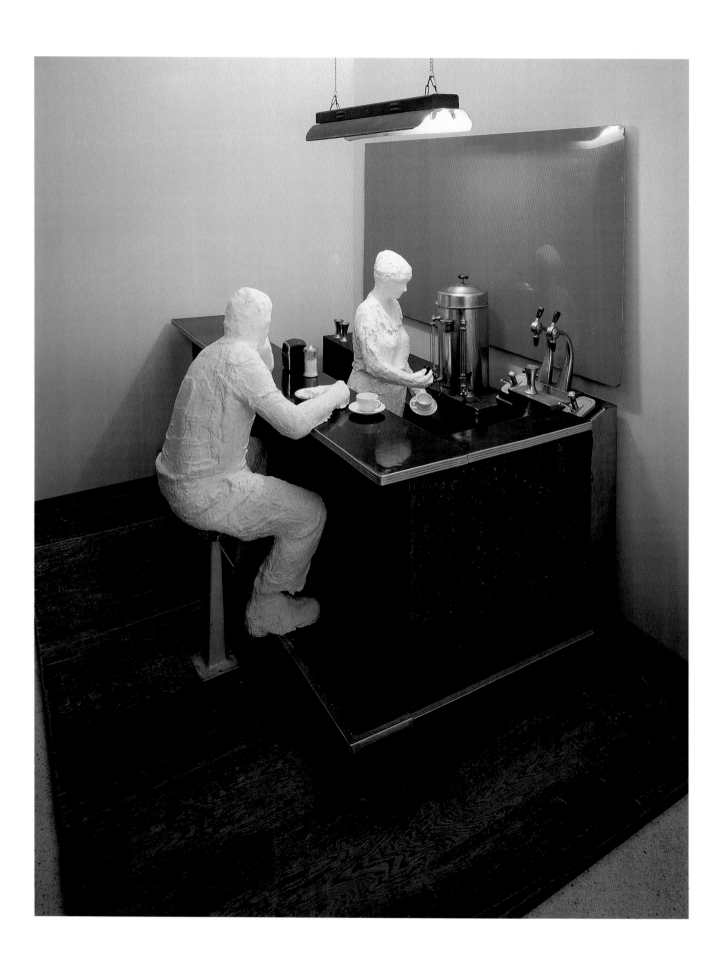

Pl. 21.

Yaacov Agam, *Double Metamor-phosis, II,* 1964, oil on corru-gated aluminum in 11 parts, 106 × 166¼ in. (269.2 × 401.8 cm). The Museum of Modern Art, New York, gift of Mr. and Mrs. George M. Jaffin.

Pl. 22.

Lorser Feitelson, *Hard-Edge Line Painting,* 1964, oil and enamel on canvas, University of Virginia Art Museum, Charlottesville. Photo by Ed Roseberry.

Pl. 23.
Richard Anuszkiewicz, *All Things
Do Live in the Three,* 1963,
acrylic on Masonite, 21⅞ ×
35⅞ in. (55.56 × 91.12 cm).
Collection of Mrs. R. M.
Benjamin.

Pl. 24.
Larry Poons, *Untitled,* 1966,
synthetic polymer on canvas,
120 × 90 in. (330.2 × 228.6
cm). The Whitney Museum of
American Art, museum
purchase. Photo by Geoffrey
Clements.

Pl. 25.

Ellsworth Kelly, *Green, Blue, Red*, 1964, oil on canvas, 73 × 100 in. (185.4 × 254 cm). The Whitney Museum of American Art, New York, purchased with funds from the Friends of the Whitney Museum of American Art. Photo by Robert E. Mates.

Pl. 26.

Ronald Bladen, *Untitled*, 1966–67 (first made in wood, 1965), painted and burnished aluminum in 3 slanted parts, each 10 ft. × 48 in. × 24 in. (305 × 122 × 61 cm), spaced 9 ft. 4 in. (284 cm) apart; over length 28 ft. 4 in (863 cm). The Museum of Modern Art, New York, James Thrall Soby Fund.

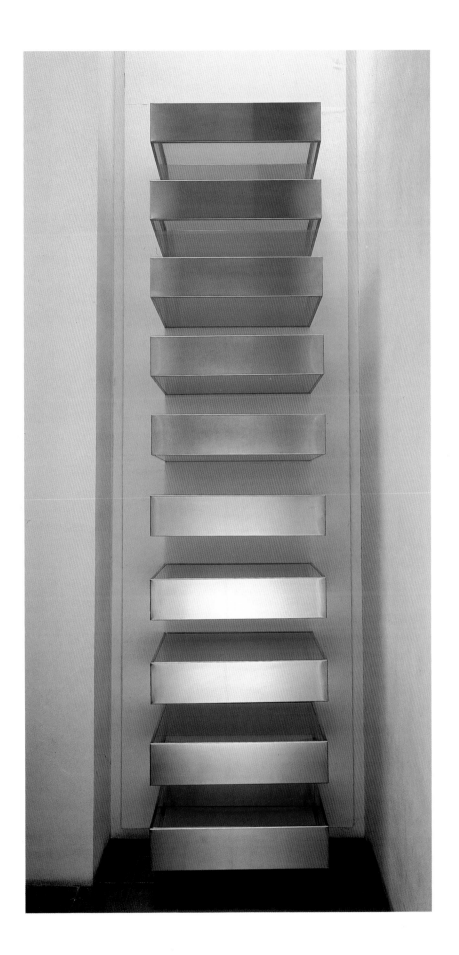

Pl. 27.
Donald Judd, *Untitled,* 1967,
stainless steel and Plexiglas,
9¹⁄₁₆ × 40¹⁄₁₆ × 31⁵⁄₁₆ in.
(24.4 × 103.2 × 78.6 cm). The
Modern Art Museum of Fort
Worth, museum purchase, Ben-
jamin J. Tillar Memorial Trust.

Pl. 28.

David Smith, *Cubi XXVIII*, 1965, stainless steel, 108 × 112⅛ × 40 in. (274.3 × 284.8 × 101.6 cm). The Modern Art Museum of Fort Worth, collection of the Sid W. Richardson Foundation.

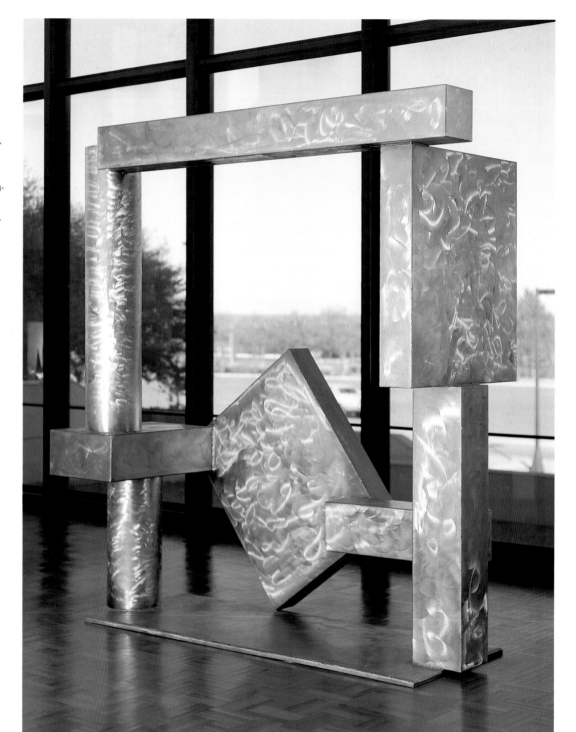

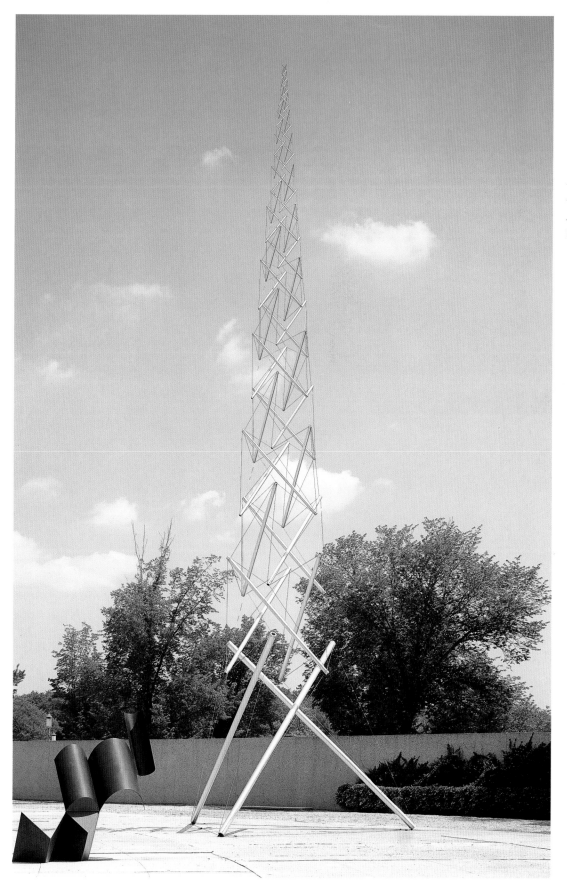

Pl. 29.

Kenneth Snelson, *Needle Tower*, 1974, aluminum, 60 ft. (198 m). Hirshhorn Museum and Sculpture Garden, Smithsonian Institution, Washington, gift of Joseph H. Hirshhorn. Photo by Lee Stalsworth.

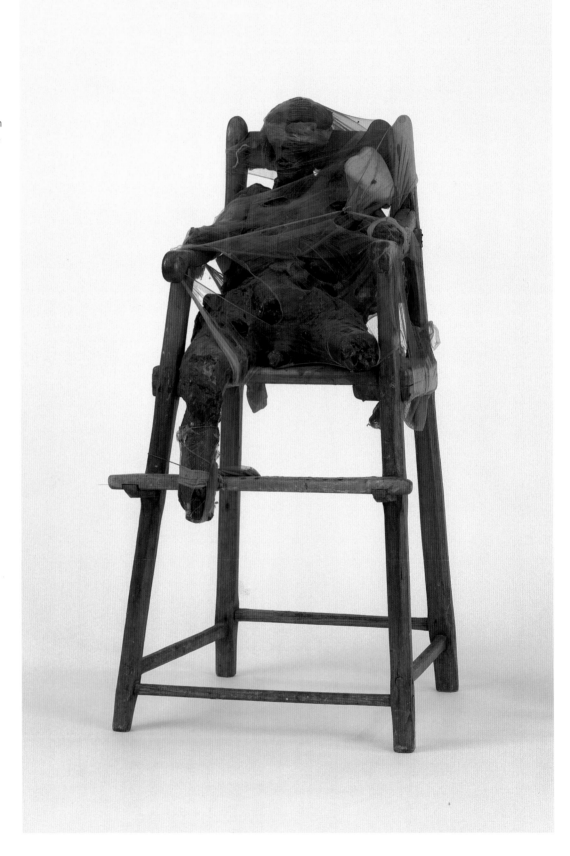

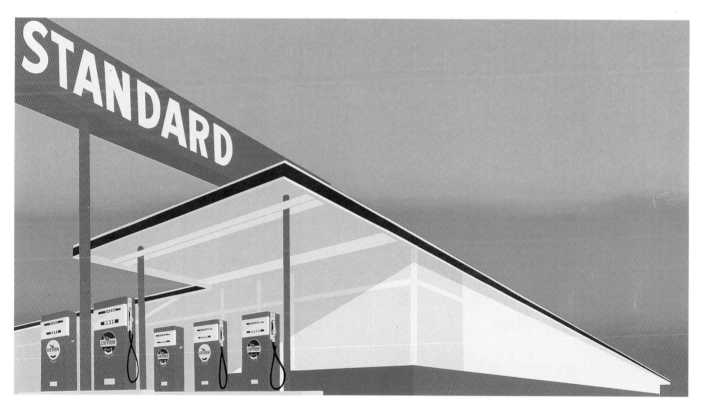

Pl. 31.
Ed Ruscha, *Standard Station*,
1966, eight-color serigraph, art-
ist's proof, 25½ × 40 in.
(64.77 × 101.6 cm). The Mod-
ern Art Museum of Fort Worth,
anonymous gift in memory of
Sam B. Cantey III.

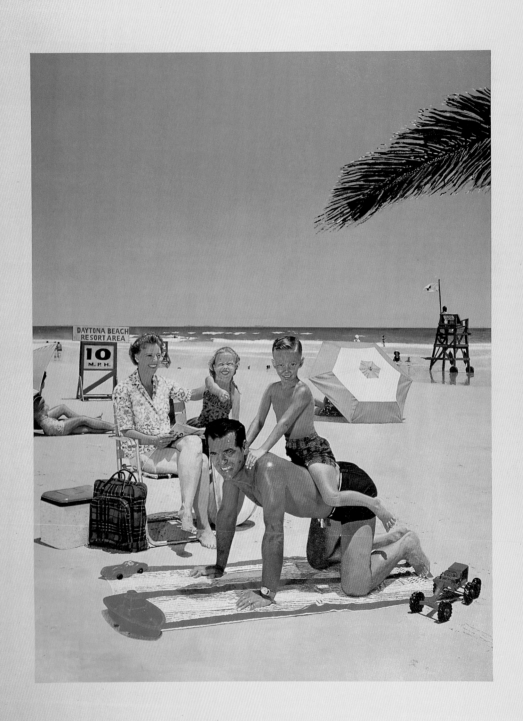

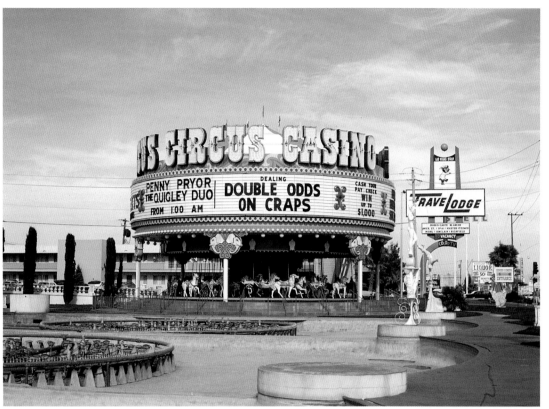

Pl. 32.

Malcolm Morley, *Beach Scene*, 1968, synthetic polymer on canvas, 110 × 90 in. (279.4 × 228.6 cm). Hirshhorn Museum and Sculpture Garden, Smithsonian Institution, Washington.

Pl. 33.

Richard Estes, *Circus, Circus Drive In, ca.* 1971, oil on canvas, 18 × 30 in. (44 × 73.5 cm), Collection of Carroll Janis. Below: Source of Estes's painting, the Circus Drive-In, Las Vegas. Photo by William C. Seitz, 1971.

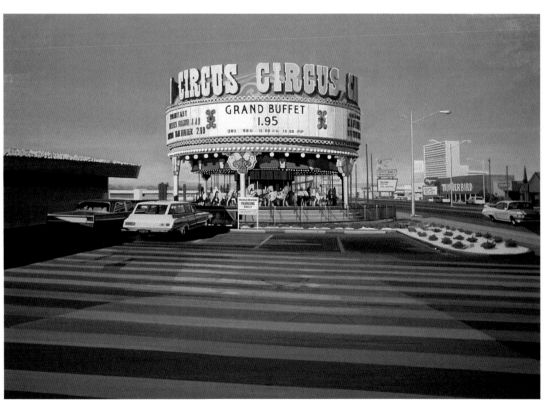

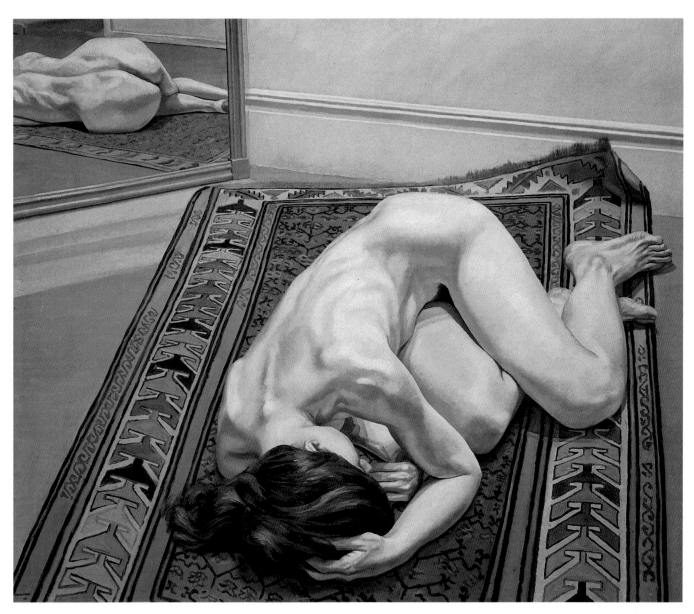

Pl. 34.
Philip Pearlstein, *Female Model on Oriental Rug with Mirror,* 1968, oil on canvas, 60 × 72 in. (152.4 × 182.9 cm). The Whitney Museum of American Art, New York, 50th anniversary gift of Mr. and Mrs. Leonard A. Lauder. Photo by Robert E. Mates.

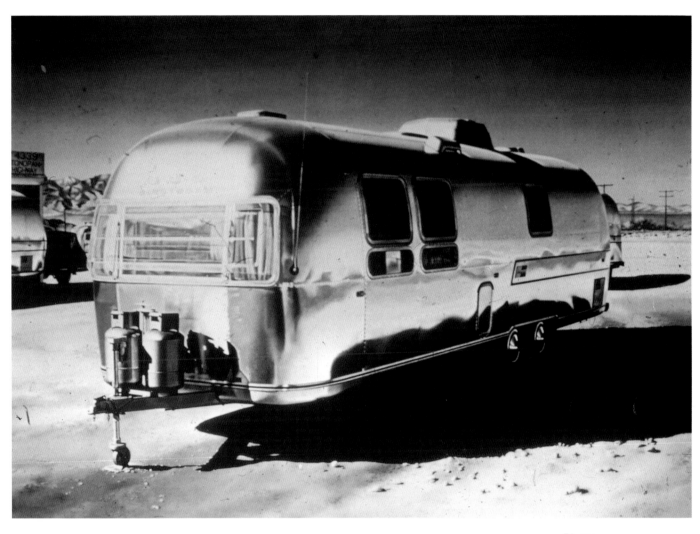

Pl. 35.
Ralph Goings, *Airstream*, 1970,
oil on canvas, 87⅓ × 62 in.
(214 × 152 cm). Neue Galerie-
Sammlung Ludwig, Aachen,
Germany.

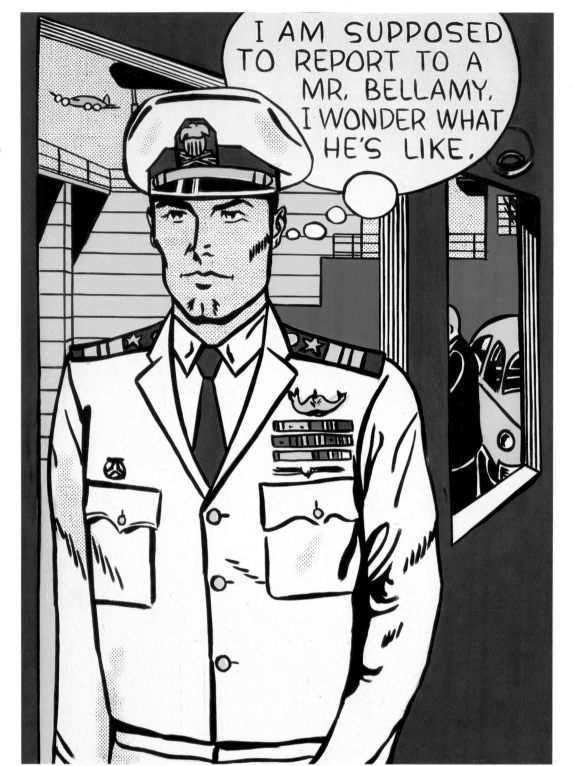

the *system*—a complex of seen and unseen forces in stable relationship—will be the form that relevant art will take. However, in *The Structure of Art,* three years later, he concludes: "The art impulse, as we have seen, is virtually a parody of its former self. And doubtless it is the domination of patriarchal institutions that accounts for the *overall rejection of art as an economic luxury and unnecessary metaphysical baggage*" (Seitz's italics).[8] One of the dangers in the articulation of any artistic vocabulary of postmodernist divination is the projection of an hypothesis the acceptance of which consigns to obsolescence work in progress, or even not begun. Acceptance can debilitate the art of contemporaries just approaching their years of vital production. With a similar closure of mind, formalist theory dismissed Burnham's art of cybernetic organisms, and all kinetic and electric art, as gimmickry. Between such mutually controverting hypotheses lies the common fallacy of the mainstream, which holds that only one notion of what art is, or what art should do, can be valid and viable at one time. Must the artist, or must we, take the word of self-elected prophets who tell us, as does Burnham, that "carving or fabricating objects as sculpture will probably continue until A.D. 2000—but with less importance as an art form,"[9] or is it still worthwhile to participate in the enrichment of the world of meaningful human artifacts. If the art object—of which the kinds of work discussed above are momentous examples—is ultimately to die from within, by the apathy and disenchantment of the artist himself, we can do little to prevent it. But shall it be killed from without, by teleological or eschatological rhetoric? People will need buildings, streets, plazas, and parks in which to work, play, think, and congregate to address their governments. They will also need, in all probability, objects to symbolize their humanness.

99

Felix W. DeWeldon, *Iwo Jima Memorial,* bronze, Washington. Courtesy of U.S. Marine Corps History and Museums Division. Photo by MSgt. R. H. Westmoreland.

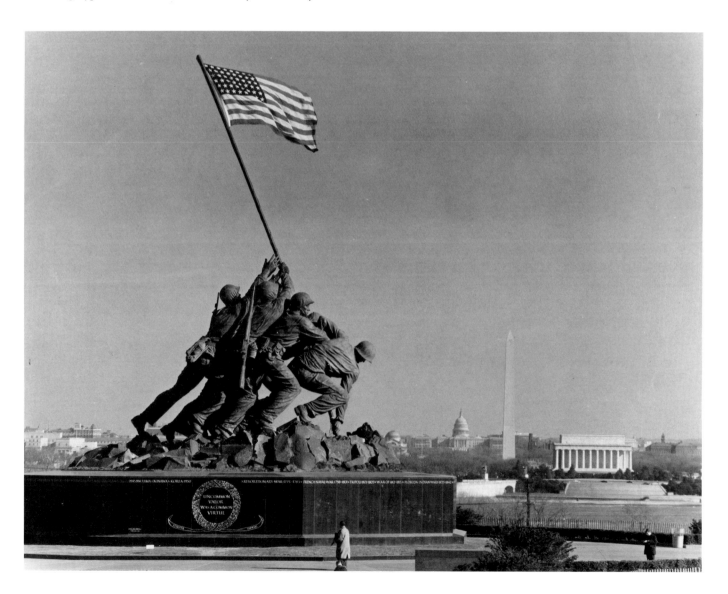

Earthworks

9

Until the beginning of the happening movement, it was commonly accepted even by the most radical modernists that it was the artist's role to fabricate objects in the studio or loft workshop that, each in a somewhat different way, epitomized his or her idea of art and life. Nonobject art events were seen as anti-art or neo-Dada. The entire socioeconomic system of the production, sale, and consumption of art assumed—and for the most part still does—the concept of an international supply of art objects produced from inner necessity and on speculation, of which the majority would be discarded and a few, chosen by a consensus of critics, dealers, curators, and collectors, would finally find a place in the world's museums and private collections. A pivotal moment in the change from avant-garde to post-avant-garde art occurred when radical artists became dissatisfied with their accepted role as self-motivated producers of commodities to be culled by an art establishment that had once rejected, then affectionately and profitably accepted, modernist innovation. By the mid-sixties, in a historical turning point, upper-class patronage began to be rejected by the artist. The business and communications complex, for the first time, surprisingly and willingly adjusted to the most outrageous, even hostile, diversions of their formerly eager suppliers.

Minimal art, and later the conceptual art of ideas, words, and raw data began to paralyze the art combine by attenuating the art object, ultimately to nonexistence. Like happenings, earthworks exerted a subversive impact in the opposite way: by conceiving of projects of such size, and made with such unconventional materials and tools, as to defy presentation in galleries and museums. These were

works uncollectible except in photographs, preparatory drawings, or documents of their fabrication.

Willoughby Sharp, a curator, critic, and editor of the journal *Avalanche,* listed a few of the new materials of art after 1966 as "air, alcohol, asbestos, ashes, bamboo, benzine, candles, chalk, charcoal, down, dust, earth, excelsior, felt, fire, flares, flock, foam, graphite, grease, hair, ice, lead, mercury, mineral oil, moss, rocks, rope, rubber, sand, sawdust, seeds, slate, snow, steel wool, string, tar, twigs, twine, water and wax."[1] Sharp also called attention to some prototypical works, among them Herbert Bayer's outdoor playground *Earth Mound* (1955) in Aspen, Colorado; Walter de Maria's proposal for an "art yard" (1960) using earthmovers in an empty lot; and Heinz Mack's *Sahara Project* (1961)—an "art reservation" that aimed to activate sculpturally a large-scale landmass. Other sources that have been cited include meteor craters, volcanic pits, dams, aqueducts, fortifications, glacial deposits, Stonehenge, and other English prehistoric alterations of terrain, American Indian mounds and sand paintings, large-scale formal gardens, and the appearance of Earth as seen from an airplane. In 1964 the Museum of Modern Art presented an exhibition under the title *Architecture Without Architects,* organized by Bernard Rudolfsky, which was concerned, in part, with the utilization of the natural forms of terrain as a basis for human habitation, an architecture of hollowing out, of adaptation to earth and rock. Earlier, among the imagist group of the New York School of the forties and fifties, in fact, there had been a powerful identification with the large spaces of the West: sand paintings for Pollock, great rock formations for Still, and Indian mounds and the endless tundra of northern Canada for Newman.

An exhibition under the title *Earthworks* took place at the Dwan Gallery in New York in 1968. It included photographs of Michael Heizer's first desert markings and depressions. Robert Morris covered the floor of a gallery with 1,200 pounds of peat moss and industrial grease, and Robert Smithson showed five containers of ore containing 140 minerals. The first museum exhibition, called *Earth Art,* was organized by Willoughby Sharp, and opened at the Andrew Dickson White Museum of Art at Cornell University in February 1969. Twelve artists were invited, including the leaders of the movement—Heizer, Dennis Oppenheim, and Smithson—though Heizer, along with Carl Andre and Walter de Maria, did not participate. Within the museum small works made of rocks, growing grass, coal, earth, asbestos, rock salt from the local Cayuga Rock Salt Company, and other natural materials of earthly origins were shown, but the major exhibits occurred outdoors, in the environs of Ithaca and on frozen Beebe Lake. But museum and gallery exhibitions of earth art, then and later, were in reality tokens of the movement's tendency toward documentation of projects—a genre henceforward seen as a category of Conceptual Art.

Perhaps accelerated by the explosion, in 1969, of concern for an ecological rebalance, the battles against pollution, exhaustion of natural resources, and destruction of the world's ecosystems, earthworks rapidly gained impetus. The movement's major concepts and methods, and its level of serious interaction with nature, are best demonstrated in the projects of its major practitioners: Heizer, Oppenheim, Peter Hutchinson, Smithson, and (although his work began from a totally different position) Christo.

There was about the projects of Michael Heizer high seriousness and a grand drama of the individual human being asserting his presence and will in the vast, desiccated expanses of the desert that make him the classic earth artist. More than any other environment, the dry lakes of California and Nevada direct the mind toward contemplation of *duration:* "time perceived as indivisible," to use Bergson's phrase, unmeasured and unhumanized. Heizer abandoned figurative expressionist painting in 1964 and, after a period of doing shaped abstract canvases, began to work in the desert he knew as a native Californian. These early efforts remain unknown, but from the spring of 1968 on, he made careful photographic records. *Circular Surface Drawing* was an eighty-foot circular drawing on the bed of El Mirage Dry Lake, made by dumping two truckloads of backfill from another work out of a truck being driven in a circular pattern at high speed. Even more geometric in form was the work that brought Heizer to public attention—*Dissipate,* one of a group of his Nevada Depressions. The design was established, in the method used by Duchamp and Jean Arp, by chance: five matchsticks were dropped from two feet on a sheet of paper, taped down, and enlarged to form five lined depressions, each twelve feet long, one foot wide, and one foot deep, and dispersed over an area forty-five feet by fifty feet. Against the vast expanse of the desert, flat like a stretched canvas, the dark negative bars, utterly human in their free-planned geometricity, contrasted starkly with the planar geometry of the site and uttered a poignant assertion of human presence. Yet no monolith, no menhir marked the naked expanse; the gesture was one of removal rather than addition (fig. 100).

In a photograph taken one year after the completion of *Dissipate,* the framings had sprung from the cracked earth, and the geometry was no longer

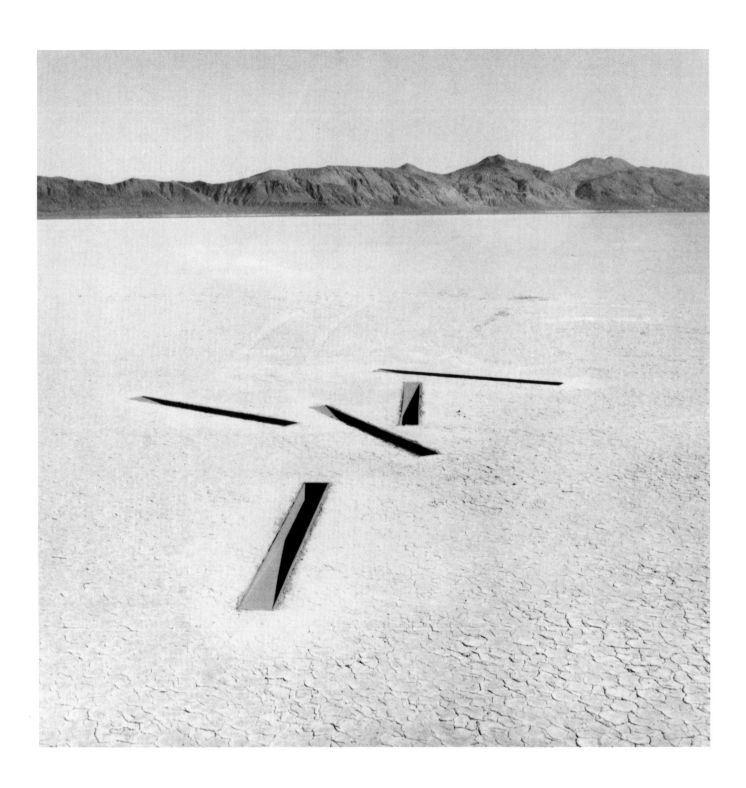

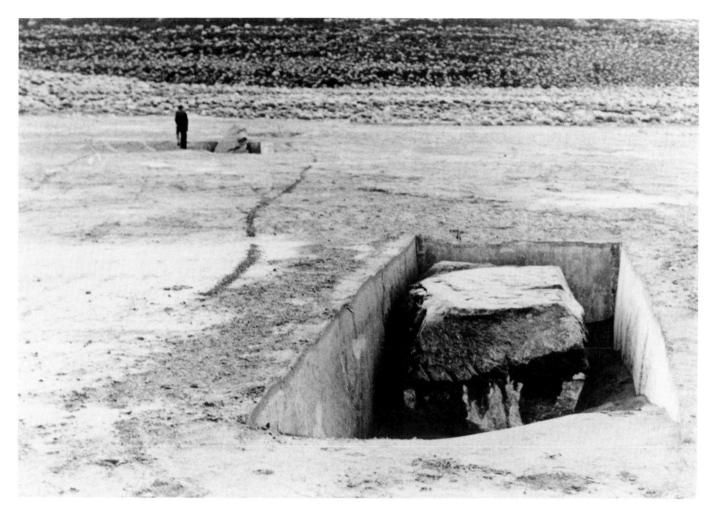

sharp. "Next year," Heizer wrote, "the third and possibly final photo will be taken. It will probably only be the landscape. Climate has extended the process; it is being photographed throughout its disintegration. As the physical deteriorates, the abstract proliferates, exchanging point of view." [2] Implicit in Heizer's concept, it would appear, is the romantic idea of such artists as Hubert Robert, Friedrich, Turner, and Wordsworth, of the transience of human marks on nature. Updated, the realization is restated when Heizer writes: "Man will never create anything really large in relation to the world—only in relation to himself and his size. The most formidable objects that man has touched are the earth and the moon. The greatest scale he understands is the distance between them, and this is nothing compared to what he suspects to exist." [3]

Except for those works of boards, fill, dye, or powder that are dispersed and dissolved by natural forces, all of Heizer's works were excavations forming *negative* spaces—removals, man-made depressions, all but invisible at ground level. *#1/3* and *#2/3,* excavations into a dry lake at Silver Springs,

Nevada, in August 1969, were roughly rectangular, concrete-lined depressions, one twenty-three feet and the other fifty-one feet in length, into which were placed, respectively, a thirty-ton and a fifty-ton granite mass moved from another site (figs. 101 and 102). *#3/3,* on the same site, relocated a sixty-eight-ton granite rock, which had been "thrust 9000 feet upward" by a natural faulting. "In effect," Heizer wrote, "it has been returned to its source, to its original elevation at 4000 feet." [4] *Double Negative,* finished in 1970, relates two parallel cuts from which 24,000 tons of earth were displaced (figs. 103 and 104). These stupendous projects, too, must ultimately fill with blowing dust, their concrete walls erode. They are a contradictory blend of hubris and abnegation.

In their rejection of phallic projection for feminine receptivity, confrontation of volume and mass, and location at deserted sites where only the artist, his patron, and a few professionally involved curators and critics would ever witness the actual works with understanding eyes, these projects have the ring of real and elevated experience. The forms are

100

Michael Heizer, *Dissipate, #8* of Nine Nevada Depressions, deteriorated, 1968, wood in playa surface, 45 × 50 × 1 ft. (13.64 × 15.15 × .3 m). Black Rock Desert, Nevada. Commissioned by Robert Scull. Courtesy of M. Knoedler & Co., Inc., New York.

101

Michael Heizer, *Displaced Replaced Mass, #1/3,* dismantled, 1969, granite and concrete in playa surface, overall: 100 × 800 × 9 ft. 6 in. (30.3 × 242.42 × 2.88 m). *#1/3* mass: 15 × 5½ × 4½ ft. (4.55 × 1.66 × 1.36 m). *#1/3* depression: 23 × 6 × 5 ft. (6.97 × 1.82 × 1.52 m). Courtesy of M. Knoedler & Co., Inc., New York.

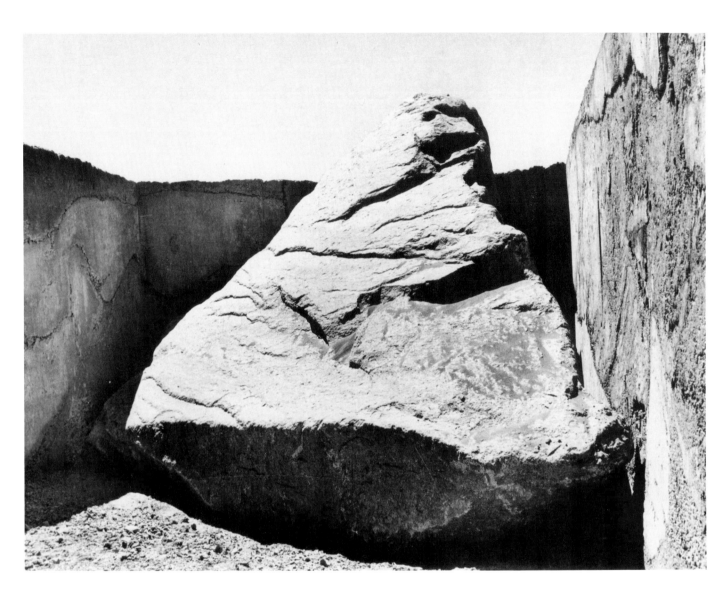

102
Michael Heizer, *Displaced Replaced Mass, #2/3*, dismantled, 1969, granite and concrete in playa surface, overall: 100 × 800 × 9 ft. 6 in. (30.3 × 242.42 × 2.88 m). #2/3 mass: 18 × 15 × 11 × 4 ft. (5.45 × 4.55 × 3.33 × 1.21 m). #2/3 depression: 51 × 16 × 9½ ft. (15.45 × 4.85 × 2.88 m). Courtesy of M. Knoedler & Co., Inc., New York.

often disarmingly unassuming: *Isolated Mass/Circumflex*, at Massacre Dry Lake, Nevada (1968), was a 120-foot linear trench resembling a looped fragment of string dropped on a kitchen floor (fig. 105); *Five Conic Displacements*, at Coyote Dry Lake, Nevada (1969), from which 150 tons of earth were removed, filled with rainwater (figs. 106 and 107). In one airplane view, it was a painting in free brush resembling, appropriately, one of Mathieu's "gestures in the void." Using flatbed trucks, truck-mounted cement mixers, cranes, and huge land-moving equipment instead of pencil or brush, Heizer's projects were in every way works of art, but were entirely beyond manipulation, marketing, sale and resale, though they needed the support of a patron. Nor did he ever try to promote documentation as art. A scheduled exhibition at the Heiner Friedrich Gallery in Munich, included only one drawing. An announcement canceled the indoor exhibition and

called attention to *Munich Depression*, a hundred-foot crater fifteen feet deep, from which a thousand tons of earth had been displaced. It was the artist's hope that the setting would be retained so that shadows of buildings would not fall on it. Within two months, however, it had been filled for the construction of high-rise apartments.

As Clement Greenberg has written, the modernist artist always faced a socioeconomic dilemma: his values were seldom those of society, yet he needed an income to work and survive. "And in the case of the avant-garde this was provided by an elite among the ruling class of that society from which it assumed itself to be cut off, but to which it has always remained attached by an umbilical cord of gold." [5] In the post-avant-garde period, the paradox remained, exacerbated by the artist's deepening dissatisfaction not only with the corporate state, but also with the industry of disseminating art objects for profit. Art-

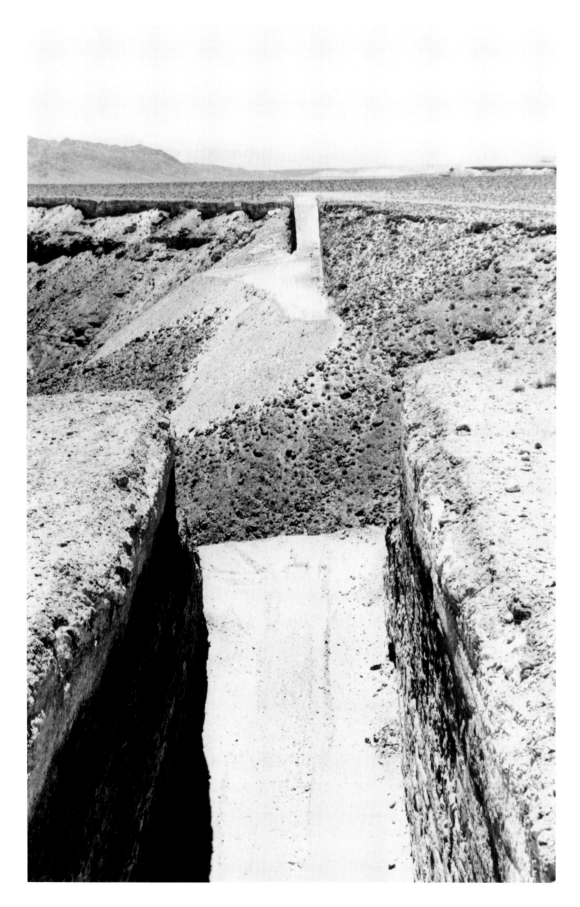

103
Michael Heizer, *Double Negative,* 1969–70, 240,000-ton displacement in rhyolite and sandstone, 1,500 × 50 × 30 ft. (454.55 × 15.2 × 9.09 m). Mormon Mesa, Overton, Nevada. Courtesy of M. Knoedler & Co., Inc., New York.

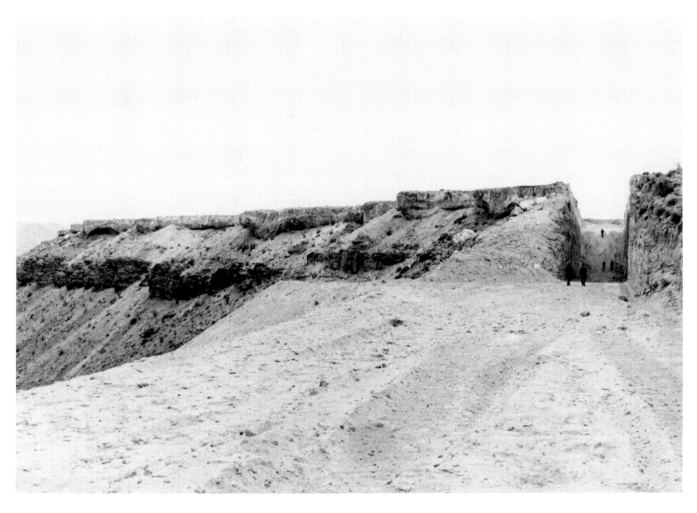

104
Michael Heizer, *Double Negative, detail of southwest cut,* 1969–70, 240,000-ton displacement in rhyolite and sandstone, 1,500 × 50 × 30 ft. (454.55 × 15.2 × 9.09 m). Mormon Mesa, Overton, Nevada. Courtesy of M. Knoedler & Co., Inc., New York.

105
Michael Heizer, *Isolated Mass/ Circumflex,* #9 of Nine Nevada Depressions, deteriorated, 1968, six-ton displacement in playa surface, 120 × 12 × 1 ft. (36.36 × 3.64 × .3 m). Coyote Dry Lake, Mojave Desert, California. Courtesy of M. Knoedler & Co., Inc., New York.

ists like Heizer were devoted to the execution of immensely ambitious and expensive, immovable, yet entirely ephemeral works.

Two galleries were opened during the sixties in New York to find commissions and patrons for earth artists, the Seth Siegelub Gallery and John Gibson Commissions, Inc. Both closed after a trial period, for their "commissions" could not be coordinated with urban complexes or public and corporate needs as could large works of sculpture. Such works as Heizer's were useless and absurd in the finest sense, but they could not have done without the patron who arose from the fragmentation of capitalist values during a period of crisis, the wealthy maverick who was turned on by subsidizing the oddball artist for his own personal, social, and even economic reasons.

A surprising number of the most antitraditional artists of the sixties are products of the intractably modernist art scene of California, among them Larry Bell, Robert Irwin, Bruce Conner, Bruce Nauman, Ron Davis, and both Heizer and Oppenheim. Heizer studied at the San Francisco Art Institute and Oppenheim received a master's degree in painting at

Stanford (where in 1959 Ken Kesey was already experimenting with the effects of LSD) at the California College of Arts and Crafts. Oppenheim's adoption of earth art, after a period of primary structures, occurred about the same time as Heizer's. His projects, executed with disconcerting multiplicity at a wide range of locations, are both more open, conceptual, and imaginative than Heizer's, but less stark, less immediately significative of a confrontation with nature. Yet the scope of his bold, strenuous activities, his execution of ambitious, difficult, and entirely unsalable projects were all firsthand investigations and experience of the earth, its elements, topography, and the incommensurables of time and space (figs. 108–110).

Time Line, for example, was a three-mile pattern of the international dateline (the longest line on Earth) cut into the frozen Saint John River that separates Maine from New Brunswick, Canada (figs. 111 and 112). An early *Snow Ditch Piece* was a measure of Oppenheim's physical involvement with the act of shoveling for a limited period of time. It was the "exact measure of a unique being, working at opti-

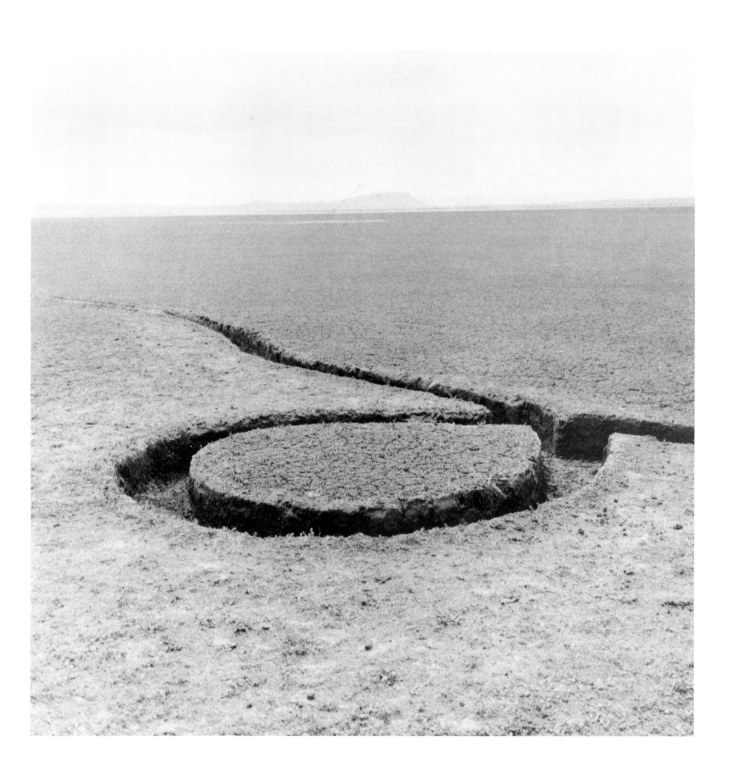

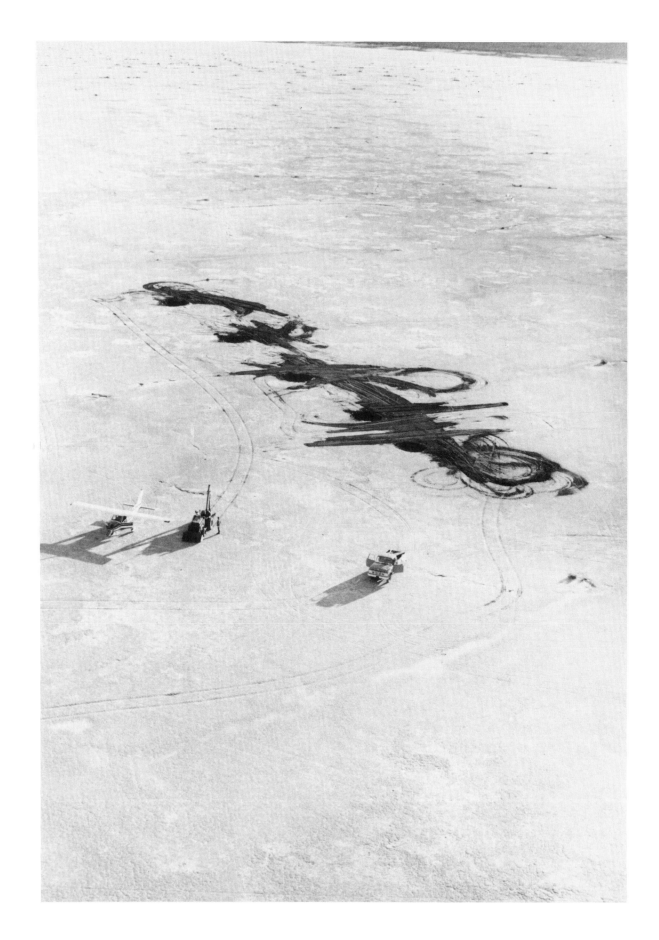

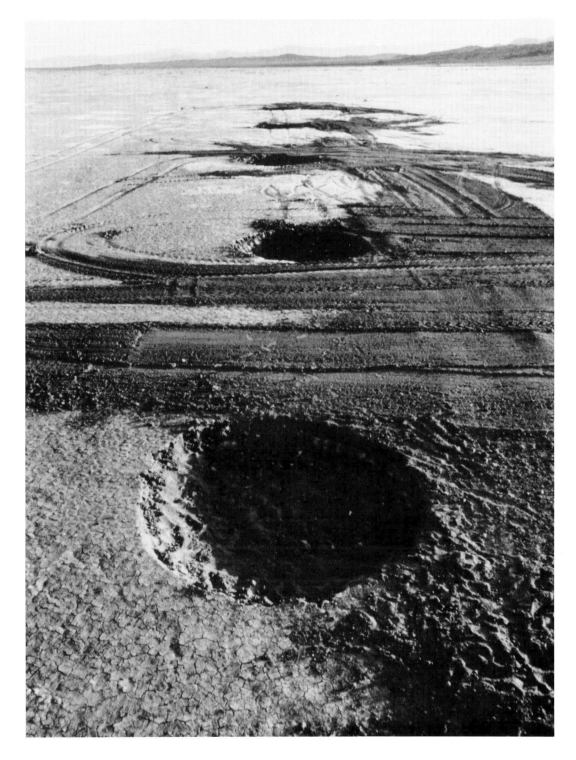

106

Michael Heizer, *Five Conic Displacements,* aerial view, deteriorated, 1969, 150-ton displacement in playa surface, 800 × 15 × 4 ft. 6 in. (242.42 × 4.55 × 1.36 m). Coyote Dry Lake, Mojave Desert, California. Courtesy of M. Knoedler & Co., Inc., New York.

107

Michael Heizer, *Five Conic Displacements,* deteriorated, 1969, 150-ton displacement in playa surface, 800 × 15 × 4 ft. 6 in. (242.42 × 4.55 × 1.36 m). Coyote Dry Lake, Mojave Desert, California. Courtesy of M. Knoedler & Co., Inc., New York.

108

Dennis Oppenheim, *Reverse Processing*, 1970, cement on sand and gravel, end product returned to location of preliminary processing stage, 75 × 250 ft. (247.5 × 825 m). Cement Plant, East River, New York. Courtesy of the artist.

mum level against resisting natural elements and forces for one hour."[6] The result was a ditch in the snow, twenty feet long, four feet wide, four feet deep. "He conceives of the world," an anonymous writer who assisted at some of his ventures observed, "as a matrix of systems and of art as the revelation of the factualness and interrelatedness of those systems. He is not making sculpture; instead he seeks to *make contact* with some fact of life and document that experience of contact."[7] *Annual Rings*, like *Time Line*, was also executed on the frozen Saint John River at Fort Kent, Maine. Huge rings were cut in the snow and ice by plowing, chopping, and sawing within an area of 100 by 150 feet.

The enlargement of scale implicit in the metaphor of the growth of a tree is further expanded in Oppenheim's use of maps in his planning and documentation, not merely as charts, but as visual stimuli to

contemplation of the hierarchy of sizes, from microcosm to macrocosm, that make up the world and the universe. Oppenheim also utilized maps in a proposal of 1968 to alter the time zones across the United States according to the flight patterns of migratory birds.

Three projects undertaken in Whitewater, Wisconsin, in 1970 well typify Oppenheim's art. The first, a "vertical penetration," was called *The Gravel Slide*. After climbing the slanted wall of an abandoned gravel pit, holding his body still in a fully extended position, he slid from the top to the bottom of a thirty-five-foot incline, careful to get good photographs of the event. The second (after a "penetration" of water—a dive into a swimming pool by the artist) was the photographing of the exact location of swimmers as they finished a race. Their relative positions were then transferred to the seating pattern

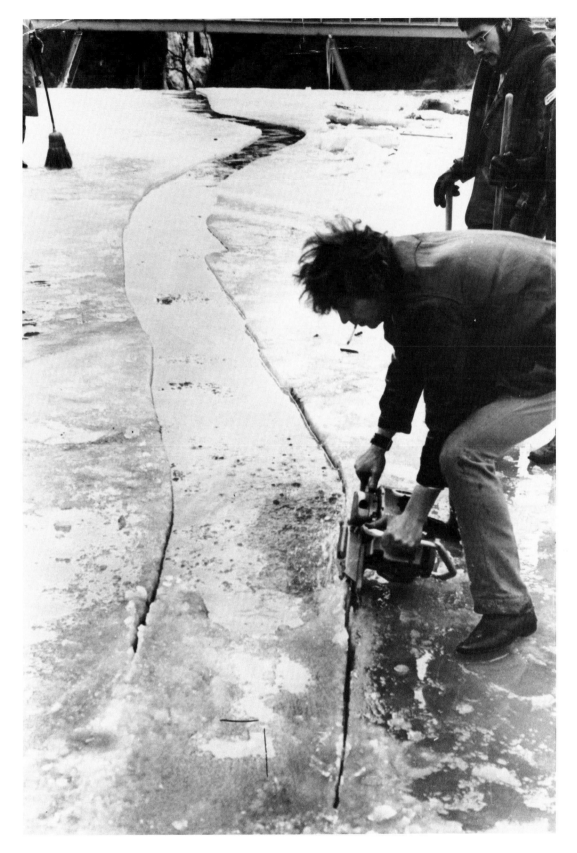

109
Dennis Oppenheim, *Beebe Lake Ice Cut,* 1968, exhibited in *Earth Art,* Andrew Dickson White Museum of Art, Cornell University, Ithaca, New York, 1969. Photo by Richard Clark.

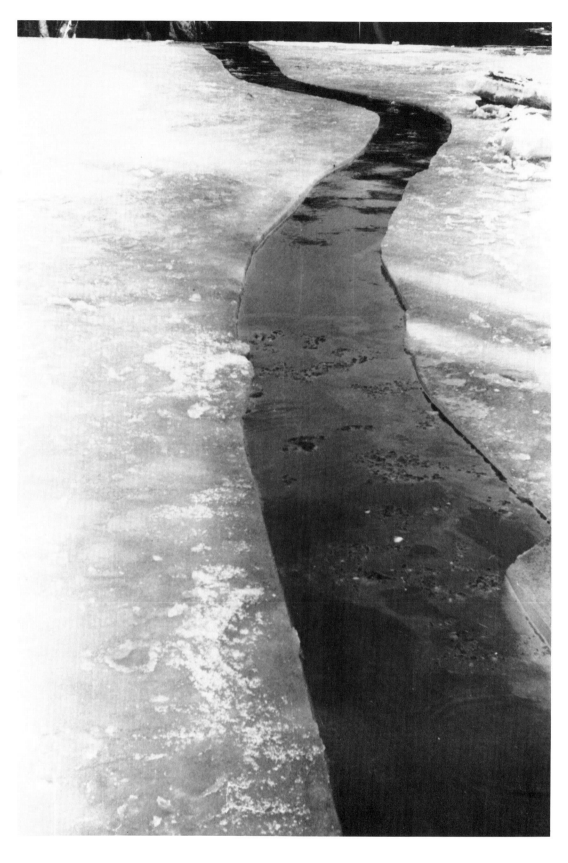

110

Dennis Oppenheim, *Beebe Lake Ice Cut,* 1968, exhibited in *Earth Art,* Andrew Dickson White Museum of Art, Cornell University, Ithaca, New York, 1969. Photo by Richard Clark.

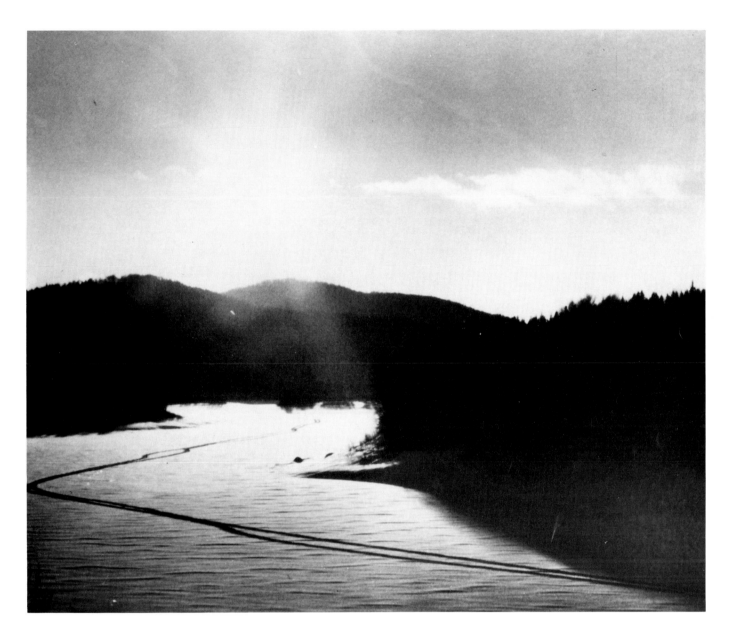

of a New York theater. The third piece, *Maze* (fig. 113), required the cooperation of a local farmer. With the assistance of art students, the pattern of a laboratory maze (like those used to experiment with rats) was imposed on an alfalfa field, using blocks of baled hay as walls. At the end of the maze, corn was strewn, and cattle were stampeded through the maze toward the food. The artist's description: "Concern is given here to the law of moving bodies through an imposed structure, and the transference of material from an external area (food deposits) to the digestive tracts of animals. The site was selected for this particular surface characteristic (similar to the spotted hides of the cattle)."[8]

By 1970 the term "ecological" had been applied to attempts to conform thinking and actions to nat-

ural processes and systems. "Ecological art," Heizer stated, "began as soon as the sculptor quit thinking about steel, metal and welding and synthetic stuff and began doing something in the ground."[9]

In the documentation by which they were recorded, Oppenheim's projects border on Conceptualism; in his active insertion of body activity and observation into his schemes, he was looking ahead to the somewhat later movement known as body art. A *Time* writer in 1970 accompanied him to an area of deserted warehouses below the Brooklyn Bridge, where Oppenheim had built two walls of cinder block on an old concrete dock. Against the background of the Brooklyn and Williamsburg bridges, he then stretched his body between the two walls, mimicking the lines, and personally re-creating the

111
Dennis Oppenheim, *Time Line*, 1968, one-foot-by-three-feet-by-three-mile cut between the United States and Canada at St. John River, Fort Kent, Maine. Photo courtesy of the artist.

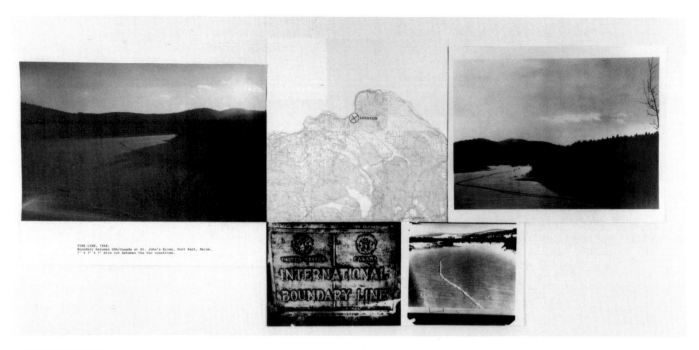

TIME LINE, 1968.
Boundary between USA/Canada at St. John's River, Fort Kent, Maine.
1" x 2" x 1" mile cut between the two countries.

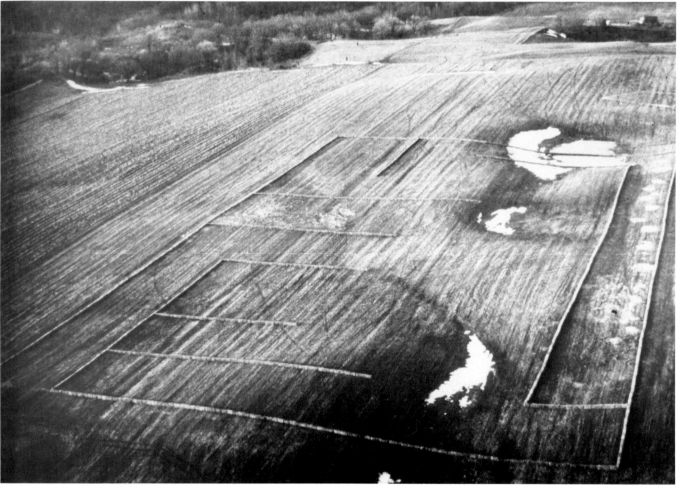

kinds of stress of the two suspension bridges, moving the walls apart by degrees until he experienced the greatest possible stress.

Other urban projects had a more political thrust. For the 1968 Sculpture Annual at the Whitney Museum Oppenheim submitted a pretty piece that looked rather like a hooked rug, called *Decomposition*. The concentric pattern, however, was composed of the raw elements from which the museum had been made, crumbled into oval rings on the floor. *Removal (Transplant) New York Stock Exchange* of 1969 was, simply, the transfer of one day's paper refuse from the Exchange to a rooftop on Park Avenue.

In the fall of 1969 Oppenheim and Peter Hutchinson traveled together to Tobago in the West Indies. Oppenheim applied the pattern of U.S. Highway 20, observed from maps, to the water of the bay. He used a powerboat to trace the pattern, pouring gasoline, which he set afire, and magenta dye in the bay, causing the beach to be washed with purplish waves for hours afterward. Peter Hutchinson strung calabashes on a long rope, extending them underwater in the bay. Their combined documentation resulted in an exhibition of beautiful color photographs at the Museum of Modern Art.

Hutchinson is English, the son of a farmer. During the fifties he studied at the University of Illinois, hoping to become a plant geneticist. After turning to art, and painting shaped canvases, he went back to his earlier obsession in the art of growing plants, yeasts, mosses, ferns, and crystals. His best-known project was conducted on Parícutin Volcano in Mexico. After reconnoitering the isolated site in a six-hour climb on horseback, he returned with a mule train carrying five hundred loaves of bread, which he crumbled on the hot ground surrounding the crater and covered with plastic to create a "greenhouse environment." When he returned six days later, the bread had sprouted in multicolored molds. Hutchinson was more concerned with ecological processes than Oppenheim, finding analogies between the formation of bacteria, molds, and algae and the earliest phases of life on Earth. What he felt he had achieved at Parícutin, according to a *Time* writer, was to "juxtapose a micro-organism against a macrocosmic landscape, to bring life to an environment that had been virtually sterile, in order to show that the old distinctions between living and dead matter are ambiguous, if not false." [10] There is, in this involvement with exotic growth and remote, uninhabited places, something that recalls the obsession of the nineteenth-century painter Frederick Edwin Church, the only student of Thomas Cole, who traveled to such inaccessible places as Labrador in the 1850s in search of out-of-the-way subjects. "He climbed to unbelievable heights in the Andes," C. W. Sears wrote, "in order to perpetuate upon his canvas the wonders of the scenes he came upon. He stumbled through the tropical jungles for miles in search of points he was looking for that would reveal the almost terrible and beautiful wealth of vegetation that spread on all sides, so dense that man could easily be absorbed into it and never return." [11] Perhaps, in a period in which exotic landscape painting was rare if not defunct, Hutchinson's ecological art can be seen as a continuation of the extravagant nature romanticism of earlier American artists.

Were it not for two gigantic projects concerned with the Earth—one, *Wrapped Coast One Million Sq. Feet,* executed at Little Bay, New South Wales, Australia, in 1969, and *The Valley Curtain,* executed at Rifle Gap, Colorado, during 1971 and 1972—Christo's work would not properly belong in this chapter, and even the thrust and context of these works contrast sharply with the ideas of other earthworks artists. Christo Javacheff, like Marisol Escobar and César Baldaccini, is commonly known by his first name. He arrived in Paris in 1958 from Sofia, Prague, and Vienna, after studying fine arts and the theater. A work of that year consisted of a group of red cans and bottles—of which two contained powdered pigment and seven of thirteen were wrapped with a brown, coated material and tied securely with cord, so that it was impossible to ascertain the specific character of the containers therein. Save for the wrappings, the group would have resembled a motif for the Italian painter of bottles, Giorgio Morandi. It could be described as a work of assemblage, as could most of Christo's similar works—small, mysterious packages, wrapped pieces of furniture with unidentifiable objects stacked on them, a bicycle packaged in plastic, a motorcycle also in plastic, and even, in 1968, a "packed" Volkswagen. William Rubin has noted the first expressively wrapped object of modern art by the Dadaist painter and object maker, Man Ray, who wrapped a sewing machine and an umbrella (the biochemical sexual symbol proposed by the Surrealists' precursor Isador Ducasse, "The Count of Lautreamont"). Entirely without the sexual reference of Ducasse or Man Ray, Christo's *empaquetages* retained an element of the mystery cherished by the Surrealists.

Package on Wheelbarrow (1963), in the Museum of Modern Art, well represents the enigmatic, and in this instance disturbing, aura of Christo's smaller assemblages. The materials are all in a range of worn grays, and the oddly shaped package on the barrow, too uniform to contain a body but nevertheless suggesting one, is lashed securely to the beat-up, foreign-appearing wheelbarrow. It is an object with

112
Dennis Oppenheim, *Time Line*, 1969, photodocumentation, four panels, total length 9½ ft. Photo courtesy of the artist.

113
Dennis Oppenheim, *Maze*, 1970, hay straw, corn, cattle, 500 × 1,000 ft. (1,980 × 3,330 m). Whitewater, Wisconsin. Courtesy of the artist.

a foreboding presence. Packaging was Christo's method and subject, but the associations his objects elicit are far from the common Pop references to the slick plastic, metal, and gaudy colors of the supermarket or the merchandise mart. His wrapping of a nude girl specifically elicited the aura of mummification that marks many of the *empaquetages.* As Lawrence Alloway has noted, the wrappings, bringing the spaces of the often unidentifiable objects within, establish an independent unity—a formal entity opposed to the separate, differently formed contents.[12] None of these objects relate in any way with the earthworks movement to come, even the full-size storefronts with masked windows made between 1964 and 1968. Earlier, but closer if only in size and outdoor setting to earth art, was the complete blockage of the ancient, narrow Rue Visconti in Paris by an "iron curtain"—a wall of empty oil drums, and a group of temporary oil drum sculptures in Centilly, France, and Cologne.

Year by year, the packaged objects increased exponentially in size: trees, public buildings, some in collages of photographs but others in situ. One project, unfulfilled because of fire regulations but exhibited as a three-dimensional photomontage in the building itself, was *The Museum of Modern Art Packed* (1968). This new genre was fully implemented in packages containing the Kunsthalle in Berne, a huge fountain in Spoleto, and the Gallery of Modern Art in Chicago, to mention the most ambitious instances. These were projects that marked the cityscape, by nullification of its features, as earthworks did the open terrain.

In 1969, with support from the Australian Scholarship Fund and assistance from Jan van der Marck, director of the Museum of Contemporary Art, Chicago, Christo's manager, John Kaldor, and the landowners, more than a half mile of rocky coast near Sydney was made available. The documentation of this project, published as a book by the sponsors in 1969,[13] accumulates exhaustive photographic coverage; the correspondence with government offices, technicians, and vendors; and records of technical data, material, and negotiations (among the items, thirty-five miles of polypropylene rope and thousands of yards of plastic, along with hardware, tools, and a labor crew). This seemingly outlandish scheme that might have been found on a scrap of paper in Duchamp's Green Box was made a reality. Impermanent, like other earthworks (it soon tore into shreds), the wrapped coast surely belongs properly to that genre, indeed by far the largest such work to date. The picturesque but forbidding promontory became for a time an enshrouded ghost of its natural ruggedness.

The Valley Curtain on which Christo labored from the summer of 1970, when he first surveyed the proposed site at a gap in the Rocky Mountains near Rifle, Colorado, some two hundred miles west of Denver, has been described by Jan van der Marck, Christo's project manager, as "the most ambitious work yet undertaken in contemporary art."[14] In several ways—aesthetic, technical, economic, and social—this apparently senseless conceit became a major event. The Valley Curtain Corporation was financed and supported by an international combine of cosponsors, museums, galleries, and private patrons, mostly European, "by buying an agreed upon number of works from the artist at an advantageous price."[15] Christo's daring proposal was to hang a 250,000-square-foot, translucent curtain across a notch near the Great Divide. The two-hundred-ton concrete-and-steel top anchors were to be 1,250 feet apart. An arched opening, thirty-seven feet high and sixty-five feet wide, was to provide access to traffic along Highway 325.

In the May–June 1972 issue of *Art in America,* Jan van der Marck graphically described the fabrication of the immense, diaphanous curtain, the disastrous miscalculations of the designing engineers, and the anguishing months during the summer and fall of 1971, climaxed by the accidental unfurlment and destruction of the curtain in October. For a brief period before the wind rent the "international orange" curtain on the rocks and hardware, it hung in dazzling beauty before the blue Colorado sky. Neither Christo and his friends nor the crew at Rifle Gap were deterred, and after weaving a new curtain during the winter of 1972–73, the team made another attempt, this time successful, during the summer of 1973. The curtain was unfurled properly on August 10. Completed at a cost of some $700,000, far more than the original estimate of $200,000, and scheduled for removal by September 30, it was shredded by the wind on August 11 and removed. "That the curtain no longer exists," Christo commented, "only makes it more interesting."[16]

Yet Christo's obsession was not just with impermanent achievement, with the aesthetics of the process, and the "dealing with hundreds of people." Earlier in 1968 he had said: "I want to present something that we never saw before. Something that is not an image, but a real thing—like the pyramids in Egypt or the Great Wall of China."[17] *The Valley Curtain* was exceptional in bridging the gap between the lay public—the citizenry and officialdom of Colorado and, though less surprisingly, the big guns of the media—and elitist modernism. At the 1971 Garfield County Fair parade, held in Rifle Gap on Labor Day, a float representing the curtain was the

grand feature, recalling the street parade in 1311, in which Duccio's *Virgin in Majesty* was carried to the cathedral through the streets of Siena "to the sound of all the bells of the city, and the music of trumpets and bagpipes." [18]

The curtain form, it appears, is related to Christo's childhood experiences of the Russian invasion of his country, Bulgaria—as the oil drum "iron curtain" in Paris emphasizes—and to his early theatrical study in Prague. A joyful and beautiful expression of massive chutzpah, *The Valley Curtain* was different in spirit from Heizer's inverse, negative markings of Nevada dry lakes and from the alleged egolessness of most earthworkers. Even more impermanent than it was intended to be, it was nevertheless a work of art almost in the traditional sense, surely the most ambitious collaboration between art and technology of the sixties.

Except for one impressive and photogenic work of 1970—*Spiral Jetty*, in Great Salt Lake, Utah—Robert Smithson could not be regarded as a maker of earthworks like those of Heizer or Oppenheim, nor did he propose or execute ambitious additions to topography, as did Christo. In the *Primary Structures* exhibition in 1966 he was represented by *Cryosphere*—six identical modules, each composed of six painted metal rectangular volumes with mirror-chrome ends, arranged in a radial pattern that formed an inner and outer hexagonal against a supporting panel. Its utterly literal and systemic character, which in itself demonstrated the maker's disinterest in sculptural form, was emphasized by his statement for the catalog: an exhaustive descriptive list of the elements and the materials of the work, and how it was assembled, including a detailed chemical analysis of the pigment Surf Green No. 2002, made by Krylon Inc., with which the modules were painted. A rambling article, "Entropy and the New Monuments," [19] which appeared in the June 1966 issue of *Artforum*, gave additional evidence that his interest lay in a study of abstract systems rather than in minimal sculpture.

The endlessly nuanced qualifications and expanding context that Smithson's writing gives to his exhibited objects and field activities defy epitomization, but the nature of the events and exhibits themselves, and his description of their intent, are consistent. They transpired in a dialectic of "site" and "nonsite." The site (or sites) was a location selected by the artist for study. Rocks or other material from the site were then transported to the gallery and placed within bins designed by the artist and exhibited, along with maps, cross-sectional drawings, or other diagrammatic material describing the chosen topography (figs. 114 and 115). Smithson's

dialectic of site and nonsite, as he wrote in 1969, [20] conceptually juxtaposed the "open limits" of the gallery (site) to "closed limits" (nonsite); "a series of points" (site) to "an array of matter" (nonsite); "outer coordinates"(site) to "inner coordinates" (nonsite); "subtraction" (of material from the sites) to "addition" (of material in the gallery); "scattered information (site) to "contained information" (nonsite); "edge" (in Smithson's vocabulary also "periphery") to "center" (nonsite); "some place (physical)" (site) to "no place (abstract)" (nonsite); "many" (site) to "one" (nonsite). Two additional pairs of oppositions demand fuller explanation. The first, "indeterminate certainty" versus "determinate certainty" counters the incommensurability and apparent disorder of the world with the quite arbitrary order of the gallery exhibit and, by implication, the attempt of the mind to order the cosmos by invented systems. At least one group of objects that provided material evidence of the site and its control—*Six Steps on a Section* shown at the Dwan Gallery in 1969—had a certain science-museum decorativeness. It was an assemblage of six metal bins containing various rocks from six points in New Jersey, each bin half covered by a sky-colored sheet inscribed with the contour of the site, along with diagrams and color photographs from the site. Although the bins were furniture rather than sculpture, their neat presentation, the variety of materials, and the apparently careful preparation were not unattractive.

Smithson was impressed, it appears, with Walter de Maria's *Mile Long Chalk Drawing* (1968): two parallel lines, twelve feet apart, drawn on the surface of the Mojave Desert in California (fig. 116). In photographs of the work, two straight lines, like widely spaced railroad tracks, converge almost to a vanishing point before they are cut off by the horizon. (See also fig. 117.) The "system" Smithson imposed on many of the sites consists of a pair of lines similarly receding toward a point, their apex truncated. The corresponding nonsite was a converging bin constructed to hold rocks or other material. In some instances cross-cuts divided the convergence into five bins, conforming, quite arbitrarily, to divisions drawn on a photograph of the site. Intentionally, it would appear, this "recession" of the bins undermined any vestigial sculptural entity. In other cases the rocks or minerals were enclosed in rectangular bins of successively smaller sites, to the same effect. Aside from the innate attractiveness of natural materials placed in a gallery setting, these exhibitions were devoid of aesthetic quality. The perspectival form seemed to explicitly deny to the objects the relational gestalt that is the sine qua non of the art object.

114
Robert Smithson, *Non-site (Pali-sades-Edgewater, New Jersey). Map and Description (site),* 1968, sculpture: painted aluminum, enamel, stone, 56 × 26 × 36 in. (142.24 × 66.04 × 91.44 cm). Map and description: ink on paper, 7⅜ × 9¾ in. (18.73 × 24.77 cm). The Whitney Museum of American Art, New York, purchased with funds from the Howard and Jean Lipman Foundation, Inc. Photo by Geoffrey Clements.

115
Robert Smithson, *Non-site—Line of Wreckage,* 1968, purple painted steel, broken cement, 59 × 69 × 12 in. (149.86 × 175.26 × 30.48 cm). Estate of Robert Smithson. Courtesy of John Weber Gallery, New York.

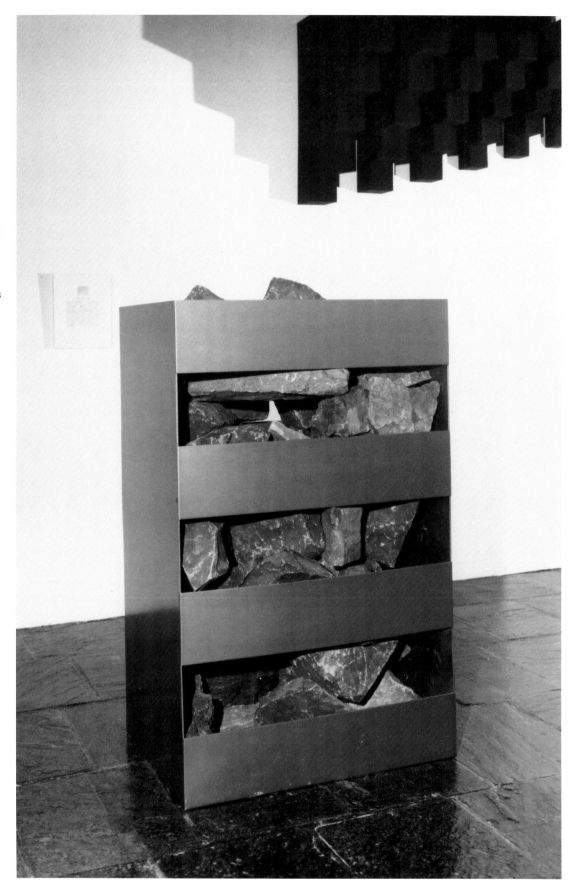

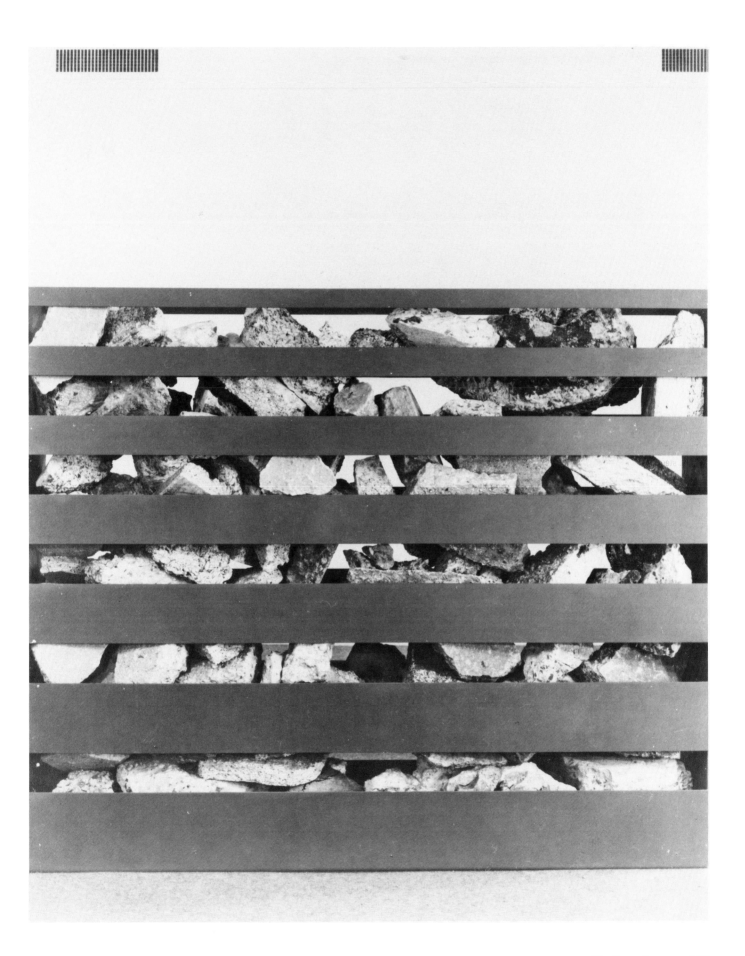

Smithson's presentation in the Cornell *Earth Art* exhibition consisted of piles of rock salt from the Cayuga Rock Salt Company mines that were simply unloaded on the floor of the museum (figs. 118 and 119): "More than a ton of material was . . . transported to the gallery and exhibited in the variously shaped piles with mirrors to be the interior section of the piece ('nonsite'). On the walls were displayed geological maps of the area; photographs of mirrors in the mine ('site'); and photographs of mirrors along the route from the mine to the Museum ('mirror trail')."[21] The use of mirrors related to the second, heretofore unmentioned item in Smithson's "dialectic": "reflection" (site) versus "mirror" (nonsite).

To Smithson the nonsite appears to have been an abstract mirroring of the real world—essentially metaphoric rather than optical. Twelve mirrors provided the pretext for a trip through Mexico, docu-

mented in an article in *Artforum* in 1969 entitled "Incidents of Mirror Travel in the Yucatan."[22] At each of nine sites Smithson left his rented car, juxtaposed the twelve mirrors in the earth, sand, or vegetation, and took colored photographs (figs. 120 and 121). After returning he wrote that the "mirrors are somewhere in New York. The reflected light (the site?) has been erased. Remembrances are but numbers on a map, vacant memories constellating the intangible terrain in deleted vicinities."[23] Accompanying these vacuous snapshots, however, was Smithson's detailed account of his trip, an archaeological traveler's account rich with observations concerning the country, his experiences as he drove, and with Mayan and Aztec history. In any other period such an account, good or bad, would be regarded as literature, not plastic art. We read and reread *The Journal of Eugène Delacroix,* partly as literature and commen-

117

Walter de Maria, *Las Vegas Piece,* 1969, 8 ft. wide × 4 mi. long directional cut, north, south, east, west. Tuli Desert, Nevada. Collection of the artist.

tary on his view of his time, but primarily because, by the works he achieved in his primary medium, he is regarded as a great artist. The same cannot be said of the artist now under consideration.

Smithson seemed plainly to believe that art, moving toward the dissolution of the obsolescent object, should be a mode of philosophical investigation. Perhaps for this reason, his writing is of infinitely greater interest than his leaden exhibition furniture—the "centers" around which his "peripheral" commentaries, published in *Artforum, Art International,* and other journals, proliferated. His centrifugal speculations concerning form and nonform, and the mind and its futile systematizing (or mirroring) of history and prehistory, are studded with an astonishing diversity of allegedly supportive quotations drawn from writers in many technical fields as well as from artists, novelists, critics, and art historians. Together they constitute a form of self-consciously arcane daydreaming that, though it usually tends also to undercut works and ideas or pronouncements of his peers, is often poetically attractive and stimulating to reasonably sympathetic readers. Such meandering commentary, to use Smithson's metaphor, is like an avalanche of the mind, or, as he wrote of footnotes, in a footnote: "a dizzying maze, full of tenuous paths and innumerable riddles." [24] Nothing is more potentially apocalyptic, more dangerous, or more creative (in the most broadly constructive/destructive and/or reconstitutive sense of that broad word) than the free, unhampered play of

questioning thought. It is possible that one paragraph, one line, even one word, from the jumble of intuitive speculation of late sixties art writing was a spark that would take flame, that could in truth demolish what has been known as art in favor of a mode of activity as yet barely envisioned. More likely these writings, like the works that occasioned them, will simply sink into oblivion until, perhaps, some candidate for a doctoral degree extricates them from the mountains of rhetoric the sixties produced. Most of the countless "problems" they raised will not be solved, but merely forgotten.

Many of the ramifications of so-called earth art or earthworks cannot be suggested by the above attention to its best-known practitioners. Like most movements of the sixties, it evolved in a period of protean flux and symbiosis in which vestiges of dissimilar movements became intermixed. In part—to follow Smithson's comments on the ineffectuality of the human mind and the words it invents to express the nature of reality—the impossibility of epitomization is the outcome of all attempts to find order in avalanches of disorder. The vocables we are forced to use, like the disjunct collage of fluorescent-lighted words that appeared in the process art of Bruce Nauman, Mario Merz, and others are themselves part of the accumulated, often formless heap of materials and events of the sixties.

Among other temporary, partial, and quasi-earth artists, Robert Morris must be again mentioned. In his commando raids on one sector or another of the

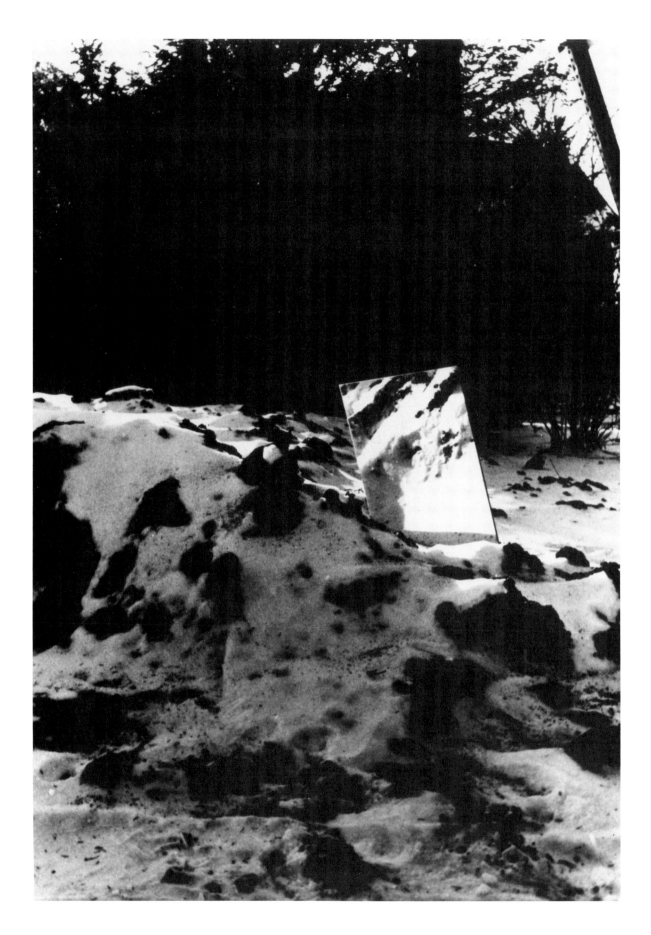

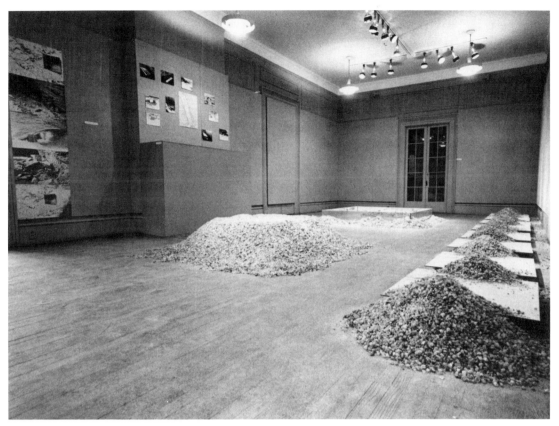

118

Robert Smithson, *Mirror Displacement,* "mirror trail" between Cayuga Salt Mine and the Andrew Dickson White Museum, 1969. Exhibited in *Earth Art,* Andrew Dickson White Museum, Cornell University, Ithaca, New York, 1969. Photo by William C. Lipke.

119

Robert Smithson, *Mirror Displacement,* gallery installation, 1969, *Earth Art,* Andrew Dickson White Museum, Cornell University, Ithaca, New York. Photo by Bernard Gotfryd.

modernist and post-modernist front, he proposed, executed, or performed in various events that trespassed on the precincts of the earth artists. He had been an early practitioner of Minimalism and invaded the theater, dance, the happening scene, environments, technological art, soft abstraction, scatter pieces, anti-form, and Conceptual Art. For the Cornell *Earth Art* exhibition, "unable to reach Ithaca because of a blizzard in New York City," he telephoned the museum and "designated the sizes of piles of earth, anthracite, and asbestos and where in the gallery they were to be dumped. The work was carried out by Museum staff and students."[25] (See fig. 122.) His early pieces that melded Duchamp and Johns in about equal parts (perhaps his "best" if such a judgment has any validity in this context) reveal his individual penchant: Morris was a history-conscious idea man, an eclectic and prescient conceptualist. At worst his zigzag movements mark him as one who knew that he might lose the spotlight if he lingered too long on one premise, a neo-avant-garde opportunist; at best (with consideration of his writings as well as his products and activities) he can be said to have seen the function of the artist as an intellectual innovator, at the cutting edge of history, for whom any single style or position was irrelevant. His speculative and neologistic thrust, in-

volving continual change, was art as process.

Among the others, in various countries, who moved in and out of the earthworks circle were the wonderfully fey Irish eccentric abstractionist Barry Flannagan, some of whose projects were carried out in natural surroundings; Jan Dibbets (Holland), who altered his chosen sites before reverting to documentation of untouched landscape; Hans Haacke (Germany), who touched almost as many bases as Morris (fig. 123); Walter de Maria, who, beside his parallel desert lines, filled three rooms in a Munich gallery with three feet of—the word is carefully chosen—"dirt"; Richard Long (England), who marked the stops on his walking tours before photographing them; the American Lawrence Wiener, who made a few inconsequential marks on various terrains as well as in interior spaces; and Giuseppe Penone (Italy), who inhibited and deformed the growth of trees. To label this movement as ecological art is misleading, for none of these artists betrays even a fragment of the deep concern for the environment demonstrated by incensed college students at almost the same point in time as the proliferation of earthworks. The earth artists were into their own thing, which had little or nothing to do with preserving the world's ecological balance. Nonetheless, the contiguity of these two occurrences is at least worth this mention.

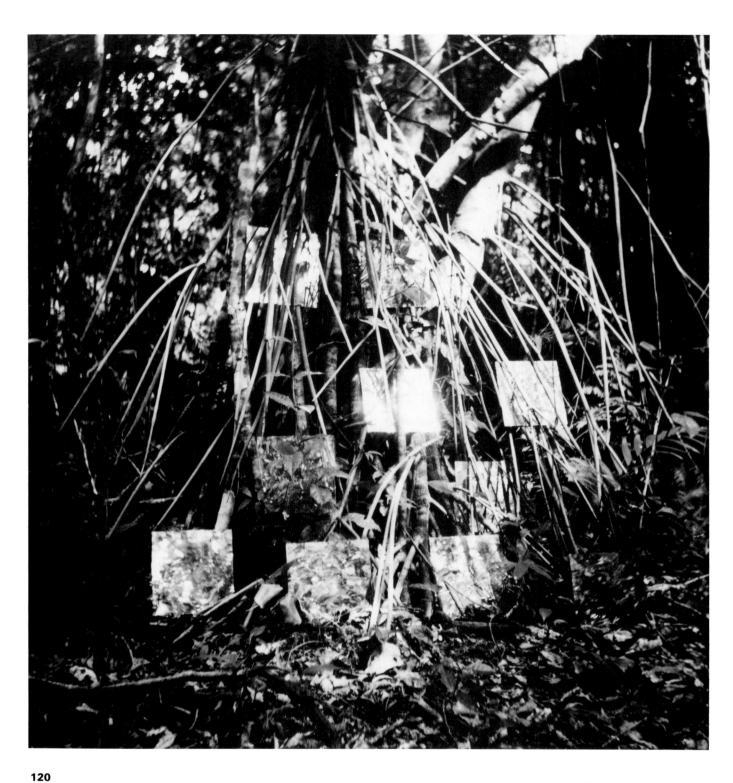

120
Robert Smithson, *7th Mirror Displacement*, 1969, Yucatán, Mexico. Estate of Robert Smithson. Courtesy of John Weber Gallery, New York.

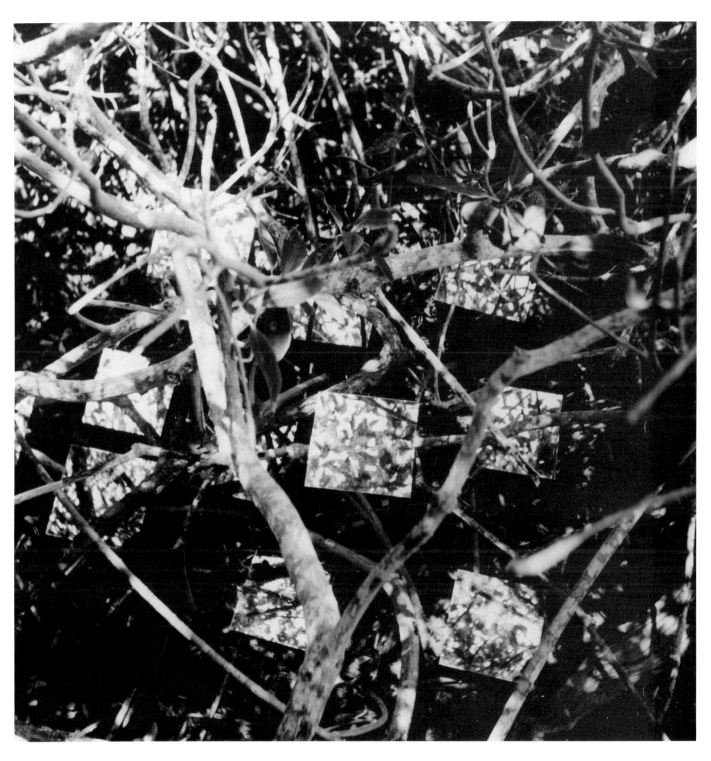

121
Robert Smithson, *9th Mirror Dis-placement*, 1969, Yucatán, Mex-ico. Estate of Robert Smithson.
Courtesy of John Weber Gallery,
New York.

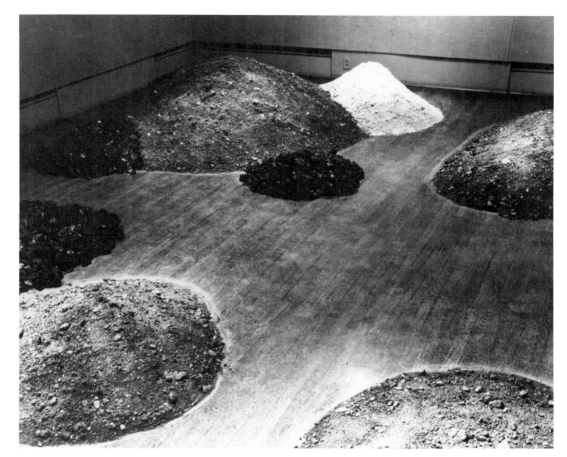

122
Robert Morris, *Untitled,* 1969. Exhibited in *Earth Art,* Andrew Dickson White Museum of Art, Cornell University, Ithaca, New York, 1969. Photo by David Morgan.

123
Hans Haacke, *Grass Grows,* 1969. Exhibited in *Earth Art,* Andrew Dickson White Museum of Art, Cornell University, Ithaca, New York, 1969. Photo by Hans Haacke.

The Disembodied Idea

IO

Very late in the history of Conceptual Art, measured by the brief life span of movements during the sixties, a symposium on that subject was held at the New School for Social Research in the spring of 1973. It was one session of an educational series organized to enlighten the layman on current art trends. Except for the moderator, the radical critic Lucy Lippard, the participants were all allegedly Conceptual artists. After Ms. Lippard and the five or six artists had muttered to each other quite inaudibly for a half hour or so, the audience (who had paid a substantial fee to attend) became restive. Finally one member of the class demanded that each artist be asked in sequence to define Conceptual Art. All refused to respond in the spirit of the question, and most professed ignorance of what the term meant, adding that they were not responsible for it. The frustration of the audience—which culminated in demands for refunds, one fistfight, and a series of angry departures—indicates the indefiniteness and lack of universal acceptance of the terms available to explicate the interlinked manifestations of the late sixties: a "Conceptual Art"—a common locution since at least 1969, when the first issue of the English publication *Art-Language: The Journal of Conceptual Art* appeared. The confusion cannot be laid entirely to the artists' impoliteness, for after 1967 earthworks, Conceptual Art, process art, body art, political art, information art—to cite a small fraction of the neologistic terminology of the period— seemed to erupt simultaneously and often appeared, in one or another aspect, in the same exhibitions. To add to the disorder, the same artist often proceeded from one mode to the others or seemed to be practicing two or more modes at the same time. (See figs. 124 and 125.)

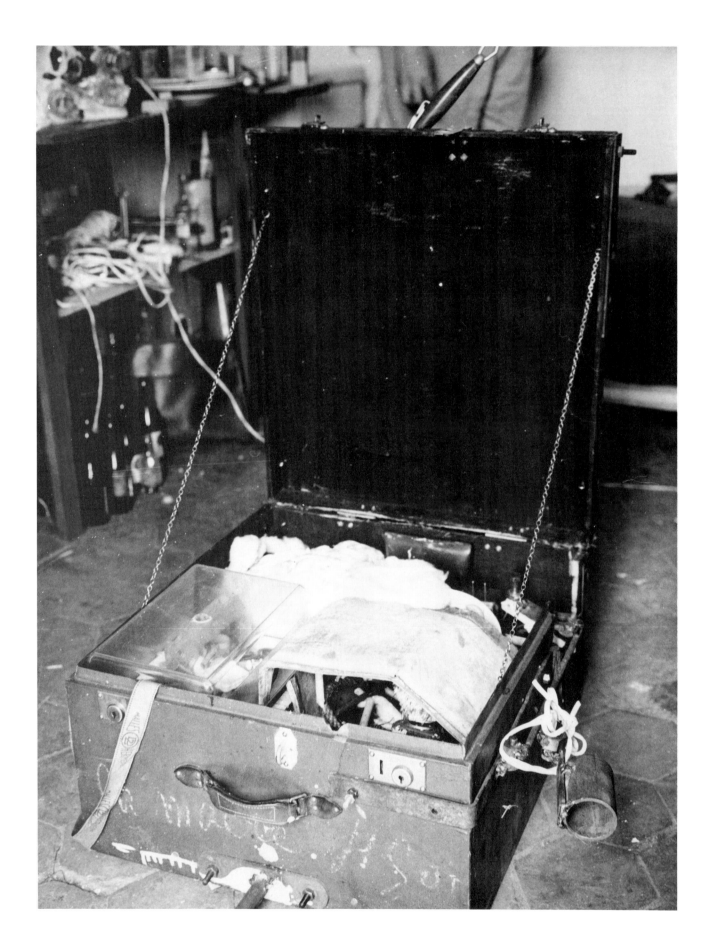

124
Daniel Spoerri, *The Suitcase,* 1959. Courtesy of Gallery Lauhus, Cologne. Photo by Vera Spoerri.

125
Robert Morris, *Fountain,* 1963, mixed media with electric pump and water, 37 × 13 × 15 in. (91 × 32 × 37 cm). Museum für Moderne Kunst, Frankfurt am Main. Photo by Werner Kumpf.

One of the first major exhibitions that announced the art of ideas was held at the Kunsthalle, Bern, and the Institute of Contemporary Art in London, long a center for innovative activity, and sponsored, it is amusing to remember, by the Philip Morris Company. It was titled *When Attitudes Become Form: Works—Concepts—Processes—Situations—Information* and included artists from the United States, England, Scotland, seven European countries, and India.[1] The state of the arts that gave rise to these phenomena were thus not just national or regional, but were a product of the international information network—or zeitgeist if you prefer a more mystical term—through which new ideas proliferated. "Works," in this exhibition, could perhaps be interpreted as "works of art": several of the objects illustrated in the catalog (but not necessarily shown in the exhibition) were surely "art objects" in their most reduced or all but formless state. These were notably those by Barry Flannagan, Eva Hesse, Sol LeWitt, Claes Oldenburg, Frederick Sandback, Allan Saret, Richard Serra, and Richard Tuttle. "Concepts" ranged from Edward Kienholz's proposal to an interested buyer (along with a purchase contract to sign) of a combined work by himself and Jean Tinguely, as yet unexecuted, which would memorialize a duck-hunting trip the two artists took together in California during the fall of 1965, to Joseph Kosuth's selection of categories from the thesaurus, reproduced in photocopies or published in journals and newspapers. "Processes" included a mound of earth on which grass was growing by Hans Haacke (which was shown also in the *Earth Art* exhibition at Cornell in 1969) and a statement by a Dutch wind artist, Marinus Boezum, who expressed the hope, before the exhibition, that the "weather will be mild during the exhibition with wind-force 3m/sec. so there will be a moderate breeze: then leaves and twigs are in constant motion, small branches begin to move. Dust and paper will whirl round and above the ground." Almost anything can be a "Situation": perhaps the theatrical happenings by the former Pop painter of life-size figures on mirrors would qualify, as would (in documentation) photographic records of various activities shown in the exhibition. "Information" was to become, for a time, a major category of Conceptual Art. Paul Cotton of Oakland, California, provided a long list of detailed data on dimensions of his body, from the distance between his eyes (1¼″) to the length of his penis (relaxed: 4″), the length of his left foot (10¼″), and of course his height, weight, and age (29 years). Here was a foretaste of body art. Behind this assortment of deviationist genres, the increasing conceptualization of art in the sixties and the grad-

ual dissolution of the art object offer comprehensible sources.

To anyone who was observing the sequence of philosophical positions taken by some modernists after 1955, the application of the term Conceptual Art to a range of activities that erupted in several countries by 1967 was not a surprise. One of the key lines of generation (or impoverishment) of art that began in the mid-fifties was the progressive attenuation, disaccreditation, and abandonment of the components, emotional, material, and perceptual, held to be desirable and necessary as constituents of a work of art. Personal emotion and the expressive use of the traditional tools of the artist were parodied and abandoned; also rejected was the process of intuitive, asymmetrical structuring by which these gestures were perceptually supported. Optical, color-field, and systemic painters and minimalistic sculptors not only further reduced the formal elements of art—they also disclaimed any concern whatever for symbolization, content, or what was earlier called "expression": anything, indeed, outside or beyond the immediate material or perceptual attributes of the art object. Mies van der Rohe's "less is more" became, simply, "less is less." For the formalists, committed to the object, this had to be the end of the reductive road. The canvas that became empty, or the sculpture that, as in the work of Anne Truitt, had been reduced to one primary element, was a terminus from which it became necessary either to move "backward" or dissolve the art object entirely, abandoning aesthetic judgment.

For Joseph Kosuth, American editor of *Art-Language,* the central premise of the movement he espoused was "art as idea as idea."[2] The idea behind Conceptual Art, it would appear to say, was that an idea was sufficient material for an artwork, and that representation, self-expression, internal relationships, and the object itself were expendable. Except as a mode of transferring data, visual perception itself was held to be irrelevant, because the kinds of information valued by the conceptualists could often be imparted aurally or even in braille. Absurd though such a theory would have seemed in 1960, it was already implicit in statements made by Ad Reinhardt concerning his black paintings, with which he froze his development and which, he held, were the last paintings in the history of art.

For those aggressive post-modernists of the sixties and early seventies most committed to perceptual aesthetic—or anti-aesthetic—revolution, whose changes in position occurred more or less in unison, it seemed far more pressing to be subversively innovative, and to push their publicized ideas farther beyond art, than it was to be an artist. Until 1965 an

artist, if not a maker of objects, was at least (like Duchamp or Spoerri) a discoverer of them, however unlike previous artworks these fabricated or found objects might appear. But in the short introduction Ursula Meyer provided to her anthology *Conceptual Art* (1972), she specified, as one of the criteria of the new genre, "the isolation of art from any material representation."[3] In this conclusion she was summarizing a premise governing activities of many artists working in several parts of the world during the previous four years. These artists produced specifications for unrealized or unrealizable projects; visual evidence of their ideas consisted of typed instructions to possible participants or gallery visitors or documentation of activities already completed, recorded in typescript, diagrammatic drawings, on film or tape, in photographs, or by other nonaesthetic media of information. In this attempt to redefine or extend what is understood as art, or to destroy previous concepts of art, art's distance from art criticism or other varieties of art writing tended to dissolve. Thus an attempt to evince some outlines as to what Conceptual Art is "held out as a 'conceptual art' work," as Terry Atkinson asserted in the first issue of *Art-Language*.[4] (This chapter, however, is *not* an artwork, for it is not so regarded by its author.)

By 1969, it can thus be recorded, certain artists had postulated the *total elimination of the art object in the name of art*. Their premise was an extension, in more than degree, of Duchamp's assertion that any object could become an artwork if so designated by an artist; of Yves Klein's "signing" of the blue sky over the Mediterranean in 1946; of Piero Manzoni's signatures on nude models as "living sculpture" (1961); and Daniel Spoerri's rubber stamp *Attention, Oeuvre d'art* with which he marked fruits and vegetables in a French grocery store early in the sixties. For a radically Conceptual Art any physical record is too solid: its "ideal medium," Jack Burnham wrote in 1970, "is telepathy."[5]

The leap from the found object to the obliteration of the disembodied idea is perhaps too great at this stage in an account of Conceptualism. A return to the final states of the art object may serve to fill this gap. The empty, untouched canvas was flirted with between 1960 and 1970 by Ad Reinhardt (barely invisible geometry), Ralph Humphrey (slight texture), Walter Darby Bannard (division of a monochrome surface by a coat of varnish over one area), Ellsworth Kelly (two or more contiguous monochrome canvases each of a different color), Agnes Martin (a barely visible grid of pencil lines over a monochrome canvas), Patricia Johnson (one blue horizontal stripe, interrupted by reversals to complementary "blips"

across the center of a 28-foot-wide canvas), Robert Ryman (slightly modulated, freely brushed patches of white pigment against white canvas), Peter Gourfain (repetition of a single geometric unit across the canvas surface), and dozens of other late-minimalist painters. (Rauschenberg's early all white and all black, or Yves Klein's all-blue paintings appeared in too different a context to be cited here.) In the best of this work, considerable artistry, sensibility, and care were applied to produce works that, to the devotee, provided the pleasurable, meditative, and even tranquilizing experience of perceiving qualities of form and artistic individuality manifested through infinitesimal distinctions—a perceptual equivalent of the approaches to nothingness found in the writings of mystical religion. But in the sequence of sixties reductions, each time the utter minimum of information and artistry was reached, artists who did not wish to abandon painting were forced to return to geometry, color variety, modulation, or even brush, as was the case in the minor movement of lyrical abstraction—a pallid, contentless, unstructured reincarnation of Abstract Expressionism.

The ultimate state of, and statement about, the art object was made in 1970 by the French artist Daniel Buren. His works consisted of striped panels, *affiches,* and banners placed, usually at night, in unexpected places in urban centers or, in one instance in Paris, carried like advertising sandwich boards. Although he wrote with an appealing precision, Buren was not a radical conceptualist: he still regarded art as something to look at and saw his writing as an explanation of his art, not as the artwork. Although his first stripes—in one color alternating redundantly with white—were painted, they were subsequently printed on paper, the color for the run decided by the printer. The stripe motif—a hallmark of the sixties—recalls the early collages of Ellsworth Kelly, the striped canvases of Gene Davis, Morris Louis, or Guido Molinari, except that in these prototypes the colors were varied and chosen by intuition. Buren thus described his work, repeated in different sizes and numbers of units: "Vertically striped sheets of paper, the bands of which are 8.7 meters wide, alternate white and colored, are stuck over internal and external surfaces: and/or cloth/canvas support, vertical stripes."[6] He continued: ". . . the succession of vertical bands is also arranged methodically, always the same . . . thus creating no composition on the inside of the surface or area to be looked at, or if you like, a minimum or zero of neutral composition."[7] The surreptitious placement of these works could be seen (like the activities of most post-modernists) as in some degree

self-publicizing, and also (because the valueless works appeared in unexpected places, sometimes illegally) as both elitist and tentatively political. Buren's paintings lay on the threshold between ego and self-obliteration, art and non-art, vision and disembodied conception. His carefully articulated comments on his work, moreover, had the convincing ring of a real dilemma. More than the monochrome canvas, they punctuate a last moment of minimal painting.

Seen in the unmodulated whiteness of the modernist gallery, the rectangular boxes of Morris and Judd somehow retained more presence than an untouched canvas. There were six planes and eight corners, rather than just a flat panel, to observe; and being volumetric, and often large, they inevitably measured the observer's kinetic presence between the box or frame on view and the surrounding box of the room that contained both work and spectator. It became a phenomenological situation. Other gallery "situations," however, were nonvisual: they involved heat and cold, sound, wind, mist, gas, and electronic responses stimulated by the observer's movements. In such situations, the vigorous conceptualists argued, an "object" was still present—one that responded to senses other than the visual. Bruce Nauman, Keith Sonnier, Mario Merz, and others arranged situations in which illuminated fluorescent tubes and their exposed fixtures and wiring provided perceptual arrangements, which in some cases (Merz for example) included words. It would be a question of judgment of intent, and of the specific work, whether one perceived or did not perceive an aesthetic gestalt, or whether the electrical equipment was merely supporting hardware. What boxes achieved by compressing the object into a homogeneous monad, these loose systems—as well as random distributions of small units (scatter pieces), galleries filled with dirt, heaps of loose felt or almost any material—accomplished by dispersion: the final disintegration of a minimally relational art object which one could still adjudge successful or unsuccessful, good or bad. When such a judgment became impossible or irrelevant, the art object had been wholly dispensed with.

Art, like philosophy, science, and engineering, has always involved concepts. Gabo's utopian design for a radio station, the apartment cities of the Futurist architect Sant'Elia, or even the architectural drawings of Hugh Ferriss, were concepts that conceivably could be at some time realized. In 1960 the Museum of Modern Art mounted an exhibition called *Visionary Architecture:* an assortment of fascinating concepts unrealized by current technology. Even the drawings submitted to the Chicago Trib-

une Building competition in 1922, many of them monumentally absurd like Oldenburg's monuments, were concepts for realizable projects. Certain of the projects of conceptual artists were in the prospective "real world" proposals. In this sense, Oldenburg's drawings for monuments, some of which were realized, belong in the evident area of conceptuality. The idea is clearly stated without being (or before being) begun. In a few cases, a concept is wholly sufficient to immediately justify its presentation: one such example was *The Base of the World,* by the precursor of Conceptual Art, Piero Manzoni. It is a parallelepiped of iron, placed in a park on the outskirts of Herning in Denmark: it bears, upside-down, the inscription "Socle du Monde, socle magic n. 3 de Piero Manzoni 1961—Homage a Galileo": the base, being itself upside-down, holds up the entire world.[8] One's parameters are enlarged by this idea.

The objects, photographs, typescript, or other information presented visually in conceptual and information exhibitions between 1968 and 1972 in various parts of the Western world were, it should now go without saying, usually devoid of an aesthetic interest. Thus, as conceptual artists sometimes admitted, they could be as fully observed in catalogs and books as in galleries or museums. Although utopian and eschatological concepts could be singled out in conceptual work, the material described was usually not prospective, but descriptive and/or retrospective. Smithson's "nonsites," for example, were simultaneously a form of indoor earth art, a nonaesthetic object to be shown in an art gallery, and, in their systematic procedure directed toward a nonfunctional end, a form of Conceptual Art. Such records, devoted to a topographical or geodetic study related to a practical project, resemble technical research in fields far from the activity of art. Smithson was imposing on himself a careful methodology and often as well restrictions projected from his period of systemic art, for no reason other than the assertion of method, system, and documentation. A large part of the production of conceptual artists falls under the heading of documentation; the compilation of records in photographs, charts, diagrams, audio, and video. What the activity was seemed hardly to matter if it filled the conceptual requirement, although the fewer persons who witnessed the actual event, or the more banal and unnoteworthy it was, the more documentation could stand as the primary event.

Prospective proposals, of varying degrees of possibility, make up a smaller group, of which a very few examples follow. In one work for the Jewish Museum's *Software* exhibition of 1970, John Baldessari gave specifications for an actual future work, *Crema-*

tion Piece. It involved the burning of all his paintings, placing their ashes within a wall of the Jewish Museum, and affixing a commemorative plaque to the wall. For the Museum of Modern Art's *Information* exhibition in 1970, Yoko Ono submitted several works. One, *Cloud Piece* (1963), directed the spectator/reader to "imagine the clouds dripping. Dig a hole in your garden to put them in." The Addison Gallery of American Art in 1970 published an "important work," a booklet by Donald Burgy entitled *Art Ideas for the Year 4000.* Among the propositions was *Time Information Idea #1:* "After eating a piece of fruit, save the seeds and plant them. When a seed has grown to fruit, pick it and eat it. Accurately record the time between eatings. April 1969."[9]

Documentations and descriptions of real situations or past events were more numerous. Douglas Heubler's *Site Sculptures* are recordings, on maps, of slight alterations of chosen sites by the removal of material, placing of marbles, or other means. *Duration Pieces* are sequential photographs of a road or other site documenting changing activity and appearances at selected time intervals. Photographs of different cities were taken at arbitrary points established by imposing a geometric form on maps of the cities. *42 Parallel* consists of a map marked with fourteen towns located from coast to coast across the United States at that latitude, eleven certified postal receipts of mail sent to certain of these towns, and ten certified postal receipts of mail received from them. At the tenth Venice Biennale in 1972, the main presentation in the exhibition by Jan Dibbets (the only Dutch artist represented) was a sequence of photographs, taken at different positions, of the sea, horizon, and sky on the Netherlands seacoast. A work by Bernard and Hilla Becher consisted of a typed explanation of the function of cooling towers, accompanied by photographs of thirty examples. Richard Long photographed records of his walking trips through England, Germany, Africa, and America during which he altered the terrain with runelike markings. John van Saun, in 1969, brought a series of his works to the Richard Feigen Gallery in Chicago, burned them before a paying audience, and published a short book of photographs of the burning objects. (He insisted the book was an artwork rather than a documentation of an event.)

These few examples were selected because they are both characteristic and susceptible to brief notation. But from this capsule recollection, one can picture the dearth of visual interest such material offered to the public at one of the many such exhibitions organized between 1969 and 1972. Few honest visitors would deny the tedium, or the inappropriateness, of viewing on the walls of modern galleries material

that could better be seen, as the artists often admitted, in catalogs and books. In his book *Arte Povera,* published in 1969, Germano Celant observed that spectators of Conceptual Art are like visitors at a zoo: it is necessary to be on the other side of the bars to apprehend the nature of the art form. Surely it is true that the complex, mobile activities essential to the ultimate form, and the care taken in precise documentation and presentation, which were invariably meticulous, must be an absorbing experience for the artists, involved in perceiving the real world, in the enigma of time, place, duration, and change. But for the spectator, exhibitions of Conceptual Art, especially when lists, definitions, documentations, and record photographs were not interspersed with objects of some kind, were massively monotonous. (For various installation views of the exhibition *Information,* see figs. 126–132.) A gallery occupied by nothing but a few white fluorescent tubes by Flavin, a dead gray plywood box by Morris, or a row of bricks by Andre also offered a paucity of visual experience, unless one was willing to devote his attention to a heightened awareness of space, its division, and the nature of perception. But to an eye used to the challenge of rich "maximal" art, that of words and record photographs was duller.

Yet boredom too—as it was introduced by Erik Satie's *Vexations,* a piano piece of one page intended to be repeated 840 times (performed by John Cage in New York in 1963), by certain pieces by La Monte Young, or by Warhol's multiple silk-screen images or his early films, such as the eight-hour *Empire State Building*—is a matrix from which new experience can arise. These qualifications notwithstanding, the row of neat photographs and typescript were boring in an irksome way that bordered on the political. These exhibitions were in fact the usurpation, often, of fine new gallery spaces (like the Hayward Gallery in London) designed for the exhibition of dazzling works of art. In this application such material functioned as Con Art, as it was called, in which the gullible "avant-garde" curator was the patsy caught between disenchanted, if not dissident, artists and the establishment personified by museum trustees. Boredom, indeed, seemed almost to be sought after. Duchamp was the founding master, yet the bitter humor of Duchamp, Francis Picabia, and Dada was either absent (except in an occasional reviving instance) or so attenuated that its tang was deadened. Short of going back to Yves Klein's exhibition *The Void* in 1959—an empty gallery painted white—Mel Bochner's 1971 "exhibition"—*3 Ideas + 7 Procedures*—at the Museum of Modern Art provides an all but ultimate example.

126–132

Installation views of the exhibition *Information.* July 2 through September 20, 1970. The Museum of Modern Art, New York.

162 **The Disembodied Idea**

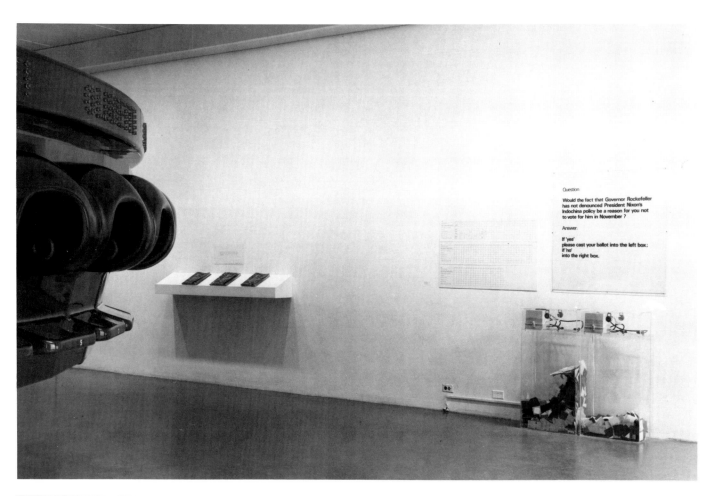

Question:

Would the fact that Governor Rockefeller
has not denounced President Nixon's
Indochina policy be a reason for you not
to vote for him in November ?

Answer:

If 'yes'
please cast your ballot into the left box ;
if 'no'
into the right box.

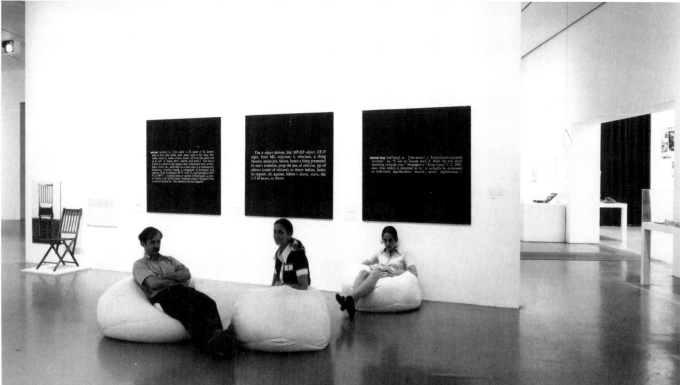

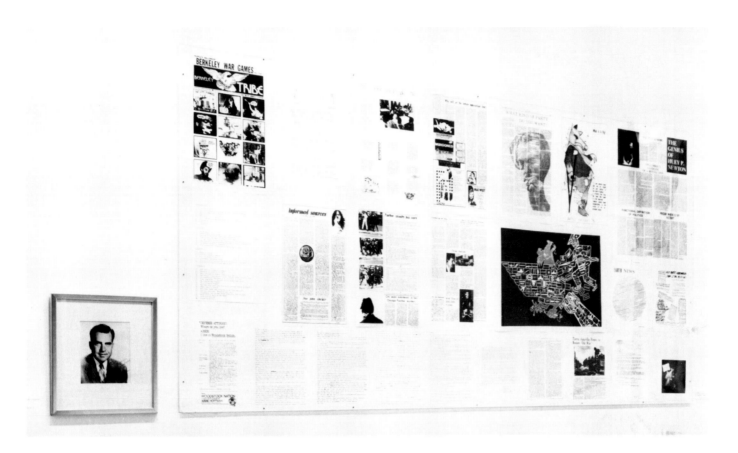

The galleries were occupied solely by a line of Scotch tape (placed at the artist's eye level) on which two number sequences, representing his various projects, were written in opposing directions with two colors of a Dryflo pen.

Joseph Kosuth's "information room" at the exhibition *Conceptual Art and Conceptual Aspects* at the New York Cultural Center in 1970 underlined the context from which terminal Conceptual Art arose. It was a table heaped with paperback books. Mainly from the period of post-philosophical writing, they included many works by and about Ludwig Wittgenstein, books on logic, language, and linguistics by A. J. Ayer, Rudolph Carnap, Noam Chomsky, and others, and even a very few on art, among them William Mills Ivins's *Art and Geometry* and (a surprise) Wilhelm Worringer's *Abstraction and Empathy.* This bibliographical display resembled, in an arid way, and in a much narrower compass, Maurice Stein's charts published that same year under the title *Blueprint for Counter Education.* However, crude though they were, Stein's charts hoped to direct the entire constellation of current knowledge toward the formation of a new and better social order, whereas Kosuth's library narrowed thinking from a confrontation with real problems to concentration on the mind's observation of itself: idea as idea as idea.

Conceptual Art was the ultimately reductive movement—and in the web of its international communications it surely became a movement—of the sixties. Its most revered master Marcel Duchamp, the most publicized spokesman for conceptual artists as a group, was for Kosuth the initiator of modern art as Conceptualism. As an ironic jest (which for Duchamp was also serious), Duchamp once described himself not as an artist or even an anti-artist: *anartist* was the word he used—"no artist at all." Yet Kosuth did not relinquish the claim that his definitions, categories, and dry prose were indeed art, and he took the sculptor Richard Serra to task for stating "I do not make art . . . I am engaged in activity." [10] Although Duchamp was also a pioneer of optical art, Kosuth goes further, following his remark in derogation of retinality, in dismissing the formal qualities of Manet, Cézanne, Cubism, and color-field painting as "decoration," adding that the "art condition" of formalist painting and sculpture "is so minimal that for all functional purposes it is not art at all, but pure exercises in aesthetics." [11] As a footnote, he added "that the conceptual level of the work of Kenneth Noland, Jules Olitski, Morris Louis, Ron Davis, Anthony Caro . . . *et al.* is so dismally low, that any that is there is supplied by the critics promoting it." [12] A critical

switch was thus made by Kosuth: what is commonly called art is *not* art, but writing on art *is* art; or still further, any verbal demonstration of analytical mental activity is art. One can find a bitter-tasting amusement in the agreement of his denigration of formalist painting, at the late end of the sixties, with that made earlier by realists and Abstract Expressionists. It lacked content, and for Kosuth, was nothing but *content*. However, for him most of the previous content of art being "synthetic" (i.e., related to the outside world) make it invalid. Here Kosuth followed the pattern of British linguistic philosophy, buttressed his argument with quotations from Wittgenstein and Ayer, and concluded, in that spirit the "unsaid is unsaid because it is unsayable," a principle applied to criticism for the formalists. A work of art is by this definition a closed, analytical proposition, complete in itself, without contradictions, having no connection whatever with the world outside it: "art is a kind of *proposition* presented within the context of art as a comment on art." [13]

Kosuth's incantation "art as idea as idea" (1967) has its origin in Reinhardt's 1962 statement "Art is art-as-art and everything else is everything else. Art as art is nothing but art. Art is not what is not art." [14] Reinhardt, an ironist and devil's advocate, was to the end a painter among painters and sculptors. His single-minded, tautological views were listened to because they were the capstone of a life devoted to art and to the medium of painting. Absurdity had a fullness in the world he inhabited that became empty rhetoric in the pretentious stance of Kosuth.

Had his pronouncements, and those of other radical conceptualists been widely accepted, there would have been no more painting and sculpture, judgments of quality would have become meaningless, the collection of artworks would have ended, galleries and museums devoted to new art would have closed their doors, and the content of art would have become a tautology of words or symbols. Not all conceptualist writing went to this nihilistic extreme, and all of it is of interest in determining the reasons, psychological, social, and political, for a movement that ended by obliterating every vestige of art as it has been known. In viewing the future (without trying to predict it), one should entertain the most extreme possibilities, like that presented in Germano Celant's comments at the end of *Arte Povera*, a time when, he observed, the "epoch of Aquarius is now preparing itself": "To conclude we want to say that it is useless to predict the end of art. Art was done with fifty years ago. Enough of this lamentation, art is a word." [15] Happily, it is not necessary to accept Celant's diagnosis.

Art as Adversary Politics

II

Since the time of Courbet, whose social theories
were influenced, if not authored, by his friend the
anarchist Pierre Joseph Proudhon, modernist artists
have most often associated themselves with liberal,
radical, and sometimes revolutionary political posi-
tions when they were not apolitical or neutral in
their social and political views. There are exceptions:
Cézanne was a devout Catholic and a conservative;
Degas was a middle-class royalist; Dalí was a Catho-
lic and a rightist eccentric; Ezra Pound was pro-
fascist. Beginning in the twentieth century, the
connection between avant-gardism and politics was,
if anything, closer than in the nineteenth century.

Early in the century, Picasso, Braque, and Delau-
nay were too intent on implementing their break-
throughs in art for overt political views, though
their formal redirections postulated a new, radical
vision of reality. The social and technological radi-
calism of the Italian Futurists, which began as anar-
chist and populist, ended as a nationalistic, prowar
movement that was absorbed into Mussolini's fas-
cism. At the opposite pole from the Futurists, the
Dadaists and Surrealists initiated a convulsive re-
orientation in life style, which surely affected the
eruptions of the sixties. Their aesthetic subversive-
ness and detestation of middle-class values, compla-
cency, imperialism, and war, made them allies of
anarchists and communists. The major German
Expressionists, with the exception of Emil Nolde,
were violently opposed to capitalism, imperialism,
and war, and, long before the hippies of the sixties,
pioneered a life style of emotional liberation and sex-
ual freedom. Until Stalinism repressed modernism
in the twenties, Russian artists were committed to
an unfettered reformation of social as well as aes-

thetic disruption and reconstruction. Both Mondrian and Kandinsky saw their art as a utopian force that would undermine materialism and bring about a new order, and Mondrian, like the Dadaists and Futurists, felt the importance of the destructive in art.

Yet though modernism was radical or revolutionary, it was also elitist, and its support, paradoxically, has always come from wealthy, often politically conservative patrons and from governments whose political programs artists have usually deplored and often opposed. Since the time of the Impressionists, modern art has been repeatedly denounced as communistic by government bodies and conservative critics, but it has never appealed to more than a small minority of the public—and least of all to members of the working class. Notable exceptions occurred in the sixties, when the adulteration of elitist modernism by the media, flashy technology, and popular and commercial arts made modernist work, in some instances, seem more comprehensible and acceptable to the unprepared spectator. As a group, modernist artists can always be counted upon to support humanitarian, liberal, or even radical causes as well as the rights of minority groups. But however egalitarian their sympathies, their art has almost never overtly propagandized these views.

The socially conscious painting of the United States in the thirties, most of which was bad, and much more importantly that of Mexico is now almost forgotten with the exception of a few masters that history will retain—notably José Guadalupe Posada, José Clemente Orozco, Diego Rivera, and Ben Shahn. These artists quite deliberately cut themselves off from the successive innovations of the twentieth century. Whatever its many styles, modernism was never an illustrational art, and therefore it failed to attract a mass audience however much it was publicized. Conversely, propaganda art, whatever its level of amplification into major significance—from Goya's *Disasters of War* to Rivera's frescoes removed from Radio City Music Hall in New York in the thirties because of their heroizing of Lenin—retained an illustrational core.

Even in the thirties and forties, avant-garde artists rarely pressed their political sympathies in the subject matter of their art. Stuart Davis, a leftist leader, broke off his friendship with Arshile Gorky because of the conservatism of the latter's politics; yet this political leftism cannot be detected in his Americanized Cubism. David Smith, in his *Medals for Dishonor* (1939–40), attacked war, munitions makers, the "food trust," and draft exemptions for sons of the rich, but this minor group of works is unique in his oeuvre (figs. 133–135). In their dis-

taste for the social realism of the thirties, the Abstract Expressionists proscribed any trace of political comment, even in their more figurative work. Newman, a follower of the Russian anarchist Pëtr Kropotkin, hated injustice as much as he did regionalist realism. Although he generally saw the government as an enemy of the people—and ran for election as mayor of New York in 1933 on an artists' ticket—no mark of these views can be found on the surfaces of his entirely abstract canvases. Reinhardt, who detested propaganda art (except for his cartoons) and initiated the reductionism of the sixties, always supported leftist causes. The postwar avant-garde, in the most pronounced modernist tradition, were abstract artists for whom propaganda art, as the lone conservative Gorky observed, was "poor painting for poor people."

But an alternative view, political in a much broader sense, can be held of modernism: that its very obsession with change, innovation, and redirection was in itself inherently revolutionary. This hypothesis was advanced passionately by Michael Kustow, director of the Institute of Contemporary Art in London, during a debate entitled "The Role of the Artist Is to Change the World" held at Cambridge University in 1970. After citing Marx and Trotsky on the ineffectuality of art as propaganda and concluding that "two of the great revolutionaries of our time agree that art obeys an order of its own, cannot be relied upon, cannot be frogmarched in the services of any ideology or social cause," [1] he went on to write:

And yet, there's more than this. Every work of art, every real creation, is a revolt. A revolt first against culture, against its custom of naming and placing and judging. A revolt against esthetic norms, against existing artistic languages. A revolt in the name of fresh perception, in the name of a tradition ignored by the dominant culture, a revolt which invents new languages, unsuspected forms, surprising juxtapositions. Every work of art, like every act of human liberation—like the process of growing from a dependent child into an independent adult, from a "nigger" into a person, from a Cong to be zapped into a human being—involves denial of an existing order, involves affirmation and struggle. And in this world, and in every human society we have known, such a denial of what is there in order to pave the way for what is not there, means revolution and involves violence. . . . "Transform the world," said Marx; "Change life," said Rimbaud. . . . True art today is anticipation; anticipation of styles of life, structures of feeling we do not yet have. It gives us a forecast of a world to come. [2]

133
David Smith, *Medal for Dishonor: Death by Gas,* 1939–40, bronze, edition of 3, 10¼ × 11⅜ × 1⅜ in. (26.03 × 28.89 × 3.49 cm), weight 4 lbs. Hirshhorn Museum and Sculpture Garden, Smithsonian Institution, Washington, gift of Joseph H. Hirshhorn, 1966.

134

David Smith, *Medal for Dishonor: Propaganda for War,* 1939–40, bronze, edition of 3, 9½ × 11⅞ in. (24.13 × 30.16 cm), weight 5 lbs. Hirshhorn Museum and Sculpture Garden, Smithsonian Institution, Washington, gift of Joseph H. Hirshhorn, 1966.

In the remainder of his statement, Kustow gave recognition of his aggressive tone, and, if only in their inclusiveness, are his remarks overstated. But just *because* of this exaggeration, he underscores the fact, often ignored, that redirections of form, medium, and intent can be as sweeping in their rejection of the premises and practices of a society as is illustrational propaganda. Indeed, in a period when propagandistic images are the provinces of press, television, and film, these media can be more potent. Kustow's pronouncement demands qualification. It would be unconvincing, for example, to include color-field painters such as Louis, Noland, Stella, or Kelly or the formalist dogma of an *internal* devolution of modernist style from multileveled and intricate to abstract and reduced forms to which

these artists conform within Kustow's romantic characterization. However "tough" and holistic their sparseness may have appeared in 1960, and however spectacular the changes in form and medium they introduced, the ultimate appeal of their painting is decorative, and it rapidly found its way, as high-fashion decor, into the salons of sophisticated millionaires.

A more general observation is suggested by these examples: until the phase in the post-formalist devolution when the existence of the art object was threatened—as long as a large and dazzling work could still be offered to the art market—the counterestablishmentarian impact of formalist painting and sculpture was slight. To generalize further: it was not the reductive, elitist styles that had the

135

David Smith, *Medal for Dishonor: War Exempt Sons of the Rich,* 1939–40, bronze, edition of 3, 10⅜ × 9 × ⅞ in. (26.35 × 22.86 × 2.22 cm), weight 3 lbs. Hirshhorn Museum and Sculpture Garden, Smithsonian Institution, Washington, gift of Joseph H. Hirshhorn, 1966.

most subversive potential, but the dispersive "junk cultures," which intentionally vulgarized movements. Unlike formalist art, these were linked with the radical and revolutionary counterculture, announced, in all its essential premises, by Allen Ginsberg's *Howl* in 1955, by rock music, and by the happening movement. It was San Francisco and, to a lesser degree, Chicago that initiated the disenchanted, anarchistic spirit that took hold in New York after 1967.

The San Francisco assemblagists, together with the group gathered around the Delexi and Ferus galleries in Los Angeles—notably Wallace Berman, George Herms, Bruce Conner, and Edward Kienholz—produced works that, in their erotic and scatological content, connotations of drug culture, and scathing social commentary, were the first to merge, by new figurative modes, modernism with social criticism. (Included here should also be the "Chicago Monster School" represented in Peter Selz's exhibition *New Images of Man* at the Museum of Modern Art in 1959.) Of this group Kienholz must be singled out as the most unrelenting social critic among the artists of his generation. When his first environmental tableau, *Roxy's*—a symbolist reconstruction of a wartime Las Vegas brothel that in-

cluded the madam, seven whores, a towel boy, and a portrait of General MacArthur—was exhibited in 1963, Dore Ashton wrote, "Intentionally or not, Kienholz scourges the worst of America with the implacable wrath of a moralist."[3] He avoided the aesthetic dilemma—the dampening effect of style—by totally relinquishing amenities of line, color, form, and facile execution rather than mitigate the searing acidity of his subjects.

Renunciation of aesthetic appeal was evident even in Kienholz's early "broom paintings," which were abstract reliefs built up from scraps of wood nailed and glued to panels, over which unappetizing broths of questionable pigments were roughly brushed. In 1959 these wall reliefs began to project forward and, largely by the incorporation of actual objects such as animal heads and parts of mannequins, to become figurative and grimly symbolistic rather than abstract expressionist. Heavy set, muscular, and ironically jovial, Kienholz is the son of a Washington State farmer. Kienholz's background—he has been a high-school athlete and musician, college dropout, automobile dealer, bootlegger, vacuum cleaner salesman, restaurant proprietor, mental hospital attendant, man-of-all-work, and art gallery operator—was entirely outside the influence of New York and Europe and provided themes as well as the ideal technical training for his later work.

Kienholz once invited me to dinner—the main dish, he said, would be horse meat. On another occasion he offered me a gift—an old photograph album in which faded, brown family snapshots in gilt-edged oval mats were each paired with a newly inserted pornographic pendant. He later suggested to me, quite seriously, that packages containing the bloody necks and heads of turkeys be mailed, from several world centers simultaneously, to an influential but conservative art critic. One could not always be sure, when Kienholz began to apply his special knowledge, diverse skills, and what the critic John Coplans called his "savage eye"[4] to the medium of assemblage, whether he was an advocate of virtue or an apostle of vice. It is the double cut of Kienholz's art, along with the veristic immediacy of assemblage, that frees it of self-righteousness and raises its voltage so high.

Kienholz's ideas evolved through four categories: "broom paintings," assemblages, environmental tableaux, and typed proposals for unexecuted tableaux. In works such as *Roxy's* or *Portable War Memorial* (which includes a replica of the bronze version of Norman Rockwell's Iwo Jima flag raising), the specific theme is safely in the past, but the target is the present. Such a combination of bitterly violated nostalgia, distaste, and social criticism would have been all but impossible in New York early in the sixties, where even such extreme works as Rauschenberg's *Monogram* belong to the sophisticated tradition of Dada collage (fig. 136). Whatever affinity Kienholz's assemblages had with European modernism lay with the surrealist constructions made in the thirties and forties by André Breton, Meret Oppenheim, Hans Bellmer, and Salvador Dalí, in which the components are combined in a unified if "convulsive" object rather than abstractly juxtaposed. Kienholz's form is always a side effect of content and impact, although, flowering through evil, certain pieces arrive at beauty and all are marked by a distinctive personal style.

Kienholz's tableaux, which ask to be entered rather than merely observed, are sordid and dreadful. They draw on the spectator's guilt, repulsion, and voyeurism, as well as on the artist's own experience. In retrospect, however, Kienholz emerges as censurer rather than malefactor, for his savage thrusts have been directed against fundamental human, social, and political vices: middle-class hypocrisy (*Jane Doe* and *John Doe*); capital punishment (*The Psycho-Vendetta Case*); persecution of the Jews (*History as a Planter*); prostitution (*Roxy's*); treatment of mental illness (*The State Hospital*); anti-abortion laws (*The Illegal Operation*); the tragedies and problems of old age (*The Wait*) (fig. 137); and war (*Portable War Memorial*). The matrix of Kienholz's unmitigated, anti-art harshness rose, like the counterculture of the decade, from the acerbic radicalism of the West Coast; his disquieting works are devastating in their denunciation of private and public inhumanity.

More recalcitrant but less interesting or important were the raw collages of a group that showed, beginning in 1957, at the March Gallery on Tenth Street and led by Boris Lurie and Sam Goodman. Their exhibitions were directed against not only the targets of social protest then current but also the alleged corruption of art by "aesthete-intellectuals and speculator-collectors' greed to pounce upon any acceptable novelty providing there is enough 'sophistication,' titillation, chauvinism and a potential market for it."[5] Their collages juxtaposed clippings from cheap sex publications with shots of atomic and hydrogen bomb explosions. One exhibition called *Doom* also included lurid, three-dimensional tableaux of the ravages of war. Such collage and assemblage, usually made of impermanent materials and now forgotten, was characteristic of the Lower East Side exhibitions in New York in the early sixties. Their climax was reached in 1964 in an Uptown exhibition of "no-sculptures" by Sam Goodman at the Gertrude Stein Gallery. It consisted of a

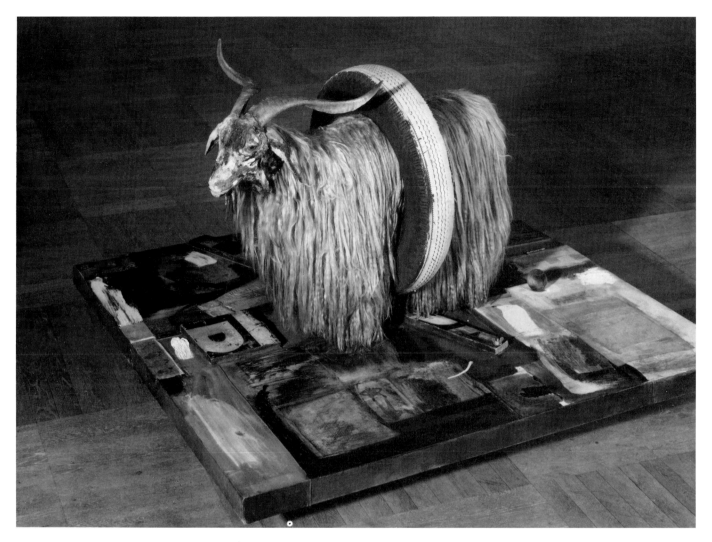

group of three-dimensional pieces executed in the manner of Oldenburg's pies and sundaes that were facsimilies of heaps of human excrement displayed like more typical gallery sculpture on white bases. Goodman's cry of denunciation in this exhibition was directed most specifically against fashionable modernist styles: "the whole complex of Paris New Realists and its American Chauvinistic derivation and bastardization called pop-art. It is a demand to reopen inquiry on the falsification of today's art-history."[6]

Many politically slanted works were shown in the sixties, but most of these were of little lasting aesthetic value. Indeed, aside from the acerbic tableaux of Kienholz, the most effective pieces produced by an artist who gained recognition were Peter Dail's stinging post-Pop indictments of the corruption, pollution, drug traffic, prostitution, and slaughter occasioned by the American occupation of Saigon. These amalgamated an exaggeration of the raw color confrontations of Pop and Op and the distortions of

comic books in a harsh, hard-edged style. They are unique in their almost nauseating effectiveness.

The militant realism of black artists during the late sixties was, needless to say, political, both because of the black demand for equality in every field and because the subjects dealt with black life, "soul," and the militant black struggle against racism. But the line between black artists who worked in a modernist style—among them former Abstract Expressionist Romaire Beardon, the fine sculptor Richard Hunt (whose manner was also generated before the sixties), Sam Gilliam, Tom Lloyd (a kinetic light artist), Alma Thomas, and William Williams (whose large compositions evolved from conventions established by Stella and perhaps Kandinsky)—remained sharply drawn. Modernist galleries and critics were, in general, open in their (white) judgments of black artists, but those artists who, like Jacob Lawrence, chose to represent "black experience" usually abhorred the modernist tradition and the institutions it had engendered. Important though it was

136

Robert Rauschenberg, *Monogram*, 1955–56, diverse material, 48 × 72 × 72 in. (122 × 183 × 183 cm). Moderna Museet, Stockholm.

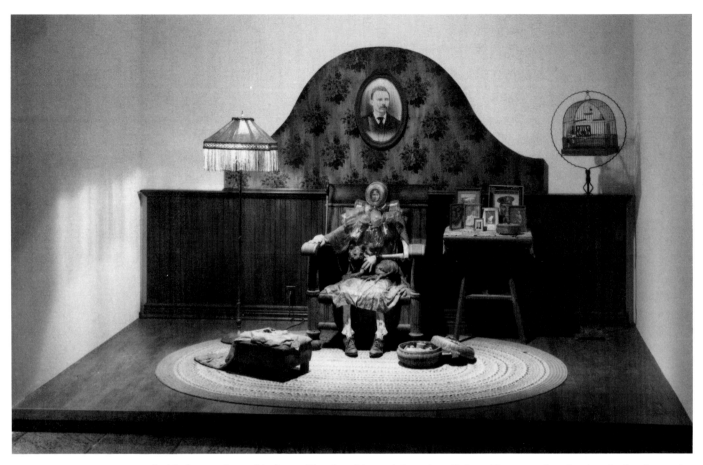

137
Edward Kienholz, *The Wait*,
1964–65, tableau, 80 ×
148 × 78 in. (2.03 × 3.76 ×
1.98 m). The Whitney Museum
of American Art, New York, gift
of the Howard and Jean Lipman
Foundation, Inc. Photo by Jerry
L. Thompson.

for black ascendancy, black art, like the white social realism of the thirties it often resembles, belongs outside an account of modernism. Despite its indebtedness to Africa and Oceania, modernism is a white tradition.

A break seemed to occur about 1965 as a profit-conscious infatuation with the new set in. It is hard to re-create the first effervescent years of the decade when John and Jackie Kennedy, the most stellar of the beautiful people, were adored on both sides of the iron curtain, or the anguishing shock of his assassination on November 22, 1963. Perhaps the change began at that moment. It was followed in 1964 by the Harlem race riots, the free-speech movement at the University of California at Berkeley, murders of civil rights marchers, and, in 1965, by the massive involvement of the United States in Southeast Asia, the Watts riots in Los Angeles, Mario Savio's motto "Don't trust anyone over thirty," and the invention of the terms hippies and flower power. These are but a buckshot selection from the hundreds of events that mark the disruption of the games of the new avant-garde.

For the artists' community, also, five years of protest began in 1965 with a full-page advertisement in the *New York Times* under the headline "End Your Si-

lence" signed by more than five hundred artists and influential art-oriented persons and calling for a protest against both the Vietnam War and the United States intervention in the Dominican Republic. It was a petition in the spirit of the dissent expressed by French intellectuals against the Vietnam War a decade earlier. Abe Ajay, one of the most concerned among the signers, whose experiences went back to prerevolutionary Russia, later commented that, as a "strict constructivist," he believed that "an artist's work should be clean as a hound's tooth of politics and social protest imagery. It is always bad art, sad and dreary and witless. . . . Good art is never social work. There is no message in the medium."[7] Ajay's statement capsulized precisely the dilemma, pinpointed by Robert Motherwell and Harold Rosenberg back in the forties, between abstract modernism and political responsibility. Yet although the political positions and interests of modernist artists do not necessarily agree, and are often qualified by concern for their careers, their sympathies range from liberal to revolutionary: a conservative modernist has always been as rare as an atheist at a Baptist picnic.

In 1966 a dramatic attempt was made to bridge the conflict between art and adversary politics when

some one hundred artists of the Los Angeles Artists Protest Committee raised $10,000, rented an empty lot between Hollywood and Los Angeles for an "art exhibition" and constructed a Peace Tower—an entirely abstract steel construction designed by the sculptor Mark di Suvero. It was accompanied by immense billboards inscribed "STOP THE WAR IN VIETNAM" to which were appended a mosaic of more than four hundred equal-sized paintings contributed from across the country and in many styles. Attempts to find a permanent location for di Suvero's work were unsuccessful, and the paintings—many of these propaganda statements and inferior in quality—were auctioned off anonymously. These events were among the first that initiated five years of artist protests in North and South America, France, Germany, Italy, Belgium, and Holland, against not only the crucial social issues but also the world combine of galleries, dealers, museums, collectors, and the international exhibitions at which the "art crowd" surveyed the current inventory of art objects with an eye to sponsorship, sales, and acquisition.

Protests against museums focused on specific, art-centered issues were of course not unknown earlier, but the period in which museums and galleries were drawn into the whirlpool of disaffiliation could be said to have begun in March 1968, when a group led by three critics, Gregory Battcock, John Perrault of the *Village Voice,* and Gene Swenson, picketed the Museum of Modern Art's exhibition *Dada, Surrealism, and Their Heritage* carrying such signs as "MOMA KILLS DAD" and "SURREALISM MEANS REVOLUTION NOT SPECTATOR SPORTS." From that time until 1970, artists' demonstrations, protest exhibitions, meetings, and dissident organizations proliferated in close synchrony with those of the new international youth culture, black militants, and the New Left. In the spring of 1968 French artists and intellectuals participated with students and workers in the abortive "revolution" in Paris, and during that same summer, the thirty-fourth Venice Biennale was disrupted and finally closed when many of the exhibitors and jurors resigned in sympathy.

Protests that summer also interrupted *Documenta IV* in Kassel, Germany. In the fall of 1969 American technological artists refused to participate in the ninth *Bienal* in São Paulo, and in 1970 the best-known American painter-printmakers refused participation in the American contribution to the thirty-fifth Venice Biennale—a show involving artists' participation that was intended to avoid the crisis of two years earlier. In 1969 and 1970 the accumulation of such activities became increasingly dense, but although broad political and economic issues still profoundly colored the mood of American artists (as they did the liberal membership of national associations of art historians, psychologists, sociologists, and other academics), the issues raised were increasingly art-centered.

Many artists had taken part in the disturbances in Chicago during the Democratic National Convention in the summer of 1968, but in September a movement to refuse to exhibit in Chicago until the expiration of Mayor Daley's incumbency failed to get the support of most well-known modernists. In October, however, Newman, Oldenburg, Rosenquist, Motherwell, and other well-known artists participated in a condemnatory exhibition called *Richard J. Daley* at the Richard Feigen Gallery in Chicago; after that art activity in the Second City continued as before.

The climactic period in the campaign against the museums—already beset by financial crises, conflicts of interest forced upon directors and curators, and the support of art activities not designed to fit within their gallery spaces—began when, on January 3, 1969, the Greek technological artist Takis Vassilakis removed one of his works without permission from the Museum of Modern Art's exhibition *The Machine as Seen at the End of the Mechanical Age.* His justification was that the work included was not the new piece that the artist wished to show, but an unauthorized substitution from the museum's permanent collection: the artist's control over his work was being violated. As a result of this encounter, the dissident Art Workers Coalition (AWC) was formed. In January this group forced the director, Bates Lowry, to discuss thirteen demands, of which the two most militantly pressed were a demand that a section of the museum be permanently reserved for black artists and that the museum be free at all times and open two evenings a week until midnight. These were unacceptable to the administration because the former violated the curator's right to select works and exhibitions solely on the basis of what he or she felt to possess quality and relevance; to have acquiesced to the latter, for a privately endowed museum beset with economic difficulties, would have meant closing its doors. Like the "nonnegotiable" demands presented to universities during these years that resulted in partial accommodations, plainly impractical ultimatums, to which trustees were seldom willing to submit, were the rule. As a result of these and other crises, Lowry resigned in May 1969.

Activity directed against the Metropolitan Museum had begun with the unfortunate 1969 exhibition *Harlem on My Mind,* rightly felt by the black community to embody a white rather than a black viewpoint, and was continued in 1970 by the AWC

and other groups formed in its wake. A climax came when the AWC managed to release a jar of cockroaches on the table of delicacies during a black-tie dinner meeting of the trustees held in a French period room at the museum. When, after demonstrations in May 1970, the Great Hall was opened in October to a mass discussion on the relation of the artists to the museum, the meeting was attended by the AWC, the New York Strikers (who had initiated a week's closure of New York museums as a protest against the Vietnam War), Women Artists in Revolt, the SoHo (South Houston) Artists Association, and other protest organizations. The gallery/collector/auction house/museum combine was seen by these groups as a concentration of the evils of society that produced them, but for the successful artist of whatever sympathies, the combine was essential to the maintenance of his or her public position and the practice of his or her art. Entirely central to this account, however, is the redirection, both reductive and dispersive, of the central streams of modernist and post-modernist art and activities themselves, which were moving ineluctably toward the fragmentation, de-aestheticization, and dematerialization of the object of art that, since 1960, had become a more stable and lucrative investment than stocks or real estate—the negotiable product without which the international art market could not operate. What is most at issue in this chapter is not propaganda art, but the inherently disenchanted and disruptive nature of post-modernist innovations after 1965, and the gradual politicization of art not overtly political in subject.

Like all crucial punctuations of history, the sweeping mid-sixties divergence from inattention to acute concern for political issues illuminates what had happened in art earlier by a clarified hindsight. It suggests a reinterpretation, for example, of the previous employment of the American flag as a motif. By 1965, used in ways that symbolized condemnation of the government's policies, it appeared in protest demonstrations and was on occasion desecrated and even burned. In December 1966 Steve Radich, the highly respected owner of a well-known Madison Avenue gallery, sponsored an exhibition by Marc Morrell made up of corpselike figures wrapped in flags. The next summer, Radich (not Morrell) was convicted of flag desecration by a New York City court. The Radich case became a crucial issue for gallery operators and critics concerned with freedom of expression, as well as for artists. In 1970, in an atmosphere of almost universal sympathy by the art community, *The People's Flag Show* was mounted at the Judson Memorial Church, long a center of innovative art activity in New York. Radich spoke at the

opening, and an assemblage of eminent lawyers, artists, gallery operators, museum personnel, among them John Hightower, the new director of the Museum of Modern Art, and even one city councilman participated in the rally that followed the arrest of three of the participating artists. Their subsequent conviction, during a period when flag motifs were blatantly used by manufacturers for everything from neckties to girdles and bikinis in violation of provision 136 of the General Business Law of the State of New York, was plainly for the political views they expressed.

Such events of the post-1965 period that once more demonstrate the atmosphere of confrontation between art and authority lead us to retrogress to the year 1954, when Jasper Johns painted his first flag motif. Rigid, like a target, a row of numbers, a beer can, or a coat hanger, it was used as one of Johns's pointedly insignificant motifs, but the flag had always been a revered symbol of patriotism. The image of the flag was not desecrated, however, as it was with the later protestors who carried it upside down (or with Johns himself who later made an anti-war poster in which the blue field was rendered in black) but made *banal:* it was a gesture of irony rather than protest.

The year before (1953) Larry Rivers painted his *Washington Crossing the Delaware,* a collage-style pastiche of Emanuel Leutze's vapid history picture (fig. 138). In 1955 he used the flag as a random collage element, and in 1960, along with the Confederate flag, it was draped over the first version of his *The Last Civil War Veteran,* derived from a *Life* magazine photograph (fig. 139). Rivers's hip, pre-Pop paintings arose from the disaffiliated underground of black jazz, and in the sixties he became a close friend of LeRoi Jones. Can one assume, then, that these early neutralized uses of nationally sacred patriotic symbols and subjects were an expression of political disenchantment, if not of criticism? Did the incipient protest in the art of the sixties begin, like the subliminal revolt of rock-and-roll music, in the mid-fifties? Later the flag became a routine motif in the iconography of Pop—most blatantly in Tom Wesselmann's Great American Nudes, in which it was the analog of lipsticks, cigarettes, toilet bowls, and vapid pseudo-pornography. These uses of the flag (like a harder core instance in the film of Gore Vidal's *Myra Breckenridge* in which Raquel Welch wears stars-and-stripes panties while she commits sodomy on a football player) were never prosecuted, perhaps because their social comment, if it was present, was not overtly critical of government policies. Yet they surely belong to the reascension of flag iconography that culminated in Kienholz's 1971 *Port-*

able War Memorial, which includes a recapitulation of the Iwo Jima Memorial in Washington enacted by empty uniforms; or the poster by a German artist that shows the five marines raising a flag emblazoned Coca-Cola.

Oldenburg fabricated deformed flag images as early as 1960, and in 1965–66 made a film, *Birth of the Flag,* in which a fabric flag emerges beneath the skirt of an actress simulating childbirth. Although it was not so regarded early in the decade, his entire career can be seen, at one of its many levels of meaning, as a critique of the society in which he has lived—its symbols, pretensions, and public monuments. Indeed, many years earlier Oldenburg had written: "I am for an art that is political—erotical—mystical, that does something other than sit on its ass in a museum."[8]

By its early detractors, Pop art was held to be flaccid capitulation to the commercial materialism that modernism had always resisted, and surely this was in part true. But Pop was a manifestation of immense complexity, seldom naive and often nuanced and ironic in its shades of meaning. Were Warhol's redundant photo-silk-screen images of race riots, automobile disaster, and electric chairs mere bids for publicity and bourgeois titillation, or were they efforts to demonstrate the desensitizing effect of the endlessly repeated scenes of horror in the press and on the tube? Or did they, at some level, indicate an even more fundamental comment on American society? (See fig. 140.) Were his intentionally tedious reels from an immovable camera, and such provocative films as *Blow Job* and *Flesh,* just for the mill of eccentric chic, or was Warhol's bland surfacing of the underground a dissembled conduit for a more fundamental impact? When he told Gene Swenson in 1963: "I want everybody to think alike. . . . Russia is doing it under government. It's happening here all by itself without being under a strict government; so if it's working without trying, why can't it

138
Larry Rivers, *Washington Crossing the Delaware,* 1953, oil, graphite, and charcoal on linen, 83⅝ × 111⅝ in. (212.4 × 283.5 cm). The Museum of Modern Art, New York. Anonymous gift.

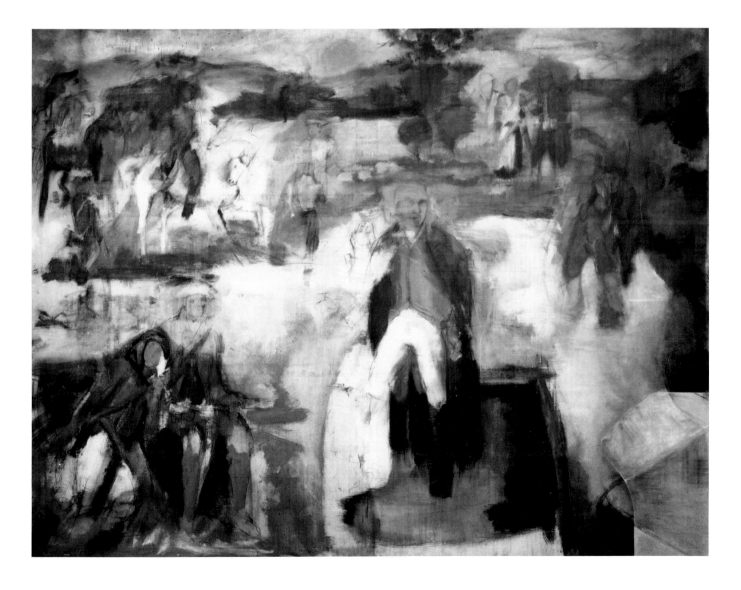

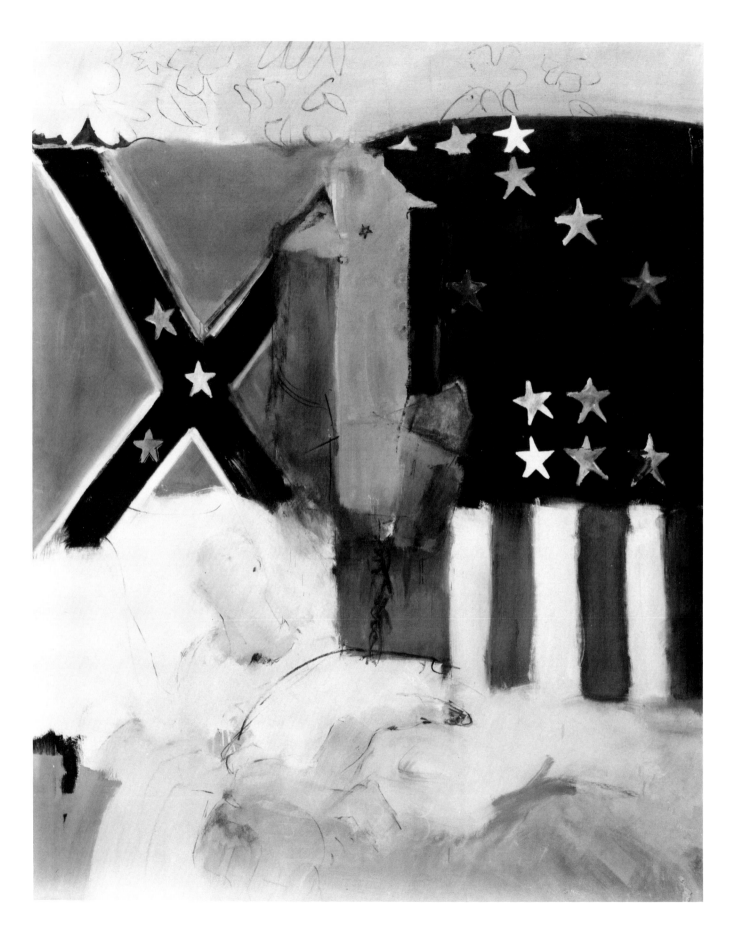

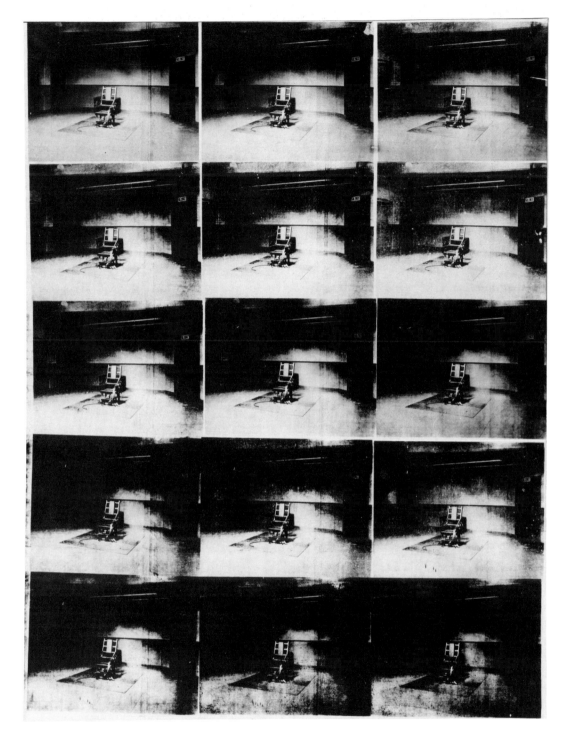

139
Larry Rivers, *The Last Civil War Veteran,* 1959, oil and charcoal on canvas, 82½ × 64⅛ in. (209.6 × 162.9 cm). The Museum of Modern Art, New York, Blanchette Rockefeller Fund.

140
Andy Warhol, *Lavender Disaster,* 1963, acrylic and enamel silk-screened on canvas, 106 × 82 in. (269.24 × 208.28 cm). The Menil Collection, Houston. Photo by Hickey-Robertson.

work without being Communist? Everybody looks alike and acts alike, and we're getting more and more that way. I think everybody should be a machine." [9]

Is this a cool joke, or a comment on dehumanization in a society dominated by profit and conformity? Some possible answers to these questions Warhol's art raises, his apparently naive acceptance of every deviation or so-called perversion, and his brilliant exploitation of a contradictory moment in history, are given in theories advanced in the late sixties by Herbert Marcuse, the father figure of the New Left. The populist and dispersive trends of the sixties, as well as the counterculture multimedia forms, could be said to have evolved, indeed, by an interaction between Marshall McLuhan's avowedly amoral and uncritical commentaries on the media and Marcuse's synthesis of Marx and Freud as a basis for a moralistic and radical dissection of capitalist and, to a lesser degree, communist society. It is not within the province of this account to attack, defend, or even summarize in any detail the circumlocutory theories of Marcuse. However, because Marcuse demands of society the satisfaction of deeply psychic and aesthetic as well as material needs, he, more totally than Marxist economic interpretations, rejects the entire fabric and structure of corporate capitalism. Only capitalism's technology and potential for universal affluence, redirected toward human fulfillment rather than profit, aggression, or repression, is worthy of preservation. In 1969 and 1971, the critic Gregory Battcock devoted two articles in *Arts Magazine*[10] to an application of Marcuse's argumentation (in which the arts are assigned a crucial revolutionary role) to the developments of the late sixties, drawing most of his material not from Marcuse's large body of dense theoretical writing, but from a short paperback, *An Essay on Liberation,* published in 1969 in response to the heightened atmosphere that merged crisis with a longing for new life styles, and a lecture, "Art as Form or Reality," delivered in a series, *On the Future of Art,* organized by the Guggenheim Museum in that year. The following capsulization of a fragment of Marcuse's analysis for its applicability to the later activities of the sixties is drawn from these sources as well as from earlier writing by Marcuse. It bears only on the issue in question: new art as a force leading toward a totally revised reality and (to use a phrase common by 1968) the *new sensibility.*

Acceptable art, according to Marcuse, is, like excess profits, repression, and war, an attribute of the prevailing structure. Therefore to be truly avantgarde, art must be inherently unacceptable to the power structure, its extensions, and its institutions.

(Sam Goodman's "no-sculptures" might qualify.) In Marcuse's words: "Art itself appears as part and force of the tradition which perpetuates that which *is* and prevents the realization of that which can and ought to be." [11] Assuming Marcuse's supposition, in the second phase that followed the original avantgarde—the first was a period of beatific symbiosis with the establishment—the artist, whether he knew it or not, was trying to break the suffocating bourgeois embrace, and he faced a real problem: what was distasteful to the combine one year became chic by the next. This historical process had begun, but at a much slower pace, in the years Duchamp showed his first ready-mades, or even with Impressionist painting; but by 1965 a half-century of mutation was compressed into a few months. Under such conditions, Marcuse argues, not only art but also the most hostile anti-art (or what was temporarily regarded as anti-art) is progressively absorbed, nullified, and in some form becomes *exchange* value or commodity. And it is precisely the Commodity Form, as the form of reality, that is the target of today's rebellion. Following Marcuse's thinking, Battcock determined that the only living, still virulent art forms—those that retained their negative relationship to the system—were the new pulp-paper sex magazines being sold at the time. Unlike the old pornography and even the underground press, he argued, these embodied a wholly liberated attitude toward all deviations from the norm and therefore were intrinsically unacceptable; to be included as well were such works as Warhol's films that were either too utterly boring, silly, scatological, disgusting, and unprofessional for anyone to have more than a passing interest in them.

Marcuse himself, however, rejects the effectuality of new forms of anti-art, returning to a traditional concept of art as a pursuit of beauty and sublimity, but this reanimated idealism must bridge the agonizing gap between what is and what could be. Once the old order is destroyed, art can break away from historical determinism: "And perhaps for the first time men would *see* with the eyes of Corot, of Cézanne, of Monet because the perception of these artists has helped to form this reality." [12]

Marcuse's utopian speculations, however, are not germane to the post-modernist progression of the late sixties. What is important to recognize is that many of the radical artists of this period acted *as if* they were following Marcuse's prescription, however futile their efforts might be, for a confrontational and subversive art that would in every way undermine the forms that, by the beautification of industrial parks, offices, or other institutions of the corporate state, would perpetuate capitalism by

ameliorating its dehumanizing conditions and concealing its true nature.

Boredom, whether or not so intended, can be a more subversive turnoff than horror or virulence, which—as in Bruce Conner's *Child* (pl. 30), Kienholz's tableaux, or even Mathias Grunewald's *Colmar Altarpiece*—exerts a morbid fascination. In minimal sculpture, the most stringently sparse painting, process and random distribution art, unorganized heaps of scraps or dirt, what was simply without visual appeal could provoke rage in a stray spectator from outside the scene. There is a breaking point in the scale of spectator interest in abstract forms that occurs when the object or situation plainly lacks even a vestige of controlled, felt relationships, whether as a result of reduction to a virtually empty canvas or monadic lump, random dispersion, or some other approach to anti-form. This juncture—the end of formal art—is the point at which the line between modernism and post-modernism can be drawn.

Unless a spectator is willing to readjust his attention from a visual, physical object to a nonvisual, conceptual "object" that can be projected in words or documentation, unadulterated Conceptual Art—or a virtually empty gallery—can be the most provocative of all anti-art. Quite understandably, artists usually object to having their ideas, which they see as independently arrived at, placed in a devolving historical context. In a disapproving review of Lucy Lippard's book *Six Years: The Dematerialization of the Art Object from 1966 to 1972*, the conceptualist Mel Bochner complains (perhaps quite justly) "that many of the artists she lists outlined the premises of their art quite early . . ."; yet he calls for an "analysis of the political and economic issues that inform esthetic problems." [13]

That the allegedly aesthetic can, with a jolt, become controversially political was demonstrated by the cancellation of an exhibition of the work of the German artist Hans Haacke by the Guggenheim Museum in the spring of 1971. For several years Haacke had been working with such active forces as wind, rain, evaporation, condensation, ice, growing grass, and live creatures. His interest was not, however, simply in "nature," but in real-time systems that interact with their environment and continually change. As Haacke's submission to the exhibition *Information* in 1970, the Museum of Modern Art permitted him to install plastic voting boxes recording the spectator's intention to support or oppose Governor Nelson Rockefeller, a founder and patron of the museum, on the basis of the governor's apparent approval of the Vietnam War. When the Guggenheim's one-man show of Haacke's work was ready to open, however, it was found that one exhibit, an-

other piece of real documentation, this time from public records, consisted of amplified photographs of slum tenements along with a listing of the owners' names. Possibly faced with adamant objections from his trustees, the director, Thomas Messer, canceled the exhibition; Edward Fry, the curator who was arranging it, resigned in protest. In documenting the real world of social systems, what looked like Conceptual Art had become Political Art. This work was later shown at the New York Cultural Center, an activity of Fairleigh Dickinson University: the confrontation of artists with slumlords is more distant, perhaps, in academia.

The centrifugal evolution of happenings toward political intent unfolded in a different fashion, and with different cultural interrelations than elitist reductionism, yet before 1970 their vast influence merged with it in a similar situation. In the first period—from the crypto-happenings conducted by John Cage at Black Mountain College until the precedence of Pop art—happenings had anything but a confrontational atmosphere. A who's who of the Uptown art set could be compiled from photographs taken at the Reuben Gallery and other disintegrating stores, lofts, vacant, and field lots, before 1964. In retrospect, what strikes the memory about these part-planned, part-impromptu, part-collage, part-theater occurrences was the proximity of bodies—those of the spectator-participants as well as those of the performer-participants between which, as in the so-called New Theater, a sharp distinction was usually avoided. Everyone milled, breathed, pulsated, and complained within the same, often confined space. Although little that was really iniquitous transpired, the groping, crawling, writhing, and gesturing among "junk" environments of balloons, stuffed dummies, old newspapers, plastic, dripping paint, chicken wire, papier-mâché, rags, dough, jam, diverse soft and yielding materials, suggestions of nudity, and the Dionysian abandon gave to the first happenings a heady, vaguely orgiastic atmosphere. In two years the first fever of fashion subsided in New York, but by then Allan Kaprow, the ubiquitous maestro of the medium, was carrying the message around the country and the world. The term "happening" was appropriated by Thomas Hoving, New York's swinging new Park Commissioner; happenings became one of the public attractions of "fun city."

As distinguished from multimedia—combinations of light, sound, multiple projections from banks of automated slide projectors bombarding the senses from every direction—happenings are "intermedia" manifestations that occupy a middle ground between environmental collage, participatory the-

ater, group demonstrations, and the general disorderliness of everyday life. All writers on happenings emphasize that, dissolving Rauschenberg's gap between art and life, one primary aim was the synonymity of these two poles. Michael Kirby has traced the diverse origins of the happening in Futurism, Dada, Surrealism, avant-garde theater, and dance: all these movements share this aim in one way or another. Common to them also is the interaction of persons in a state of heightened perception and sense of involvement. Similarly, in youth culture, from its beginnings in the screams of swooning teenagers at the concerts of Elvis Presley in the fifties on through rhythm-and-blues, rock-and-roll, hard rock, and the Woodstockian festivals of the sixties, a ritualistic merger of bodies and souls is the leitmotif. Even at the Watkins Glen Rock Festival of 1973, attendance at which surpassed Woodstock, one of the participants stated that she came not primarily for the music, but to be close to other people. Unlike the Dada confrontations between avant-garde and bourgeois, these mass events were characterized—as the press, police, and even the disquieted townspeople observed with amazement—by a total lack of violence. The adversary was absent. In a Marcusean sense, these were rites in which love and cooperation ruled rather than repression, competition, and hostility. They were the intoxicating agapes of those who, in temporary respite from things-as-they-are, improvised a new society in which rules arose from the common ground, rather than being imposed from above. On different levels of intensity, the manifestations of the alternative society between 1964 and 1969—the love-ins and be-ins that took place from New York's Central Park to Haight-Ashbury in San Francisco—these pockets of the new sensibility gave temporary reinforcement through proximity and sympathy to a generation that felt alienated from their elders and their governments. Except for the Students for a Democratic Society and other militant groups whose aims were expressly revolutionary, the early counterculture, and such cult figures as Allen Ginsberg and Ken Kesey, were not political; they simply chose to tune out an inequitable system.

A large part of Udo Kultermann's book *Art and Life* [14] is devoted to listing and illustrating some of the more notable happenings and interactional events that sprang from a similar rejection of the status quo; between 1955 and 1971, with the peak years being from 1960 to 1962, more than three hundred well-publicized such events occurred in at least twelve countries. In this account it is therefore necessary, in ascertaining their political thrust, to typify the various tendencies and locales by a very few examples.

In following the evolving patterns of what could be called happenings in the broadest sense, it would be best to avoid the term entirely if there were another more inclusive one; used as the only alternative, it must be stretched almost to the breaking point. And by no means could all happenings be said to be leftist, or even countercultural, activities. Indeed, in the chic Zen events organized by James Byars, and the unsuccessful *Nine Evenings: Theater and Engineering* at the 69th Regiment Armory in New York in 1966, which initiated the national group called Experiments in Art and Technology, the identification was with the media and a group of wealthy sponsors. Yves Klein's first public showing of human impressions, in which three nude models placed paint on their bodies and imprinted themselves on canvas following the directions of the artist who was dressed in sartorial evening clothes, was presented to an immaculately groomed audience gathered in a Paris salon. Many of Klein's activities, in fact, went beyond jet-set chic or elitist snobbery, toward the right-wing radicalism of Dalí: from his early training in judo to his ritualistic happening-marriage conducted in the presence of the Chevaliers of the Order of Saint Sebastian, to which Klein belonged, his events had a rightist emphasis.

Tinguely's *Homage to New York* (see pp. 57–60), like his later enactment of the end of the world by atomic explosion held near a proving ground in Nevada, was a spectator event, like Klein's "imprintastions." But it cut in more than one direction. The large junk assemblage, painted white, was a beautiful object before its demolition; its title indicated both a homage and a destruction; enacted before a lustrous establishment audience, the event exuded fashionableness—yet Tinguely surreptitiously introduced fire into his scenario in a museum that only three years before had undergone a conflagration that had destroyed major works of art. At the same time, destructiveness was also the theme of the English artist G. Metzer, whose "auto-destructive art" in 1960–61 employed acid to disintegrate plastic sheet; and he proposed iron sculpture that would rust away in the weather. As his manifestos stated, auto-destructive art mirrored the H-bomb's destruction of the individual, masses of people, and nature by man's disintegrative power—the application of technology to modern welfare.

The best-known French happening maestro of the early sixties was Jean-Jacques Lebel. His piece *For Exorcising the Spirit of Catastrophe*, performed and filmed in a Paris studio, combined exaggerated sex symbols employing huge papier-mâché phalluses, political collage, and two almost nude women wearing masks caricaturing John Kennedy and Nikita

Khrushchev, who entered an "international blood bath"—a bathtub full of chicken blood and water. The combination of defiant sexuality with social protest (announced in the early collages and assemblages of San Francisco and New York) also characterized the Paris happenings of the Japanese artist Tetsumi Kudo. In such participatory events, rising to an agonizing crescendo by 1970, eroticism and political caricature gave way to repulsive rites of birth, violence, and death, not in France but in American and especially German happenings.

Of immense interest in documenting the dissolution of the line between art and life as political action, however, was the appropriation of the happening by militants. The "Will Shakespeare" of this dissemination was the yippie leader Abbie Hoffman, who "culled the esoteric concepts formulated by Dada and Surrealist artists . . . worked over for years in East Village lofts and West Coast workshops, and made them relevant to an audience of millions." [15] These real-life street happenings, labeled the Theater of the Apocalypse, merged all that had occurred in the underground and counterculture, and during the history and prehistory of the happening, with political demonstration. A classic example was offered one day in 1967, when Jerry Rubin and his yippies forced their way into the balcony of the New York Stock Exchange with a supply of paper money: "We throw dollar bills over the ledge. Floating currency fills the air," Rubin recalled in his book *Do It.* "Like wild animals, the stockbrokers climb all over each other (as in René Clair's film *Le Million*) to grab the money. *This is what it's all about, real live money!!! Real dollar bills! People are starving in Biafra!! we shout.* We introduce a little reality into their fantasy lives." [16] "Revolution," he wrote, "is Theater in the streets." Its Wagnerian climax was the program of demonstrations performed at the Democratic National Convention in Chicago in 1968. In a suite of happening scenarios like those of Kaprow, Dine, Whitman, and Oldenburg brilliantly staged before the media and the world, the roles, entrances, and exits of demonstrators, sympathetic liberals, police, the media, and spectators were programmed by Rubin, Hoffman, and other radical leaders. Impressive in their scale, the protests at the Democratic Convention are only one among many instance of the theatrical planning of political demonstrations. "Artaud is alive at the walls of the Pentagon," [17] Hoffman wrote of the massive Washington demonstration of 1967.

Even more historic, the Paris uprising in the spring of 1968—the same year as Chicago—included fully staged theater pieces, some using the porticoes and steps of public buildings as settings.

The related posters remain among the best art to come out of Paris during that discordant twelve months. In New York, Yayoi Kusama, who became known for her objects and environments carefully assembled from hundreds of compulsively multiplied phalluses made of stuffed cloth, turned to directing "naked events." After infiltrating such public places as the garden of the Museum of Modern Art, the portico of the U.S. Treasury Building, and the base of the Statue of Liberty, Kusama's women rapidly stripped and performed Dionysian dances. Eroticism, violation of taboos, and incipient protest were smoothly blended in these provocative yet quite orthodox happenings.

The substitution of the artist's body, or those of others, for the art object, from a public point of view often in eccentric and even aberrant demonstrations, became an international phenomenon after 1969. One playful and amusing instance was an exhibition of "living sculpture" organized by Pi Lind in Stockholm in 1969: white sculpture bases served as platforms for quite ordinary fully clothed people rather than works of stone or bronze. A step closer to "living sculpture" was made by two young art students at St. Martin's School in London who called themselves Gilbert and George. After experimenting with a variety of forms and activities that carried sculpture beyond its accepted limitations, they hit upon a solution that made not only their bodies into moving sculpture but also redirected their entire lives, at least as they appeared to the public, into a bizarre but total commitment. The first performance of the ritualistic form that rapidly made them famous throughout the small international coterie that follows such innovations took place at St. Martin's in 1969. It was a mechanically performed music-hall presentation accompanied by a record of the English song *Underneath the Arches.* Their "singing" was a mimicry of a phonograph record by a team known as Hardy and Hudson. This intentionally stiff, mock rendition was by 1970 polished into precisely planned presentation that took only a few minutes, but was repeated endlessly. They appeared in English art schools, museums, galleries, studios, and halls in Germany, Holland, Italy, and finally of course New York. The phonograph was replaced by a cassette tape recorder, and their old artists' clothes replaced by new but ill-fitting, old-fashioned identical brownish shoes and imitation gray flannel suits, their faces and hands colored an imitation bronze like the cheap novelty-store sculpture. They performed on a table, in front of which was placed the tape recorder—on the floor. Otherwise, the elements of their art consisted of "two sculptors, one stick, one glove and one song."

141

Gilbert and George, *Underneath the Arches,* drawings. Courtesy of Sonnabend Gallery, New York. Photo by Nick Sheidy.

The Ritz we never sigh for, the Carlton they can keep, there's only one place that we know and that is where we sleep. Underneath the arches we dream our dreams away, underneath the arches on cobblestones we lay. Every night you'll find us tired out and worn, happy when the day-break comes creeping heralding the dawn. Sleeping when it's raining and sleeping when it's fine, we hear trains rattling by above. Pavement is our pillow no matter where we stray, underneath the arches we dream our dreams away.[18]

After each mimicked rendition of the sad lyrics and squeaky, haunting melody of *Underneath the Arches,* the burnished faces perfectly dubbing the thin distant voices of the actual singers, first one and then the other of the pair of living artworks changed his prop—a glove for one and a cane for the other—from one hand to the other, descended slowly and deliberately from the table, and reversed the cassette, thus beginning the same verse again. The effect of these bland young Englishmen, completely dehumanized by the perfection of their clockwork mimicry and jerky movements, was both hypnotiz-

ing and frightening. In their longest performances, in Cologne, Aachen, and Krefeld, *Underneath the Arches* was repeated for ten almost consecutive days at ten-hour stretches without intermission. Always bland and gentle in their demeanor, Gilbert and George in their other activities were less traumatizing. "To be with art," they wrote in one of the characteristic inscriptions on their drawings and in their mailings, "is all we ask." Their accompanying square, wall-size drawings represent the pair of living works of sculpture ostensibly in their walks through suburban groves of trees, living a life entirely devoted to the aestheticized dream of their single song. Rendered in rough charcoal style, the large drawings call to mind the English landscape tradition and, strangely, the outdoor subjects of Francis Bacon, and are embellished with carefully lettered inscriptions extolling their philosophy of life-become-art (fig. 141). The wistful charm of the utopian, mechanized redundancy of these performances at the end of the sixties could not be more unlike Kienholz's powerful tableaux from the decade's first years.

Post-Pop and Photorealism

Since the forties, programmatic "returns" to figuration have been intermittent, even though the figure, like other recognizable subjects, had never really "left." The resurgence of figuration in the late sixties began with the exhibition *Realism Now,* organized in 1968 by students at Vassar College under the direction of Professor Linda Nochlin. It was premised on the perennial battle between abstraction and representation and on the assumption that a significant link exists between nineteenth-century French realism, new cinema, and the dissimilar works and ideas of such painters as Lennart Anderson, Richard Artschwager, Jack Beal, Robert Bechtle, John Button, Larry Day, Richard Estes, Jane Freilicher, Paul Georges, Sidney Goodman, Alex Katz, Gabriel Laderman, Alfred Leslie, Malcolm Morley, Lowell Nesbitt, Philip Pearlstein, and Sidney Tillim. The miscellany at Vassar was explicable in terms of propaganda or, perhaps better, counterpropaganda: Nochlin's student committee was plainly mustered to deal a deathblow to Greenbergian formalism. "The new realism," Nochlin's introduction proclaimed, "has exploded the modernist myth entirely." [1]

A second roundup, again of a "new realism," turned up at the Milwaukee Art Museum in 1969 (seventeen painters), and a third in *Twenty-two Realists* at the Whitney Museum in 1970. These exhibitions can perhaps be theoretically justified as demonstrations of the options open to a figurative artist, and it is not the intention here to badger their organizers through twenty-twenty hindsight, but simply to recall the pattern of curatorial imprecision, however defensible, from which the old idea of a "new realism" is repeatedly dusted off for reuse.

It is more than two decades since Andrew Ritchie was journalistically trounced for dividing his exhibition *Abstract Painting and Sculpture in America* at the Museum of Modern Art into the categories "Pure Geometric," "Architectural and Mechanical Geometric," "Naturalistic Geometric," "Expressionist Geometric," and "Expressionist Biomorphic."[2] He was looking for order in a tradition at that time little more than four decades long. I shall not presume, therefore to so categorize representation, a practice that began some 20,000 years ago. One distinction is too fundamental to evade, however. Consideration of the most recent recurrence of figuration must begin by pointing out that most of the criticism that dealt with new realism failed to separate painted images generated by photographs, the media, and other mechanical modes of reproduction from those based on the traditional transformation of three-dimensional equivalents.[3] As one painter, Tom Blackwell, says, "The camera makes a two-dimensional approximation of a three-dimensional reality in a way that no painter would."[4] Criticism has also failed—a strange omission in studying realistic art—to give close attention to subject matter: it just *might* still make a difference whether a painter depicts parking lots, green pears, jelly jars, naked people, or quarter horses.

The exhibition *Environment U.S.A.,* organized for the São Paulo *Bienal* in 1967, was constituted of artworks reflecting the world of artifacts within which most Americans live most of the time, and the use of new methods of arriving at figurative images. Claes Oldenburg's notorious environment, *Bedroom* (1963), shown in that exhibition, provided an acidly relevant background for synthetic realism. "Every visible surface is false to its material: the dresser and the paired night tables are of formica which imitates marble; the mirror is not glass but metal; the white rug is artificial fur; the outlandish lounge is upholstered with 'Zebravelour'; thrown on it is a vinyl leopard-skin coat and an immense, mirror-black handbag. The towering lamp shades . . . are 'marbelized'; the quilted bedspread is plastic, and the sheets shine luridly . . . in white vinyl. The paintings on the walls are textiles that imitate the drip style of Jackson Pollock."[5]

Edward Ruscha's *Standard Station, Amarillo, Texas (Day),* a prime work of the new genre (pl. 31), as well as Lowell Nesbitt's paintings of IBM machines and Malcolm Morley's *Ship's Dinner Party* were also in that exhibition. (Later, the California painter Jack Mendelsohn, in such works as *Yellow Sofa and Swan Vase,* combined the ambience of Oldenburg and Morley, offering anti-homage to egregious and degraded taste in interior decoration.)

As has repeatedly been remarked, a predilection for sharp-focus imitation of objects is characteristically American, if not characteristically human. In the introduction to an exhibition of trompe l'oeil painting (a native tradition continued, on 1960s scale, in Stephen Posen's illusionistic paintings of cloth-covered arrangements of box forms), Alfred Frankenstein, the acknowledged authority on this genre, once more recalled the well-known account, related by the Roman historian Pliny, of a painting competition that took place in ancient Athens between the painters Zeuxis and Parrhasios.[6] According to this story, Zeuxis painted a bunch of grapes so convincingly that the birds flew toward them. When Parrhasios appeared with a work to challenge this feat of imitation, Zeuxis requested that he pull back the curtain and display his picture. It was only then that Zeuxis realized that he had been conned, and graciously conceded defeat. Another account concerns the Greek painter Apelles, who is said to have painted a horse so lifelike that other horses neighed at it. These folktales suggest that, like most Americans, most Greeks seemed to equate the highest achievement in art with the ultimate degree of likeness.

Although it is not known what ancient Greek paintings looked like, and though they surely did not resemble modern photorealism, confirmation that the reigning concept of art's function as imitation is corroborated by Plato's objection to art as a source of knowledge in the *Republic.* The artist, he contended, does not represent ideas. Hence works of representational art are *imitations of imitations:* doubly artificial. Some 2,400 years afterward, the abstract painter Hans Hofmann titled a book on his work *The Search for the Real,* an essence which he, like Mondrian, Kandinsky, and Klee, believed to exist in natural principles and relationships rather than forms.

In 1968 an exhibition of minimal abstract painting and sculpture was organized for the Museum of Modern Art under the title *The Art of the Real.* "Today's real," E. C. Goossen wrote in the catalog, "makes no direct appeal to the emotions, nor is it involved in uplift. Indeed, it seems to have no desire at all to justify itself, but instead offers itself for whatever its uniqueness is worth—in the form of the simple, irreducible, irrefutable, object."[7] Here, contradicting both Zeuxis and Plato, reality is held to exist in artifacts that are both *non*representational and *non*symbolic. Even without considering the Surrealists' convincing defense of reality as intrasubjective—the movement could have been called, more accurately, *sous-realisme*—it is evident that the most ancient of all philosophical debates, over what can

be held to be "real," has not been resolved in the twentieth century. Short of a sequence of styles and examples that would include all figurative art since the caves, and an interminable range of theoretical distinctions, the term "realism" is of use only in carefully specified contexts. And among the vague labels commonly applied to the study of artworks, "new realism" is surely among the emptiest of fresh connotations.

To fit the purposes of this essay, the stringently realistic artist in any medium is one who replicates some segment of the physical environment with precision, and without apparent bias, taste, emphasis, or subject deformation. The disquieting veristic sculpture of Duane Hanson (fig. 142) and John de Andrea (fig. 143), in which the clothes and objects are actual, hair seems to be so, and bodies are simulated more precisely than ever before in the history of art, all but conform with these requirements. In the direct, nonillusionistic method of casting from a live model, there is no need for the mediation of a photographic or mass-media image. But, similarly, wholly realistic *painting*, however generated, would eschew all imposed principles of form, pictorial composition, hierarchic graduation of focus, accentuated brushwork, or even a direct interest toward one part or another of the surface. To the archetypical realist a hubcap would be as interesting, or uninteresting, as a face. Every square inch of canvas surface would be given equal attention; realism would be, in Richard Estes's words, a "cold, abstract way of looking at things, without comment or commitment."[8] A romantic, expressionist, humanist, naturalist, or formalist would be banned from the realist temple, for he would surely betray his beliefs and predispositions, if only by selectivity and emphasis. Like a medieval nominalist (the opposite of a medieval realist), he would believe only in the reality of particular things that he could see and, vicariously at least, touch. "I think if there is one thing that is consistent with new realist painters," Posen says, "it is a concern for an accumulation of information."[9]

These conditions add up to absolute neutrality and objectivity—a state of consciousness impossible to maintain. But what is more radical about photo-generated paintings than their approach to impartiality is, precisely, that their source is *not* the physical world. They are triply artificial: the term "artifactualism" would describe them more accurately than "realism." Unlike Courbet, Monet, Cézanne, Matisse, Hopper, or even Stuart Davis, the photorealists do not make a personalized transformation from objects and phenomena as they exist extended in space and directly experienced. They utilize mechanical intermediary images already two-dimensional: slides, photographs, projections, or printed material.

Since the time of Delacroix, photographs have served as stimuli and ancillary source material for painters, but never before wholly and unabashedly. It is their radical abbreviation of the creative process, as well as the new synthetic look, that provoked this intemperate paragraph in an article on new realism by the *New York Times* critic Hilton Kramer:

> And then, inevitably, there is the lunatic fringe, struggling to revive the moribund pop movement, a realism that prides itself on its mindlessness, on its ability to approximate the impersonal mechanism of the machine. . . . [This kind of work] is interesting only as evidence of the kind of rubbish that follows in the wake of every turn in the history of taste.[10]

However incongruous it appears, the striking, photo-derived portraiture of Chuck Close (fig. 144) was the immediate target of Kramer's distaste, but its circle of detestation expands to surround an apparently insidiously motivated, albeit unidentified, coterie. It is of course true that such painting (best identified as photorealism, or by Udo Kultermann's term "radical realism") had its origin in the Pop movement. The term "pop," as Lawrence Alloway recognized when he first used it in 1958, "was a friendly way of saying mass media."[11] Technically, Pop art was a mode of making images from images—as one of the lead items in the incunabula of Pop, Richard Hamilton's collage *Just What Is It That Makes Today's Homes So Different, So Appealing?* demonstrated, two years before, in 1956. Alloway's name for what he later called "likenesses" of the commercial environment was "post-Pop," a term which, like "post-Impressionism," tells nothing about the work but a bit about its antecedents. Marshall McLuhan was surely the philosopher of the movement, for Pop art marked the incursion of the media, with the entire multivalent potpourri that term connotes, into the elitist precinct of the fine arts.

Pop artists casually but ruthlessly flipped the coin of taste: the sanctioned images, modernist as well as traditional, engraved on one face were replaced, quite intentionally, by the crass simulacra on the other. Values customarily espoused by cultivated people were displaced or adulterated by those held to be coarse, meretricious, and vulgar. On the surface, Pop was a victory for commercialism, pluralism, and populism over elitism. Reviving the iconoclasm of Duchamp, Picabia, and Dada, it was a

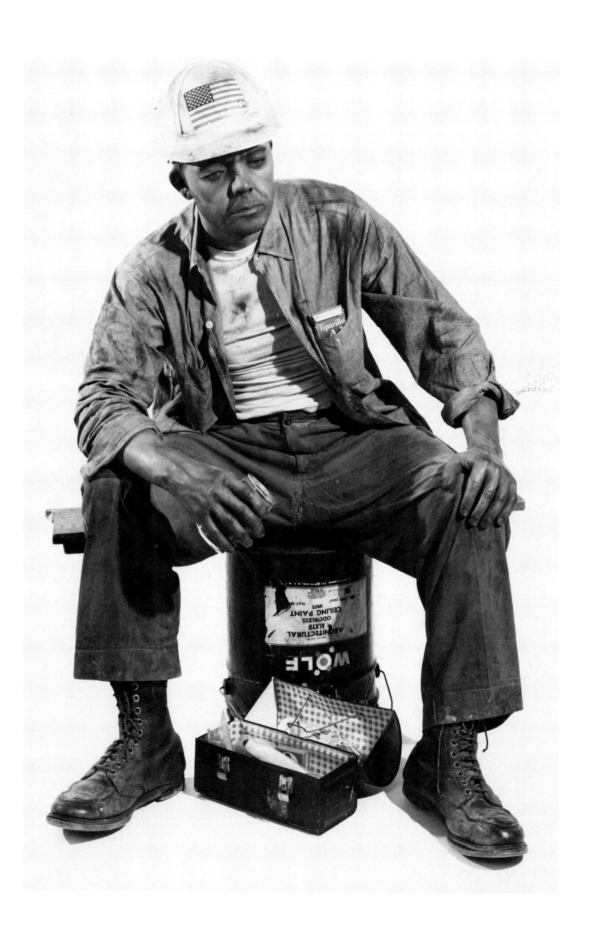

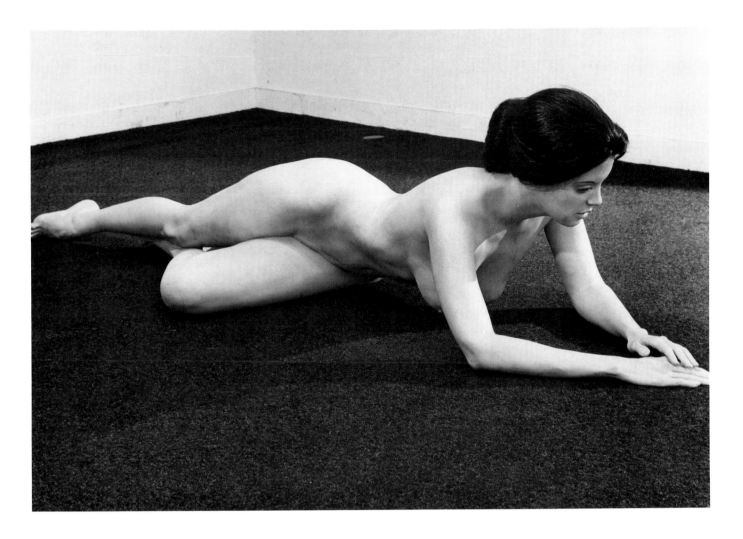

cool put-down of ideas and images that Western culture had enshrined. In recent history, the subversion of high art began with Larry Rivers's *Washington Crossing the Delaware* in 1953, but was implemented most effectively by Roy Lichtenstein, who painted a series of pictures parodying Cézanne, Picasso, Mondrian, Monet, Abstract Expressionism, and modern art in general, rendered in simulations of cheap techniques. This procedure in turn gave impetus to the revival of Art Deco, initiated largely by Lichtenstein's friend the dealer Ivan Karp, who more than any other nonartist was the advocate of radical realism. After 1965, camp depreciation of high art became a genre involving several painters. One of the first was the French Pop artist Martial Raysse, but the most publicized was the American John Clem Clarke. His procedure at that time was first to project an image from a reproduction or even a television image of a Velásquez, Rubens, Copley, Titian, or some other master on the screen, cut stencils from the projection, and fabricate a coarse facsimile by spraying paint through the stencils onto a canvas

laid on the floor. Mention of this uninteresting game of corrupting masterworks is essential to establish the context of photorealism and to call attention to the chain of artificialities by which this form of art-from-art came into existence.

In what were some of the most distasteful and coldly aversive images of the sixties, Richard Artschwager, maker of functional as well as reductively symbolistic furniture, simulated black-and-white photographs of New York apartment houses, commercial buildings, and other American images as early as 1964, using a rancid liquitex grisaille on celotex. Sooty and repellent, like the mood of a Beckett play, they seemed to be directed against the system that produced the source material. These are surely among the first radical realist works. But the early media-generated paintings of the English painter Malcolm Morley, like Oldenburg's *Bedroom*, define the direction in all its contradictions. Morley, who moved to New York in 1958, did not use a projector, but started with a travel brochure, a color photograph, or an illustration from a magazine. He

142

Duane Hanson, *Hard Hat Construction Worker,* 1970, painted polyester resin, clothes, wood, metal, and plastic, 47½ × 35 × 42 in. (120.65 × 88.9 × 106.68 cm). Virginia Museum of Fine Arts, Richmond, gift of Sydney and Frances Lewis.

143

John de Andrea, *Reclining Woman,* 1970, polyester and fiberglass, life-sized. Collection of David Bermant. Photo by Joel Peter Witkin. Courtesy of O. K. Harris Gallery, New York.

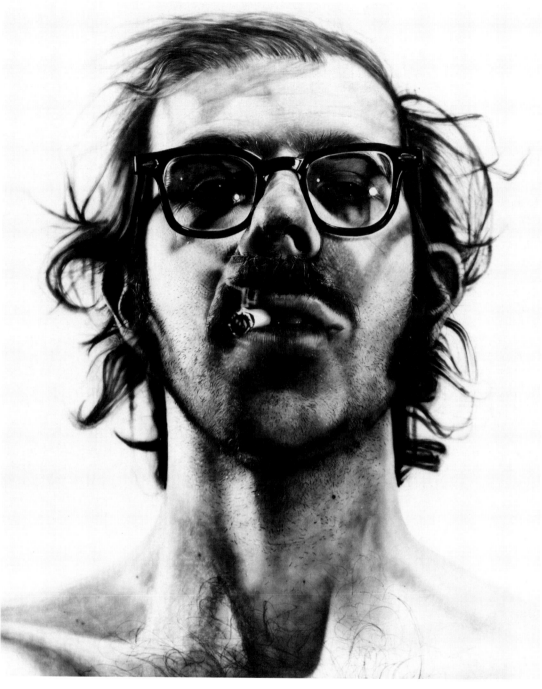

144

Chuck Close, *Big Self-Portrait*,
1968, acrylic on canvas, 107½
× 83½ in. (273.05 × 212.09
cm). The Walker Art Center,
Minneapolis, Art Center Acqui-
sition Fund, 1969.

divided, and often cut, this reference material into
numbered squares, enlarging each meticulously by
the traditional mural painter's method, at times
keeping both original and painted enlargement up-
side down during the process so he could concen-
trate only on one *subjectless* fragment of shape and
color without recognizing it as an eye, a geranium,
or a drinking glass—a post-Pop equivalent of the
wish expressed by Monet to paint without previous

knowledge of his subject. By this means Morley,
who admired Malevich and Newman, avoided even a
vicarious involvement with actual depth, space, sol-
idity, or light, while producing a simulacrum of ac-
tuality by an imitative but still abstract procedure.
A white border was retained as part of the picture,
directing attention pointedly to his artificial source.

Morley denied any interest whatever in his Pop
subject matter and by 1970 had abandoned his

magnifying-glass precision for a heavily brushed manner through the impasto of which the image appears "to be floating just behind the surface of a choppy sea, or a field of leaves, or a bed of feathers."[12] The new result was an optical-conceptual pulsation, in which "different areas compete for the attention of the conceptualizing mind."[13] He also disclaims a socially critical intent in such pictures as *Ship's Dinner Party* (1966) or *Beach Scene* (1968) (pl. 32), in which everyone saw a resemblance to Richard Nixon, yet it *was* Morley who chose his subjects, and the acerbity of his portrayals of Americans at play read loud and clear. Almost without thinking about it, most artists place themselves outside the social hierarchy and thus constitute their own counterculture; perhaps such a disaffirmation as Morley's is the mark of a true ironist. But whatever his intention, these super-Kodachromes of carefree affluence, painted during a period of dehumanization and social convulsion, elicit a response approaching nausea and put such once-unquestioned goals of American life as commercialized enjoyment, affluence, power, and social status in devastatingly sharp focus. More than any other artist, it was Morley who gave a sardonic edge to the new realism or "artificialism."

In contrast with Morley, Richard Estes, who also lives and works in New York and represented this country in the thirty-sixth Venice Biennale, is a straightforward environmental realist, and his work has little affinity with Pop. He begins by taking his own color slides, usually of a business street or a few commercial buildings in his neighborhood, the Upper West Side (pl. 33). His apartment/studio is secluded and conservatively decorated. As did the Surrealist René Magritte, he paints with fastidious care and neatness at an easel placed on an uncovered and unsoiled oriental rug. There are occasional wraithlike figures in his paintings, but these are usually seen from across the street, inside telephone booths, as distorted reflections on polished metal surfaces and store windows, or as fragments through these. By these devices the figure is dehumanized—trapped within a maze of interlocking surfaces (figs. 145 and 146). Estes makes pictures that are superbly realized, patterned with painstaking artistry, icily beautiful, and of immense optical complexity, but he chooses material because he finds it ugly, or even, as he said in 1968, "hideous," rather than because it is attractive: "I don't enjoy looking at the things I paint, so why should you enjoy it."[14] Such microscopically precise, masterfully nuanced close-ups of commercial modernism as *Subway* (1969), *Nedick's,* and *Diner* (both 1970) seem to endure in an eternal vacuum (figs. 147–149). Habitation, even respiration, would be impossible here not because of pollu-

tion, but because neither life nor decay can take place within this sterile, glittering labyrinth.

The artists with whom Estes identifies in approaching the world of concrete, steel, and glass are from the past—the French urban photographer Eugène Atget and the eighteenth-century Italian painters of *vedute,* especially the Venetian Antonio Canaletto and his nephew Bernardo Bellotto, who painted in Dresden, Vienna, and Munich as well as in Italy. In color slides, Estes has made his own comparisons between their motifs and their paintings. His historical perspective is a reminder that Leonardo, Dürer, the Canaletti, Vermeer, and many other masters utilized the camera obscura or other optical viewing and drawing devices. In the same way, Estes uses the camera to give specificity, color tonality, and sharp-focus veracity to his immobile icons of the inner city.

One can shed real tears over the passing of that rich and meditative process of transformation from nature into art for which we revere Cézanne—but even Monet selected and viewed his motifs like a photographer and with less aesthetic transformation of the underlying pattern of elements than Estes. Robert Cottingham, formerly an advertising art director, also paints the city center, but his camera has been directed toward out-of-date electric signs and by an abstractionist's criteria of composition and simplification, thereby relating his work more to formalist than realist principles. Noel Mahaffey also paints cities—until recently, mainly panoramic views. But *Parkway House* (1972) memorializes a specific example of adulterated modernist architecture, striking, like Artschwager's office buildings, in its blatant ugliness.

Assuming that the environment of artifacts, in a period of changing technology, can be a legitimate concern of the painter (a premise not everyone would grant), how should he or she go about it? In painting the Circus in Las Vegas (this circular "building" is actually a three-dimensional electric sign for the much larger gambling casino), should Ralph Goings have sat—an anachronistic Impressionist, wearing a broad-brimmed straw hat and perhaps a gas mask—on the highway divider of the Strip, squinting through the screen of speeding traffic?

Venice, like New York or Las Vegas, is an all-but-total artifact, but one that relates to these cities as a jeweled altar frontal does to a cash register or a slot machine. In such works as Ambrogio Lorenzetti's fourteenth-century *Good Government in the City* fresco in Siena, major painting of the urban environment began in Italy and its history parallels that of the culture of cities. As late as 1900, in Pissarro's views of Paris, the city still offered a sensuous and scintil-

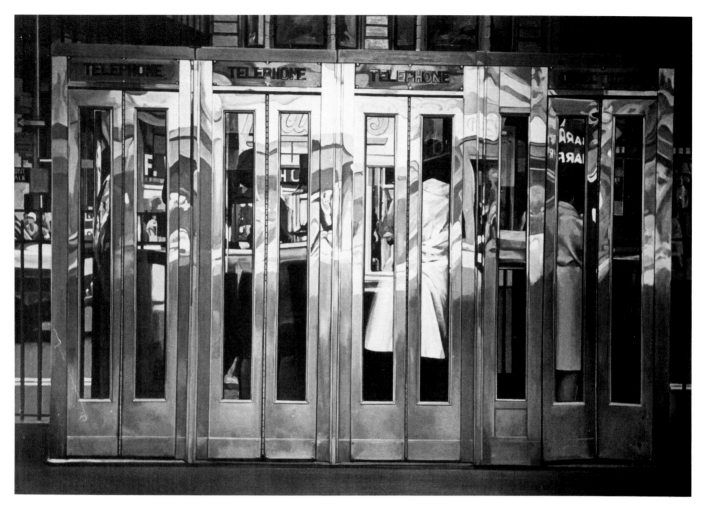

145
Richard Estes, *Booths,* 1967, oil
on canvas, 48 × 69 in.
(121.92 × 175.26 cm). Courtesy
of Allan Stone Galleries, Inc.,
New York.

lating setting scaled for human activity; but, as
Léger and the Italian Futurists sensed, it was eventu-
ally to become an encompassing mechanical totality
by which its inhabitants would be stimulated but
also altered and dominated.

There were three major American precursors of
unsentimental urban painting: Stuart Davis, Edward
Hopper, and Charles Sheeler, who might be seen as
the first radical realist. These artists emphasized
contradictory aspects of the city: Davis, its garish,
kinetic splendor; Sheeler, its geometric clarity; and
Hopper, its dehumanizing hardness, accidental
sprawl, and alienating effect of interpersonal and so-
cial relationships. "No painter was more aware of the
ugliness in certain aspects of our country," [15] Lloyd
Goodrich wrote of Hopper. Conversely in Sheeler's
environmental paintings, city, suburb, and country
are transformed into an immaculate, sharp-focus
classicism in which a grain elevator becomes an ana-
logue of the Parthenon. Davis's urban paintings, like
those of Léger, realized their subject by an abstract
reconstruction. Hopper, in the spirit of his early im-
pressionist oils, painted watercolors direct from na-

ture, but assembled his later oil compositions,
carefully and conceptually, from drawings, water-
colors, fragmentary studies, and memory. Sheeler, a
friend of the American modernists Morton Sham-
berg and Marius De Zayas and the collector Walter
Arensberg, made his living, beginning in 1912, as a
commercial photographer. His precisionist painting
reflected avant-garde abstract and mechanist art, but
often derived directly from photographic images.
The organizers and lenders of his work to a retro-
spective at the National Collection of Fine Arts in
Washington, D.C., in 1968 would not permit the
exhibition of photographs identical with the paint-
ings shown, because the transcription in certain
cases was all but exact. Those concerned with Shee-
ler's images acted on a fear that was justified: the
stigma attached to the use of representational de-
vices, by which the photorealists have been marked,
seems to have already been operative in seventeenth-
century Holland. "It does not appear unreasonable,"
Daniel A. Fink writes in commenting on the eclipse
of Vermeer after his death, "to believe that some of
Vermeer's work may have been rejected by an un-

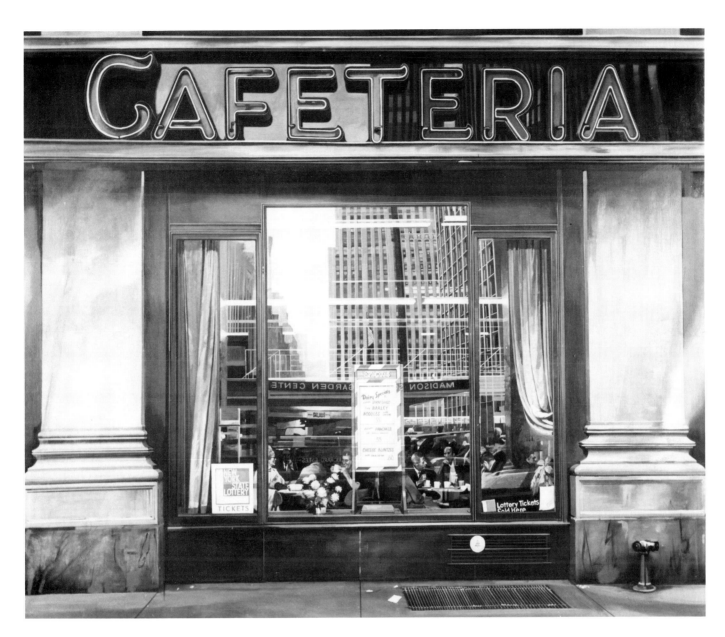

knowing public as being inferior to the realism they had come to expect from paintings which did not include optical phenomena from the camera obscura."[16]

In the preface of *The Painter and the Photograph*, Van Deren Coke recalls that Emily Genauer leveled a virtual charge of plagiarism at photo-derived painting in 1964.[17] This time-worn bias against any image-generating means other than pencil, charcoal, and brush has now taken on the complexion of a moral crusade, with a Philip Pearlstein nude emblazoned on its banner. Nochlin is too well-informed an art historian to have assumed this posture: her introduction to the Pearlstein exhibition at the Georgia Museum of Art in 1970, as well as her book on nineteenth-century French realism, show full recog-

nition of the importance of photography for painting, and, in reference to Estes, Robert Bechtle, and Edward Ruscha, its relevance to "their way of perceiving the world."[18] But (one is forced to add "unfortunately") Pearlstein himself welcomed this double standard of approbation: "It never occurred to me," he obliged a *Time* reporter in an article on the *Sharp-focus Realism* exhibition at the Sidney Janis Gallery, "that people could work from photos—because I never had any difficulty drawing or painting."[19] The comments on certain details of Pearlstein's figure drawing made by Bechtle, Goings, and Richard McLean as they read this complacent quotation were understandably ungracious. Pearlstein, who in 1952 took a prescient fling at Pop expressionism, paints directly from the model in re-

146

Richard Estes, *Cafeteria*, 1970, oil on canvas, 41½ × 48½ in. (105.41 × 123.19 cm). Courtesy of Allan Stone Galleries, Inc., New York. Photo by John D. Schiff.

current sessions; but he is scarcely more a "realist," new or old, than were Ingres or David. Unlike Courbet, the painter of that great double nude, *The Sleepers,* he excises every communicative gesture and indication of sensuousness or sexuality from his figures. Male or female, they are pretty cold meat, lacking any but the most inertly corporeal human attributes, and are systematically modeled in artificial flesh tones that, as compared with nudes by painters from Rubens to Renoir, are anything but real—i.e., lifelike (pl. 34).

Pearlstein's very serious work is not at issue here, but it is important to observe that it has in common with other art of the sixties—optical, coloristic, minimal, and conceptual—an unprecedented and intentional coldness. In 1963, when Pop was only one year old, Ivan Karp wrote an article in which he spoke of "Anti-Sensibility Painting" rather than Pop. "The American urban landscape is fantastically ugly," he began. "Detroit is a fine example. The packaged horror of the super shopping center inspires at its worst (or best) a degree of revulsion instructive to the open eye. All others flee to Venice." He concluded, with a characteristic sense of timing,

that "sensitivity is a bore. Common image painting is an art of calm, profound observation and humorous wonderment without sensibility. It does not criticize. It only records. . . . The environment is overwhelming, and thus [the common image painter] observes it."[20] What Karp did not say, and perhaps did not fully recognize in 1963, was that "anti-sensibility" would in itself become a minimalized and ironic form of sensibility.

The attraction toward common subjects continues the tradition of The Eight, Hopper, the great Walker Evans, and indeed the entire history of photography. Hopper was surely the first painter of importance to represent what Alloway in 1967 called "highway culture."[21]

Early in the last decade a friend occupied an apartment at the seaward end of the amusement pier in Santa Monica. At its outermost projection was a terrace on which was installed a horizontally rotating vane that, when the wind blew, alternately read "love/hate/love/hate/love/hate/love/hate/love/hate . . . " I remember this Pop gadget as epitomizing the attitude of the sixties toward an environment described, in an art-critical comment by John Hol-

147

Richard Estes, *Subway,* 1969, oil on canvas, 42 × 60 in. (106.68 × 152.4 cm). Courtesy of Allan Stone Galleries, Inc., New York. Photo by John D. Schiff.

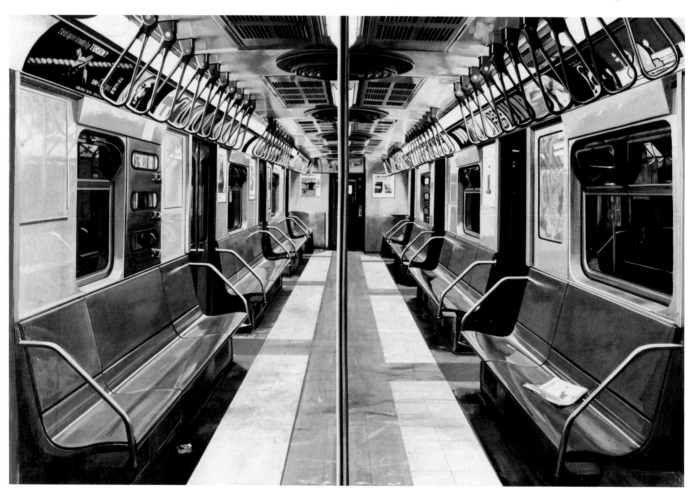

lingsworth, vice president of Burger King (Home of the Whopper), as the "external imagery of the 'now' world." [22] Its Marlborough Country, as English artists were among the first to discover, was California. Johns's flags and Rauschenberg's Coke bottles notwithstanding, it could be argued that "media art" originated in London and Los Angeles rather than New York. It is appropriate, therefore, to call special attention to the Californian advocates of, to use J. Patrice Marandel's term, the "deductive image."

Although Wayne Thiebaud has never utilized intermediary media, he is one of the most influential California painters associated with the Pop movement, but the combination of formal, traditional, topical, and entirely personal components in Thiebaud's painting demonstrates how false the grouping of artists under a general category can be. It is impossible to consider the Pop, post-Pop, or photorealist phases of the figurative art of the sixties very deeply without taking account of his work and influence.

Thiebaud's taste for the ordinary environment and commercial artifacts began in the fifties when he was working as a commercial artist, years before the Pop wave. His first successful one-man show at the Allan Stone Gallery in New York in April 1962, included paintings of ice-cream sodas, bakery pies, and gumball machines—the same genre of subjects caricatured by Oldenburg in his show at the Green Gallery the next fall—and both repertoires drawn from a ubiquitous environment not previously regarded as fit for art. In addition, Thiebaud's synthetic range of hues and tints and his luscious paint surfaces projected the color predilections of the merchandiser into the painter's medium. A *casual* observer of still lifes by Thiebaud might miss, however, a knowledgeable modernist's adjustment of each banal motif to the framing edge of the panel; scrupulously ambiguous, floating reconciliations of surface and recession; and, in his Howard Johnson palette of pinks, lavenders, and milk-shake browns, a master colorist's control of relative tonalities. In the large *Pies*

148
Richard Estes, *Nedicks,* 1970, oil on canvas, 48 × 66 in. (121.92 × 167.64 cm). Courtesy of Allan Stone Galleries, Inc., New York. Photo by John D. Schiff.

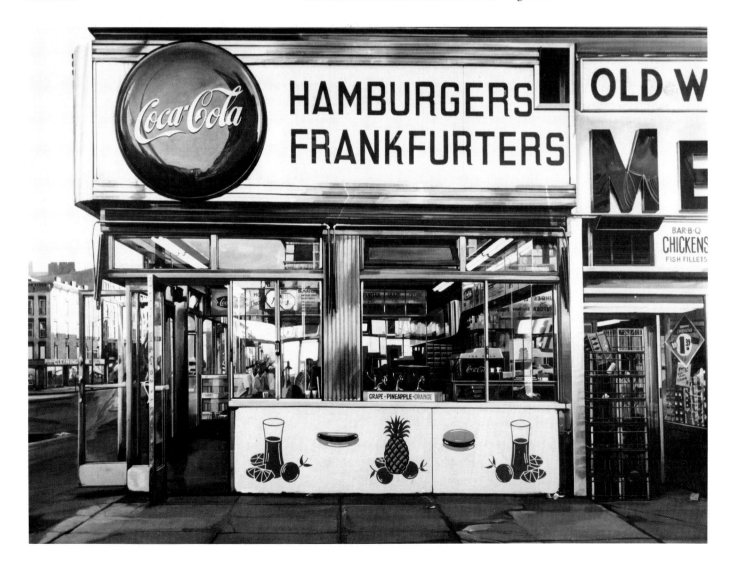

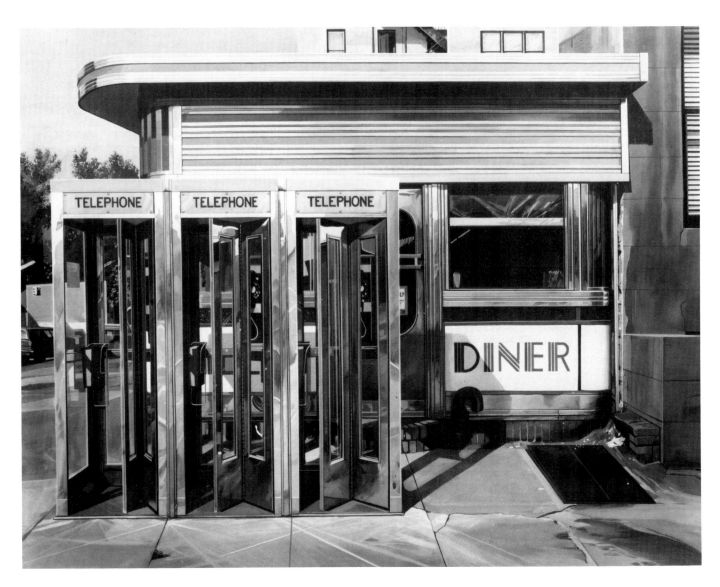

149
Richard Estes, *Diner,* 1971, oil
on canvas, 40½ × 50 in.
(102.87 × 127 cm). Hirshhorn
Museum and Sculpture Garden,
Smithsonian Institution, Wash-
ington. Courtesy of Allan Stone
Galleries, Inc., New York. Photo
by Eric Pollitzer.

Pies Pies, Thiebaud seems to have entered the soul of
a pastry chef.

Thiebaud is entirely open concerning his borrow-
ings from schools and artists of the past: Giorgio
Morandi, Van Gogh, Fauvism, and even Cubism.
And his cafeteria-counter displays and cabinets seem
to bring Hopper into the sixties by making close-up
shots of details unworthy of the older realist's full at-
tention. Thiebaud speaks of his work and subject
matter in terms of its painterly seductiveness:
"Stroking the paint is something I do constantly. I
think of it as a way of love," he wrote in 1967. "The
food and cosmetic still lifes are all predicated on the
premise of actualism . . . an attempt at replication.
The food must look alive, fresh, and available. Wet-
ness, softness are elements of lusciousness, this at-
traction is certainly sexual." [23]

Perhaps (in another cliché of the sixties) Thiebaud
should be called an Erotic artist rather than a Pop
artist. By whatever name, his superbly realized
drawings, watercolors, prints, and paintings are
among the highlights of the sixties; from his home
in Sacramento, where he taught from 1951 to 1960,
he influenced a generation of California photoreal-
ists—Ramos, Goings, Bechtle, and McLean.
Among them, Mel Ramos's works are mock-erotic
and exaggeratedly synthetic, but Ralph Goings,
who in 1968 was painting straightforward studies of
students that resemble those of Thiebaud though
they were derived from photographs, soon turned to
franchise lunchrooms, gasoline stations, parking
lots, and, with special success, pickup trucks. Such
pictures contain as little overt clue to his attitude to-
ward his subjects as those of Estes and, though en-
tirely different in personal style, are painted with an
equally disciplined but affectionate craftsmanship
that can make ugly or mundane subjects almost
lyrical.

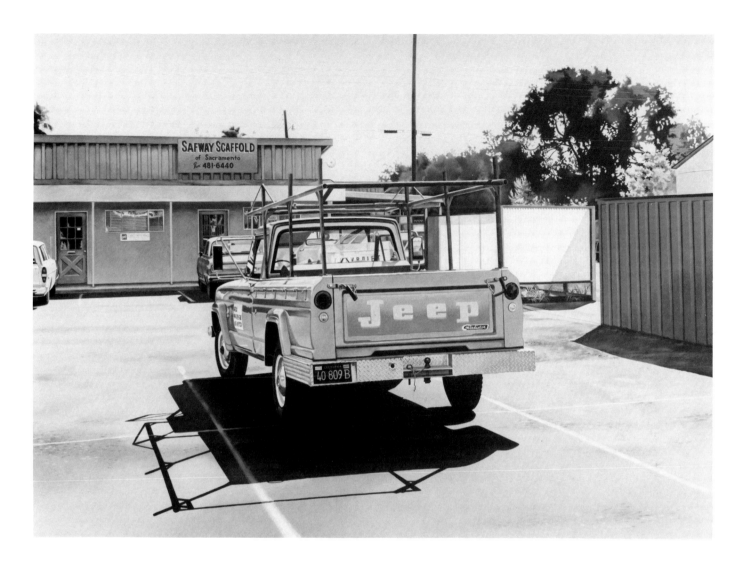

Among the primary hallmarks of the best radical realism are superbly professional use of the medium, whether oil or acrylic, brush or air gun, and perfection of both mechanical and optical detail (or controlled variation and blurring of photographic focus). In these qualities, as well as in the choice of mechanical subjects, we are seeing an updating of the "immaculates" of the twenties. Except that everything in sight in paintings by Goings (as in those of Sheeler) has been scrupulously swept and dusted, and every detail of his trucks and automobiles (like the steel and glass in Estes's scenes of New York) is new and polished, these environments are the ones we pass through daily, usually without looking at them. His immaculate images somewhat resemble sterilized automotive advertising, except that happy consumers, mountains, and sunsets are absent, and the vehicles are presented in workday, utilitarian situations. But more has been altered—for example, in *Jeep 40809B* (1969)—than sweeping

and polishing (fig. 150). Common artifacts and effects have been formalized, most conspicuously in the beautifully formed shadow of the truck, the relation of the verticals of the superstructure of its bed to the posts of the porch, and the opposition of these to the horizontal building lines. The surface of the canvas is so glassily obliterated that, in a reproduction, it is hard to see it as painted by hand. Yet in viewing the originals, the paint surface evidences a sensuousness, however muted, like that spoken of by Thiebaud. A surrogate nature still exists in the tree at the upper right, but only as a patterned remnant. *Air Stream Trailer* (1970) has a strange, surreal presence (pl. 35). Each dent in the aluminum surface provides an occasion for a play of light and dark, for passages of fine, essentially abstract tonal painting. Isolated on a desert lot, this gleaming artifact of the sixties, it seems, is presented for examination as if in it concentrated the value system of an entire culture.

Such a response is subjective. Objective depiction

150
Ralph Goings, *Jeep: 40809B*, 1969, acrylic on canvas, 45 × 52 in. (114.3 × 132.08 cm). Courtesy of O. K. Harris Gallery, New York. Photo by Dan Lenore.

("no invention at all," to use Chuck Close's phrase) is a razor edge, and interpretation is affected by the viewpoint and background of the spectator, both personal and social. It is also colored by both the objects and situation presented and the group or society that they reflect, as well as by standards of visualization, style, and quality. Most of the radical realists sidestep questions concerning socially critical intent; but the subjects they choose and their anti-art manner of presentation both belie total neutrality. They may not, indeed, be fully aware of their own biases. Sheeler saw an immaculate classical beauty through the unpolluted air of his industrial landscape: but that was the thirties, not the seventies.

Among the most emotionally loaded public artifacts, the automobile and the motorcycle are central to the iconography of radical realism, as they were to Pop. John Salt, an English painter who lives in New York, concentrates on junked car bodies, using a blurred airbrush technique that softens their "radicality." "I don't want things to be contrived," he says, "just accidental."[24] Yet he has often borrowed from the media that stereotype of automobile advertisements, the familiar inward shot. In works such as *Chevy with Red Pickup* (1972), the neo-romantic soft focus is even more evident, and weeds grow symbolistically around the rusting hulks. Yet in these, as in the large, lusciously misty imitations of landscape watercolors by Stephen Woodburn, which show bare white canvas areas as evidence of their artificiality, the nostalgia is synthetic: image is transposed into image.

Exactly opposite in their precision and acceptance of sunlit factuality, the canvases painted in 1971 by Don Eddy of Santa Barbara dispassionately celebrate the Volkswagen, chariot of American youth. *Private Parking X* (1971) includes, as if it were a national emblem, an outsized Bank Americard affixed to a chain-link fence—that most utilitarian of enclosures—which factually asserts the picture plane. Lucidly finished in airbrush, surfaces of chromium and shining paint serve as mirrors to reflect fragments of the modern vista. Eddy's painting career began, appropriately, on the cars themselves, first doing spot refinishing in his father's garage and then, while he was still in high school, doing custom paint jobs on cars and motorcycles. In his meticulously adjusted works of 1972, such as *Cadillac Showroom* and *Pontiac Showroom,* he compounds the maze of glass and metal, reflections and things-seen-through-things earlier associated only with Estes's New York pictures. The pale, atmospheric color has an almost Impressionist delicacy. In brush and oil, David Parrish, like Tom Blackwell, paints that ardent symbol of machismo, the motorcycle. At a time when anatom-

ical close-ups have become a commonplace of the neighborhood cinema, the fluorescent enamels, glistening metal, and Duchampian intricacy of pipes, wires, and levers viewed in intimate detail provide a biomechanical imagery for a new generation of occultist witnesses. *Motorcycle Salesroom* (1972) uses shallow depth of field and "circles of confusion" for emphasis and more nuanced opticality.

Should radical realist works be looked at only formally and phenomenologically, as they usually have been, even though qualities held essential to artworks seem to have been eradicated and though radical realist subjects have a common thrust? Or is it not imperative, as in studying earlier figurative art, to see both the selection and treatment of motifs as significant decisions? Is what we see in these pictures (whether the artist shares our concern or not) significantly indicative of our way of life and the current state of our culture? If the subject is banal, ugly, or provocatively seductive, is the artist an ironist (if he is one) intentionally or in spite of himself?

The source material of some California artificialist painting was painstakingly recorded in the sixties in a series of important photographic albums by the painter Edward Ruscha. Among these were *Twenty-Six Gasoline Stations, Some Los Angeles Apartments, Thirty-Four Parking Lots* (photographed from the air), and his classic, *Every Building on the Sunset Strip,* which unfolds like a road map to twenty-five feet, and includes the entire length of the Strip, every cross street, and identifies each building by number. Artificialism has long been the regional style of Los Angeles County—a dreamlike proliferation of suburbs without a center, where one must drive to go to the drugstore to buy a newspaper. Against the sham grandeur and kitsch modernism of the Triscuit-like stuccowork and pastel tones of its buildings, lush palms and magueys look entirely ersatz. It seemed appropriate to hear, in February 1971, that the county was planting plastic trees, bushes, and flowers, impervious to smog and unbiodegradable, along its highways, and it seemed an expression of civic ingratitude when public pressure forced the commonsense supervisors "to return to the use of nature's products to landscape county roads." But nine hundred artificial plants, "placed along a boulevard at a cost of $74,504," remain, according to a February 3, 1972, NBC News telecast.

Although Robert Bechtle lives in Oakland, his pictures of immaculate streets, pink and white multiple dwellings, palms, and parked automobiles commemorate the same repetitive vista as Ruscha's photographs. Those of commercial buildings, such as *Date Palms* (1971), recall pages in trade journals—bland, flat-toned, ordinary. On closer study,

however, both Bechtle's style and subject matter become more personal. The viewpoint is usually from across the street or through a window, and the picture's surface is divided into a pattern of parallel or slightly receding repetitions. The compositions are intentionally "dumb," and the wan colors and velvet-edged paint handling are well controlled and somehow gentle. The pictorial space usually ends abruptly at a painted wall or laterally disposed building. In appearance things are real, yet they all—sun, blue sky, palm trees, Camaros—seem parts of a minimally affluent way of life that is, at its core, prefabricated. In the strangely poignant '61 Pontiac (1969)—a family portrait—this interpretation is hard to avoid. Indeed, in the paintings of Estes, Goings, and Bechtle, one reads an acquiescence to a ubiquitous kind of manufactured uniformity that extends from automobiles and living units—packaging, not architecture—to television, home drug therapy, and processed foods as well as life styles and opinions. Inside this subliminally manipulated, prefabricated environment, the painter concentrates on the act of making a picture, as if in accepting things as they are, abandoning both the heroics of Abstract Expressionism and the pretension of "ambitious" painting, sublimating his need for a wider range of experience and a more responsive environment, he feels free to function as an artist in the America of the seventies.

This interpretation—i.e., quietly ironic submission to the Nixonian era—is somewhat shaken by Richard McLean's paintings after the black-and-white photographs used for ranch and stable advertisements in such journals as *Thoroughbred of California, Quarter Horse Journal,* and *Appaloosa News.* In the photographs McLean selects, owners, judges, and jockeys pose stiffly with their mounts against backgrounds of foliage, stables, race tracks, billboards, and fences. Although variations from photograph to painting are microscopic (except for the addition of color), the flanks of the smoothly groomed thoroughbreds, quarter horses, and appaloosas are rendered with tactile affection, while, as in *Rustler Charger* (1971), the owners and trainers emanate a coarse arrogance as venomous as that of Morley's ugly Americans (fig. 151). McLean has no special interest in horses, and it is hard to believe in his neutrality, yet (when compared to the source photograph) no expressive alteration tells one that he is not innocent of bias or that he does not condone the tastes, goals, and values of his subjects. Nevertheless the ambience is that of the Festival of Roses in Pasadena seen on the tube and Gore Vidal's *Myra Breckenridge.* Unlike the Pop artists in their period of ascendancy, these four photorealists—Bechtle,

Estes, Goings, and McLean—like most of the others, lead quiet, workmanlike, essentially middle-class lives. An hour spent with one of them would make their alleged collusion in Madison Avenue–SoHo chicanery seem distant and absurd.

It used to be a contention of modernist art history that prime forms are brought into existence by great originators, that only gradually does their influence permeate popular culture, diluted and degraded in the process of dissemination. Pop art reversed this sequence in painting and sculpture, but the lofty purism of modernist architects seemed immune to adulteration, its sanctified monuments and principles standing as a silent denunciation of commercial modernism. This stance was challenged in 1966, at the time when post-Pop realism was beginning, by Robert Venturi, both in his buildings and *Complexity and Contradiction in Architecture.* Venturi's "very American book" was judged by Vincent Scully, in his introduction, to be "probably the most important writing on the making of architecture since Le Corbusier's *Vers une Architecture,* of 1923." [25] Even before Venturi's love affair with Las Vegas, he had enraged elitists by arguing for an architecture of eclecticism and accommodation rather than modernist principles, drawing freely on the new environment of motels, gasoline stations, billboards, and electric highway signs, as well as on serious architecture, both modern and historical. This is not the context within which to either advocate or deplore Venturi's relativism. However, his viewpoint now seems an inevitable outcome of the sixties, and his recognition that we live in a highly complex world that is continually changing, by which the arts have been profoundly affected (or adulterated), cannot be evaded. Venturi quotes August Heckscher, who explains the historical situation as the "movement from a view of life as essentially simple and orderly to a view of life as complex and ironic," in which "equilibrium must be created out of opposition." [26]

The contradictory nature of reality is not a new idea; it has never ceased to recur ever since it was advanced by Heraclitus. For a wide range of reasons—high among them the accumulation of encyclopedic knowledge, a familiarity with an infinity of ideological options, and the explosive acceleration of communication—the concept of reality as encompassed by a periphery of apparently irreconcilable contradictions applies especially to the sixties and seventies. This is a period in which the real and the artificial, freedom and repression, truth and falsehood, morality and immorality, life, horror, and death have been absorbed into cool, global, economic, and political game plans. "A feeling for paradox," the quotation from Heckscher concludes,

Richard McLean, *Rustler Charger*, 1971, oil on canvas, 66 × 66 in. (167.64 × 167.64 cm). Neue Galerie-Sammlung Ludwig, Aachen, Germany. Courtesy of O. K. Harris Gallery.

"allows seemingly dissimilar things to exist side by side, their very incongruity suggesting a kind of truth."[27]

Painting of the ordinary contemporary environment, in the radical, photorealist manner, undoubtedly incorporates a view of the world shared by many serious and accomplished artists of a new generation. In the teeth of almost unanimous disapprobation by New York critics, radical realism has since

1967 continued to develop, reveal new potentialities, and proliferate. With New York as a showroom and information center, it seems, relevant ideas and forms can interact and evolve through a network of individuals, groups, universities, and centers less dominating than New York. What has become a powerful international movement, acutely expressive of modern life, took form without the imprimatur of an approving critical establishment.[28]

Epilogue

The cover designs of the goodbye-to-the-sixties issues of *Time, Newsweek, Look,* and *Life* that appeared in December 1969 juxtaposed images from that "unbelievable" decade of assassinations, theatrical and political celebrities, blacks and whites, war and insurrection, moon expeditions, miniskirts, love-ins, cartoons, and Pop art. This practice of combining thematically related pictorial fragments into a single image was followed in the nineteenth-century tradition established by naive collagists and assemblers and such trompe l'oeil painters as Harnett and Peto and was later reinvented by Picasso and Braque. By the sixties, it had been absorbed by the mass media as the most striking means of representing conflicting events and forces.

The *technique* of pasting, rather than drawing or painting, was not all that gave collage its importance for twentieth-century art and life, however. By extension, that term came to designate any artwork in which diverse images or materials were sharply juxtaposed, by whatever means. The "pasted papers" of the Cubists were one manifestation of a radical new mode of structuring works of art in all mediums; but even more significant, they forecast the actual world environment constructed after World War II.

"Poets and artists plot the characteristic of their epoch," Guillaume Apollinaire wrote in 1913, "and the future docilely falls in with their desires." [1] Who can cavil, in retrospect, to such naive but vital creative insolence? Marshall McLuhan, whose writings and influence are symptomatically fundamental to an understanding of the sixties, pointed to new art as an "early warning system"—a social radar or "feedback loop" through which the observer can be-

come "aware of the psychic and social consequences of the new environment," which, like water to a fish, would otherwise be invisible. Those people too immersed in the environment to be alerted react "with the precision of marionettes," turning "whole populations into servo-mechanisms." According to McLuhan's social-feedback hypothesis, the artists construct anti-environments, and new art forms serve as a "way of seeing new environments and all that they possess as powers for the distortion of human perception." The artist is a "man who is always training perception on the unseen invisible environment."[2]

When he first directed his attention to advertising in *The Mechanical Bride* (1951), McLuhan held his subject in disdain—the intellectual observing commercial culture from the ivory tower. However, beginning with *Understanding Media* (1963), he began to eschew value judgments and urged the use of his ideas, the truth, falsity, or overstatement of which he refused to defend. As he became part of the scene himself, he categorized these ideas as "probes" to intensify awareness of approaching social and technological challenges. As many specialized scholars complained, his rationale was not always adequate nor his copious documentation always relevant. His first specialization was English literature, his knowledge of other arts was spotty, and his citations from the history of painting and sculpture were oversimplified and sometimes even absurd, reflecting the advice of poor consultants. Yet his insights, especially his brilliant revelations concerning the media, are not only indispensable to the study of modernism in the sixties, but they also shed new light on the period of avant-garde art that largely ended with World War I.

Massive though the influence of art before 1915 was on art after 1955, at issue here is not that at all, but the prefiguration, by neo-Impressionists, Symbolists, Cubists, Futurists, Rayonnists, and Dadaists, of the conditions of *life* after 1955. Why then does the work of the great Cubist masters seem less pivotal than that of Léger, Delaunay, Duchamp, and the Futurists? Primarily it is because their art, revolutionary and transcendent as it was, was studio-centered. By contrast, the Futurists and more environmental "open" Cubists looked outward and forward, anticipating the global, garish, technological world to come. They were really "turned on" by the dynamism and radical technology of the automobile, the airplane, the Eiffel Tower, war, and outer space. Marcel Duchamp even saw the body itself as a sex machine.

In the telescopic hindsight of the seventies, the aesthetic of the related techniques of collage, assemblage, and construction seem inevitable. The substitution for oil pigment of rope, oil cloth, fragments of wood, string, wire, newsprint, tobacco, and aperetif labels by Picasso and Braque was an intrusion of the alien world into ateliers still linked by the chain of tradition with the Renaissance. By contrast, the Futurists launched their sensibilities into the commotion of the street, the railway station, the shopping concourse, the battlefield, and, in the cases of Delaunay and La Fresnaye, into the air. Both their manifestos and their raw, often discordant works were committed to the new technological environment. What they preached was not continuity, but a revolution dedicated to razing not only the walls between the studio and the street but also every barrier that protected the sanctity of art from the unpredictable rush of modern life.

In a symposium at Brandeis University on June 3, 1963, I designated two opposed types of avant-garde: *concentric* and *polemic*. "The members of the first type . . . were so wrapped up in their own work that they were oblivious to everything outside it. Those of the second type mixed contempt or hatred for middle-class culture with their art. Impressionism and Cubism were concentric; Dada, Futurism, and Surrealism were polemic."[3] No value judgment was implied in this distinction. On May 13, 1970, in a lecture titled *Counter-Avant-Garde,* delivered on the same platform as the 1963 symposium and later revised and expanded,[4] Clement Greenberg proposed a similar opposition, but with a biting value judgment, between what he regarded as the legitimate or true avant-garde and "avant-gard*ness*" (italics in the original). According to Greenberg, the Futurists were the first to think in these terms and "to envisage newness in art as an end in itself." They therefore discovered avant-gardness; but it was left for Marcel Duchamp to go further and initiate "avant-gard*ism*." Both Duchamp and the Futurists adoped "a program, a posture, attitude, stance that was consciously avant-garde."[5]

This dichotomy is crucial for Greenberg's judgment of art in the fifties and sixties, for Abstract Expressionism is seen as wholly in the first (my concentric) tradition, as are, I assume, those artists of the sixties that he preferred. Duchamp is cast as the high priest of an academic, pseudo-avant-gardism of the sixties that included assemblage, happenings, Op and Pop art, technological art, most minimal art, earthworks, and other tendencies that, though he might find elements of interest in them, Greenberg regarded as outside the significant modernist tradition. Impossible though it is to maintain this distinction between good guys and bad guys against detailed and specific objections, it focuses on a cru-

cial point in the ethics and aesthetics of the art of the sixties.

In Paris, Amsterdam, Dresden, Milan, Berlin, Moscow, or New York before 1920, avant-garde artists were dissecting, fragmenting, or exploding past art and reassembling its pieces interspersed, as it were, with fragments of the real, non-art world. It was therefore the world-embracing environmental collage *outside* the circle of art that the first modernists forecast. This disruption of earlier modes of organization in the arts corresponds precisely with McLuhan's Marconi Galaxy, so-called after the Italian physicist who transmitted wireless signals across the Atlantic in 1901. McLuhan's startling thesis that "media"—wheels, highways, automobiles, electric light, railroads, airplanes, as well as press, radio, and television—are in themselves more potent in their impact than the functions they fulfill or the messages they convey bears directly on the arts of 1916 as well as 1966. The validity of his theories aside, what made him a guru of the sixties was the recognition that—fifty years after the formal innovations of the early avant-gardists—new technologies had fundamentally altered the interaction of human beings, both with each other and with their astronomically proliferating artifacts, hardware and software, and ideas.

One wonders how Apollinaire, Filippo Tommaso Marinetti and Carlo Carrà, de Chirico and Schwitters would have responded to Las Vegas, Times Square, Miami Beach, concrete-paved miles lined with the gaudy heraldry of Esso, Sunoco, and Citgo, acres of oversized automobiles and heaps of their rusting corpses, motels, drive-ins, Holiday Inns, Howard Johnsons, and the golden arches of McDonald's. The collage of the core cities was different—compressed and dirty, patches of the fading past confronting the debris, torn billboards, and slickness of the present. This mega-environment, extending from the smog of Los Angeles to the traffic jams of the world's major cities, was that of the sixties. "Nature," in the years before "ecology" replaced "conservation," was Kenya, the Everglades, two weeks at Aspen or Cape Cod, or the disappearing fields replaced by endless suburbs. The physical setting for art, like other human activity in the sixties, was the relentlessly encroaching assemblage of artifacts assembled, without plan, by human ingenuity, greed, and negligence. For a time it glowed with an iridescent if ominous beauty: a mind-boggling, global superwork of art.

A single artist can seldom be held up as an archetype or epitome of a single period, if only because of its diversity and internal contradictions, and the task is made more difficult by the fractionated, para-

doxical nature of the sixties, a decade that seemed to change month by month, so that the sensibility of 1970 was not that of 1965, nor 1965 of 1960. Depending on one's point of view, Warhol, Stella, Rauschenberg, or Kienholz could be put forward, convincingly, as the paradigm. (Because of their absorption with form, Louis, Noland, and other reductive color painters seem insulated from such a consideration.)

But, as is often true, a statement invalidating a position precedes its advocation: in this case the presentation of Roy Lichtenstein as the most characteristic and focused representative of the sensibility of the sixties. This schematic, simplistic assertion demands an arbitrary epitomization of the decade—a reduction to hallmarks and an obliteration of evolution, opposition, and nuance—just as Lichtenstein schematized canvases by Cézanne, Mondrian, Picasso, de Kooning, and Monet in the masterful variations of his cartoons. This license granted it can be further said that the sixties emptied, leveled, or numbed the character of the forties and fifties, depersonalized and congealed the autographic style, made a travesty of its life-and-death ethic, and mocked the traditional separation of what was ambitious and profound from what was gaudy and banal. If stated negatively, this was the central thrust of the decade in the circles of modern art.

Lichtenstein was its personification, and he was to Pop art what Monet was to Impressionism (pl. 36). He rejected the idea of art as a transformation of nature—in part, it appears, as a result of studies at Ohio State University with Professor Hoyt L. Sherman, whose perceptualistic analysis of Cézanne was published in 1952. "Organized perception is what art is all about," Lichtenstein said in 1963. "It is working with paint, not nature."[6]

Lichtenstein's interest in popular art began early in the fifties. He painted abstractly after 1957, but later introduced comic images into his pictures and, in 1961, began to search out the most tawdry commercial models, such as the Yellow Pages of the telephone book, and to render them with techniques (or the appearance of them) farthest from those of the so-called fine arts, aiming for a style that would appear entirely impersonal and mechanical. "I was very interested," he told John Coplans in 1967, "in . . . caricaturing a brush stroke. The very nature of a brush stroke is anathema to outlining and filling in as used in cartoons."[7]

With greater *froideur,* but on a lower metaphysical level, he made overt what was covert in the flags, targets, and numbers of the great transitional master Jasper Johns. Lichtenstein was the coolest of cats, and he developed his style by intentional reversals.

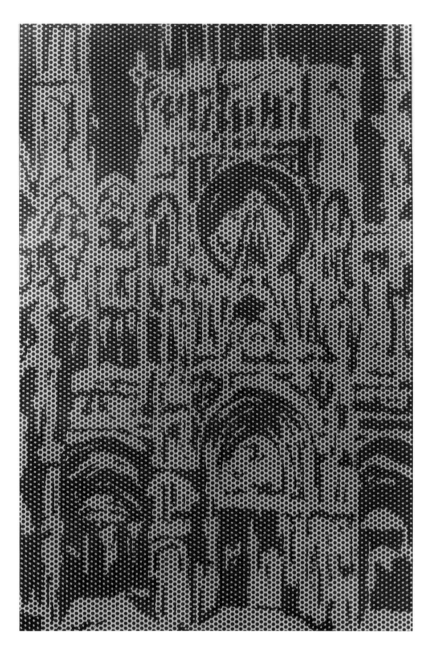

152
Roy Lichtenstein, *Rouen Cathedral,* Set I panels I–III, 1968, 3 paintings, each 63 × 42 in. (160.02 × 106.68 cm). Collection of Mr. and Mrs. C. Gerard Goldsmith. Courtesy of Leo Castelli Gallery, New York. Photo by Eric Pollitzer.

Previous modernism being relational and cubistic, his elementary representations of representations of rotobroilers and turkeys were plopped into the middle of the canvas, exorcising all appearance of structural judgment. He juggled the clichés of depth, flatness, and light derived from inert two-dimensional stereotypes. Like the anonymous comic book artists he celebrated, Lichtenstein deflated their dramatic, passionate, and tragic pseudo-themes into total meaninglessness. In a Lichtenstein painting, love and war are identical, and the heat and blast of an explosion in midair is a static, industrially fabricated object. The back of the canvas, used as a subject, is as significant as the front.

No venal copyist of gross commercial illustration, as he was accused of being in the palmy days of Pop, Lichtenstein became the self-possessed Apollonian of the post-avant-garde collage of the sixties—a milieu in which irony and humor were all but essential to survival. His merciless travesties of the most revered masters and styles were calculated both to deflate the myths that animated them and make the kitsch styles he adopted mythic.

Lichtenstein's "modern sculpture" of 1967–68 surely contributed to the revival of Art Deco. In addition, because he is himself an accomplished master, his "modern paintings" and "modern sculpture" established their own innate style. Monet gave perceptual rather than devotional significance to the facade of Rouen Cathedral; in 1969 Lichtenstein reduced Monet's luministic integument to enlarged pointillist newsprint (fig. 152). The next year—deprecating his motif—he dealt with commercial modes of representing mirrors and reflections. In immaculate pictures assembled from vertical panels, the mirrors paraphrase the metaphysics of Picasso's *Still Life with Chair Caning* in a new vocabulary, paradoxes of flatness/depth, object/representation, surface/void, object/ideogram, realism/illusion, and, for the sixties, Sears Roebuck/Sotheby's.

Chronology

1955

Contemporary Events

January 18
Beginning of first mass immunization against polio by use of the Salk vaccine.

March 24
Tennessee Williams's *Cat on a Hot Tin Roof* premieres on Broadway.

April
Vietnam appeals to U.N. over alleged breach of Geneva agreement by Viet Minh.

April 6
Winston Churchill resigns, replaced by Anthony Eden.

May
Elvis Presley (born January 8, 1935) records "Heartbreak Hotel."

May 5
Federal Republic of West Germany becomes a sovereign state.

May 14
Warsaw Pact signed.

June 23
Walt Disney's *Lady and the Tramp* released.

September 19
Argentina: Downfall of Perón.

October 3
Death of James Dean, shortly before release of *Rebel Without a Cause*.

December 1
Montgomery, Ala.: Rosa Parks refuses to give up her bus seat to a white man and is arrested. Martin Luther King, Jr., leads black boycott of city bus system; desegregated service begins December 21.

Art Events

San Francisco: Allen Ginsberg reads his long poem "Howl" at the Six Gallery to a boisterous and receptive audience.

Chicago: Claes Oldenburg edits art column of *Chicago Magazine*.

New York: James Rosenquist comes to New York from Minnesota with a scholarship to Art Students League.

New York: Cedar Bar becomes gathering place for Abstract Expressionist artists and beats.

New York: In *Gotham News*, Willem de Kooning transfers newsprint to pigment.

Dallas: A local ladies' lunch club, the American Legion, and the Inwood Lion's Club demand the removal of works by Picasso, Rivera, and others from the walls of the Dallas Museum of Fine Arts due to the artists' involvement with the Communist party. The museum complies.

Hilton Kramer becomes managing editor of *Arts Magazine*.

Winter
New York: Robert Rauschenberg moves to a loft studio on Pearl Street and meets Jasper Johns who has a studio in the same building. The two artists support themselves by collaborating on window displays for Tiffany's, etc., using the name "Matson Jones."

January
Japan: First issue of journal *Gutai*, published by the Gutai Art Association; the group also presents outdoor environments in Ashiya City on the banks of the Ashiya River.

February
London: Institute of Contemporary Arts, Richard Hamilton's paintings discussed by the Independent Group with particular reference to popular serial imagery. Later meetings of the Independent Group in 1955 deal with automobile styling, advertising, information theory, pop music, and industrial design.

Summer
Williamstown, Mass.: Sterling and Francine Clark Art Institute opens.

August
Death of Léger.

Exhibitions

London: Hanover Gallery, *Takis*. First one-man show.

Paris: Galerie Arnaud, *International Collage Exhibition*.

Youngstown, Ohio: Butler Institute of American Art, *Richard Anuszkiewicz*. First one-man show.

New York: Whitney Museum of American Art, *American Drawings 1955–1965*.

January 21–February 10
New York: Tanager Gallery, *Philip Pearlstein, Paintings*. First one-man show.

April 6–30
Paris: Galerie Denise René, *Le Mouvement* (Agam, Bury, Calder, Duchamp, Jacobsen, Soto, Tinguely, Vasarely). First survey of kinetic art.

May 10–August 7
New York: MOMA, *The New Decade: 22 European Painters and Sculptors* (Afro, Appel, Armitage, Bacon, Bazaine, Burri, Butler, Capogrossi, Chadwick, Dubuffet, Hajdu, Manessier, Minguzzi, Mirko, Pignon, Richier, Scott, da Silva, Soulages, Uhlmann, Werner, Winter).

May 11–August 7
New York: Whitney Museum of American Art, *The New Decade: 35 American Painters and Sculptors*.

July 6–30
London: Institute of Contemporary Arts, *Man, Machine and Motion*, organized by Richard Hamilton.

July 15–September 18
Kassel: *Documenta I*.

August 19–September 30
New York: MOMA, *Léger Memorial*.

October 23–December 5
Minneapolis: Walker Art Center, *Vanguard 1955*. Twenty painters.

November 22–December 7
London: Royal Society of British Artists Galleries, *Art in British Advertising*.

November 29–December 23
New York: Stable Gallery, *U.S. Painting: Some Recent Directions* (Bell, Blaine, Briggs, Brodie, E. de Kooning, de Niro, Dzubas, Forst, Frankenthaler, Goldberg, Goodnough, Kahn, Mitchell, Stephen Pace, Pasilis, Porter, Rauschenberg, Seymour, Remenick, Resnick, Rivers, and Solomon).

December 19–January 14, 1956
New York: Betty Parsons Gallery, *Ten Years.* Preface by C. Greenberg.

Publications

Ashton, Dore, "What is 'avant-garde'?" *Arts Digest* 29 (September 15): 6–8.

De Kooning, Elaine, "Subject: What, How or Who?" *Art News* 54 (April): 26–29.

Golub, Leon, "A Critique of Abstract Expressionism," *College Art Journal* 14 (Winter): 142–147.

Greenberg, Clement, " 'American Type Painting,' " *Partisan Review* 22 (Spring): 179–196.

Huxley, Aldous, *Heaven and Hell.*

Marcuse, Herbert, *Eros and Civilization: A Philosophical Inquiry into Freud.*

Nabokov, Vladimir, *Lolita.*

Steichen, Edward, *The Family of Man.*

Sweeney, James Johnson, "Recent Trends in American Painting,"

Bennington College Alumnae Quarterly 7 (Fall).

1956

Contemporary Events

Ingmar Bergman's *Seventh Seal* released.

July 26
Egypt takes control of the Suez Canal.

October 22
Mass demonstrations in Hungary; Soviet troops invade on October 24.

October 29
Israel attacks Egypt's Sinai Peninsula.

November
Dwight Eisenhower reelected.

Art Events

North Carolina: Black Mountain College closes.

New York: Allan Kaprow begins studies with John Cage at the New York School.

New York: Tom Wesselmann, a psychology graduate of Hiram College, Ohio, enters Cooper Union School of Art.

New York: MOMA purchases Monet's *Water Lilies* (1918–1923).

Los Angeles: Ed Kienholz opens the Now Gallery, one of the first galleries in the area to show vanguard art.

James Fitzsimmons begins publishing *European Art This Month* (in 1958, name changed to *Art International*).

January 13
Death of Lyonel Feininger.

April 13
Death of Emil Nolde.

August 11
Easthampton, N.Y.: Death of Jackson Pollock in an automobile accident.

November–December
New York: In *Penny Arcade*, Kaprow transforms his exhibit of collages into a carnival side show.

November
Tokyo: Contemporary World Art Exhibition held at Takashimaya; for the first time, members of the Gutai group see works by Art Informel, including Mathieu and Tapie.

Exhibitions

Milan: Galleria del Naviglio, *Anthony Caro.* First one-man exhibition (20 sculptures).

Paris: Galerie Haut Pavé, *Arman.* First one-man show.

Tokyo: Ohara Hall, first Gutai exhibition; Ashiya City, second Gutai exhibition.

January 5– February 12
London: Tate Gallery, *Modern Art in the United States: A Selection from the Collections of the Museum of Modern Art* (Baziotes, de Kooning, Gorky, Guston, Kline, Motherwell, Pollock, Rothko, Still, Tomlin).

February 6–March 3
New York: Sidney Janis Gallery, *Recent Paintings by Philip Guston.* One-man show.

February 13–March 17
New York: Rose Fried Gallery, *International Collage Exhibition.*

February 14–March 3
New York: Bodley Gallery, *Drawings for a Boy-Book by Andy Warhol.* Second one-man show. (First one-man show in New York in 1952.)

February 23–March 10
New York: Hansa Gallery, *George Segal.* First one-man show.

May 21–June 8
New York: Betty Parsons Gallery, *Ellsworth Kelly.* First one-man show in the U.S. (previously working in Paris).

May 30–September 9
New York: MOMA, *Twelve Americans* (Briggs, Brooks, de Rivera, Francis, Glarner, Guston, Hague, Hartigan, Kline, Lassaw, Lipton, Rivers).

August 8 –September 9
London: Whitechapel Art Gallery, *This Is Tomorrow* (includes Crosby, Hamilton, Henderson, McHale, Paolozzi, the Smithsons, Turnbull, Voelcker). Emergence of key themes of Pop: Marilyn Monroe, giant beer bottles, advertisements.

October 8–27
New York: M. Knoedler and Co., exhibition of Monet's *Water Lilies.*

October 30–November 5
Houston: Contemporary Arts Museum, *Large Scale Paintings II* (includes Baziotes, Ernst, Francis, Gorky, Gottlieb, Hofmann, Kline, Reinhardt, Stamos, Tomlin).

December
New York: Tanager Gallery, *Painters and Sculptors on Tenth Street,* 25 artists, all of whom lived on the street.

December 3–22
New York: Bodley Gallery, *Andy Warhol: The Golden Slipper Show or Shoes in America.*

December 19–February 3, 1957
New York: MOMA, *Jackson Pollock* memorial exhibition.

Publications

Alloway, Lawrence, "Introduction to 'Action'," *Architectural Design* 26 (January).

———, "U.S. Modern: Paintings," *Art News and Review* 26 (January 21).

Ashton, Dore, "Painting in New York Today," *Cimaise* 4 (November–December).

Blesh, Rudi, *Modern Art USA: Men, Rebellion, Conquest, 1900–1956.*

Finkelstein, Louis, "New Look: Abstract-Impressionism," *Art News* 55 (March).

Ginsberg, Allen, *Howl and Other Poems;* introduction by William Carlos Williams, dedicated to Jack Kerouac, William S. Burroughs, and Neal Cassady.

Huxley, Aldous, *The Doors of Perception.*

Mills, C. Wright, *The Power Elite.*

Schapiro, Meyer, "The Younger American Painters of Today," *Listener* 60 (January): 146–147.

Sweeney, James Johnson, "The Cat That Walks by Itself," *Quadrum* 2.

Sylvester, David, "Expressionism, German and American," *Arts Magazine* 31 (December).

"The Wild Ones," *Time* (February 20), coins phrase "Jack The Dripper" in reference to Jackson Pollock.

1957

Contemporary Events

California: Jack Kerouac and friends band together to become the first beatniks.

Treaty of Rome establishes European Common Market, to become effective January 1, 1958.

Leonard Bernstein's *West Side Story* opens.

January 5
Washington, D.C.: Eisenhower Doctrine pronounces that the U.S. will defend the Middle East against Soviet attack.

September 24
Little Rock, Ark.: Federal-state controversy over admission of blacks to previously all-white Central High School; President Eisenhower sends federal troops to enforce order and begin integration.

October 4
Russians launch first space satellite, Sputnik I.

November
Russians launch Sputnik II carrying a dog, Laika, the first Earth creature to travel in outer space.

Art Events

Richard Hamilton gives definition of Pop art in a letter to Alison and Peter Smithson; later paints *Hommage à Chrysler Corporation.*

New York: Rauschenberg creates *Factum I* and *Factum II*, a near-copy.

San Francisco: Word "funky" used by San Francisco Bay artists to indicate wry approval of odd works by other artists.

Tokyo: Third Gutai Exhibition at Sankei.

Southampton, N.Y.: John Chamberlain makes *Shortstop*, his first

sculpture made from auto-body parts, at the home of Larry Rivers.

Newcastle: King's College, Richard Hamilton and Victor Pasmore collaborate on *An Exhibit,* in which black, gray, white, and red acrylic panels are suspended from a ceiling grid of wire.

New York: Leo Castelli Gallery opens.

New York: Metropolitan Museum buys Pollock's *Autumn Rhythm* for $30,000.

Los Angeles: Kienholz closes Now Gallery and starts Ferus Gallery with Walter Hopps; first work shown is Kienholz's *George Washington in Drag.* Irving Blum becomes a partner in 1959.

April
New York: Allan Kaprow's first public happening, *Communication.*

Exhibitions

Chicago: Wells Street Gallery, *John Chamberlain.* First one-man show.

Los Angeles: Felix Landau Gallery, *Robert Irwin.* First one-man show.

San Francisco: Delexi Gallery, *Robert Morris.* First one-man show.

Tokyo: Sankei Hall, third Gutai exhibition.

January 2–19
New York: Tibor de Nagy Gallery, *Kenneth Noland.* First one-man show in New York. (First one-man show, Paris, 1949.)

January 6–February 25
Washington, D.C.: Phillips Gallery, *Collages by Kurt Schwitters.*

February 27–April 4
New York: Whitney Museum of American Art, *Young America 1957.*

March 10–April 28
New York: Jewish Museum, *Artists of the New York School: Second Generation* (Brodie, E. de Kooning, de Niro, Jean Follet, Forst, Frankenthaler, Goodnough, Hartigan, Johns, Johnson, Kahn, Kaprow, Leslie, Mitchell, Muller, Pasil, Rauschenberg, Resnick, Segal, Solomon).

April 1–20
New York: Sidney Janis Gallery, *Eight Americans* (Albers, de Kooning, Gorky, Guston, Kline, Motherwell, Pollock, Rothko).

April 24–June 16
New York: Whitney Museum of American Art, *Hans Hofmann,* catalog by Frederick Wight.

May 13–June 1
New York: Poindexter Gallery, *David von Schlegell.* First one-man show.

May 22–September 8
New York: MOMA, *Picasso: 75th Anniversary* (retrospective).

June 24–July 6
New York: Panoras Gallery, *Don Judd.* First one-man show.

September 4–28
Oakland, Calif.: Oakland Art Museum, *Contemporary Bay Area Figurative Painting* (Bischoff, Brooks, Brown, Diebenkorn, Downs, McGraw, Park, Qualters, Snelgrove, Villierme, Weeks, Wonner).

September 11–October 20
New York: MOMA, *David Smith.*

November 5–23
New York: Martha Jackson Gallery, *Morris Louis.* First one-man show in New York (first one-man exhibition, Washington D.C., 1953).

November 18–December 7
New York: Leo Castelli Gallery, *Marisol*. First one-woman show.

December 16–January 4, 1958
New York: Zabriskie Gallery, *Collage in America*.

Publications

Alloway, Lawrence, "Background to Action: A Series of Six Articles on Post-War Painting," *Art News and Review* 9 (October—January 18, 1958).

Baur, John I. H., et al., eds., *New Art in America*.

Falk, Ray, "Japanese Innovators," *New York Times*, December 8, sec. 2, p. 24. The first American article on the happenings performed by the Gutai group.

Kerouac, Jack, *On the Road*.

Rodman, Selden, *Conversations with Artists*.

Schapiro, Meyer, "The Liberating Quality of Avant-Garde Art," *Art News* 56 (Summer): 36–42.

1958

Contemporary Events

Leftist students contest student government elections at Berkeley, University of Chicago, Columbia, and Oberlin.

Introduction of the Barbie doll.

Vice-President Nixon attacked by anti-American mobs during South American goodwill tour.

Washington, D.C.: State Department responds to growing African nationalism by establishing a special bureau of African affairs.

January 31
Cape Canaveral, Fla.: First U.S. satellite, Explorer I, is launched.

February 1
Egypt and Syria merge to form the United Arab Republic.

March 27
Khrushchev becomes premier of the Soviet Union on resignation of Bulganin.

April
Cuba: Fidel Castro begins "total war" against Batista government.

June 1
Charles de Gaulle becomes president of France; establishment of the Fifth Republic.

July 15
Eisenhower orders U.S. Marines into Lebanon.

October
NASA created by President Eisenhower.

October 4
First transatlantic jet passenger service begins between New York and London on BOAC.

Art Events

Kienholz creates *The Little Eagle Rock Incident* in response to racial integration in Little Rock, Arkansas.

Johns paints over comic strip (Alley Oop) and produces flashlight and light bulb sculptures.

Malcolm Morley moves to New York from London.

Frank Stella graduates from Princeton, moves to New York, and begins Black paintings.

Philip Pavia begins to publish *It Is*, a magazine to promote Abstract Expressionism. Five issues were published between 1958 and 1960.

Osaka, Japan: Fourth Gutai Exhibition.

Paris: Yves Klein begins to use "living brushes"—nude models covered with paint who press themselves against canvases at Klein's direction.

Paris: Christo begins wrapping objects.

New York: Red Grooms opens a gallery in his studio, shows Oldenburg and Dine, among others.

New York: Judson Gallery opens in basement of Judson Memorial Church to show experimental visual and performance art.

January 29
Death of Jan Muller, age 36.

April–October
Brussels: World's Fair.

Summer
Provincetown, Mass.: Red Grooms's *Play Called Fire* is staged at Sun Gallery; he paints a canvas for 25 minutes before an audience.

Exhibitions

Mexico City: Galerie Genova, *Allan D'Arcangelo*. First one-man exhibition.

New York: Zodiac Gallery, *Jules Olitski*. First one-man show in the United States.

New York: The Contemporaries (Gallery), *Richard Anuszkiewicz*. First one-man show in New York.

Paris: Galerie Iris Clert, *Arman*. One-man show.

January
Los Angeles: Ferus Gallery, *Edward Kienholz* (exhibition with Altoon, De Feo).

January 14–March 16
New York: Whitney Museum of American Art, *Nature in Abstraction: The Relation of Abstract Painting and Sculpture to Nature in Twentieth-Century American Art*.

January 20–February 8
New York: Leo Castelli Gallery, *Jasper Johns*. First major one-man show.

February 17–March 8
New York: Hansa Gallery, *George Segal*.

February 17–April 6
Houston: Contemporary Arts Museum, *Collage International: From Picasso to the Present*.

March 4–29
New York: Leo Castelli Gallery, *Robert Rauschenberg*.

April
Tokyo: *International Art of a New Era—Informel and Gutai*, organized by Michel Tapie.

April 9–May 5
New York: Davida Gallery, *John Chamberlain*. First show in New York, a two-man exhibition with Joseph Fiore.

April 19–May 26
Basel: Kunsthalle, *Die neue amerikanische Malerei* (Baziotes, Brooks, de Kooning, Francis, Gorky, Gottlieb, Guston, Hartigan, Kline, Motherwell, Newman, Pollock, Rothko, Stamos, Still, Tomlin, Tworkov). (*The New American Painting*, organized by the International Council at the MOMA, traveled to eight European cities.)

April 28–May
Paris: Galerie Iris Clert, Yves Klein's *Exposition of the Void*.

May 4–24
Bennington College, Vt.: *Barnett Newman: First Retrospective Exhibition*.

May 9–29
New York: Brata Gallery, *Ronald Bladen*. One-man show.

September 25–October 25
New York: Martha Jackson Gallery, *The Gutai Group*. First exhibition in the U.S.

Publications

First publication of English translation of *The Theater and Its Double*, by Antonin Artaud; advocates the rejection of the supremacy of speech, the creation of pure theatrical language in which representation would be secondary, and a change in the traditional spectator-presentation relationship by placing the audience within the spectacle.

Alloway, Lawrence, "The Arts and the Mass Media," *Architectural Design* 28 (February): 84–85. First published use of term "Pop art."

———, "Art in New York Today," *Listener* 60 (October 23).

Beckett, Samuel, *The Unnameable*.

Ferren, John, "Epitaph for an Avant-Garde: The Motivating Ideas of the Abstract Expressionist Movement as Seen by an Artist Active on the New York Scene," *Arts Magazine* 33 (November).

Goosen, E. C., "The Big Canvas," *Art International* 2.

Kaprow, Allan, "The Legacy of Jackson Pollock," *Art News* 57 (October): 24–60.

Longren, Lillian, "Abstract Expressionism in America," *Art International* 2 (February): 54–56.

Pasternak, Boris, *Doctor Zhivago*.

Rand, Ayn, *Atlas Shrugged*.

Rubin, William, "The New York School—Then and Now," two-part series in *Art International* 3 (March–April, May–June).

1959

Contemporary Events

Alaska and Hawaii become 49th and 50th American states.

Breathless (Godard), *The 400 Blows* (Truffaut), and *Hiroshima mon Amour* (Resnais) are released.

England: Obscene Publications Act permits *Lolita* in Britain.

January
Lunik I launched by Soviet scientists, goes into orbit around the sun as first man-made planet.

January 1
Batista's government overthrown in movement headed by Castro, who becomes premier.

February
Ginsberg, Corso, and Orlovsky read at the benefit for the magazine *Big Table*; *Time* (June 9) criticizes them severely and calls them "itinerate hucksters."

March 31
The Dalai Lama escapes to India from Tibet.

September
Lunik II hits the moon, about 35 hours after launch by Soviet scientists.

September
Khrushchev visits the United States.

October
Lunik III is launched by Soviet scientists, circles moon, and transmits photographs of moon's surface to Earth.

Art Events

Jules Langsner uses the term "hard edge" for the works of Karl Benjamin, Frederick Hammersley, Lorser Feitelson, and John McLaughlin in the catalog *Four Abstract Classicists* at the Los Angeles County Museum.

Edition MAT (Multiplication d'Oeuvres d'Art) organized by Daniel Spoerri; first mass-produced multiple art objects.

Kienholz creates *God-Tracking Station #1* in response to Russia's launching of Sputnik.

Word "happening" used in Rutgers magazine *Anthologist*.

Anthony Caro visits New York on a Ford Foundation fellowship; meets Kenneth Noland and David Smith.

New York: Clement Greenberg assumes directorship of French and Company's new gallery devoted to current art.

London: Gustav Metzger develops "expendable art," in which acid is applied to stretched nylon that dissolves in patches, resulting in the idea of sculpture slowly disintegrating.

San Francisco: Bruce Conner creates *Child*, a wax figure tied to a highchair with burnt nylon stocking shreds.

Washington, D.C.: Howard Mehring and Tom Downing found the Origo Gallery with Betty Pejac.

Robert Rauschenberg's *Canyon* incorporates a stuffed eagle; his *Broadcast*, three radios that viewers could play.

April 19
Death of Frank Lloyd Wright.

May
New York: Works by De Kooning at Sidney Janis Gallery; show sells out in first day.

September
John Canaday becomes art critic for the *New York Times*.

October
New York: Solomon R. Guggenheim Museum, designed by Frank Lloyd Wright, opens.

October
Death of Bernard Berenson.

Winter 1959–1960
San Francisco: Group called Vortrex presents programs of abstract films and electronic music.

Exhibitions

Antwerp: Hessenhuis, *Vision in Motion—Motion in Vision*.

January 5–31
New York: Sidney Janis Gallery, *Eight Americans* (Albers, de Kooning, Gorky, Guston, Kline, Motherwell, Pollock, Rothko).

January 16–February 8
Houston: Museum of Fine Arts, *New York and Paris: Painting in the Fifties*.

February 2–21
New York: Hansa Gallery, *George Segal*. First exhibition of life-size plaster figures.

February 3–March 2
New York: G Gallery, *Lee Bontecou*. First one-man show (metal, terracotta, and bronze sculptures).

March 11–April 5
New York: French and Company, *Barnett Newman: A Selection 1946–1952* (29 canvases). Inaugural exhibition of gallery.

May 22– June 10
New York: Judson Gallery, *Drawings, Sculptures, Poems by Claes Oldenburg*. First one-man show.

June 2–27
New York: Condon Riley Gallery, *Roy Lichtenstein*.

June 15–30
Malden, Mass.: Malden Public Library, *Frank Stella*, first one-man show.

July 11– October 11
Kassel, Germany: *Documenta II*.

September 30–November 29
New York: MOMA, *New Images of Man*.

October
New York: Kaprow presents *18 Happenings in 6 Parts* at the Reuben Gallery, a loft on New York's lower Fourth Avenue; inaugural exhibition of the gallery.

October 17–November 5
New York: Artist's Gallery, *Robert Smithson*. First one-man show (painted collages).

October 29–January 13, 1960
New York: MOMA, *The Artist in His Studio*, Alexander Liberman's first one-man show (photography).

November 6–26
New York: Reuben Gallery, *Lucas Samaras*.

November 13–December 3
New York: Judson Gallery, *Oldenburg-Dine*.

November 27–December 27
Houston: Contemporary Arts Museum, *Out of the Ordinary* (neo-Dada collages and objects).

December
Gelsenkirchen, West Germany: Klein's *Mural d'Eponges*.

December 1–24
New York: Bodley Gallery, *Wild Raspberries by Andy Warhol* (drawings of food).

December 16–February 14, 1960
New York: MOMA, *Sixteen Americans* (De Feo, Hedrick, Jarvaise, Johns, Kelly, Leslie, Lewitin, Lytle, Mallary, Nevelson, Rauschenberg, Schmidt, Stankiewicz, Stella, Urban, Youngerman).

Publications

Alloway, Lawrence, "Paintings from the Big Country," *Art News and Review* 11 (March 14).

———, "The New American Painting," *Art International* 3.

Barker, Virgil, *From Realism to Reality in Recent American Painting.*

Burroughs, William S., *Naked Lunch.*

Calas, Nicolas, "ContiNuance," *Art News* 57 (February): 36–39.

Friedman, B. H., ed., *School of New York: Some Younger Artists* (New York: Grove Press), essays on 11 artists (Frankenthaler, Goodnough, Hartigan, Johns, Leslie, Mitchell, Parker, Rauschenberg, Rivers, Schueler, and Stankiewicz).

Goldwater, Robert, "Everyone Knew What Everyone Else Meant," *It Is* 4 (Autumn).

Grass, Günter, *The Tin Drum.*

Greenberg, Clement, "The Case for Abstract Art," *Saturday Evening Post* (August 1): 18ff.

Hunter, Sam, *Modern American Painting and Sculpture.*

Kramer, Hilton, "Month in Review," *Arts Magazine* 33 (February): 48–51.

Lebel, Robert, *Marcel Duchamp.*

Rosenberg, Harold, *The Tradition of the New.*

Sandler, Irving, "Is There a New Academy?" two-part series in *Art News* 58 (Summer 1959, September 1959).

Uris, Leon, *Exodus.*

1960

Contemporary Events

Dr. Humphrey Osmond invents term *psychedelic* (originally *psychodelic*).

Ray Charles emerges as a "black Elvis Presley."

SDS (Students for a Democratic Society) organized.

SNCC (Student Nonviolent Coordinating Committee) formed in Atlanta.

First Playboy Club opens.

U.S. Post Office ban on D. H. Lawrence's *Lady Chatterly's Lover* overturned.

Birth control pills appear on the market.

The Howdy Doody Show goes off the air.

First working model of lasers.

Psycho (Hitchcock), *Shoot the Piano Player* (Truffaut), and *La Dolce Vita* (Fellini) are released.

Brazil: Brasilia opens as capital.

Cambridge, Mass.: Harvard University, Dr. Timothy Leary interests Dr. Richard Alpert and Aldous Huxley in a series of mind-altering experiments.

Palo Alto, Calif.: Ken Kesey attends Stanford University.

Greensboro, N.C.: Four black students occupy seats at a Woolworth lunch counter; first sit-in.

February
France explodes its first atomic bomb.

May 1
Soviets shoot down U.S. spy plane, piloted by Francis Gary Powers, 1300 miles inside the USSR.

May 13
Police, with hoses and clubs, attack Berkeley students protesting San Francisco hearings of the House Un-American Activities Committee; first violent encounter between militant students and police.

May 23
Argentina: Israelis capture Adolf Eichmann.

June
Japan: Students riot in protest against Mutual Cooperation and Security Treaty with U.S.

June
Belgium grants independence to the Congo (now Zaire).

August
Cuernavaca, Mexico: Leary, friends, and researchers experiment with psychedelic mushrooms.

November
Kennedy defeats Nixon in presidential election.

Art Events

Johns paints bronze ale cans; Rosenquist begins to develop his Pop style; Warhol creates *Dick Tracy*.

Kienholz creates *The Psycho-Vendetta Case* in reference to the execution of Caryl Chessman.

Milan: French critic Pierre Restany issues the first manifesto of New Realism.

New Brunswick, N.J., and New York: Segal takes his first cast from a human body and begins to show his figures as part of an environment.

New York: Tanager Gallery, Tom Wesselmann shows his first "Great American Nudes."

January
New York: Tinguely arrives from Paris and begins to collect materials for his *Homage to New York* at the Newark dumps.

March
Paris: In *Le vent du voyage*, Klein exposes freshly painted canvases to the wind by attaching them to the top of a moving car.

March 9
Paris: At the Galerie International d'Art Contemporain, Klein's models cover themselves with paint and imprint themselves on canvas according to directions from the artist while an orchestra plays Klein's *Monotone Symphony*.

March 17
New York: *Homage to New York*, Jean Tinguely's self-destroying work of art, presented in sculpture garden of the MOMA.

April
Paris: In *Cosmogonies de la pluie*, Klein records patterns of falling rain on paintings.

October
Paris: Nouveau Realistes group formed under leadership of Restany and Klein.

November
New York: Reuben Gallery, Jim Dine happening, *Car Crash*.

November–December
New York: Reuben Gallery, Robert Whitman happening, *The American Moon*.

December
MOMA buys *Marriage of Reason and Squalor* by Frank Stella who is 23 and has not yet had a one-man show.

Exhibitions

Los Angeles: Ferus Gallery, *Edward Kienholz*. First one-man show.

January 1
New York Times reports that paintings by Jackson Pollock outperform blue chip stocks.

January 5–30
New York: Martha Jackson Gallery, *John Chamberlain: Sculptures*. First one-man show in New York.

January 9–28
New York: Reuben Gallery, *Red Grooms* (paintings, collages, and contructions for stage sets).

January 18–February 6
New York: Alan Gallery, *Bruce Conner*. One-man show.

January 26–February 13
New York: Staempfli Gallery, *Jean Tinguely*. First one-man show in the U.S.

January 26–March 2
New York: Jewish Museum, *Helen Frankenthaler*. First one-woman museum exhibition.

January 30–March 17
New York: Judson Gallery, *Ray-Gun* (two-artist exhibition: Jim Dine, *The House*; Claes Oldenburg, *The Street*).

February
Milan: Galleria Bruno Danese, *Opere d'arte animate e moltiplicate*.

March
New York: Galerie Chalette, *Construction and Geometry in Painting—From Malevich to "Tomorrow."*

March 9–May 15
New York: MOMA, *Monet: Seasons and Moments*.

April 4–23
New York: Betty Parsons Gallery, *Alexander Liberman*. First one-man show of paintings and sculpture.

April 19–May 9
New York: Iolas Gallery, *Takis*. First one-man show in the U.S.

May–June
Zurich: Kunstgewerbemuseum, *Kinetische Kunst* (Calder mobiles and stabiles, plus Edition MAT, Agam, Albers, Bury, Duchamp, Ek, Gerstner, Mack, Malina, Mari, Munari, Man Ray, Dieter Rot, Soto, Tinguely, Vasarely).

June 6–24
New York: Martha Jackson Gallery, *New Media—New Forms I: In Painting and Sculpture* (71 artists, including Brecht, Dine, Flavin, Grooms, Johns, Kaprow, Oldenburg, Rauschenberg, Whitman).

June 6–September 6
New York: MOMA, *Art Nouveau: Art and Design at the Turn of the Century*.

June 8–August 14
Zurich: Heimhaus, *Konkrete Kunst*.

June 10– August 28
Munich: Stadtische Galerie, *Neue Malerei: Form, Struktur, Bedeutung* (includes de Kooning, Gorky, Hofmann, Kline, Pollock).

June 17–September 19
New York: MOMA, *Jazz by Henri Matisse*.

July 12–August 31
Pasadena, Calif.: Pasadena Art Museum, *Robert Irwin*. First one-man museum show.

September
London: Royal Society of British Artists Galleries, *Situation: An Exhibition of British Abstract Painting*.

September 6–30
Los Angeles: Ferus Gallery, simultaneous exhibitions of Johns sculpture and Schwitters collages.

September 14–October 30
New York: Whitney Museum of American Art, *Young America 1960*.

September 27–October 15
New York: Leo Castelli Gallery, *Frank Stella*. First one-man show in New York.

September 28–October 22
New York: Martha Jackson Gallery and David Anderson Gallery, *New Media—New Forms II: In Painting and Sculpture* (72 artists, including Brecht, Dine, Flavin, Johns, Kaprow, Oldenburg, Rauschenberg, Samaras, Whitman).

October 6–November 18
London: Hanover Gallery, Cesar shows his "governed compressions"; Rotella and Hains present salvaged posters; Spoerri shows "snare pictures" of common objects glued and hung; Restany, in catalog, uses term "new realism" for these works.

October 18–November 10
New York: Greene Gallery, *Mark di Suvero*. First one-man show.

November 30–December 24
New York: Judson Gallery, *Allan Kaprow: An Apple Shrine*.

Publications

Alloway, Lawrence, "Sign and Surface: Notes on Black and White Painting in New York," *Quadrum* 9: 49–62.

Amaya, Mario, "The New Super Realism," *Sculpture International* 1 (January): 14.

"Form Is Language: Statements by Kenneth Rexroth, Frederick J. Kiesler, John Cage, Julian Beck," *Art News* 59: 34–35, 62.

Goldwater, Robert, "Reflections on the New York School," *Quadrum* 8.

Greenberg, Clement, "Louis and Noland," *Art International* 4 (May): 26–29.

Hess, Thomas B., "U.S. Art, Notes from 1960," *Art News* 58: 24–29, 56–58.

Kepes, Gyorgy, *The Visual Arts Today*.

Kramer, Hilton, "The Sculpture of David Smith," *Arts* 34 (February): 22–43.

Meyers, John Bernard, "The Impact of Surrealism on the New York School," *Evergreen Review* 4 (March): 75–85.

Read, Sir Herbert, and H. H. Arnason, "Dialogue on Modern U.S. Painting," *Art News* 59: 32–36.

Rosenblum, Robert, "Jasper Johns," *Art International* 4 (September).

Rubin, William, "Younger American Painters," *Art International* 4.

1961

Contemporary Events

CORE (Congress of Racial Equality) and SNCC (Student Non-Violent Coordinating Committee) begin Freedom Rides in the South; SNCC begins voter registration drive.

Dmitri Shostakovich's *Twelth Symphony* debuts.

Bob Dylan arrives in New York.

New York: The Twist starts in the Peppermint Lounge.

North Carolina: Robert Williams calls for armed self-defense by blacks and is forced into exile.

January
Release of Captains Freeman B. Olmstead and John R. McKone, members of crew of USAF RB-47 detained in USSR since July 1, 1960.

January 20
John F. Kennedy inaugurated.

March
Cambridge, Mass.: Richard Alpert takes 10 milligrams of psilocybin at Leary's house.

March 1
Peace Corps created by executive order of President Kennedy.

April 12
Yuri Gagarin of the Soviet Union becomes the first human space traveler in Vostok I; returns to Earth safely after one orbit of the globe.

April 17
Bay of Pigs organized by CIA.

May 5
Alan B. Shepard, Jr., becomes first U.S. space traveler.

July 21
Virgil I. Grissom makes similar flight to Shepard's; his Mercury capsule sinks and is lost, but he is rescued.

August 6
A second Soviet astronaut, Gherman S. Titov, makes 17 orbits of the Earth in Vostok II and lands safely.

August 13
East Germany closes the border between East and West Berlin to stop exodus of East Germans to the West; Berlin Wall is built.

Fall
Ginsberg leaves for India and goes back and forth during the next four years.

Fall
Cambridge, Mass.: Harvard University, Leary and Alpert give psilocybin to 12 graduate students.

October 29
USSR: Nuclear blast of 50 megatons, largest man-made explosion to date.

Art Events

Robert Indiana, Richard Smith, and Stephen Durkee show "premiums" at the Studio for Dance.

David Hockney visits New York for the first time.

Larry Rivers's first use of tacked-on appendages to his paintings is in series *Friendship of America and France*.

Richard Smith's *MM* derived from Paris Match cover of Marilyn Monroe.

California: Kienholz makes his first large tableau, *Roxy's*.

Cologne: Stockhausen, Nam June Paik, Hans G. Helms, Mary Eaumeister, et al., present *Originae*. Performed in New York in 1964 with Breer, Ginsberg, Kaprow, Kluver, et al.

Holland: NUL is founded by Peeters, Schoonhoven, Armando.

New York: Richard Bellamy (Greene Gallery) and Leo Castelli begin to promote Pop art.

Paris: A collaborative performance at the American Embassy: Rauschenberg creates paintings on stage, Tudor plays Cage's music, Tinguely's motorized sculpture does a striptease, and Niki de Saint Phalle does a picture shoot.

Turin: Lucio Fontana suspends 6,000 feet of neon vertically from Italy's Exposition Hall.

London: Demonstration of Auto-Destructive Art by G. Metzger.

Liverpool: Kitaj, Blake, and Hockney are prizewinners at John Moore's exhibition.

Paris: Yves Klein makes his first five paintings with a flamethrower at the Centre d'Essai du Gaz de France, in the Paris suburbs.

New York: Reuben Gallery closes.

February 26
Forty-nine leading art world figures sign letter to the *New York Times* protesting the writings of art critic John Canaday.

November 27
A *New York Times* article notes "soaring museum attendance."

December–January 1962
New York: Claes Oldenburg opens "Store" at 107 East 2nd Street, selling sculpted food.

Exhibitions

Paris: Galerie Denise René, *Groupe de Recherche d'Art Visuel.*

Paris: Galerie Rive Droite, *Le Nouveau Realisme—A Paris et á New York.*

Zagreb, Yugoslavia: Nova Tendencija (New Tendency) exhibitions.

Cologne: Galerie Haro Lauhus, *Christo.* First one-man exhibition.

January 18–March 12
New York: MOMA, *Mark Rothko.*

February 20–March 11
New York: Betty Parsons Gallery, *Alfonso Ossorrio.*

March 10–April 17
Amsterdam: Stedelijk Museum, *Bewogen Beweging* (Movement in Art).

April
New York: MOMA, Len Lye's "Tangible Motion Sculpture."

April 4–29
New York: Greene Gallery, *Richard Smith.* First one-man show.

April 11–29
New York: Leo Castelli Gallery, *Yves Klein le Monochrome.* First one-man show in U.S.

May 8–June 5
New York: Judson Gallery, *Dan Flavin: Constructions and Watercolors.* First one-man show.

May 17–June 21
Pasadena, Calif.: Pasadena Art Museum, *Recent Works by Edward Kienholz.* One-man show.

May 17–September 3
Stockholm: Moderna Museet, *Rörelse i konsten.*

May 25–June 23
New York: Martha Jackson Gallery at David Anderson Gallery, *Environments, Situations, Spaces* (includes Brecht, Dine, Gaudnek, Kaprow, Oldenburg, Whitman).

May 29–June 17
Los Angeles: Huysman Gallery, *War Babies* (includes Bell, Bereal, Goode, Miyashiro), organized by Henry Hopkins.

May 31–September 5
New York: MOMA, *Futurism.*

August–September
New York: MOMA, *Roads.*

September–September 1962
London: *British Constructivist Art.* Toured by American Federation of Arts.

October 2–November 12
New York: MOMA, *The Art of Assemblage* (142 artists). Curated by William C. Seitz.

October 13–December 31
New York: Solomon R. Guggenheim Museum, *Abstract Expressionists and Imagists.*

October 18–December 3
New York: MOMA, *The Last Works of Henri Matisse, Large Cut Gouaches.*

November 7–December 1
New York: Leo Castelli Gallery, *Robert Rauschenberg*, combine paintings. As works were installed and de-installed on a daily basis, the exhibition became a happening.

December 8–30
New York: Tanager Gallery, *Tom Wesselmann: Great American Nude.* First one-man show, featuring both the large and small Great American Nude collages.

Publications

Alloway, Lawrence, "Easel Painting at the Guggenheim," *Art International* 5 (December): 26–34.

Cage, John, *Silence.*

Greenberg, Clement, *Art and Culture.*

Hess, Thomas B., "Collage as an Historical Method," *Art News* 60 (November): 7.

Kaprow, Allan, "Happenings in the New York Scene," *Art News* 60 (May): 36–90.

Restany, Pierre, "Jasper Johns and the Metaphysic of the Common Place," *Cimaise* 8 (September): 90–97.

Rosenblum, Robert, "The Abstract Sublime," *Art News* 59 (February).

Rush, Richard H., *Art as an Investment.*

Salinger, J. D., *Franny and Zooey.*

Tillim, S., "John Graham and Richard Lindner," *Arts Magazine* 36 (November): 34–37.

Watts, Alan W., *Psychotherapy East and West.*

1962

Contemporary Events

England: Pat Williams edits first women's liberation journal.

Lolita (Kubrick), *Jules et Jim* (Truffaut), *The Manchurian Candidate* (Frankenheimer), and *Dr. No* (Terence Young), the first James Bond movie, are released.

Edward Albee's *Who's Afraid of Virginia Woolf?* first performed.

February
Paris: Anti-O.A.S. (Secret Army Organization) riots over terrorism in Algeria.

February
South Vietnam: U.S. Military Command is established under Gen. Paul D. Harkins.

February
USSR exchanges U-2 pilot Francis G. Powers for imprisioned Soviet spy.

February 20
John H. Glenn, Jr., first American in orbit, circles Earth three times in Friendship 7; seen via television.

May
M. Scott Carpenter makes a three-orbit flight in Aurora 7.

May 31
Israel: Adolph Eichmann executed.

June
Port Huron Statement (the testament of the New Left) approved by SDS convention.

June
U.S. Supreme Court rules in a 6-1 decision that the reciting of an official prayer in the public schools of New York State is unconstitutional.

July
Second Geneva Conference calls for an independent, neutral Laos.

July
Algeria achieves independence; ends a seven-year Moslem revolt against French rule.

July
Geneva: Draft declaration prohibits establishment of foreign military bases in Laos.

August
The third and fourth Soviet astronauts are sent into orbit; Andrian G. Nikolayev makes a record 64 orbits of the Earth and Pavel R. Popovich makes 48 orbits.

August 5
Hollywood: Death of Marilyn Monroe at age 36.

Fall
Cambridge, Mass.: International Federation for Internal Freedom is formed to promote use of drugs.

October 1
Oxford, Miss.: James Meredith, escorted by federal marshals, registers at the University of Mississippi.

October 3
Walter M. Schirra, Jr., orbits Earth six times in Mercury capsule Sigma 7.

October 11
Opening of the Vatican Council II, presided over by Pope John XXIII.

October 22
Cuban missile crisis: President Kennedy announces via television a naval "quarantine" of Cuba.

November
Edward Kennedy elected to the U.S. Senate from Massachusetts.

November
Nixon is defeated for governor of California.

Art Events

Tony Smith creates *The Black Box*, a made-to-order welded steel box based on a card file box enlarged by five times.

Judson Dance Theater formed in Judson Memorial Church by Yvonne Rainer and Steve Paxton.

Congress of Racial Equality (CORE) begins holding annual exhibitions and sales of paintings and sculptures donated by artists.

Picasso wins the Lenin Prize.

England: BBC-TV film, *Pop Goes the Easel*, with Boshier, Phillips, Blake, and Boty.

Wiesbaden: Fluxus Group initiated by George Maciunas with Wolf Vostell and Nam June Paik.

Paris: First international meeting of Nouvelle Tendence, recherche continuelle (NTrc).

January–March
New York: Oldenburg's Ray-Gun Theatre on Lower East Side.

March
Nevada: *Study No. 2 for an End of the World* detonated in the desert south of Las Vegas by Jean Tinguely.

April–October
Seattle, Wash.: Century 21 Exposition.

May
Spoleto, Italy: David Smith's *Voltri* series, 26 sculptures completed in 30 days.

May
Oldenburg converts his "Store" or Ray Gun Mfg Co. into a theater for happenings taking place over ten weekends, a different happening each weekend.

May 13
Death of Franz Kline.

June 6
Paris: Death of Yves Klein, age 34.

June 27
Paris: Traffic is blocked for six hours on the rue Visconti due to Christo's first barrel environment, a wall of 240 oil drums, erected in protest of the Berlin Wall.

August
New York: "Automatic Art Show," a mechanical painting machine paints a work for $2.

September 7
Death of Morris Louis.

October
Edinburgh: International Arts Festival; Kaprow's happening at the end of the festival.

October 30
Washington, D.C.: Washington Gallery of Modern Art opens with Franz Kline Memorial Exhibition.

December 13
New York: MOMA, *Pop Art*, a panel discussion with Peter Selz, moderator, Dore Ashton, Henry Geldzahler, Hilton Kramer, Leo Steinberg, and Stanley Unitz.

Exhibitions

Bern: Kunsthalle, *Francis Picabia, Jasper Johns, Alfred Leslie, Robert Rauschenberg, Richard Stankeiwicz*.

Darmstadt: Hessische Landesmuseum, *Abstrakte Amerikanische malerei*.

Milan: *Arte Programmata* (Programmed Art) sponsored by Olivetti (shown at Royal College of Art, London, and Smithsonian Institution, Washington, D.C.).

Washington, D.C.: Washington Gallery of Modern Art, *Formalists*.

January 9–February 3
New York: Martha Jackson Gallery with David Anderson Gallery, *Jim Dine: New Works*. First post-happening show.

January 30–February 17
New York: Greene Gallery, *James Rosenquist*. First one-man show.

February 10–March 3
New York: Leo Castelli Gallery, *Roy Lichtenstein*. First one-man show.

February 19–April 8
New York: MOMA, *Jean Dubuffet*.

March–April
London: New Marlborough London Gallery, *Painters of the Bauhaus*.

March 24–April 14
Los Angeles: Ferus Gallery, *Larry Bell*. First one-man show.

April 3–May 13
Dallas: Dallas Museum for Contemporary Arts, *1961* (36 artists, including Dine, Johns, Lichtenstein, Oldenburg, Rauschenberg, and Rosenquist).

April 17–May 5
New York: Allan Stone Gallery, *Wayne Thiebaud*. First one-man show in New York.

May–September
New York: MOMA, *Picasso*, 80th Birthday Exhibition.

May 8–June 2
New York: Greene Gallery, *George Segal*. First works from life casts.

June
Amsterdam: Stedelijk Museum, *4 Amerikanen* (Johns, Lesley, Rauschenburg, Stankiewicz).

July 9–August 4
Los Angeles: Ferus Gallery, *Andy Warhol* (paintings of Campbell's soup cans).

September
Pasadena, Calif.: Pasadena Art Museum, *New Painting of Common Objects* (includes Dine, Dowd, Goode, Hefferton, Lichtenstein, Ruscha, Thiebaud, Warhol).

September 11–22
New York: Smolin Gallery, *Words*. Environment by Allan Kaprow.

September 12–November 4
New York: MOMA, *Mark Tobey*.

September 18–October 20
New York: Greene Gallery, *Claes Oldenburg* (large-scale "soft" sculptures).

October 16–November 3
New York: Stable Gallery, *Robert Indiana*. First one-man show.

October 24–December 2
New York: Whitney Museum of American Art, *Fifty California Artists*.

October 25–November 7
Philadelphia: YM/YWHA, *Art 1963—A New Vocabulary* (includes Brecht, Brees, Dine, Johns, Kaprow, Lichtenstein, Marisol, Oldenburg, Rosenquist, Rauschenberg, Segal, and Watts); does not use the term Pop art; however, a definition of pop culture appears in the catalog in a useful lexicon of current terminology.

October 31–December 1
New York: Sidney Janis, *The New Realists* (29 artists, including Dine, Lichtenstein, Oldenburg, Rosenquist, Segal, Warhol, and Wesselmann).

November–December 30
New York: Iolas Gallery, *Jean Tinguely* (radio constructions).

November 6–24
New York: Stable Gallery, *Andy Warhol*. One-man show.

November 13–December 1
New York: Greene Gallery, *Wesselmann: Collages/Great American Nude and Still Life*.

November 18–December l5
Los Angeles: Dwan Gallery, *My Country 'Tis of Thee*.

December 19–February 12, 1963
New York: MOMA, *Arshile Gorky*.

Publications

Ashton, Dore, "Abstract Expressionism Isn't Dead," *Studio* 162 (September): 104–107.

——, *The Unknown Shore: A View of Contemporary Art*.

Baldwin, James, *Another Country*.

Brown, Helen Gurley, *Sex and the Single Girl*.

Burdick, Eugene, *Fail Safe*.

Canaday, John, *The Embattled Critic*.

Coplans, John, "The New Paintings of Common Objects," *Artforum* 1 (November): 26–29.

Fuck You: A Magazine of the Arts, published by Ed Sander, writer for "The Fugs," a pornographic rock group.

Gottlieb, Carla, "The Present Woman, the Flag, the Eye: Three New Themes in Twentieth Century Art," *Journal of Aesthetics and Art Criticism* (Winter): 117–187.

Greenberg, Clement, "After Abstract Expressionism," *Art International* 6 (October): 24–32.

Groupe de Recherche d'Art Visuel, *General Propositions*.

Heller, Joseph, *Catch-22*.

Janis, Harriet, and Rudi Blesh, *Collage: Personalities, Concepts, Techniques* (Philadelphia: Chilton).

Knebel, Fletcher, and Charles W. Bailey II, *Seven Days in May*.

Kubler, George, *The Shape of Time*.

Kesey, Ken, *One Flew Over the Cuckoo's Nest*.

Kozloff, Max, "Pop Culture, Metaphysical Disgust and the New Vulgarians," *Art International* 6 (March): 33–36.

Marshall McLuhan's *Gutenberg Galaxy* is given the Canadian Governor General's Award.

Rosenberg, Harold, "The Art Galleries—The Game of Illusion," *New Yorker* (November 24): 161–167.

Seckler, Dorothy Gees, "Folklore of the Banal," *Art in America* 50 (Winter): 57.

Solzhenitsyn, Aleksandr, *One Day in the Life of Ivan Denisovich*.

Swenson, G. R., "The New American 'Sign Painters' " *Art News* 61 (September): 44–47, 60–62.

Time, Life, and *Newsweek* covers feature Pop art.

1963

Contemporary Events

Film Makers Co-op releases *Scorpio Rising*, motorcycle film by Kenneth Anger.

Leary and Alpert are fired from Harvard University for LSD experiments with students.

Newport, R.I.: Dylan emerges as the new leader of American folk music with the song "Blowin' in the Wind."

Washington, D.C.: Pop Arts Festival, organized by Billy Kluver.

March 18
U.S. Supreme Court decision in *Gideon v. Wainright* safeguards the constitutional rights of defendants.

May 15–16
Leroy Gordon Cooper orbits earth 22 times in final and longest flight of Project Mercury.

June 3
Death of Pope John XXIII.

June 12
Jackson, Miss.: Murder of Medgar Evers.

June 16–19
The first woman space traveler, Soviet Valentina V. Tereshkova, makes 48 orbits in Vostok VI.

June 17
U.S. Supreme Court rules 8-1 that state and local regulations requiring recitation of the Lord's Prayer or Bible verses in public schools are unconstitutional.

July 25
A limited nuclear test-ban treaty is agreed upon by the U.S., Soviet Union, and Britain; bars all nuclear tests except those conducted underground.

August 28
Washington, D.C.: demonstration by 200,000 persons in support of demands for equal rights by blacks; highlight is Dr. Martin Luther King's "I have a dream" speech.

September 15
Birmingham, Ala.: A bomb at the Sixteenth Street Baptist Church kills four young black girls.

November 1
South Vietnam: Overthrow of President Ngo Dinh Diem in a coup by armed forces.

November 22
Dallas: John F. Kennedy, 35th president of the United States, is assassinated; vice-president Lyndon Johnson takes presidential oath of office on Air Force One.

November 24
Dallas: Lee Harvey Oswald shot and killed by Jack Ruby.

Art Events

Washington, D.C.: Pop Arts Festival, organized by Billy Kluver.

Wuppertal, West Germany: Galerie Parnass, first exhibition of video art by Nam June Paik.

Paris: Paris Biennale, Groupe de Recherche d'Art Visuel wins first prize.

New York: Opening of the Factory, Andy Warhol's studio and gathering place for his "entourage," at 231 East 47th Street.

May
Fluxus artists arrive in the U.S. from Germany, organize a Yam Festival (May spelled backwards)—a series of events and performances at George Segal's farm in New Jersey and the Smolin Gallery, New York.

August 30
Death of Georges Braque.

November
Warhol does Jackie Kennedy portraits—all done shortly before, during, and shortly after JFK's murder.

Exhibitions

New York: Pace Gallery, *Ernest Trova*. First one-man show in New York. (First one-man show at Image Gallery, St. Louis, 1959.)

New York: Thibaut Gallery, *According to the Letter*.

Waltham, Mass.: Rose Art Museum, Brandeis University, *New Directions in American Painting*.

Washington, D.C.: Adams-Morgan Gallery, *Sam Gilliam*. First one-man show.

January 11–February 15
Regina, Canada: Norman MacKenzie Art Gallery, *Three New American Painters* (Louis, Noland, Olitski).

March
New York: Allan Stone Gallery, *Eva Hesse, Recent Drawings*. First one-woman show.

March–April
Paris: Musée des Arts Décoratifs, Louvre, *Victor Vasarely* (retrospective).

March–April
Los Angeles: UCLA Art Galleries, *Jacques Lipchitz* (retrospective).

March 4–15
Brooklyn: Pratt Institute School of Architecture, *Kenneth Snelson*, first one-man show.

March 14–June 12
New York: Solomon R. Guggenheim Museum, *Six Painters and the Object* (Dine, Johns, Lichtenstein, Rauschenberg, Rosenquist, Warhol).

March 31–May 12
New York: Jewish Museum, *Robert Rauschenberg*. First one-man museum show.

April
Houston: Contemporary Arts Museum, *Pop! Goes the Easel* (includes Blosum, Dine, Klachek, Lichtenstein, McAfee, Wesselmann).

April 1–27
New York: Sidney Janis Gallery, *Arman*. First one-man show in New York.

April 17–May 26
New York: Whitney Museum of American Art, *Richard Pousette-Dart*. First museum retrospective.

April 18–June 2
Washington, D.C.: Washington Gallery of Modern Art, *The Popular Image* (includes Brecht, Dine, Johns, Lichtenstein, Oldenburg, Rauschenberg, Rosenquist, Warhol, Watts, Wesley, and Wesselmann).

April 28–May 26
Kansas City, Mo.: Nelson Atkins Museum of Fine Arts, *Popular Art, Artistic Projections of Common American Symbols*.

May–September
Paris: Galerie Denise René, *Esquisse d'un Salon*.

May–September
London: Battersea Park, *Sculpture in the Open Air*.

May 1–September 10
New York: MOMA, *Rodin* (largest exhibition of his sculpture seen in U.S.; assembled in cooperation with the Palace of the Legion of Honor, San Francisco).

July–August
Frankfurt am Main: Galerie d. Zeigt, *Europäische Avant-garde* (includes Arte Programmata, Neue Tendenzen, Zero).

July 24–August 25
Los Angeles: Los Angeles County Museum of Art, *Six Painters and the Object—and Six More* (six California painters added to the Guggenheim exhibition).

August 1–September 15
Zagreb, Yugoslavia: Galerija Suvremene Umjetnosti, *Nove Tendecije 2*.

September–October
London: Whitechapel Art Gallery, *Anthony Caro: Sculpture 1960–1963*. First one-man exhibition of abstract steel sculpture.

September 7–29
Oakland, Calif.: Oakland Art Museum, *Pop Art U.S.A.* (47 artists, including Brecht, Dine, Johns, Lichtenstein, Oldenburg, Rauschenberg, Rosenquist, Warhol, and Wesselmann).

September 11–November 28
New York: MOMA, *Hans Hofmann*.

September 17–October 5
New York: Poindexter Gallery, *Gene Davis: First New York Exhibition*. (First one-man show 1952, Washington, D.C., Dupont Theatre Gallery.)

October 2–November 23
New York: MOMA, *Medardo Rosso, 1858–1928*. First museum exhibition in U.S.

October 9–November 3
Pasadena: Pasadena Art Museum, *By or of Marcel Duchamp or Rrose Sélavy*.

October 15–November 2
New York: Greene Gallery, *Robert Morris*. First one-man show in New York.

October 24–November 23
London: Institute of Contemporary Art, *The Popular Image*.

New York: Greene Gallery, *Larry Poons*. First one-man show.

November 19–December 15
Buffalo, N.Y.: Buffalo Fine Arts Academy, Albright-Knox Art Gallery, *Mixed Media and Pop Art* (66 artists, including Brecht, Dine, Johns, Lichtenstein, Morris, Rauschenberg, Rosenquist, Samaras, Segal, Warhol, and Wesselmann).

December
London: Kasmin Limited Gallery, *David Hockney: Pictures with People In*. First one-man show.

December 11–January 26, 1964
Washington, D.C.: Gallery of Modern Art, *Paintings, Sculpture and Drawings by Ellsworth Kelly*. First one-man museum show.

December 17–January 11, 1964
New York: Greene Gallery, *Don Judd*. Second one-man show.

December 17–January 12, 1964
Washington, D.C.: Corcoran Gallery of Art, *Gene Davis: Washington Artists' Exhibition No. 21*. First one-man museum show.

Publications

Albers, Josef, *Interaction of Color*.

Alloway, Lawrence, "Notes on 5 New York painters," *Albright-Knox Gallery Notes* 26 (Autumn): 16–17.

Baldwin, James, *The Fire Next Time*.

Coplans, John, "Pop Art, U.S.A.," *Artforum* 2 (October): 27–30.

——, "An Interview with Roy Lichtenstein," *Artforum* 2 (October): 31.

Friedan, Betty, *The Feminine Mystique*.

Geldzahler, Henry, "Robert Rauschenberg," *Art International* 7 (September): 62–67.

Kennedy, John F., *Profiles in Courage*.

Lévi-Strauss, Claude, *Structural Anthropology*.

Loran, Erle, "Cézanne and Lichtenstein: Problems of Transformation," *Artforum* 2 (September).

——, "Pop Artists or Copy Cats?" *Art News* 62 (September): 48–49, 61.

McCarthy, Mary, *The Group*.

Nordland, Gerald, "Pop Goes the West," *Arts Magazine* 37 (February): 60–61.

Rauschenberg, Robert, with text by Dore Ashton and Robert Rauschenberg, *Illustrations for Dante's Inferno* (New York: Abrams).

Rose, Barbara, "Pop Art at the Guggenheim," *Art International* 7 (May): 20–22.

Ruscha, Ed, *Twentysix Gasoline Stations* (Heavy Industry Publications).

Salinger, J. D., *Raise High the Roof Beam, Carpenters, and Seymour—An Introduction*.

Seitz, William C., "The Rise and Dissolution of the Avant Garde," *Vogue* 102, no. 4 (September).

Selz, Peter, "A Symposium on Pop Art," *Art Magazine* 37 (April): 36.

Swensen, Gene, "Rauschenberg Paints a Picture," *Art News* 62 (April): 44–47, 65–67.

"What Is Pop Art?," interviews by G. R. Swenson. Answers by eight painters. Part I, *Art News* 62 (November): 24–27, 60–64, (Jim Dine, Robert Indiana, Roy Lichtenstein, Andy Warhol).

Part II, *Art News* 62 (February 1964): 40–43, 62–66 (Stephen Durkee, Jasper Johns, James Rosenquist, Tom Wesselman)

1964

Contemporary Events

Rejection of North Vietnamese peace offers.

21,000 servicemen called "advisors" in Vietnam.

Nobel Peace Prize awarded to Martin Luther King, Jr.

Malcolm X breaks with Black Muslims.

Segregation in public schools outlawed in the South.

Student demonstrations gain national prominence.

Dr. Strangelove or: How I Learned to Stop Worrying and Love the Bomb (Kubrick) and *A Hard Day's Night* (Lester) are released.

January
Anti-American riots in Panama.

January 23
24th Amendment, abolishment of the poll tax.

January
Pope Paul VI tours the Holy Land; he is the first pope to visit there, the first to travel by air, and the first to leave Italy in over 150 years.

February 9
The Beatles appear on the *Ed Sullivan Show*.

March
England: Outbreaks of Mods vs. Rockers.

April–October
New York: World's Fair.

July 2
President Lyndon Johnson signs Civil Rights Act.

July
U.S. spacecraft, Ranger 7, relays thousands of close-up pictures of the moon back to Earth before crashing on the lunar surface.

August
Gulf of Tonkin Incident: U.S. planes bomb North Vietnamese bases and sink or damage 24 North Vietnamese patrol boats in retaliation against North Vietnamese attacks on U.S. destroyers in the Gulf of Tonkin. Gulf of Tonkin Resolution gives President Johnson authority to take "all steps necessary" to keep communism out of the region.

August
Mississippi: The bodies of three civil rights workers, reported missing in June, are found buried; twenty-one men are arrested.

August
Death of Ian Fleming, creator of James Bond.

September
Washington, D.C.: Leaders of Johnson Administration authorize attacks against North Vietnam.

September
The Warren Commission releases a report concluding that Lee Harvey Oswald was solely responsible for the assassination of President Kennedy.

October 15
Khrushchev is ousted as Soviet premier and Communist party chief; Aleksei N. Kosygin replaces him as premier and Leonid I. Brezhnev takes over the party leadership.

October l6
Communist China conducts a successful test explosion of its first atomic bomb.

November 3
Lyndon Johnson elected president.

December
Berkeley: 800 Berkeley students are arrested in sit-in.

December
Lenny Bruce is found guilty of giving "obscene, indecent, immoral, and impure" performances at Cafe Au Go-Go in Greenwich Village.

Art Events

Kienholz creates *Instant On* in reference to the Kennedy assassination.

Bonn: Otto Piene designs trio of "light sculptures" and a retractable light ceiling for Bonn's new City Opera House.

Venice Biennale: For the first time an American, Robert Rauschenberg, is awarded the top prize.

Larry Rivers paints a portrait of Napoleon after Jacques-Louis David and titles it *The Greatest Homosexual*.

New York: Christo arrives and begins building fake storefronts.

June 24
Death of Stuart Davis.

Edward Kienholz's *The Beanery*, environmental assemblage representing the L.A. bar, Barney's Beanery, on August 28, 1964 (date indicated by a newspaper outside the bar—issue of the *Herald-Examiner* with the headline "Children Kill Children in Viet Nam Riots").

Peter Weiss's *Marat/Sade* opens.

Washington, D.C.: Establishment of the National Foundation for the Arts and Humanities.

Exhibitions

January 9–February 1
New York: Howard Wise Gallery, *On the Move*.

January 9–February 9
Hartford, Conn.: Wadsworth Atheneum, *Black, White and Grey*. Pop and Minimal artists (Brecht, Dine, Flavin, Johns, Lichtenstein, Morris, Rauschenberg, Stella, Warhol).

January–February
San Francisco: San Francisco Museum of Art, *Robert Bechtle* (lithographs).

February 16–April 12
New York: Jewish Museum, *Jasper Johns* (retrospective).

February 20–March 26
London: Institute of Contemporary Art, *Study for an Exhibition of Violence in Contemporary Art*.

February 29–April 12
Stockholm: Moderna Museet, *Amerikansk Pop-konst*.

March 5–29
New York: Kaymar Gallery, *Dan Flavin: Some Light*.

March 13–May 3
Leverkusen, West Germany: Staditsches Museum, *Neue Tendenzen*.

April–May
Paris: Musée des Arts Décoratifs, *Nouvelle Tendence*.

April 21–May 9
New York: Stable Gallery, *Andy Warhol*, exhibition of Brillo boxes and Del Monte boxes.

April 22–June 28
London: Tate Gallery, *Painting and Sculpture of a Decade—54/64*.

April 23–June 7
Los Angeles: Los Angeles County Museum of Art, *Post Painterly Abstraction* (includes Bannard, Bireline, Bush, Davis, Dieringer, Downing, DuCasse, Dzubas, Feeley, Ferren, Francis, Frankenthaler, Hamilton, Held, Jensen, Kelly, Krushenick, Liberman, Lochhead, Louis, McKay, Mehring, Noland, Olitski, Parker, Sander, Simpson, Stadler, Stella, Wells, Woelffer).

June–October
Paris: Galerie Denise René, *Hard-Edge* (Albers, Arp, Baertling, Herbin, Liberman, Lohse, Mortensen, Taeuber-Arp, Vasarely).

June 20–October l5
Venice: *XXXII Esposizione Biennale Internazionale d'Arte* United States of America, *Four Germinal Painters* (Johns, Louis, Noland, Rauschenberg); *Four Younger Artists* (Chamberlain, Dine, Oldenburg, Stella).

June 24–August 30
The Hague: Gemeentemuseum, *Nieuwe Realisten*.

June 27–October 15
Kassel, Germany: *Documenta III*.

July
New York: MOMA, Thomas Wilfred, Lumia Suite, op. 158.

September–October 17
New York: Alan Gallery, *David Hockney*. First one-man show in U.S.

September 16–October 10
New York: Greene Gallery, *Lucas Samaras*.

September 19–October 31
Vienna: Museum des 20. Jahrhunderts, *Pop, etc.*

October 11–25
Yonkers, N.Y.: Hudson River Museum, *Eight Young Artists*. Early Minimal show.

October 17–November 5
New York: Kornblee Gallery, *Malcolm Morley*. First one-man show.

November 6–December 6
Cincinnati: Contemporary Arts Center, *Motion and Movement: An Exhibition of Kinetic Painting and Sculpture*.

November 9–February 7, l965
New York: MOMA, *Architecture Without Architects*.

December
London: Whitechapel Art Gallery, *Jasper Johns: Paintings, Drawings, and Sculpture, 1954–1964* (retrospective exhibition).

December 2–19
New York: Andre Emmerich Gallery, Anthony Caro's first one-man show in U.S. Sculptures consist of isolated elements joined by long, low steel panels.

December 15–February 28, 1965
Paris: Galerie Denise René, *Mouvement 2* (kinetic and optical art).

Publications

Ashton, Dore, "Al Held: New Spatial Experiences," *Studio International* 168 (November): 210–213.

———, "Richard Lindner, the Secret of the Inner Voice with French, Italian and German Summaries," *Studio* 167 (January): 12–17.

Baro, Gene, "The Venice Biennale," *Arts Magazine* 38 (September): 32–37.

Bellow, Saul, *Herzog*.

Cage, John, "26 Statements re Duchamp," *Art and Literature* 31 (Autumn–Winter): 9–10.

Canaday, John, "Pop Art Sells On and On—Why?," *New York Times Magazine* (May 31): 48–53.

"The Changing Guard," *Times Literary Supplement* (August 6): 258.

Coke, Van Deren, *The Painter and the Photograph*.

Colt, Priscilla, "Notes on Ad Reinhardt," *Art International* 9 (October 20): 32–34.

Constable, Rosalind, "New York's Avant Garde, and How It Got There," *New York Herald Tribune* Sunday magazine (May 17): 7–10.

Coplans, John, "Post Painterly Abstraction: The Long-Awaited Greenberg Exhibition Fails to Make Its Point," *Artforum* 2 (June): 4–9.

Danto, Arthur, "The Art World," *Journal of Philosophy* 61: 571.

Factor, Donald, "Assemblage," *Artforum* 2 (Summer): 38–41.

Fried, Michael, "Modernist Painting and Formal Criticism," *American Scholar* 33 (Autumn): 642–648.

Fuller, Mary, "San Francisco Sculptors," *Art in America* 52 (March): 52–59.

Genauer, Emily, "The Amazing Rise of Jasper Johns in World of Art," *New York Herald Tribune* (February).

Gendel, Milton, "Hugger-Mugger in the Giardini," *Art News* 63 (September): 32–35.

Greenberg, Clement, "Post-Painterly Abstraction," *Art International* 8 (Summer): 63–65.

——, "The 'Crisis' of Abstract Art," *Arts Yearbook* 7: 89–92.

Halas, John, "Kinetics and Automated Movements," *Ark* 35 (Spring): 18–21.

Herbert, Robert L., editor, *Modern Artists on Art*.

Hess, Thomas B., "Editorial: The Artist as a Company Man," *Art News* 63 (October): 19.

Hopps, Walter, "Boxes," *Art International* 8 (March): 38–42.

Hunter, Sam, "Abstract Expressionism Then and Now," *Canadian Art* (September–October): 266–269.

Johnson, Philip, "Young Artists at the Fair and at Lincoln Center," *Art in America* 52 (April): 112–127.

Judd, Donald, "Black, White and Gray," *Arts Magazine* 38 (March): 36–38.

Kaprow, Allen, "Should the Artist Be a Man of the World?" *Art News* 63 (October): 34–37, 58–59.

Kelly, Edward T., "Neo-Dada: A Critique of Pop Art," *College Art Journal* (Spring) 192–201.

Kesey, Ken, *Sometimes a Great Notion*.

Kozloff, Max, "American Sculpture in Transition," *Arts Magazine* 38 (May–June): 19–24.

——, "Art and the New York Avant-Garde," *Partisan Review* (Fall): 535–554.

——, "Johns and Duchamp," *Art International* 8 (March 20): 42–45.

——, "The Dilemma of Expressionism," *Artforum* 3 (November): 32–35.

——, "The Honest Elusiveness of Jim Dine," *Artforum* 3 (December): 36–40.

——, "The Many Colorations of Black and White," *Artforum* 2 (February): 22–25.

Kramer, Hilton, "Notes on Painting in New York," *Arts Yearbook: 7* 9–20.

——, " 'Realists' and Others," *Arts Magazine* 38 (January): 18–23.

Leider, Phillip, "The Cool School," *Artforum* 8 (December): 47–52.

McLuhan, Marshall, "Culture and Technology," *Times Literary Supplement* (August 6) 700–701.

——, *Understanding Media: The Extensions of Man*.

Marchis, Giorgio De, "The Significance of the 1964 Venice Biennale," *Art International* 8 (November 25): 21–23.

Marcuse, Herbert, *One Dimensional Man*.

Michelson, Annette, "The 1964 Venice Biennale," *Art International* 8 (September 25): 38–40.

Myers, John Bernard, "Junkdump Fair Surveryed," *Art and Literature* 3 (Autumn–Winter): 122–141.

Nordland, Gerald, "Marcel Duchamp and Common Object Art," *Art International* 8 (February): 30–32.

Popper, Frank, "Movement and Light in Today's Arts," *Arts and Architecture* 8 (April): 24–25.

Reinhardt, Ad, "The Next Revolution in Art," *Art News* 62 (February): 48–49.

——, "The Next Revolution in Art: Art-As-Art Dogma, Part II," *Art International* 8 (March 20): 57–58.

Restany, Pierre, "The World of Art: An American Year," *Art in America* 52 (January): 96–98.

Robbins, Daniel, "Sculpture by Louise Bourgeois," *Art International* 8 (October 20): 29–31.

Rose, Barbara, "The Primacy of Color," *Art International* 8 (May): 22–26.

Ruscha, Ed, *Various Small Fires*.

Russell, John, "Perspectives: Tenth Street and the Thames," *Art in America* 52 (February): 96–101.

Sandler, Irving, "Al Held Paints a Picture," *Art News* 62 (May): 28–30.

Schorr, Justin, "Destination: Realism," *Art in America* 52 (June): 115–18.

Solomon, Alan, "Jim Dine and the Psychology of the New Art," *Art International* 8 (October 20): 52–56.

——, "The New American Art," *Art International* 8 (March): 50–55.

Sontag, Susan, "Notes on Camp," *Partisan Review* 31 (Fall): 515–530.

——, "Against Interpretation," *Evergreen Review* (December).

Taylor, Brie, "Toward a Plastic Revolution," *Art News* 62 (March): 46–49.

Tillim, Sidney, "Ten Years of Jasper Johns," *Arts Magazine* 38 (April): 22–26.

——, "The New Avant Garde," *Arts Magazine* 39 (February): 18–21.

Wagstaff, Samuel J., "Paintings to Think About," *Art News* 62 (January): 33.

The Warren Commission Report on the Assassination of John F. Kennedy.

Willard, Charlotte, "Art Centers: New York—Dealer's-Eye View," *Art in America* 52 (February): 120–34.

1965

Contemporary Events

President Johnson begins systematic bombing of North Vietnam; deploys U.S. troops to South Vietnam with air support; U.S. action escalates into war.

Ken Kesey and the Merry Pranksters cross U.S. in a bus painted in "psychedelic" colors.

Alabama: First all-black party, Lowndes County Freedom Organization, is formed.

Berkeley: Vietnam War protests start.

London: Albert Hall, poetry reading focuses on "Anti-Bomb" Movement with Ginsberg, Corso, Ferlinghetti, Vosnesensky, et al.; 7,000 attend.

New York: First free university and first draft card burning.

China: Beginning of the Cultural Revolution.

February
New York: Malcolm X shot and killed at rally at age 40.

March 18
Aleksei A. Leonov becomes first man to "walk in space" from Soviet spaceship Voskhod 2; by June 3, Edward H. White repeats the Russian feat in U.S.'s Gemini 4 and remains outside the ship for 20 minutes.

March
Canadian customs charges duty on Warhol's Brillo, Apple Juice, and Corn Flake boxes, declaring them not to be art.

March
Teach-ins on the Vietnam War begin at the University of Michigan and spread quickly to other campuses.

March
Selma to Montgomery, Ala.: Civil rights march, led by Dr. Martin Luther King, Jr., starts with 3,200 and gains 25,000; guarded by 4,000 troops dispatched by President Johnson.

Spring
Berkeley: Mario Savio, "Don't trust anyone over thirty."

April
President Johnson orders U.S. invasion of Dominican Republic.

April–October
New York: World's Fair (2nd year).

August
Los Angeles: Race riots by discontented blacks in Watts area results in death of 35 persons and property damages estimated at $200 million.

September 5
San Francisco: Michael Fallon, a writer on the *San Francisco Examiner*, uses term "hippies" for Haight-Ashbury residents.

Fall
Ginsberg is awarded a Guggenheim poetry fellowship.

Fall
Berkeley: Ginsberg induces peace marchers to use "masses of flowers" to confront opposition; origin of "flower power."

October
New York: Pope Paul VI visits and delivers a personal appeal for peace to the U.N.; the first visit of a pope to the U.S.

November 6
Norman Morrison, a Quaker and father of three, immolates himself outside of the Pentagon; a week later, Roger la Porte, a Catholic worker, does the same at the U.N.

November 9–10
Massive electric power failure blacks out most of northeastern U.S. plus parts of two Canadian provinces, affecting approximately 80,000 square miles with a population of 30,000,000; in New York City, over 800,000 are trapped in subways for hours.

December
Frank Borman and James A. Lovell, Jr., orbit in Gemini 7; they stay aloft 14 days and participate in first manned space rendezvous with Gemini 6 on December 15 with Walter M. Schirra, Jr., and Thomas P. Stafford, who come within ten feet of Gemini 7.

December
Southeast Asia: Beginning of Operation Barrel Roll, 30 days of air strikes in the Laos panhandle.

Art Events

January 3
New York: Death of Milton Avery.

May 23
Bennington, Vt.: David Smith dies following an auto accident.

June
Washington, D.C.: First White House Arts Festival, held for a select list of guests, a failure because of criticism of Vietnam War policy.

Summer
New Haven, Conn.: Don Lippincott Company establishes the Environmental Arts, the first factory in U.S. devoted to fabricating large sculpture.

Exhibitions

January 5–23
New York: Tibor de Nagy Gallery, *Shape and Structure* (organized by Rose, Stella, and Geldzahler; features Andre, Bannard, Bell, Hinman, Insley, Judd, Morris, Murray, Williams, Zox).

January 6–31
New York: Martha Jackson Gallery, *Vibrations Eleven: The Anonima Group and Others.*

January 12–30
New York: Johnson Gallery, *Walter de Maria.* One-man show.

February 2–March 14
The Hague: Gemeentemuseum, *Kinetische Kunst* (includes works by Agam, Albers, Calder, Duchamp, Klein, Man Ray, Morris, Spoerri, Vasarely).

February 4–March 7
New York: Jewish Museum, *Kenneth Noland.*

February 18–April 4
Worcester, Mass.: Worcester Art Museum, *The New American Realism.*

February 25–April 4
London: Tate Gallery, *British Sculpture in the Sixties.*

February 25–April 25
New York: MOMA, *The Responsive Eye.*

February 27–March 28
Buffalo, N.Y.: Albright-Knox Art Gallery, *Kinetic and Optic Art Today.*

March 9–27
New York: Kootz Gallery, *Vibrations by Soto.* Jesus Raphael Soto's First one-man show in the U.S. (First one-man show in Caracas, 1949.)

March
New York: Feigen Gallery, *Bridget Riley.* First one-woman show in the U.S.; works sell out on opening day.

April–May 12
New York: Leo Castelli Gallery, *James Rosenquist.* F-111 is shown in first one-man show at the gallery.

April 6–29
New York: New York University, *Concrete Expressionism* (Bladen, Held, Knox Martin, Sugarman, Weinrib; catalog by Irving Sandler).

April 9–May 9
Milwaukee: Milwaukee Art Center, *Pop Art and American Tradition.*

April 21–May 30
Cambridge, Mass.: Fogg Art Museum, *Three American Painters: Kenneth Noland, Jules Olitski, Frank Stella.* Catalog essay by Michael Fried.

April 15–June 8
Amsterdam: Stedelijk Museum, *Nul negentienhonderd vijf en zestig* (Arman, Bury, Castellani, Dorazio, Fontana, Gruppo T, Gutai group, Haacke, Klein, Kusama, Manzoni, Rickey, Soto, Vigo, Zero).

May 22–June 11
New York: Alan Stone Gallery, *Daniel Spoerri exhibition.*

May–June
Tel Aviv: Musée de Tel Aviv, *Art et Mouvement (Art Optique et Cinématique).*

June 25–September 5
Washington, D.C.: Washington Gallery of Modern Art, *The Washington Color Painters* (includes Davis, Downing, Louis, Mehring, Noland, Paul Roed).

June 16–August 1
Los Angeles: Los Angeles County Museum of Art, *New York School: The First Generation Paintings of the 1940's and 1950's* (Baziotes, de Kooning, Gorky, Gottlieb, Guston, Hofmann, Kline, Motherwell, Newman, Pollock, Pousette-Dart, Reinhardt, Rothko, Still, Tomlin).

July 3–September 5
Bern: Kunsthalle, *Licht und Bewegung.*

August l3–September l9
Zagreb, Yugoslavia: Galerija Suvremene Umjetnosti, *Nove Tendencija 3.*

September 4–November 28
São Paulo, Brazil: *VIII São Paulo Bienal* (Barnett Newman).

October 22–December 13
Amsterdam: Stedelijk Museum, *Yves Klein retrospective.*

November 23, 1965–January 2, 1966
New York: Jewish Museum, *Two Kinetic Sculptors, Schöffer and Tinguely.*

December 1–31
New York: Sidney Janis Gallery, *Pop & Op.*

December–January 8, 1966
New York: Bianchini Gallery, *Ten From Rutgers* (Brecht, Hendricks, Kaprow, Kuehn, Lichtenstein, Orenstein, Segal, Vasey, Watts, Whitman).

December 10, 1965–January 30, 1966
Boston: Institute of Contemporary Art, *Art Turned On.*

Publications

Alfieri, Bruno, "Art's Condition: 'Pop' Means 'Not Popular,' " *Metro* 9: 4–13.

Amayo, Mario, *Pop as Art . . . and After* (New York: Studio/Viking).

Argan, Guilo Carlo, "Un 'futuro tecnologico' per l'arte?" *Metro* 9 (March–April): 14–19.

Ashton, Dore, "Helen Frankenthaler," *Studio International* 168 (August): 52–55.

Baro, Gene, "Britain's New Sculpture," *Art International* 9 (June): 26–31.

Berkson, William, "Poet of the Surface," *Arts Magazine* 39 (May–June): 44–50.

Berne, Eric, M.D., *Games People Play.*

Biederman, Charles, "The Visual Revolution of Structurist Art," *Artforum* 3 (April): 34–38.

Calas, Nicolas, "Why Not Pop Art?" *Art and Literature* 4 (Spring): 178–184.

Canaday, John, "Art That Pulses, Quivers and Fascinates," *New York Times Magazine* (February 21): 59.

——, "Larry Bell," *Artforum* 3 (June): 27–29.

Coplans, John, "Los Angeles: The Scene," *Art News* 63 (March): 28–29, 56–58.

Fitzgerald, Francis, "What's New, Henry Geldzahler, What's New?" *New York Herald Tribune* Sunday magazine (November 21): 14–20.

Flavin, Dan, ". . . in Daylight or Cool White: An Autobiographical Sketch," *Artforum* 4 (December): 20–24.

Forge, Andrew, "Some New British Sculptors," *Artforum* 3 (May): 31–35.

Fried, Michael, "Anthony Caro and Kenneth Noland: Some Notes on Not Composing," *Lugano Review* (Summer): 198–206.

Gablik, Suzi, "Meta-Trompe-l'oeil," *Art News* 63 (March): 46–49.

Geldzahler, Henry, *American Painting in the Twentieth Century* (New York: Metropolitan Museum of Art).

——, "An Interview with Helen Frankenthaler," *Artforum* 4 (October): 36–38.

Golden, Amy, "The Dada Legacy," *Arts Magazine* 39 (September–October): 26–28.

Greenberg, Clement, "America Takes the Lead: 1945–1965," *Art in America* 53 (August–September): 108–129.

——, "Modernist Painting," *Art and Literature* 4 (Spring): 193–201.

Gregory, Albert, *Construction, Colour and Moire.*

Hahn, Otto, "Christo's Packages," *Art International* 19 (April) 25–27, 30.

——, "The Avant-Garde Stance," *Arts Magazine* 39 (May–June): 22–29.

Hansen, Al, *A Primer of Happenings and Time/Space Art* (New York: Something Else Press).

Hess, Thomas B., "Editorial: Artists and the Rat-Race," *Art News* 64 (January): 23.

——, "J'accuse Marcel Duchamp," *Art News* 64 (February): 44–45.

——, "You Can Hang It in the Hall," *Art News* 64 (April): 41–43, 49.

Hopps, Walter, "An Interview with Jasper Johns," *Artforum* 3 (March): 32–36.

Johnson, Ellen H., "Jim Dine and Jasper Johns: Art About Art," *Art and Literature* 6 (Autumn): 128–140.

——, "Three New, Cool Bright Imagists," *Art News* 64 (Summer): 42–44, 62–64.

Judd, Donald, "Specific Objects," *Arts Yearbook* 8.

Kepes, Gyorgy, ed., *The Nature and Art of Motion.*

——, ed., *Vision and Value,* 6 vols.

Kirby, Michael, *Happenings: An Illustrated Anthology.*

Kozloff, Max, "Further Adventures of American Sculpture," *Arts* 39 (February): 24–3l.

——, "The Critical Reception of Abstract Expressionism," *Arts* 40 (December): 27–33.

Krauss, Rosalind, "Afterthoughts on 'Op' " *Art International* 191 (June): 75–76.

Le Carré, John, *The Looking Glass War.*

Mailer, Norman, *An American Dream.*

"The New York School," *Artforum* 4 (September): special issue.

O'Doherty, Brian, "Scene," *Newsweek* (January 4): 54–60.

Rickey, George, "Kinesis Continued," *Art in America* 53 (December—January 1966): 45–55.

——, "Scandale de Succès," *Art International* 191 (May 4): 16–23.

Robbe-Grillet, Alain, *For a New Novel: Essays on Fiction.*

Robins, Corinne, "Six Artists and the New Extended Vision," *Arts Magazine* 39 (September–October): 19–24.

Rose, Barbara, "A B C Art," *Art in America* 53 (October–November): 57–69.

——, "Beyond Vertigo: Optical Art at the Modern," *Artforum* 3 (April) 30–33.

——, "Filthy Pictures: Some Chapters in the History of Taste," *Artforum* 3 (May): 21–25.

——, "How to Murder an Avant-Garde," *Artforum,* 4 (November): 30–35.

——, "Looking at American Sculpture," *Artforum* 3 (February): 29–36.

——, "Pop in Perspective," *Encounter* (August): 59–63.

——, "The Second Generation: Academy and Breakthrough," *Artforum* 4 (September): 53–63.

Rosenblum, Robert, "Pop Art and Non-Pop Art," *Art and Literature* 5 (Summer): 80–93.

Rublowsky, John, *Pop Art* (New York: Basic Books).

Sandler, Irving, "Expressionism with Corners," *Art News* 64 (April): 38–40, 65–66.

——, "The New Cool Art," *Art in America* 55 (January): 96–101.

Seitz, William C., "The New Perceptual Art," *Vogue* 145 (February 15): 79–80, 142–143.

Selz, Peter, "Arte Programmata," *Arts Magazine* 39 (March): 16–21.

Stevens, Elisabeth, "The Washington Color Painters," *Arts Magazine* 39 (November): 29–33.

Tillim, Sidney, "Art au Go-Go or, The Spirit of '65," *Arts Magazine* 39 (September–October): 38–40.

——, "Further Observations on the Pop Phenomenon: 'All Revolutions Have Their Ugly Aspects,' " *Artforum* 3 (November): 17–19.

——, "Optical Art: Pending or Ending?" *Arts Magazine* 39 (January): 16–23.

——, "The Figure and the Figurative in Abstract Expressionism," *Artforum* 4 (September): 45–48.

——, "Toward a Literary Revival?" *Arts Magazine* 39 (May–June): 30–33.

Tomkins, Calvin, "The Big Show in Venice," *Harper's Magazine* (April): 96–104.

——, *The Bride and the Bachelors.*

Vaughan, Roger, "Superpop or A Night at the Factory," *New York Herald Tribune* (August 3): 7–9.

Wolfe, Tom, "New Manners for New York," *New York Herald Tribune* (February 7).

——, *The Kandy-Colored-Tangerine-Flake Streamline Baby.*

——, "The New Life Out There: Marshall McLuhan. Suppose he is what he sounds like, the most important thinker since Newton, Darwin, Freud, Einstein and Pavlov—What If He Is Right?" *New York Herald Tribune* (November 21): 6–27.

Wollheim, Richard, "Minimal Art," *Arts Magazine* 39 (January): 26–32.

1966

Contemporary Events

The Wild Angels (Corman) and *Blow-Up* (Antonioni) are released.

Rise of black rock singer Jimi Hendrix.

Terms "groovy" and "hippie" are used.

National Organization for Women (NOW) begun by Betty Friedan.

Berkeley: University of California students demand "student power."

Berkeley: *Ramparts* editor, Scheer, runs as radical for Congress in Bay Area; gets 45 percent of vote.

New York: Max's Kansas City Steak House opens at 18th Street and Park Avenue South; it caters to artists and poets.

New York: The Cheetah, a rock dance hall, opens.

San Francisco: Fillmore Auditorium becomes center of "acid rock."

Bob Dylan's *Blonde on Blonde* is released.

Winter
California: LSD declared illegal.

January
Debut of the TV series *Batman*—Pop art come to life.

January
Indira Gandhi becomes prime minister of India.

January
Selective Service System abolishes policy of automatic draft deferments to college students.

January–June
Chemicals lethal to plant life are sprayed over 59,000 acres of crops in Viet Cong–controlled territory.

January
San Francisco: North Beach, Ken Kesey is arrested for the second time on a charge of possession of marijuana.

January
San Francisco: Longshoremen's Hall, Great Trips Festival. Saturday of the Festival is called "The Acid Test" and features Ken Kesey and the Merry Pranksters.

February
First soft landing on surface of moon by an unmanned spacecraft, USSR's Luna 9; U.S. achieves similar feat on June 2 with Surveyor I.

April
Leary Defense Fund is supported by Ginsberg, Susan Sontag, Ted Berrigan, Jules Feiffer, Peter Fonda, Al Leslie, Ad Reinhardt, Alan Watts, et al.

May
Stokely Carmichael, new chairman of SNCC, articulates slogan "Black Power"; forms Black Panther Party.

June
Martin Luther King, Jr., takes leadership of James Meredith Freedom March after Meredith is wounded by a white sniper while on a voting rights march from Memphis, Tenn., to Jackson, Miss..

Summer
Black rebellions in Cleveland, Jersey City, Jacksonville, Omaha, Baltimore, Minneapolis, Los Angeles, Atlanta, San Francisco, and Chicago.

July
Medicare, federal program to pay part of the medical expenses of citizens over 65, goes into effect.

August 3
Hollywood: Death of Lenny Bruce at age 40.

September
San Francisco Airport: Secret meeting involving CIA, FBI, University of California officials, top businessmen, Defense Department officials, and five California police chiefs is held to "pacify" Berkeley by removing low-cost housing.

October
Oakland, Calif.: Black Panthers battle Oakland police.

November 8
Massachusetts: Edward Brooke, Republican, elected as first black U.S. senator in 85 years.

Art Events

Kienholz's retrospective at the Los Angeles County Museum of Art creates such controversy that the board of supervisors tries, unsuccessfully, to close the exhibition.

U.S. government receives the Hirshhorn Collection.

Los Angeles: *Tower for Peace*, designed by Mark di Suvero, erected with money donated by local artists. Flanked by walls of over 400 pictures donated by artists.

New York: Whitney Museum of American Art, designed by Marcel Breuer, opens.

February 17
New York: Death of Hans Hofmann, age 85.

April
New York: East Village, first appearance of Warhol's "Exploding Plastic Inevitable"—the Velvet Underground rock band and mixed-media show including sound, image, and lights, held at the upstairs hall of the Polsky Dom Narodny (i.e., The Electric Circus).

July 25
Death of Frank O'Hara.

October 13–23
New York: 25th Street Armory, "9 Evenings, Theatre and Engineering" is the first large-scale attempt by engineers and artists to join together, seeking common goal. Experiments in Art and Technology (E.A.T.) formed soon after, instigated by Kluver and Rauschenberg.

November
New York: New York University, panel discussion, "Is Easel Painting Dead?" Barbara Rose, moderator, with Bannard, Judd, Poons, and Rauschenberg.

December
New York: Stephen Radich Gallery shows a one-man exhibition by Mac Morrel of corpselike figures wrapped in American flags for which Radich is indicted and found guilty of desecrating the flag.

Exhibitions

New York: Solomon R. Guggenheim Museum, *Word and Image*.

January 31–February 19
London: Robert Fraser Gallery, *Los Angeles Now* (Berman, Kauffman, Price, Ruscha).

February 23–March 12
New York: Howard Wise Gallery, *Yvaral* (Jean-Pierre Vasarely). One-man show.

March 18–May 1
Berkeley: University Museum, *Directions in Kinetic Sculpture* (Benton, Boriani, Breer, Bury, Columbo, von Graevenitz, Haacke, Kramer, Lye, Mack, Mattox, Rickey, Takis, Tinguely).

April–May 4
New York: Pace Gallery, Paul Thek exhibition of putrescent plastic animal organs.

April 27–June 12
New York: Jewish Museum, *Primary Structures: Younger American and British Sculptors*.

May 6–June 5
Eindhoven, the Netherlands: Stedelijk van Abbemuseum, *Christo*. First one-man museum show.

May 10–June 2
Los Angeles: Nicolas Wilder Gallery, *Bruce Nauman*. First one-man show.

May 11–June 11
New York: Marlborough-Gerson Gallery, *Yaacov Agam*. First one-man show in U.S. (First one-man show at Galerie Craven, Paris, 1953.)

June 18–October 16
Venice: XXXIII International Biennale. Julio le Parc (Argentina) wins grand prize; Robert Jacobson (Denmark) wins first prize for sculptor. Frankenthaler, Kelly, Lichtenstein, and Olitski represent U.S.

July–September
Seattle: Seattle Art Museum Pavilion, *Ten from Los Angeles* (Bell, Bengston, Delap, Gray, Goode, Kauffman, Mattox, McCracken, Price, Ruscha).

September–October
Stockholm: Moderna Museet, *Claes Oldenburg Retrospective*.

September 11–October 16
Los Angeles: UCLA Art Galleries, *The Negro in American Art*.

September 20–October 16
Cleveland: Cleveland Museum of Art, *Some Recent Paintings by Richard Anuskiewicz*. First one-man museum show.

September 20–October 8
New York: Fischbach Gallery, *Eccentric Abstraction*. Organized by Lucy Lippard, the title refers to soft, stuffed, ungainly, or otherwise odd works of abstract sculpture.

September 25–December 4
Eindhoven, the Netherlands: Stedelijk Van Abbemuseum, *Kunst Licht Lunst*.

September–November 27
New York: Solomon R. Guggenheim Museum, *Systemic Painting*.

October 4–29
New York: Dwan Gallery, *10 X 10* (Andre, Baer, Flavin, Judd, Lewitt, Martin, Morris, Reinhardt, Smithson, Steiner).

October 3–29
New York: Sidney Janis Gallery, *Erotic Art '66* (21 Pop artists).

October 15–August 26, 1967
New York: MOMA, *Two Decades of American Painting* (organized by the International Council of the Museum of Modern Art and circulated to Japan, India, Australia).

November 22–January 6, 1967
Philadelphia, Institute of Contemporary Art at University of Pennsylvania, and Hartford, Connecticut, Wadsworth Atheneum: *Tony Smith.* First one-man show (concurrent exhibitions).

Publications

Aldrich, Larry, "New Talent U.S.A.," *Art in America* 54 (July–August): 22–69.

Alloway, Lawrence, "Background to Systemic," *Art News* 65 (October): 30–33.

——, "Hybrid," *Arts Magazine* 40 (May): 38–42.

Amaya, Mario, *Pop Art . . . and After.*

——, "The New Super Realism," *Sculpture International* 1 (January): 19.

Antin, David, "Another Category: 'Eccentric Abstraction,' " *Artforum* 5 (November): 56–57.

——, "D'Arcangelo and the New Landscape," *Art and Literature* 9: 102–115.

Artforum 5 (September): Special issue on surrealism.

Ashbery, John, "Brooms and Prisms," *Art News* 65 (March): 58–59.

Baigell, Matthew, "American Abstract Expressionism and Hard-Edge: Some Comparisons," *Studio International* 171 (January): 10–15.

Bann, Stephen, Reg Gadney, and Frank Popper, *Four Essays on Kinetic Art.*

Bannard, Walter Darby, "Color, Paint and Present-Day Painting," *Artforum* 4 (April): 34–36.

——, "Present-Day Art and Ready-Made Styles," *Artforum* 5 (December): 30–35.

Battcock, Gregory, *The New Art.*

Baro, Gene, "Claes Oldenburg or the Things of This World," *Art International* 10 (November): 36, 40–43.

——, "Oldenburg's Monuments," *Art and Artists* 1 (December): 28–31.

Berrigan, Ted, "Red Power," *Art News* 65 (December): 44–46.

Bochner, Mel, "Art in Process—Structures," *Arts Magazine* 40 (September–October): 38–39.

——, "Less Is Less (for Dan Flavin)," *Art and Artists* (December): 24–27.

——, "Primary Structures," *Arts Magazine* 40 (June): 32–35.

——, "Systemic," *Arts Magazine* 40 (November): 40.

——, and Robert Smithson, "The Domain of the Great Bear," *Art Voices* 5 (Fall): 24–31.

Bourdon, David, "Christo," *Art and Artists* 1 (October): 50–53.

——, "E=MC2 a Go-Go," *Art News* 64 (January): 22–25, 57–59.

——, "The Raised Sites of Carl Andre," *Artforum* 5 (October): 14–17.

Brown, Norman O., *Love's Body.*

Capote, Truman, *In Cold Blood.*

Carraher, Ronald, and Jacqueline Thurston, *Optical Illusions and the Visual Arts.*

Donner, Stanley T., ed., *The Meaning of Commercial Television.*

Feigen, Richard, "Art 'Boom,' " *Arts Magazine* (November): 23–24.

Flavin, Dan, "Some Remarks . . .; Excerpts from a Spleenish Journal," *Artforum* 5 (December): 27–29.

Forge, Andrew, "An Interview with Anthony Caro, *Studio International* 171 (January): 6–9.

Fraser, Robert, "Dining with Jim" (an interview), *Art and Artists* 1 (September): 49–53.

Freidman, B. H., "Toward the Total Color Image," *Art News* 65 (Summer): 31–33, 67–68.

Geldzahler, Henry, "Frankenthaler, Kelly, Lichtenstein, Olitski: A Preview of the American Selection at the 1966 Venice Biennale," *Artforum* 4 (June): 32–38.

Glaser, Bruce, "Lichtenstein, Oldenburg, Warhol: A Discussion," *Artforum* 4 (February): 20–24.

——, "The New Abstraction: A Discussion [with Paul Brach, Al Held, and Ray Parker]," *Art International* 10 (February): 41–45.

——, and Lucy R. Lippard, eds., "Questions to Stella and Judd," *Art News* 65 (September): 55–61.

Goldin, Amy, "A Note on Opticality," *Arts Magazine* 40 (May): 53–54.

——, "McLuhan's Message: Participate, Enjoy!" *Arts Magazine* 40 (May): 27–31.

——, "Requiem for a Gallery," *Arts Magazine* 40 (March): 25–29.

Goosen, E. C., "Distillation: A Joint Showing," *Artforum* 5 (November): 31–33.

Hahn, Otto, "Passport No G2553000: United States of America," *Art and Artists* 1 (July): 6–11.

Hahn, Otto, and Pierre Restany, *Christo* (Milan: Editioni Appollinaire).

Hansen, Al, "London: Destruction in Art Symposium," *Arts Magazine* 40 (November): 53–54.

Hess, Thomas B., "Editorial: Notes on American Museums," *Art News* 65 (November): 27.

Hutchinson, Peter, "Is There Life on Earth?" *Art in America* 54 (November–December): 68–69.

——, "Mannerism in the Abstract," *Art and Artists* 1 (September): 18–22.

Irwin, David, "Pop Art and Surrealism," *Studio International* 171 (May): 187–191.

Johnson, Ellen H. "The Image Duplicators—Lichtenstein, Rauschenberg, Warhol," *Canadian Art* 23 (January–February): 12–19.

Kaprow, Allan, *Assemblages, Environments and Happenings.*

——, "Experimental Art," *Art News* 65 (March): 60–63, 77–82.

——, "The Happenings Are Dead—Long Live the Happenings," *Artforum* 4 (March): 37–39.

Kirby, Michael, *Happenings: An Illustrated Anthology.*

Kozloff, Max, "The Inert and the Frenetic," *Artforum* 4 (March): 40–44.

Leider, Philip, "Kinetic Sculpture at Berkeley," *Artforum* 4 (May): 40–44.

LeWitt, Sol, "Ziggurats," *Arts Magazine* 40 (November): 24–25.

Lippard, Lucy R., "An Impure Situation (New York and Philadelphia Letter)," *Art International* 10 (May): 60–65.

———, "Eccentric Abstraction," *Art International* 10 (November): 28, 34–40.

———,"New York Letter: Recent Sculpture as Escape," *Art International* 10 (February): 48–58.

———, *Pop Art.*

———, "Rejective Art," *Art International* 10 (October): 33–37.

"Los Angeles: Tower of Peace," *Art News* 65 (April): 25, 71.

Lynton, Norbert, "Venice 1966," *Art International* 10 (September 15): 83–89.

Mao Tse-tung, *Quotations of Chairman Mao.*

Marmer, Nancy, "Matisse and the Strategy of Decoration," *Artforum* 4 (March): 28–33.

Masters, William H., and Virginia E. Johnson, *Human Sexual Response.*

Michelson, Annette, "10 X 10: 'Concrete Reasonableness,' " *Artforum* 4 (January): 30–31.

Morris, Robert, "Notes on Sculpture, Part 1," *Artforum* 4 (February): 42–44; "Part 2," *Artforum* 5 (Summer 1967): 20–23; "Part 3: Notes and Nonsequiturs," *Artforum* 5 (Summer 1967): 24–29.

Naifeh, Steven W., *Culture Making: Money, Success, and the New York Art World.*

Narotzky, Norman, "The Venice Biennale," *Arts Magazine* 40 (September–October): 42–44.

Nimser, Cindy, "Sculpture and the New Realism," *Arts Magazine* 44 (April): 39–41.

O'Doherty, Brian, "Minus Plato," *Art and Artists* 1 (September): 10–11.

Oster, Gerald, "Phosphenes," *Art International* 10 (May 20): 43–44.

Pelligrini, Aldo, *New Tendencies in Art.*

Piene, Nan R., "What's Next After Next," *Arts Magazine* 40 (March–April): 31–39.

Pincus-Witten, Robert, " 'Systemic' Painting," *Artforum* 5 (November): 42–45.

Plagens, Peter, "Present-Day Styles and Ready-Made Criticism," *Artforum* 5 (December): 36–39.

Robbins, Eugenia S., "Performing Art," *Art in America* 54 (July–August): 107–111.

Robins, Corinne, "Object, Structure or Sculpture: Where Are We?" *Arts Magazine* 40 (September–October): 33–37.

Rose, Barbara, "Los Angeles: The Second City," *Art in America* 54 (January–February): 110–115.

Rosenberg, Harold, "A Guide for the Unperplexed," *Art News* 65 (September): 46–47, 68.

Rosenblum, Robert, "Pop and Non-pop: An Essay in Distinction," *Canadian Art* 23 (January): 50–54.

Ruscha, Ed, *Every Building on Sunset Strip.*

Russell, John, "Concrete Poetry," *Art in America* 54 (January–February): 86–89.

———, "Portrait: Anthony Caro," *Art in America* 54 (September–October): 80–87.

Sandler, Irving, "Ad Reinhardt: The Purist Blacklash," *Artforum* 5 (December): 40–47.

———, "Ronald Bladen: '. . . sensations of a different order . . .' " *Artforum* 5 (October): 32–35.

Schulze, Franz, "Chicago Popcycle," *Art in America* 54 (November–December): 102–104.

Seltz, Peter, *Directions in Kinetic Art.*

Siegel, Jeanne, "Why Spiral?" *Art News* 65 (September): 48–51, 67–68.

Smith, Brydon, "Jim Dine—Magic and Reality," *Canadian Art* 23 (January): 30–34.

Smithson, Robert, "Entropy and the New Monuments," *Artforum* 4 (June): 26–31.

———, "Quasi-Infinities and the Waning of Space," *Arts Magazine* 40 (November): 28–31.

Solomon, Alan, "American Art Between Two Biennales," *Metro* 11 (June): 25–35.

———, "The Green Mountain Boys," *Vogue* (August): 104–109, 151–152.

Sontag, Susan, *Against Interpretation and Other Essays.*

Susann, Jacqueline, *Valley of the Dolls.*

Swenson, G. R., "The Horizons of Robert Indiana," *Art News* 65 (May): 48–49, 58–62.

Tomkins, Calvin, *The World of Marcel Duchamp.*

Venturi, Robert, *Complexity and Contradiction in Architecture* (New York: MOMA).

Willard, Charlotte, "Eye to I," *Art in America* 54 (March–April): 49–59.

Yalkut, Jud, "The Psychedelic Revolution," *Arts Magazine* 40 (November): 22–23.

Zach, David, "A Black Comedy . . . ," *Artforum* 4 (May): 32–34.

1967

Contemporary Events

Demonstrations at Justice Department and Pentagon follow first national turn-in of draft cards.

CIA infiltration of National Student Association is exposed.

Che Guevara killed by Bolivian troops.

Bonnie and Clyde (Penn), *Cool Hand Luke* (Rosenberg), *Valley of the Dolls* (Robson), and *The Graduate* (Nichols) are released.

San Francisco: Haight-Ashbury community flourishes. Summer of Love.

January
San Francisco: Golden Gate Park, Haight-Ashbury, Ginsberg presides over a "Gathering of the Tribes for a Human Be-In," with Gary Snider, Michael McClure, Freewheelin' Frank of Hell's Angels, and Leary.

January 27
Cape Canaveral: Apollo I catches fire on ground during routine test. All three astronauts are killed.

February 5
Premiere of *The Smothers Brothers Comedy Hour*, replaced by *Hee-Haw* in July 1969.

March 20
Twiggy arrives in U.S.

March
New York: Central Park, 30,000 people attend a be-in.

April 15
New York and San Francisco: "Spring Mobilization" demonstrations; largest anti-war demonstrations to date.

April
Cambridge, Mass.: "Vietnam Summer" of war protests proclaimed by Martin Luther King, Jr., and Dr. Benjamin Spock.

June–July
Black rebellions begin in Boston, Tampa, Cincinnati, Buffalo, Newark (26 dead, 1,500 reported injured, over 1,000 arrests, over 300 fires, $15–$30 million property damage), and surrounding area; Hartford, Waterloo, Minneapolis, Detroit (43 dead, 5,000 arrests, over 1,383 buildings burned, over $200 million in property damage), and surrounding area; New York City–East Harlem, Rochester (New York), Philadelphia, Chicago, and Milwaukee.

June 5–11
In a six-day Israeli-Arab war, Israel combats armed forces of United Arab Republic, Syria, and Jordan; Israel conquers territory four times its own size.

Summer
Dallas: City passes ordinance banning hippies from downtown area.

Summer
Sgt. Pepper's Lonely Hearts Club Band is released.

August
New York: Abbie Hoffman, Jerry Rubin, et al. throw dollar bills over ledge of visitor's gallery at New York Stock Exchange; later burn dollars in front of it.

October
Oakland: Stop the Draft Week results in indictment of seven of its leaders for conspiracy to commit a misdemeanor and a felony (a three-year prison term); they are acquitted.

October
Washington, D.C.: Thurgood Marshall becomes first black U.S. Supreme Court justice.

October
Mississippi: All-white federal jury convicts seven men who took part in Ku Klux Klan conspiracy to murder three civil rights workers from August 4, 1964, incident.

October
Washington, D.C.: Vietnam War protest by some 35,000 in peace march; at least 647 arrested, most when attempting to enter the Pentagon.

October
Tokyo: Four American sailors—Craig Anderson, Richard Bailey, John M. Barilla, and Michael Lindner—decide not to return to U.S.S. Intrepid because they are fed up with war and the military.

October
Oakland: Huey P. Newton is arrested for allegedly killing Patrolman John Frey (charges dismissed in 1968).

November
Carl B. Stokes (Democrat, Cleveland) and Richard G. Hatcher (Democrat, Gary, Ind.) are elected first black mayors of major U.S. cities; Robert G. Clark is first black elected to Mississippi Legislature since Reconstruction.

Winter
Berkeley: Ginsberg at University of California for a week as guest professor of poetry and other mystic information.

December
Capetown, South Africa: Dr. Christian Barnard performs first successful human heart transplant on Louis Washkansky, who lives for 18 days.

December
New York: Spock, Ginsberg, and 264 others are arrested as more than 1,000 demonstrate in an attempt to close down New York induction center as part of Stop the Draft Week.

December 31
Rubin, Hoffman, and Paul Krassner form the Youth International Party (Yippies).

Art Events

Cambridge, Mass.: MIT "Center for Advanced Visual Studies" is established under Gyorgy Kepes to further collaboration between artists and scientists.

Artforum moves to New York City.

Nam June Paik's partner is arrested and tried for indecent exposure during performance of *Opera Sextronique*; she receives a suspended sentence.

April–October
Montreal: Universal and International Exposition (EXPO 67).

May
Death of Edward Hopper.

July
CBS-TV special: "Eye on Art: The Walls Come Tumbling Down" studies innovations in art using advanced technology.

September
Death of Ad Reinhardt.

October
New York: News conference—a happening at Rauschenberg's studio to celebrate merger of art and technology.

November
New York: E.A.T. announces a competition for the best contribution by an engineer of a work of art produced with an artist; the winning works to be included in the MOMA machine show, Fall 1968.

New York: Warhol's Factory moves from 231 East 47th Street to 33 Union Square West.

Exhibitions

January 3–29
Cleveland: Cleveland Museum of Art, *John Chamberlain*. First one-man museum show.

January 25–March 12
New York: Jewish Museum, Yves Klein retrospective.

January–March
Ridgefield, Conn.: Aldrich Museum of Contemporary Art, *Cool Art—1967*.

January 14– February 12
Toronto: Art Gallery of Ontario, *Dine, Oldenburg, Segal* (painting/sculpture).

February 4–March 4
New York: Howard Wise Gallery, *Lights in Orbit*.

February l5–March 26
Los Angeles: Los Angeles County Museum of Art, Morris Louis retrospective.

February 24–March 31
New York: Riverside Museum, *Environments/Permutations* (includes Tosun Bayrak, Dennis Burton, Rolf Gunter Dienst, Jean Lindner, Peter Moore, Luis Felipe Noe, Frank Lincoln Viner).

March
New York: Marlborough Gerson Gallery, *Franz Kline.* First posthumous show.

April 11–May 3
New York: Bianchini Gallery, *Robert Ryman.* First one-man show.

April 18–May 28
Pasadena: Pasadena Art Museum, *Roy Lichtenstein.* First one-man museum show.

April 18–May 29
Berkeley: University Museum, *Funk* (Acton, Bob Anderson, Jeremy Anderson, Arneson, Baden, Ballaine, Bitney, Joan Brown, Conner, De Forest, Geis, Gilhooly, Henderson, Hudson, Jean Lindner, Melchert, Molitor, Morehouse, Neri, Paris, Potts, Kenneth Price, Saul, Voulkos, Wiley, Williams).

April 28–June 25
Los Angeles: Los Angeles County Museum of Art, *American Sculpture of the Sixties* (works by 80 artists, including Bladen, di Suvero, Morris, Oldenburg, Tony Smith, Smithson, Snelson).

April 28–June 11
Washington, D.C.: Corcoran Gallery of Art, *Jules Olitski: Paintings, 1963–1967.* First one-man major museum show.

April 28–October 27
Montreal: Expo 67, U.S. Pavilion (also Tokyo, International Biennial), *American Painting Now* (Anuszkiewicz, Avedisian, D'Arcangelo, Dine, Dzubas, Frankenthaler, Indiana, Johns, Kelly, Krushenick, Lichtenstein, Motherwell, Newman, Noland, Rauschenberg, Rosenquist, Stella, Warhol, Wesselmann, Zox.)

May–August
Paris: Musée d'Art Moderne de la Ville de Paris, *Lumière et mouvement.*

May 20–September 10
Trenton: New Jersey State Museum, *Focus on Light.*

September–January
São Paulo: Museum of Modern Art, *IX Biennial of the The Museum of Modern Art: Edward Hopper, Environment U.S.A. 1957–1967* (D'Arcangelo, Foulkes, Gill, Graziani, Harris, Indiana, Johns, Laing, Lichtenstein, Lindner, Morley, Nesbitt, Oldenburg, Raffaele, Rauschenberg, Rosenquist, Ruscha, Segal, Thiebaud, Warhol, Wesselmann).

September 15–October 22
Pasadena: Pasadena Art Museum, Allan Kaprow retrospective.

October
New York: First city-wide outdoor sculpture show, including works by di Suvero, Grosvenor, Marisol, Noguchi, Nevelson, Newman, Oldenburg, David Smith, Tony Smith, von Schlegell.

October 7–November 11
New York: Pace Gallery, *Robert Whitman* (laser beam imagery).

October
San Diego: Art Gallery of University of California, San Diego, *Visual Arts,* Faculty Exhibition (includes Paul Brach, Newton Harrison, Donald Lewallen, David Rifat, Miriam Schapiro).

October 7–January 7, 1968
Washington, D.C.: Corcoran Gallery of Art, *Scale as Content* (Bladen, Newman, Tony Smith).

October 24–November 30
Chicago: Museum of Contemporary Art, *Pictures to Be Read/Poetry to Be Seen* (includes Arakawa, Baruchello, Bauermeister, Brecht, Fahlstrom, Knowles, Kaprow, Kitaj, Nutt, Simonetti, Vostell).

October–December
San Francisco: Hansen Gallery, *Plastics, West Coast* (includes Baden, Ballaine, Beasley, Cooper, Edge, Gooch, Grant, Griffin, Henderson, Kauffman, McCracken, Molitor, Morehouse, Oppenheim, O'Shea, Richardson, Rose, Ross, Spratt, Stevenson, Valentine, Zammit).

December
New York: Alexander Iolas Gallery, *Edward Ruscha: Gunpowder Drawings.* First one-man show in New York.

December
Bergamo, Italy: Organizzata Dallo Studio 2B, Mostra Internazionale di poesia concreta e musica elettronica.

December 6–30
New York: Sidney Janis Gallery, *Homage to Marilyn Monroe.*

Publications

Adrian, Dennis, "Walter de Maria: Word and Thing," *Artforum* 5 (January): 28–29.

Alloway, Lawrence, "Art as Likeness With a Note on Post Pop Art, *Arts Magazine* 41 (May): 34–39.

——, "Highway Culture," *Arts Magazine* (February): 28-33.

Art Criticism in the Sixties. Texts by Michael Fried, Max Kozloff, Barbara Rose, and Sidney Tillim; introduction by William C. Seitz.

Artforum 5 (Summer): Special issue on American sculpture.

"The Artist and Politics: A Symposium," *Artforum* 5 (September): 35–39.

Artschwager, Richard, "Hydraulic Door Check," *Arts Magazine* 42 (November): 41–43.

Baker, Elizabeth C., "The Light Brigade," *Art News* 66 (March): 52–55, 63, 66.

——, and Joseph Raffaele, "The Way Out West: Interviews with 4 San Francisco Artists," *Art News* 66 (Summer): 38–40.

Baro, Gene, "The Achievement of Helen Frankenthaler," *Art International* 11 (September): 33–38.

Berkson, Bill, "Ronald Bladen: Sculpture and Where We Stand," *Art and Literature* 12 (Spring): 139–150.

Bochner, Mel, "Serial Art Systems: Solipsism," *Arts Magazine* 41 (Summer): 39–43.

——, "The Serial Attitude," *Artforum* 6 (December): 28–33.

Bowness, Alan, "The American Invasion and the British Response," *Studio International* 173 (June): 285–293.

Cage, John, "Diary: How to Improve the World (You Will Only Make Matters Worse)," *Aspen* (Spring): n.p.

——, *Silence: Lectures and Writings.*

Clay, Jean, "Vasarely: A Study of His Work," *Studio International* 173 (May): 229–41.

Compton, Michael, *Optical and Kinetic Art* (London: Tate Gallery).

Cone, Jane Harrison, "David Smith," *Artforum* 5 (Summer): 72–78.

Dali, Salvador, "How an Elvis Presley Becomes a Roy Lichtenstein," *Arts Magazine* 41 (April): 26–31.

Danieli, Fidel, "Bell's Progress," *Artforum* 5 (Summer): 68–70.

Davis, Douglas, M. "The Dimensions of the Miniarts," *Art in America* 55 (November–December): 84–91.

Flavin, Dan, "Some Other Comments . . .," *Artforum* 6 (December): 20–25.

Fleminger, Irwin, "The New Art Selection Process," *Art News* 65 (January): 56–57, 71–72.

Fried, Michael, "Art and Objecthood" *Artforum* 6 (Summer): 12–23.

——, "Caro's Abstractness," *Artforum* 6 (September): 32–34.

Fry, Edward F., "Sculpture of the Sixties," *Art in America* 55 (September–October): 26–43.

——, "The Issue of Innovation," *Art News* 66 (October): 40–43, 71–72.

Gluek, Grace, "Color It Unspectacular, New York Gallery Notes," *Art in America* 55 (March–April): 102–108.

Goldin, Amy, "Art in a Hairshirt," *Art News* 6 (February): 26, 65–68.

Golub, Leon, "The Artist as an Angry Artist," *Arts Magazine* 41 (April): 48–49.

Graham, Dan, "A Minimal Future? Models and Monuments," *Arts Magazine* 41 (March): 32.

——, "Models and Monuments: The Plague of Architecture," *Arts* Magazine 41 (March): 32–35.

——, "Muybridge Moments," *Arts Magazine* 41 (February): 23–24.

Greenberg, Clement, "Anthony Caro," *Studio International* 174 (September): 116–117.

——, "Problems of Criticism, II: Complaints of an Art Critic," *Artforum* 6 (October): 38–39.

——, "Recentness of Sculpture," *Art International* 11 (April 20): 9–21.

Gruen, John, *The New Bohemia: The Combine Generation.*

Hahn, Otto, "Live Wire Academicism," *Arts* Magazine 42 (September–October): 46–67.

Hess, Thomas B., "Editorial: Ad (Adolph Dietrich Friedrich) Reinhardt," *Art News* 6 (October): 23.

Howe, Irving, *Literary Modernism.*

Hudson, Andrew, "Scale as Content: Bladen, Newman, Smith at the Corcoran," *Artforum* 6 (December): 46–47.

Hunt, Ronald, "Yves Klein," *Artforum* 5 (January): 32–37.

Hutchinson, Peter, "The Critics' Art of Labeling: A Minimal Future," *Arts Magazine* 41 (May): 19–20.

Kaprow, Allan, "Pinpointing Happenings," *Art News* 66 (October): 46–47, 70–7l.

Katz, William, "A Mother Is a Mother," *Arts Magazine* 42 (December–January 1967): 46–48.

Kluver, Billy, "Nine Evenings of Theatre and Engineering: Notes of an Engineer," *Artforum* 5 (February): 3l–33.

——, and Simone Whitman, "Theatre and Engineering: An Experiment," *Artforum* 5 (February): 26–33.

Kozloff, Max, "Mark di Suvero: Leviathan," *Artforum* 6 (Summer): 41–46.

——, "Problems of Criticism III: Venetian Art and Florentine Criticism," *Artforum* 6 (December): 42–45.

Krauss, Rosalind, "On Anthony Caro's Latest Work," *Art International* (January 20): 26–29.

Laderman, Gabriel, "Unconventional Realists," *Artforum* 6 (November): 42–46.

Langsner, Jules, "Kinetics in L.A.," *Art in America* 55 (May–June): 107–109.

LeWitt, Sol, "Paragraphs on Conceptual Art," *Artforum* 5 (June): 79–83.

Lippard, Lucy R., "Homage to the Square," *Art in America* 55 (July–August): 50–57.

——, "Perverse Perspectives," *Art International* 11 (March–April): 28–33, 44.

——, "Ronald Bladen's 'Black Triangle,'" *Artforum* 5 (March): 26–27.

——, "The Silent Art," *Art in America* 55 (January–February): 58–63.

——, and John Chandler, "Visible Art and the Invisible World," *Art International* 11 (May): 27–30.

Loftus, John, "The Plastic Arts in the Sixties: What Is It That Has Got Lost?" *College Art Journal* (Spring): 240–245.

Mailer, Norman, *Why We Are in Vietnam.*

Marcuse, Herbert, "Art in the One-Dimensional Society," *Arts Magazine* 41 (May): 26–31.

Monte, James, "Making It with Funk," *Artforum* 6 (Summer): 56–59.

Morris, Robert, "Notes on Sculpture, Part 3: Notes and Nonsequiturs," *Artforum* 6 (Summer): 24–29.

Nodelman, Sheldon, "Sixties Art: Some Philosophical Perspectives," *Perspecta II: The Yale Architectural Journal*: 72–89.

Oldenburg, Claes, *Store Days* (New York: Something Else Press).

Paris, Harold, "Sweet Land of Funk," *Art in America* (March–April): 95–98.

Penrose, R., "Richard Lindner," *Art International* 11 (January): 30–33.

Perreault, John, "Union Made: Report on a Phenomenon," *Arts Magazine* 41 (March): 26–3l.

Picard, Lil, "Making the Scene with Lil Picard," *Arts Magazine* 41 (February): 17.

——, "Making the Scene with Lil Picard: Kill for Peace," *Arts Magazine* 41 (March): 15.

Piene, Nan R., "Light Art," *Art in America* 55 (May–June): 24–47.

Piene, Otto, "Proliferation of the Sun: On Art, Fine Arts, Present Art, Kinetic Art, Light, Light Art, Scale, Now and Then," *Arts Magazine* 41 (Summer): 24–31.

Pincus-Witten, Robert, "Sound, Light and Silence in Kansas City," *Artforum* 5 (January): 51–52.

Popper, Frank, "Luminous Trend in Kinetic Art," *Studio International* 173 (February): 72–77.

Raffaele, Joe, and Elizabeth Baker, "The Way-Out West: Interviews with 4 San Francisco Artists," *Art News* 66 (Summer): 38–41, 66–67, 72–76.

Rainer, Yvonne, "Don't Give the Game Away," *Arts Magazine* 41 (April): 44–47.

Raysse, Martial, "Refusing Duality: 'The Impeccable Trajectory of Yves Klein,'" *Arts Magazine* 41 (February): 34–36.

Reed, Ishmael, "The Black Artist: 'Calling a spade a spade,'" *Arts Magazine* 41 (May): 48–49.

Reichardt, Jasia, "Cybernetic Serendipity," *Studio International* 173 (May): 236–237.

Rickey, George, *Constructivism: Origins and Evolution.*

——, "Origins of Kinetic Art," *Studio International* 173 (January): 67.

Rivers, Larry, "Blues for Yves Klein," *Art News* 65 (February): 32–33, 75–76.

Roberts, C., "Lettre de New York," *Aujourd'hui* 8 (October): 201.

Rolling Stone, first issue (October).

Rose, Barbara, *American Art Since 1900: A Critical History.*

——, "Abstract Illusionism," *Artforum* 6 (October): 33–37.

——, "Claes Oldenburg's Soft Machines," *Artforum* 5 (Summer): 30–35.

—— and Irving Sandler, "Sensibility of the Sixties," *Art in America* 55 (January–February): 44–57.

——, "Shall We Have a Renaissance?" *Art in America* 55 (March–April): 30–39.

——, "The Value of Didactic Art," *Artforum* 5 (April): 32–36.

Rosenstein, Harris, "Di Suvero: The Pressure of Reality," *Art News* 65 (February): 36–39, 63–65.

Rubin, William, "Jackson Pollock and the Modern Tradition," four parts, *Artforum* 5 (February, March, April, May).

Ruda, Ed, "Park Place, 1963–1967: Some Informal Notes in Retrospect," *Arts Magazine* 42 (November): 30–33.

Sandberg, J., "Some Traditional Aspects of Pop Art," *Art Journal* 26 (Spring): 228–233, 245.

Saul, Peter, and Joe Raffaele,"Lost Angeles: Subversive Art," *Arts Magazine* 41 (May): 50–52.

Seitz, William C., "The Relevance of Impressionism," *Art News* 65 (January): 28–43, 56–60.

Selz, Peter, "Funk Art," *Art in America* 55 (March–April): 92–93.

——, "The Berkeley Symposium on Kinectic Sculpture," part 1, *Art and Artists* 1 (February): 26–31; part 2 (March): 46–49.

Smithson, Robert, "Ultramoderne," *Arts Magazine* 42 (September–October): 30–33.

Spear, Athena Tacha, "Sculptured Light," *Art International* 11 (December): 29–50.

Solomon, Alan, *New York: The New Art Scene*, with photos by Ugo Mulas.

Sontag, Susan, *Against Interpretation.*

Spear, Athena T., "Sculptured Light," *Art International* 11 (December): 29–49.

Stearn, Gerald Emmanuel, *McLuhan Hot and Cool.*

Styron, William, *The Confessions of Nat Turner.*

Tillim, Sidney, "Gothic Parallels: Watercolor and Luminism in American Art," *Artforum* 5 (January): 15–19.

——, "Scale and the Future of Modernism," *Artforum* 6 (October): 14–18.

Thorp, Charlotte, "Stephen Antonakos," *Arts Magazine* 41 (April): 61–62.

Tuten, Frederic, "American Sculpture of the Sixties: A Los Angeles 'Super Show,' " *Arts Magazine* 41 (May): 40–44.

Wechsler, Judith, "Why Scale?" *Art News* 66 (Summer): 32–35, 67–68.

Whitman, Simone, "Nine Evenings of Theater and Engineering: Notes of a Participant," *Artforum* 5 (February): 26–30.

Yalkut, Jud, "Propheteer?" *Arts Magazine* 41 (February): 22–23.

——, "Understanding Inter-media," *Arts Magazine* 41 (May): 18–19.

1968

Contemporary Events

Motorcycle films *The Savage Seven* and *The Mini-Skirt Mob* are released.

Boston Five and Oakland Seven are indicted for conspiracy.

Vietnam: Siege of Hué.

San Francisco: San Francisco State, the first major strike in a public American university, led by blacks and chicanos.

The Charles Manson murders.

The Graduate is the year's top film.

Bulletproof glass is installed at the New York Stock Exchange.

Philip Berrigan is sentenced to six years for pouring blood on draft files.

January
The *Pueblo* is seized in Sea of Japan off Korean coast by North Korean patrol boats.

January
South Vietnam: Beginning of the Tet offensive as Viet Cong hit 30 South Vietnamese provincial capitals, turns majority opinion strongly against Vietnam War. U.S. Embassy in Saigon is occupied by communists for six hours. Hué street fighting ends February 24.

February
Pervasive white racism and exploitation are cited as chief causes of black violence and riots in Kerner Commission report on civil disorders: "Our nation is moving toward two societies, one black, one white— separate and unequal."

March
New York: Fillmore East opens.

March
My Lai Massacre.

March
President Johnson announces he will not run again.

April 4
Memphis: Dr. Martin Luther King, Jr., 39, is assassinated, prior to heading a march by striking city sanitation workers. By April racial violence erupts in 125 cities in 29 states. James Earl Ray, an escaped convict, pleads guilty to slaying, and is sentenced to 99 years.

April
New York: Columbia University, rebellion and strike as SDS protest gym in Morningside Park and school's tie with Institute for Defense Analysis; 60 militants seize five campus buildings; 700 persons are arrested; operation of university is suspended for remainder of academic year.

April
Hair and *The Boys in the Band* open on Broadway.

April 3
2001: A Space Odyssey (Kubrick) opens, featuring Hal, the first personal computer.

May
Washington, D.C.: Poor People's Campaign builds Resurrection City (plywood structures stretching along Lincoln Memorial's reflecting pool); campaign ends with a march of 50,000, led by Dr. Ralph Abernathy.

May-June
Paris: Abortive revolution of students and workers begins as six new left students protest at University of Nanterre, France, and

grows into nearly a month of civil violence; by May 24, ten million strikers paralyze country. De Gaulle saves regime by broad reforms.

May
Paris: Preliminary Vietnam peace talks begin after 34-day impasse on selection of site.

June
Los Angeles: Senator Robert F. Kennedy, 42 (Democrat, N.Y.), is shot shortly after he has claimed victory in California Democratic presidential primary held preceding day; he dies June 6.

June
Boston: Spock and three others are convicted in federal district court of conspiring to aid and counsel draft violators; sentenced to two years imprisonment.

June
Washington, D.C.: U.S. House of Representatives passes a bill making it a federal crime to desecrate the U.S. flag.

July
Biafra: An estimated 6,000 Ibos die daily from malnutrition.

July
Pope Paul IV bans all artificial birth control methods.

August
Czechoslovakia: Soviet Union and other Warsaw Pact nations invade Czechoslovakia to crush Alexander Dubček's liberal regime.

August
Chicago: Riots at Democratic National Convention; violence erupts as police and troops clash with 10,000 to 15,000 anti-war demonstrators.

October
Mexico City: Protests by black athletes at Olympic Games.

October
Washington, D.C.: Mass demonstrations at the Pentagon.

November
Richard M. Nixon is elected 37th president of U.S.

December
Man with toy pistol forces pilot of Eastern Airlines Philadelphia-to-Miami flight with 151 persons aboard to fly to Cuba—21st hijacking of U.S. airline to Cuba during year.

December
North Korea: 82 crewman of *Pueblo* are released after U.S. signs document, previously denounced as false, admitting that ship violated North Korean waters.

December
U.S. astronauts Borman, Lovell, and Anders make ten orbits around the moon; first men to circle and view the back side of the moon.

Art Events

April–October
San Antonio: Hemisfair 1968 (Rockne Krebs).

June
Andy Warhol shot and seriously wounded by Valerie Solanas, an actress who had played in *Bike Boy* and founder of SCUM, Society for Cutting Up Men.

July
Christo wraps the Kunsthalle, Bern, his first building; his plans to wrap the MOMA are abandoned because of objections by fire and police officials.

September 5
New York: Letter proposing artists' boycott of city of Chicago during Mayor Daley's incumbency appears in the *New York Times*.

September
New York: E.A.T. announces it has received grants of $50,000 from the National Endowment for the Arts and $25,000 from the Rockefeller Fund; the organization has 3,000 members worldwide.

October
Los Angeles: Los Angeles County Museum of Art establishes $230,000 arts and technology program; 20 technological and industrial corporations agree to place artists in residence for three months.

October 2
Death of Marcel Duchamp, age 81.

November
New York: Seth Siegelaub Gallery, *Douglas Huebler: November, 1968*. First exhibition to exist solely as a catalog.

Brillo offers an inflatable Brillo Pillow with the promotional ad: "The latest in groovy Pop Art."

Black Rock Desert, Nev.: Michael Heizer's first major earthwork, *Dissipate*.

El Mirage Dry Lake, Mojave Desert: Walter de Maria's first earthwork, *Mile Long Drawing*.

Exhibitions

New York: Castelli Warehouse, "Attack on the Status of an Object."

January 6–February 4
London: Tate Gallery, *Lichtenstein*. First one-man show in England.

February–March
Pasadena: Pasadena Museum of Art, *Wayne Thiebaud*. Major one-man show.

February 20–March 9
New York: Alan Stone Gallery, *Richard Estes*. First one-man show.

February 26–March 24
New York: Whitney Museum of American Art, *Don Judd*. First one-man museum show.

March
Philadelphia: YM/YMHA Arts Council, *Air Art*.

March–May
New York: Jewish Museum, *Gene Davis, Robert Irwin, Richard Smith*.

March 27–June 9
New York: MOMA, *Dada, Surrealism and Their Heritage*.

March 31–May 5
Vancouver: Vancouver Art Gallery, *Los Angeles Six* (Bell, Davis, Irwin, Kauffman, Kienholz, McCracken).

April–May
Tampa: Tampa Bay Art Center, *Young California: 50 Painters*.

April 12–May 26
Chicago: Museum of Contemporary Art, *George Segal: 12 Human Situations*. First one-man museum show.

April 17–June 16
New York: Whitney Museum of American Art, *Isamu Noguchi* (retrospective).

May 8–June 12
Poughkeepsie, N.Y.: Vassar College Art Gallery, *Realism Now*.

May 10–June 20
New York: Finch College Museum of Art, *Destruction Art (Destroy to Create)* (includes Arman, Baj, Burri, Pol Bury, Fontana, Gilbertson, Greenbaum, Hendricks, Klein, Latham, Levinson, Levine, McCracken, Millares, Mon, Novak, Ortiz,

Picard, Piene, Rabkin, de Saint Phalle, Roche, Sonenberg, Soviak, Thelz, Tinguely, van Hoeydonck, Van Saun, Waitzkin).

May 11–June 23
Minneapolis: Walker Art Center, *6 Artists, 6 Exhibitions* (Bell, Chryssa, Insley, Irwin, Smithson, Whitman).

June 27–October 6
Kassel, West Germany: *Documenta 4.*

June 22–August 18
Milwaukee: Milwaukee Art Center, *Directions 1: Options.*

July 3–September 8
New York: MOMA, *The Art of the Real U.S.A., 1948–1968.*

July 23–September 29
New York: Whitney Museum of American Art, *Light, Object and Image.*

August–September
Venice: Bridget Riley wins first prize at the Venice Biennale.

August 2–October 20
London: Institute of Contemporary Arts, *Cybernetic Serendipity: The Computer and the Arts.*

September 1–30
Pasadena: Pasadena Art Museum, *Serial Imagery* (includes Albers, Bell, Duchamp, Jawlensky, Kelly, Klein, Louis, Mondrian, Monet, Noland, Reinhardt, Stella, Warhol).

October 5–31
New York: Dwan Gallery, *Earthworks.*

October 17–November 24
Minneapolis: Minneapolis Institute of Arts, *Thirty Contemporary Black Artists.*

October 18–January 5, 1969
New York: Jewish Museum, *Pond.* Robert Whitman multimedia show.

November 2–27
New York: Dwan Gallery, *Dan Flavin.*

November 15–December 8
Cambridge, Mass.: Hayden Gallery, MIT, *Takis: Evidence of the Unseen.*

November 27–February 9, 1969
New York: MOMA, *The Machine as Seen at the End of the Mechanical Age* (a related exhibition arranged by E.A.T. was held at the Brooklyn Museum, Nov. 24–Jan. 5, 1969).

Publications

Alloway, Lawrence, "Christo and the New Scale," *Art International* 12 (September 20): 56–67.

Antin, David, "Differences-sames: New York 1966–67," *Metro* 13 (February): 78–104.

Arnason, H. H., *History of Modern Art: Painting, Sculpture, Architecture.*

Ashton, Dore, *Modern American Sculpture.*

Baker, Elizabeth C., "Artschwager's Mental Furniture," *Art News* 66 (January): 48–49, 58–61.

Baro, Gene, "American Sculpture: A New Scene," *Studio International* 175 (January): 9–19.

Bannard, Walter Darby, "Cubism, Abstract Expressionism, David Smith," *Artforum* 6 (April): 22–32.

Battcock, Gregory, *Minimal Art: A Critical Anthology.*

———, "The Art of the Real: The Development of a Style, 1948–1968," *Arts Magazine* 42 (Summer): 44–47.

Blok, C., "Minimal Art at The Hague," *Art International* 12 (May): 18–24.

Bongard, Willi, "When Rauschenberg Won the Biennale," *Studio International* 173 (June): 288–289.

Bourdon, David, "Walter de Maria: The Singular Experience," *Art International* 12 (December 20): 39–43, 72.

Brett, Guy, *Kinetic Art: The Language of Movement.*

Burnham, Jack, *Beyond Modern Sculpture: The Effects of Science and Technology on the Sculpture of This Century.*

———, "Systems Esthetics," *Artforum* 6 (September): 30–35.

Burton, Scott, "Big H," *Art News* 67 (March): 50–53, 70–72.

Calas, Nicolas, *Art in the Age of Risk and Other Essays.*

———, "The Originality of Al Held," *Art International* 12 (May 15): 38–41.

Castle, Frederick, "Threat Art," *Art News* 67 (October): 54–55, 65–66.

Chandler, John N., "The Last Word in Graphic Art," *Art International* 12 (November): 25–28.

———, "Tony Smith and Sol LeWitt: Mutations and Permutations," *Art International* 12 (September 20): 16–19.

Chomsky, Noam, *Language and Mind.*

Clay, Jean, "A Cultural Heatwave in New York," *Studio International* 175 (February): 72–75.

Cleaver, Eldridge, *Soul on Ice.*

Coplans, John, "Serial Imagery," *Artforum* 7 (October): 34–43.

Davis, Douglas, "Art and Technology—The New Combine," *Art in America* 56 (January–February): 28–37.

Finch, Christopher, *Pop Art: Object and Image.*

Flavin, Dan, ". . . On an American Artist's Education," *Artforum* 6 (March): 28–32.

Fried, Michael, "Two Sculptures by Anthony Caro," *Artforum* 6 (February): 24–25.

Goldin, Amy, "One Cheer for Expressionism," *Art News* 67 (November): 48–49.

———, "Situation Critical," *Art News* 67 (March): 44–45, 64–67.

Graham, Dan, "Carl Andre," *Arts Magazine* 43 (January): 34–35.

Greenberg, Clement, "Poetry of Vision," *Artforum* 6 (April): 18–21.

Hill, Anthony, *D.A.T.A.: Directions in Art, Theory and Aesthetics.*

Hutchinson, Peter, "Earth in Upheaval: Earthworks and Landscapes," *Arts Magazine* 43 (November): 19, 21.

———, "Science-Fiction: An Aesthetic for Science," *Art International* 12 (October 20): 32–34, 41.

Kirby, Michael, "The Experience of Kinesis," *Art News* 66 (February): 42–45, 52–53, 7l.

Kozloff, Max, "A Confession in Buffalo: 'Plus by Minus' Rather Amounts to Less . . .," *Artforum* 6 (May): 50–53.

———, *Renderings: Critical Essays on a Century of Modern.*

Krauss, Rosalind, "On Frontality," *Artforum* 6 (May): 40–46.

Kultermann, Udo, *The New Sculpture, Environments and Assemblages.*

"La sfida del sistema: Inchiesta sulla situazioni artistica attuale negle Stati Unita e in Francia: A cura de Anna Nosei Weber e Otto Hahn," answers by Dan Graham, Don Judd, Allan Kaprow, Billy Kluver, Sol LeWitt, and Robert Smithson. E.A.T., *Metro* 14 (June–August): 35–58.

Licht, Ira, "Dan Flavin," *artscanada* (December): 50–57.

Lucie-Smith, Edward, "An Interview with Clement Greenberg," *Studio International* 175 (January): 4–5.

Mailer, Norman, *Armies of the Night*.

Masters, Robert E. L., and Jean Houston, *Psychedelic Art*.

Morris, Robert, "Anti-Form," *Artforum* 6 (April): 33–35.

Pierce, James S., "Design and Expression in Minimal Art," *Art International* 12 (May): 25–27.

Pleynet, Marcelin, "Peinture et 'Structuralisme,' " *Art International* 12 (November): 29–34.

Poggioli, Renato, *The Theory of the Avant Garde* (first English translation).

Popper, Frank, *Origins and Development of Kinetic Art*.

——, *Kinetic Art*.

Quinn, Edward, and Paul J. Dolan, eds., *The Sense of the Sixties*.

Reichardt, Jasia, ed., *Cybernetic Serendipity: The Computer and the Arts*.

Reise, Barbara, "Greenberg and the Group: A Retrospective View," part 1, *Studio International* 175 (May): 254–257; part 2, (June): 314–315.

Roberts, Francis, "Interview with Marcel Duchamp (1887–1968): 'I propose to strain the laws of physics,' " *Art News* 67 (December): 46–47, 62–64.

Rose, Barbara, "Blow-up—The Problems of Scale in Sculpture," *Art in America* 56 (July–August): 80–91.

——, "Problems of Criticism IV: The Politics of Art, Part I," *Artforum* 6 (February): 31–32.

——, *Readings in American Art Since 1900: A Documentary Survey*.

Scharf, Aaron, *Art and Photography*.

Schwartz, Barry N., "Psychedelic Art: The Artist Beyond Dreams," *Arts Magazine* 43 (April): 39–41.

Schwartz, Paul, "Anti-Humanism in Art: Alain Robbe-Grillet in an Interview with Paul Schwartz," *Studio International* 175 (April): 168–169.

Sharp, Willoughby, "Air Art," *Studio International* 175 (May): 262–65.

Smithson, Robert, "A Sedimentation of the Mind: Earth Proposals," *Artforum* 7 (September): 44–50.

——, "The Museum of Language in the Vicinity of Art," *Art International* 12 (March): 21–27.

Solzhenitsyn, Aleksandr, *The Cancer Ward*.

Stiles, Knut, "The Paintings of Al Held," *Artforum* 6 (March): 47–53.

Tillim, Sidney, "Earthworks and the New Picturesque," *Artforum* 7 (December): 42–45.

——, "Evaluations and Re-Evaluations," *Artforum* 6 (Summer): 20–23.

Venturi, Robert, and Denise Scott Brown, "A Significance for A&P Parking Lots or Learning from Las Vegas," *Architectural Forum* 128 (March): 36–43.

Wasserman, Emily, "Robert Irwin, Gene Davis, Richard Smith," *Artforum* 6 (May): 47–49.

Weaver, Mike, "And What Is Concrete Poetry?" *Art International* 12 (May 15): 30–33.

White, Robert, and Gary Michael Dault, "Word Art and Art Word," *artscanada* 118–119 (June): 17–29.

Wolfe, Tom, *The Electric Kool-Aid Acid Test*.

1969

Contemporary Events

Midnight Cowboy (Schlesinger) is released, as are several films focusing on youth revolt: *Alice's Restaurant* (Penn), *IF* (Anderson), *I Am Curious (Yellow)* (Sjoman), *Easy Rider* (Hopper), *Putney Swope* (Downey), and *Medium Cool* (Wexler); also motorcycle films *Hell's Belles* and *Hell's Angels*.

Biafra crisis of Nigerian War.

Three out of five campuses hold anti-war protests.

SDS supports women's liberation, which gains prominence.

Sesame Street premieres on Educational TV.

Golda Meir becomes prime minister of Israel.

March
Chinese and Soviet troops clash near the Ussuri River.

April
France: President Charles de Gaulle resigns after losing a referendum by a narrow margin.

May
Washington, D.C.: U.S. Supreme Court Justice Abe Fortas resigns because of public pressure, the first justice to do so in the court's history.

June
Berkeley: "People's Park" crisis.

July
Vietnam: First U.S. troops leave Vietnam in scheduled pull-out of 25,000 troops.

July
Chappaquiddick Island, Mass.: Car driven by Senator Edward Kennedy plunges off bridge into tidal pool, and body of Mary Jo Kopechne, 28-year-old secretary, is found in car.

July
U.S. astronaut Neil Armstrong, 38, commander of Apollo 11 mission, becomes the first man to set foot on moon; Edwin E. Aldrin, Jr., accompanies Armstrong on moon landing.

July
Guam: UN issues Nixon Doctrine: U.S. would protect its Asian allies, but not with troops.

August
Capetown, South Africa: Dr. Philip Blaiberg, retired dentist, dies 19 months and 15 days after transplant operation performed by Dr. Barnard; world's longest surviving heart-transplant patient to date.

August
Bethel, N.Y.: Woodstock Rock Festival, about 400,000-450,000 attend.

September
North Vietnam: Ho Chi Minh, North Vietnam's president, dies.

October 15
Vietnam Moratorium demonstrations nationwide.

November
President Nixon announces a plan for Vietnamization of the war with an appeal to the "great silent majority" for support of his program; continuing gradual withdrawal of U.S. troops from Vietnam.

November
Washington, D.C.: Over half a million demonstrate to protest Vietnam War, largest anti-war demonstration in nation's history; similar demonstration in San Francisco.

November
Helsinki: U.S. and USSR begin SALT talks.

November
Astronauts Charles Conrad, Jr., and Alan Bean begin exploration of lunar surface for over 8 1/2 hours of their 31 1/2 hour stay on moon; Richard Gordon, Jr., remains in lunar orbit in Apollo 12; second successful landing on moon.

December
Washington, D.C.: Selective Service System holds the first draft lottery since 1942 to set the order of selection for the draft in 1970.

December
The 362-seat Boeing 747 jumbo jet makes its first public flight from Seattle to New York City.

December
Chicago: Illinois Black Panther leader, Fred Hampton, and another party member are shot by police as they raid Hampton's apartment.

Art Events

Claes Oldenburg erects lipstick/war machine near Beineke Library at Yale University.

Little Bay, Australia: Christo wraps one million square feet of Australian coastline.

January
New York: Takis removes his sculpture from the the MOMA exhibition *The Machine as Seen at the End of the Mechanical Age*, beginning the Art Workers Coalition.

May
Announcement that MIT's Center for Advanced Visual Studies will collaborate with the National Collection of Fine Arts in making the U.S. show for Brazil's 10th São Paulo Biennial.

July 4
Los Angeles: Death of Martha Jackson.

August 17
Death of Mies van der Rohe.

William Rubin promoted to chief curator at the MOMA.

Exhibitions

Munich: Galerie Heiner Friedrich, *Michael Heizer*. First one-man exhibition.

January
New York: Dwan Gallery, *Conceptual Art* (includes Barry, Huebler, Kosuth, Weiner).

January–February
Philadelphia: Institute of Contemporary Art, University of Pennsylvania, *Plastics and New Art*.

January 18–April 6
New York: Metropolitan Museum of Art, *Harlem on My Mind*.

February
New York: Architectural League of New York, *Hyperspace*.

February
New York: Jewish Museum, *Laser Beam Joints* by Keiji Usami.

February
New York: Museum of Contemporary Crafts, *Feel It*.

February–March
Ithaca, N.Y.: Andrew Dickson White Museum of Art, Cornell University, *Earth Art* (includes Dibbets, Haacke, Jenney, Long, Mcdalla, Morris, Oppenheim, Smithson, Uecker).

March
Fort Worth: Fort Worth Art Museum, *Kenneth Snelson: Five Monumental Sculptures*. First one-man museum show.

March 25–April 19
New York: M. Knoedler and Co., *Barnett Newman*.

March 29–May 11
New York: Solomon R. Guggenheim Museum, *David Smith* (retrospective).

March–April
Irvine Art Gallery, University of California, *New York, The Second Breakthrough, 1959–1964* (includes Dine, Johns, Lichtenstein, Louis, Noland, Oldenburg, Rauschenberg, Rosenquist, Stella, Warhol).

March 28–April 19
Vancouver: Fine Arts Gallery, University of British Columbia, *Concrete Poetry, An Exhibition in Four Parts*.

April 1–19
New York: Betty Parsons Gallery, *Reductive Vision* (includes Castellani, Gray, Hacklin, Reinchek, Tippett).

May 17–June 4
New York: Howard Wise Gallery, *TV as a Creative Medium*.

May–June
Burnaby, British Columbia: *Simon Fraser Exhibition*, Centre for Communication and the Arts, Simon Fraser University (includes Terry Atkinson, Michael Baldwin, Robert Barry, Jan Dibbets, Douglas Huebler, Stephen Kaltenbach, Joseph Kosuth, Sol LeWitt, N.E. Thing Co., Ltd., Lawrence Weiner).

May 24–June 29
New York: Solomon R. Guggenheim Museum, *Nine Young Artists: Theodoron Awards* (Christensen, Flanagan, Nauman, Richter, Seawright, Serra, Walker, Young, Zorio).

May 19–July 6
New York: Whitney Museum of American Art, *Anti-Illusion: Procedures/Materials* (includes Andre, Asher, Benglis, Bollinger, Duff, Ferren, Fiore, Philip Glass, Hesse, Jenney, Le Va, Lobe, Morris, Nauman, Reich, Rohm, Ryman, Serra, Shapiro, Snow, Sonnier, Tuttle).

May 29–June 21
Minneapolis: Walker Art Center, *14 Sculptors, The Industrial Edge* (Alexander, Bell, Bladen, Grosvenor, Hudson, Judd, Kauffman, Kelly, Morris, Murray, Raudell, Stone, Valentine, Weinrib).

July 1–September 1
New York: Jewish Museum, *Inflatable Sculpture*.

July 9–September 3
London: Hayward Gallery, *Pop Art Redefined*.

July–August
Waltham, Mass.: Rose Art Museum, Brandeis University, *12 Black Artists from Boston* (Calvin Burnett, Dana C. Chandler, Jr., Babaluaiye S. Dele [Stanley Pinckney], Henry De Leon, Jerry Pinckney, Gary Richson, Leo Robinson, Al Smith, Richard Stroud, Lovett Thompson, John Wilson, Richard Yarde).

September 13–October 19
Ottawa: National Gallery of Canada, *Dan Flavin*.

September–October
London: Institute of Contemporary Art, *When Attitudes Become Form*.

September 25–November 23
New York: MOMA, *Claes Oldenburg*, with soft catalogue by Barbara Rose.

October
Paris: Musée d'Art Moderne et Musée Municipal, Sixth Biennale de Paris.

October 14–November 30
New York: Whitney Museum of American Art, *Human Concern/Personal Torment*.

October 16–November 30
Worcester, Mass.: Worcester Art Museum, *The Direct Image in Contemporary American Painting* (includes Louis, Noland, Reinhardt, Stella, Zox).

October–November
Albany, N.Y.: Art Gallery, State University of New York at Albany, *A Leap of Faith, Israel Art, 1969.*

November–December 14
Cincinnati: Cincinnati Art Museum, *Laser Light, A New Visual Art.*

November 1–December 14
Chicago: Museum of Contemporary Art, *Art by Telephone.*

November 5–January, 1970
Waltham, Mass.: Rose Art Museum, Brandeis University, *James Rosati.* Organized by William C. Seitz.

November 19–January 4, 1970
New York: Jewish Museum, *A Plastic Presence.*

November 21–December 28
Washington, D.C.: Corcoran Gallery of Art, *Robert Morris.* First one-man museum show.

December–January 1970
Irvine: Art Gallery, University of California, *Five Sculptors* (Andre, Flavin, Judd, Morris, Serra).

December 9–February 15, 1970
New York: Riverside Museum, *Paintings from the Photo* (includes Bruder, Estes, Flack, Kanovitz, Morley, Raffael).

December 13–January 3, 1970
New York: Castelli Warehouse, Richard Serra included in *Nine at Castelli* exhibition. His first show in New York.

December 30–March 1, 1970
New York: MOMA, *Spaces* (includes Michael Asher, Larry Bell, Dan Flavin, Robert Morris, Pulsa, Franz Erhard Walther).

Publications

Ackerman, James S., "The Demise of Avant-Garde: Notes on the Sociology of Recent American Art," *L'Arte* 6 (March): 5–17.

Alloway, Lawrence, *Christo.*

———, "Highway Culture and Pop Art," *Studio International* (July–August): 17–21.

Arnheim, Rudolph, *Art and Visual Perception.*

Art Workers Coalition, *Documents I* (New York: Art Workers Coalition).

———, *Open Hearing* (New York: Art Workers Coalition).

Ashton, Dore, "A Planned Coincidence," *Art in America* 57 (September–October): 36–47.

———, *A Reading of Modern Art.*

———, "Exercise in Anti-Style: Six Ways of Regarding Un, In, and Antiform," *Arts Magazine* 43 (April): 45–57.

———, "Response to the Crisis in American Art," *Art in America* 57 (January–February): 24–35.

Baigell, Mathew, "American Painting: On Space and Time in the Early 1960's," *Art Journal* 27 (Summer): 368–374, 387–401.

Baker, Elizabeth C., "Barnett Newman in a New Light," *Art News* 67 (February): 38–41, 60–64.

Bannard, Walter Darby, "Willem de Kooning's Retrospective at the Museum of Modern Art," *Artforum* 7 (April): 42–44.

Battcock, Gregory, "Frankenthaler," *Art and Artists* 4 (May): 52–55.

———, "Marcuse and Anti-Art (Parts I & II)" *Arts Magazine* 43 (Summer): 17–19, and 44 (November): 20–22.

Benson, Legrace G., "The Washington Scene (Some Preliminary Notes on the Evolution of Art in Washington, D.C.)," *Art International* 13 (Christmas): 21–23, 36–42, 50.

Bourdon, David, "What on Earth!" *Life* (April 25): 80–86.

Bowles, Jerry, "Helen Frankenthaler at the Whitney," *Arts Magazine* 43 (March): 20–22.

Brautigan, Richard, *Trout Fishing in America.*

Burnham, Jack, "Real Time Systems," *Artforum* 8 (September): 49–55.

Burton, Scott, "Time on Their Hands," *Art News* 68 (Summer): 40–43.

Cage, John, *A Year from Monday* (Middletown, Conn.: Wesleyan University Press).

Celant, Germano, *Arte Povera.*

———, "Walter de Maria," *Casabella* (March): 42–43.

Chandler, John N., "Art in Automata: Cybernetic Serendipity, Technology and Creativity," *Arts Magazine* 43 (January): 42–45.

———, "Art in the Electric Age," *Art International* 13 (February): 19–25.

Christo, *Wrapped Coast, One Million Square Feet* (Minneapolis: Contemporary Art Lithographers).

Cone, Jane Harrison, "Caro in London," *Artforum* 7 (April): 62–66.

Dempsey, Michael, "The Caro Experience," *Art and Artists* 4 (February): 16–19.

Flavin, Dan, "Several More Remarks . . .," *Studio International* 177 (April): 173–175.

Fohg, Monique, "On Art and Technology," *Studio International* 177 (January): 5–6.

"Four Interviews with Barry, Huebler, Kosuth, Weiner," *Arts Magazine* 43 (February): 22–23.

Gablik, Suzi, "Protagonists of Pop: Five Interviews" (Leo Castelli, Richard Bellamy, Robert C. Scull, Dr. Hubert Peeters, and Robert Fraser), *Studio International* 178 (July–August): 9–12.

Harrison, Charles, "Against Precedents," *Studio International* 178 (September): 90–93.

Heizer, Michael, "The Art of Michael Heizer," *Artforum* 8 (December): 32–39.

Hoffman, Abbie, *The Conspiracy.*

———, *Woodstock Nation, A Talk-Rock Album.*

Johnson, William, "Scuba Sculpture," *Art News* 68 (November): 52–53, 81–84.

Kirby, Michael, *The Art of Time: Essays on the Avant Garde.*

Kosuth, Joseph, "Art After Philosophy," *Studio International* 178 (October): 134–137; (November): 160–161; (December): 212–213.

Kozloff, Max, "9 in a Warehouse," *Artforum* 7 (February): 38–42.

———, *Renderings: Critical Essays on a Century of Modern Art.*

———, "Men and Machines," *Artforum* 7 (February): 22–29.

Kramer, Hilton, "The Emperor's New Bikini," *Art in America* 57 (January–February): 48–55.

———, "30 Years of the New York School," *New York Times Magazine* (October 12): 28–31, 89–90.

Kultermann, Udo, *The New Painting* (New York: Praeger).

LeWitt, Sol, ed., "Sentences on Conceptual Art," *0–9* 5 (January): 3–5.

———, "Time: A Panel Discussion," *Art International* 13 (November): 20–23.

Lucie-Smith, Edward, *Late Modern: The Visual Arts Since 1945.*

———, *Movements in Art Since 1945.*

McCoubrey, John W., "Al Held: Recent Paintings," *Art Journal* 28 (Spring): 322–324.

McGinniss, Joe, *The Selling of the President 1968.*

Marcuse, Herbert, *An Essay on Liberation.*

Margolies, John S., "TV—The Next Medium," *Art in America* 57 (September–October): 48–55.

Meadmore, Clement, "Thoughts on Earthworks, Random Distribution, Softness, Horizontality and Gravity," *Arts Magazine* 43 (February): 26–28.

Messer, Thomas M., "Impossible Art—Why Is It?" *Art in America* 57 (May–June): 30–31.

Meyer, Ursula, "De-Objectification of the Object," *Arts Magazine* 43 (Summer): 20–22.

Morris, Robert, "Notes on Sculpture, Part 4: Beyond Objects," *Artforum* 7 (April): 50–54.

Muller, Gregoire, "Michael Heizer," *Arts Magazine* 44 (December): 42–45.

———, "Robert Morris Presents Anti-Form: The Castelli Warehouse Show," *Arts Magazine* 43 (February): 29–30.

Parola, René, *Optical Art.*

Perreault, John, "Literal Light," *Art News Annual* 25: 129–141.

Phillips, Gifford, "Cultural Commercialism," *Art News* 68 (September): 27, 67–68.

Plagens, Peter, "557,087," *Artforum* 8 (November): 64–67.

———, "The Possibilities of Drawing," *Artforum* 8 (October): 50–55.

Prokopoff, Stephen S., "Christo," *Art and Artists* (April): 12–17.

Puzo, Mario, *The Godfather.*

Reise, Barbara, " 'Untitled 1969': A Footnote on Art and Minimal-stylehood," *Studio International* 177 (April): 166–172.

Robbin, Anthony, "Images: Two Oceans Projects," *Arts Magazine* 44 (November): 24–25.

Robins, Corinne, "The Artist Speaks: Ronald Bladen," *Art in America* 57 (September): 76–81.

Rose, Barbara, "Painting Within the Tradition: The Career of Helen Frankenthaler," *Artforum* 7 (April): 28–33.

———, "Problems of Criticism V: The Politics of Art, Part II," *Artforum* 7 (January): 44–49; (May): 46–51.

———, "Problems of Criticism, VI: The Politics of Art, Part III," *Artforum* 7 (May): 46–51.

Rosenberg, Harold, *Artworks and Packages.*

Rosenstein, Harris, "The Colorful Gesture," *Art News* 68 (March): 29–31, 68.

Roth, Philip, *Portnoy's Complaint.*

Rubin, William S., "Some Reflections Prompted by the Recent Work of Louise Bourgeois," *Art International* 13 (April 20): 17–18.

Russell, John, "Pop Reappraised," *Art in America* 57 (July): 78–89.

Russell, John, and Suzi Gablik, *Pop Art Redefined.*

Schorr, Justin, "Problems of Criticism VII: To Save Painting," *Artforum* 8 (December): 59–61.

Sharp, Willoughby, "An Interview with Joseph Beuys," *Artforum* 8 (December): 40–47.

———, "Place and Process," *Artforum* 8 (November): 46–49.

Shirey, David L., "Impossible Art," *Art in America* 57 (May–June): 32–47.

———, "N.Y. Painting and Sculpture, 1940–1970: The Year of the Centennial at the Met," *Arts Magazine* 43 (September–October): 35–39.

Siegelaub, Seth, in conversation with Charles Harrison, "On Exhibitions and the World at Large," *Studio International* 178 (December): 202–203.

Silver, Charles, "50 Years After, 50 Years Before," *Arts Magazine* 43 (March): 18.

Smithson, Robert, "Aerial Art," *Studio International* 177 (April): 180–181.

Spruch, Grace Marmor, "Two Contributions to the Art and Science Muddle," *Artforum* 7 (January): 28–32.

Tillim, Sidney, "The Reception of Figurative Art: Notes on a General Misunderstanding," *Artforum* 7 (February): 30–33.

———, "A Variety of Realisms," *Artforum* 7 (Summer): 42–47.

Tuchman, Maurice, *The New York School: Abstract Expressionism in the 40s and 50s.*

Van Der Marck, Jan, "Why Pack a Museum? Christo at the Museum of Contemporary Art, Chicago," *artscanada* 5 (October): 34–37.

Wasserman, Emily, "New York: Process, Whitney Museum," *Artforum* 8 (September): 57–61.

Willard, Charlotte, "Art Centers: New York—Dealer's-Eye View,"

Art in America 57 (January–February): 36–43).

Wolfram, Eddie, "Pop Art Undefined," *Art and Artists* 8 (September): 18–19.

1970

Contemporary Events

The Beatles break up.

People's Republic of China launches its first satellite.

*M*A*S*H* (Altman) is released.

January
Nigeria: The 31-month Nigerian civil war ends with surrender of secessionist Biafra after loss of about two million lives.

January
U.S. Supreme Court orders 14 school districts in Alabama, Florida, Georgia, Louisiana, Mississippi, and Texas to integrate some 300,000 pupils by February 1, reaffirming its 1969 "desegregate now" ruling.

February
Chicago: The Chicago Seven are acquitted of plotting to incite riots during the 1968 Democratic Convention.

March
New York: Greenwich Village townhouse blows up; a bomb factory discovered on 11th Street; three people, possibly Weathermen, are killed.

March
Cambodia: Prince Norodom Sihanouk is overthrown in coup; Lieutenant General Lon Nol becomes premier.

March
New York: Greenwich Village, first Gay Liberation march.

April
San Rafael, Calif.: A courtroom escape attempt ends in death of Superior Court Judge Harold Haley and three convicts after a gunman invades the trial of convict James McClain and passes guns to the defendant and three convict witnesses. The judge, three women, and an assistant district attorney are taken as hostages to a van where a brief gun battle occurs. Angela Davis, formerly an instructor at UCLA, is apprehended October 13 for her alleged role in supplying two of the guns used in the escape.

April 22
Earth Day: Establishment of ecology alert nationwide; anti-pollution demonstrations.

April 30
President Nixon tells nationwide television audience that he has ordered American troops into action against communist sanctuaries inside Cambodia to destroy enemy bases and supplies.

May
Draft resistance regenerated with organization of Union for National Draft Opposition at Princeton; 1,500,000 students participate in strikes at various colleges.

May
New Haven, Conn.: Mass rally for Bobby Seale and New Haven Panthers (in prison on charges of murder, kidnapping, and conspiracy).

May
Kent, Ohio: Kent State University, student reaction to U.S./Cambodian operations brings about confrontation between 100 National Guardsmen and 500–600 students, which results in four student deaths after guardsmen fire into the group.

May
Jackson, Miss.: Two killed, nine wounded by police at Jackson State College.

May
First women generals in American history are named by President Nixon: Colonel Elizabeth P. Holsington, director of the Women's Army Corps, and Colonel Anna Mae Hays, chief of the Army Nurse Corps, are promoted to temporary rank of brigadier general.

June
President Nixon signs into law measure giving vote to 18 year olds.

June
Cambodia: U.S. Army announces last U.S. ground combat units have withdrawn from Cambodia.

July
Anaheim, Calif.: Spiro Agnew watches sold by Dr. Hale Dougherty.

July
Congress repeals Gulf of Tonkin Resolution, tries to place restraints on president's power in time of war.

July
Vietnam: "Tiger cages" of Con Son revealed.

July
Honor America Day: counter-reaction to anti-war demonstrations.

August
Chet Huntley leaves the media.

August
Suez Canal: A 90-day ceasefire begins on the Mideast front as fighting stops within a 32-mile-deep zone on each side of the Suez Canal; on November 7 ceasefire is extended for another three-month period.

August
Block Island, R.I.: Rev. Daniel Berrigan, a Jesuit priest convicted of destroying Selective Service files, is arrested.

August
A postal reform measure is signed by President Nixon creating an independent U.S. Postal Service, thus relinquishing governmental control of the U.S. mails after almost two centuries.

August
East Meadow, Long Island: President Nixon lauds John Wayne movie *Chisum* because ". . . the good guys come out ahead in the Westerns, the bad guys lose."

September
Palestinian commandoes hijack three Western airliners bound for New York in skies over Europe and precipitate a world crisis.

September
President Nixon orders federal armed guards to start flying on overseas airline flights of U.S. airlines as first step in a three-part anti-hijacking program.

September
New Haven, Conn.: Yale University distributes booklet, "Sex and the Yale Student"; similar tracts are published by Boston University, Berkeley, and McGill University, Montreal.

September
London: Jimi Hendrix dies of a drug overdose at age 27.

September
Washington, D.C.: Attorney General John N. Mitchell states that students, professors, and "these stupid bastards who are running our educational institutions" are uninformed about the issues within the government.

September
President's Commission on Campus Unrest warns of a rising crest of violence on college campuses.

September
Cairo, Egypt: President Gamal Abdul Nasser, 52, the most powerful leader in the Arab world, dies after a heart attack.

October
Eric Sevareid answers Agnew's proposition that news commentators should be examined by a government panel to determine their views.

October
Hollywood: Janis Joplin dies of a drug overdose at age 27.

November
Colombey-les-deux-Eglises, France: Charles de Gaulle, 79, dies of a heart attack.

November
FBI Director J. Edgar Hoover tells a Senate subcommittee that the anti-war group headed by Revs. Daniel and Philip Berrigan, brothers serving in jail for destroying draft records, planned to kidnap Henry Kissinger and to hold him for ransom to force a halt of U.S. air raids in Indochina along with release of "political prisoners."

Christmas
Altamount, Calif.: Free festival organized by the Rolling Stones has disastrous results with four dead, hundreds injured, and thousands freaked out.

Art Events

Berkeley: New University Art Museum opens, directed by Peter Selz.

February 25
New York: Death of Mark Rothko, by suicide, age 66.

March–September
Osaka: Expo 70 (Japan World Exposition).

April
Robert Smithson's earthwork, *Spiral Jetty*, constructed in Utah's Great Salt Lake.

April
Lynda Benglis experiments with viscosity as structure—blobs of polyurethane foam.

May 29
Death of Eva Hesse, age 34.

July 4
New York: Death of Barnett Newman, age 65.

December
Automation House: Benefit to raise matching funds for E.A.T.'s $15,000 grant from John D. Rockefeller Foundation to send artists to India for collaboration.

William Rubin named director of Department of Painting and Sculpture at the MOMA.

Exhibitions

New York: Dwan Gallery, *Michael Heizer: New York: Nevada.* First one-man exhibition in New York.

January 10–31
New York: O.K. Harris Works of Art, *Duane Hanson.* First one-man show in New York. (First one-man show, 1951, Museum of Art, Cranbook Academy of Art, Bloomfield Hills, Mich.)

New York: Whitney Museum of American Art, *22 Realists* (Bailey, Beal, Bechtle, Bruder, Clem Clarke, Close, Elias, Estes, Flack, Hendler, Joseph, Kanovitz, Laderman, Leslie, McLean, Morley, Pearlstein, Perlis, Staiger, Tillim, Wiesenfeld, Wynn).

January 14–February 25
Philadelphia: Institute of Contemporary Art, University of Pennsylvania, *The Highway.*

February–May
New York: MOMA, *Frank Stella* (retrospective).

May 12–June 21
Pasadena: Pasadena Art Museum, *Andy Warhol* retrospective.

January–February
Waltham, Mass.: Rose Art Museum, Brandeis University, *Vision and Television.*

February
Los Angeles: Molly Barnes Gallery, *Donald F. Eddy.* First one-man show in Los Angeles.

February 26–March 1
Pasadena: Pasadena Art Museum, *Three Sculptors* (de Maria, Serra, di Suvero).

February 27–April 19
New York: Whitney Museum of American Art, *Jim Dine* (retrospective).

April 4–May 10
Cambridge, Mass.: Hayden Gallery, MIT, *Explorations* (includes Antonakos, Apple, Jack Wesley Burnham, Jr., Erdman, Frazier, Goodyear, Harrison, Katzen, Kepes, Kraynik, Levine, McClanahan, Piene, Rieveschl, Ross, St. Florian, Seawright, Simons, Takis, Van Der Beek, Venezky, Wainwright, Wen-Ying).

March
Osaka: 1970 World Exposition, Pepsi Cola Pavilion created by Experiments in Art and Technology at a cost of $2.5 million.

April 10–August 30
New York: Cultural Center (in association with Fairleigh Dickinson University), *Conceptual Art and Conceptual Aspects.*

April 21–May 31
Buffalo: Albright-Knox Gallery, *Modular Painting* (includes Huot, Mangold, Marden, Mogensen, Novros, Ohlson, Ryman, Shaw).

May–June
Minneapolis: Walker Art Center, *Figures-Environments* (includes Grooms, Haworth, Hanson, Katz, Segal, Thek, Wells, Whitman).

May–June
Boston: Museum of the National Center of Afro-American Artists, School of the Museum of Fine Arts, *Afro-American Artists: New York and Boston.*

May 13–June 27
New York: Solomon R. Guggenheim Museum, *Carl Andre.*

July 2–September 20
New York: MOMA, *Information.*

September
New York: Association for Computing Machinery's 25th National Conference, *Computer Art.*

September 16–November 8
New York: Jewish Museum, *Software Information Technology: Its New Meaning for Art.*

September 19–October 10
New York: O.K. Harris Gallery, *Ralph Goings.* One-man show.

September 30–November 6
Philadelphia: Institute of Contemporary Art, University of Pennsylvania, *Two Generations of Color Painting* (includes Aylon, Bannard, Bhavarr, Davis, Dias, Downing, Frankenthaler, Gilliam, Gliko, Landfield, Louis, Mehring, Noland, Olitski, Pettet, Poons, Rudo, Schiffrin, Seery, Shields).

October
New York: Automation House, *Intermedia at Automation House.*

October 8–November 29
New York: Whitney Museum of American Art, *Georgia O'Keeffe.* Largest and most complete retrospective to date.

October 14–November 30
New York: Finch College Museum of Art, *Art Deco.*

November 14–December 22
Philadelphia: Institute of Contemporary Art, University of Pennsylvania, *Against Order: Chance and Art.*

Publications

Alloway, Lawrence, "Artists and Photographs," *Studio International* 179 (April): 162–164.

———, "Notes on Realism," *Arts* Magazine 44 (April): 26–29.

Andrews, Benny, "The B.E.C.C.: Black Emergency Cultural Coalition," *Arts Magazine* 44 (Summer): 18–22.

Antin, David, "Lead Kindly Blight," *Art News* 69 (November): 36–39.

"The Artist and Politics: A Symposium," *Artforum* 9 (September): 35–39.

Atkinson, Teer, "From and Art & Language Point of View," *Art-Language* (February): 25–60.

Baker, Elizabeth, C. "Pickets on Parnassus," *Art News* 69 (September): 30–33, 64–65.

Bannard, Walter Darby, "Notes on American Painting of the Sixties," *Artforum* 8 (January): 40–45.

Baro, Gene, "Caro," *Vogue* (May): 208–211.

Barrett, Cyril, *Op Art.*

Battcock, Gregory, "Re-Evaluating Abstract Expressionism," *Arts Magazine* 44 (December 1969–January): 45–49.

——, "Informative Exhibition at the Museum of Modern Art," *Arts Magazine* 44 (Summer): 24–27.

——, "Monuments to Technology," *Art and Artists* 5 (May): 52–55.

——, "The Politics of Space," *Arts Magazine* 44 (February): 40–43.

Bochner, Mel, "Excerpts from Speculations," *Artforum* 8 (May): 70–73.

——, "No Thoughts Exist Without a Sustaining Support," *Arts Magazine* 44 (April): 44.

Bongartz, Roy, "It's Called Earth Art—and Boulderdash," *New York Times Magazine* (February 1): 16–17, 22–30.

Bonin, Wilke Von, "Germany: The American Presence," *Arts Magazine* 44 (March): 52–55.

Brook, Donald, "Art Criticism: Authority and Argument," *Studio International* 180 (September): 66–69.

Burnham, Jack, "Alice's Head: Reflections on Conceptual Art," *Artforum* 8 (February): 37–43.

Calas, Nicolas, "Documentizing," *Arts Magazine* 44 (May): 30–32.

——, "The Sphinx: The Tradition of the New," *Arts Magazine* 45 (November): 24–26.

Celant, Germano, "Conceptual Art," *Casabella* (April): 42–49.

Compton, Michael, *Pop Art.*

Develing, Enno, "Sculpture in Place," *Art and Artists* 5 (November): 18–21.

Dibbets, Jan, "Send the right page . . .," *Studio International* 180 (July–August): 41–44.

Domingo, Willis, "Color Abstraction: A Survey of Recent American Painting," *Arts Magazine* 45 (December–January 1971): 34–40.

Donat, John, "Buckminster Fuller: A Personal Assessment," *Studio International* 179 (June): 242–244.

Doty, Robert, "Richard Anuszkiewicz," *Museum News* 48 (January): 11–12.

Frankenstein, Alfred, *The Reality of Appearance: The Trompe l'Oeil Tradition in American Painting.*

Friedman, Martin Lee, "14 Sculptors: The Industrial Edge," *Art International* 14 (February): 35–36.

Fry, Edward F., ed., *On the Future of Art.*

Fuller, Mary, "An Ad Reinhardt Monologue," *Artforum* 9 (October): 36–41.

Glaser, Bruce, "Modern Art and the Critics: A Panel Discussion" (with Maz Koxloff, Barbara Rose, and Sidney Tillim), *Art Journal* (Winter): 154–159.

Goldin, Amy, and Robert Kushner, "Concept Art as Opera," *Art News* 69 (April): 40–43.

Goodman, Mitchell, *The Movement Toward a New America: The Beginnings of a Long Revolution.*

Graham, Dan, "Flavin's Proposal," *Arts Magazine* 44 (February): 44–45.

Greenberg, Clement, "Avant-Garde Attitudes: New Art in the Sixties," *Studio International* 179 (April): 142–145.

Halas, John, and Roger Manvell, *Art in Movement: New Directions in Animation.*

Harrison, Charles, "A Very Abstract Context," *Studio International* 180 (November): 194–198.

"J," *The Sensuous Woman.*

Judd, Donald, "Aspects of Flavin," *Art and Artists* 4 (March): 48–49.

Kosuth, Joseph, "Introductory Note by the American Editor," *Art-Language* 1 (February): 1–4.

Kramer, Hilton, "Episodes from the Sixties," *Art in America* 58 (January–February): 56–6l.

Laderman, Gabriel, "Problems of Criticism VIII: Notes from the Underground," *Artforum* 9 (September): 59–61.

Lucie-Smith, Edward, *Art Now: From Abstract Expressionism to Superrealism.*

McCoubrey, John W., *American Painting, 1900–1970.*

Márquez, Gabriel García, *One Hundred Years of Solitude.*

Metzger, Gustav, "Kinetics," *Art and Artists* 5 (September): 22–25.

Meyer, Ursula, and Al Brunelle, *Art-Anti-Art.*

Michelson, Annette, "Three Notes on an Exhibition as a Work," *Artforum* 8 (June): 62–64.

Millet, Kate, *Sexual Politics.*

Morris, Robert, "Some Notes on the Phenomenology of Making: The Search for the Motivated," *Artforum* 8 (April): 67–75.

Moynihan, Michael, "Gilbert and George," *Studio International* 179 (May): 196–197.

Nemser, Cindy, "An Interview with Chuck Close," *Artforum* 8 (January): 51–55.

——, "Presenting Charles Close," *Art in America* 58 (January): 98–101.

Ratcliff, Carter, "The New Informalists," *Art News* 68 (February): 46–50.

Reich, Charles, *The Greening of America.*

Reuben, David, *Everything You Wanted to Know About Sex but Were Afraid to Ask.*

Robbin, Anthony, "Peter Hutchinson's Ecological Art," *Art International* 14 (February): 52–55.

Robins, Corinne, "Four Directions at Park Place," *Arts Magazine* 44 (September–October): 27.

Rubin, Jerry, *Do It.*

Sandler, Irving, *The Triumph of American Painting: A History of Abstract Expressionism.*

Segal, Erich, *Love Story.*

Shapiro, David, "Jim Dines's Life-in-Progress," *Art News* 69 (March): 42–46.

——, "Mr. Processionary at the Conceptacle," *Art News* 69 (September): 58–61.

Sharp, Willoughby, "Carl Andre," an interview, *Avalanche* (Fall): 18–27.

——, "Discussions with Heizer, Oppenheim, Smithson," *Avalanche* (Fall): 48–71.

——, "Willoughby Sharp Interviews Jack Burnham," *Arts Magazine* 45 (November): 21–23.

——, "Willoughby Sharp Interviews John Coplans," *Arts Magazine* 44 (Summer): 39–41.

Siegel, Jeanne, "Carl Andre: Artworker," *Studio International* 180 (November): 175–179.

Spies, Werner, *Albers*.

Stein, Maurice, and Larry Miller, *Blueprint for a Counter Education*.

Toffler, Alvin, *Future Shock*.

Towle, Tony, "Notes on Jim Dine's Lithographs," *Studio International* 179 (April): 165–168.

Tuchman, Maurice, "An Interview with Carl Andre," *Artforum* 8 (June): 55–61.

——, "Art and Technology," *Art in America* 58 (March–April): 78–79.

Van Tieghem, Jean-Pierre, "Carl Andre," *Opus International* (March): 79–80.

Vinklers, Bittie, "Art and Information: 'Software' at the Jewish Museum," *Arts Magazine* 45 (Summer): 46–49.

Waldman, Diane, "Holding the Floor," *Art News* 69 (October): 60–62, 75–79.

Wheeler, Dennis F., "Ronald Bladen and Robert Murray in Vancouver," *Artforum* 8 (June): 50–54.

Wilson, William S., "Dan Flavin: Fiat Lux," *Art News* 68 (January): 48–51.

Winton, Malcom, "Sculptures That Blow Away," *Ark* (Spring): 18–19.

Wolfe, Tom, *Radical Chic . . .*

Notes

Introduction

1. Theodore Roszak, *The Making of a Counter Culture: Reflections on the Technocratic Society and its Youthful Opposition* (Garden City, N.Y.: Doubleday & Co., 1969).
2. Alvin Toffler, *Future Shock* (New York: Random House, 1970).
3. Roszak, *The Making of a Counter Culture*, pp. 110–144.
4. David Hackett Fischer, *Historians' Fallacies* (New York: Harper & Row, 1970), passim.

1. The Disintegration of the Postwar Synthesis

1. Meyer Schapiro, "The Liberating Quality of Avant-Garde Art," address to the annual meeting of the American Federation of Arts, Houston, Tex., 5 Apr. 1957; reprinted in Schapiro, *Modern Art 19th and 20th Centuries: Selected Papers* (New York: George Braziller, 1979).
2. Hans Hofmann, *Search for the Real and Other Essays* (Andover, Mass.: Addison Gallery of American Art, 1948).
3. *The New American Painting,* Kunsthalle, Basel (19 Apr.–26 May 1958); Galleria civica d'arte moderna, Milan (1–30 June 1958); Museo nacional de arte contemporaneo, Madrid (16 July–11 Aug. 1958); Hochschule für Bildende Kunst, Berlin (3 Sept.–1 Oct. 1958); Stedelijk Museum, Amsterdam (17 Oct.–24 Nov. 1958); Palais des Beaux-Arts, Brussels (6 Dec. 1958–4 Jan. 1959); Musée national d'art moderne, Paris (16 Jan.–15 Feb. 1959); Tate Gallery, London (24 Feb.–22 Mar. 1959); Museum of Modern Art, New York (28 May–8 Sept. 1959).
4. For a complete narrative of this incident, see Calvin Tomkins, *The Bride and the Bachelors: The Heretical Courtship in Modern Art* (London: Weidenfeld & Nicolson, 1965), pp. 210–211.

5. *American Abstract Expressionists and Imagists* (New York: Solomon R. Guggenheim Museum, 13 Oct.–31 Dec. 1961), organized by H. H. Arnason.

6. Claude Monet, *Water Lilies*, c. 1920. Oil, 6′ 6½″ × 19′ 7½″. Collection of the Museum of Modern Art, Mrs. Simon Guggenheim Fund.

7. John Canaday, *Mainstreams of Modern Art* (New York: Holt, Rinehart, & Wilson, 1959), pp. 228–229.

8. Roger Fry as quoted in Aldous Huxley, *The Doors of Perception, and Heaven and Hell* (London: Weidenfeld & Nicolson, 1956), p. 44.

9. See, for example, William Rubin, "Jackson Pollock and the Modern Tradition Part II," *Artforum* 5 (Mar. 1967): 28–37.

10. See Motherwell's notes and diagram in the Appendix of William C. Seitz, *Abstract Expressionist Painting in America* (Cambridge, Mass. and London: Harvard University Press, 1983).

11. Clement Greenberg, "Later Monet," *Art News Annual* 26 (1957): 196.

12. Clement Greenberg, "Letter to the Editor," *Art International* 9 (May 1965): 66; reprinted in *Morris Louis 1912–1962* (Boston: Museum of Fine Arts, 1967), p. 11.

13. Greenberg, "Later Monet," 196.

14. John Canaday, "Happy New Year! Thoughts on Critics and Certain Painters as the Season Opens," *New York Times*, 6 Sept. 1959, section 2, p. 16.

15. Canaday, "Promising Mutations," *New York Times*, 24 July 1960, section 2, p. 8.

16. Quoted in "Catalytic Critic," *Newsweek*, 16 Apr. 1962, p. 108.

17. See Robert Rosenblum, "The Abstract Sublime," *Art News* 59 (Feb. 1961): 38ff., and Rosenblum, *Modern Painting and the Northern Romantic Tradition: Friedrich to Rothko* (New York: Harper & Row, 1975).

18. Brian O'Doherty, *American Masters: The Voice and the Myth in Modern Art* (New York: Random House, 1973).

19. William C. Seitz, "The Rise and Dissolution of the Avant-Garde," *Vogue* (Sept. 1963): 182ff.

20. Ibid., p. 182.

21. Harold Rosenberg, "D.M.Z. Vanguardism," in *The De-definition of Art: Action Art to Pop to Earthworks* (New York: Horizon Press, 1966), pp. 212–222.

22. Hilton Kramer, *The Age of the Avant-Garde* (New York: Farrar, Straus & Giroux, 1973).

23. Gregory Battcock, "Marcuse and Anti-Art," *Artsmagazine* 43 (Summer 1969): 17–19.

24. Brian O'Doherty, "Issues and Commentary: What Is Post-Modernism?" *Art in America* 59 (May–June 1971): 19–21.

2. The Inchoate Threshold

1. Clement Greenberg, *Art and Culture* (Boston: Beacon Press, 1961), p. 208.

2. John Cage, "Jasper Johns: Stories and Ideas," in *Jasper Johns* (New York: Jewish Museum, 1964), p. 23; reprinted in Gregory Battcock, ed., *The New Art: A Critical Anthology* (New York: E. P. Dutton & Co., Inc., 1973), pp. 29–45.

3. Robert Rauschenberg in *Sixteen Americans* (New York: Museum of Modern Art, 1959), p. 58.

4. Guillaume Apollinaire, *Selected Writings of Guillaume Apollinaire* (New York: New Directions, 1971), p. 117.

5. Werner Schmalenbach, *Kurt Schwitters* (New York: Harry N. Abrams, 1970), p. 104.

6. Tomkins, *The Bride and the Bachelors*, p. 205.

7. Ibid., p. 86.

8. Ibid., p. 90.

9. Ibid., p. 210.

10. Ibid., p. 231.

11. Willem de Kooning, in "What Abstract Art Means to Me," *The Museum of Modern Art/Bulletin* 18 (Spring 1951): 7.

12. Robert Mallary, in *Sixteen Americans*, p. 12.

13. Carl Andre, "Preface to Stripe Painting," in *Sixteen Americans*, p. 76.

14. Frank Stella, quoted in William S. Rubin, *Frank Stella* (New York: Museum of Modern Art, 1970), p. 149.

15. Barbara Rose, "The Black Paintings," in *Ad Reinhardt: Black Paintings 1951–1967* (New York: Marlborough Gallery, Inc., 1970), p. 17.

16. First published as "Auto-critique de Reinhardt," in *Iris-Time*, 10 June 1963, the newsletter of the Galerie Iris Clert, Paris, on the occasion of *Ad Reinhardt "Les forces immobiles,"* 10 June–10 July 1963; quoted in Rose, "The Black Paintings," p. 16. See also Margit Rowell, *Ad Reinhardt and Color* (New York: Solomon R. Guggenheim Museum, 1980), p. 22, and Rose, ed., *Art as Art: The Selected Writings of Ad Reinhardt* (New York: Viking, 1975), pp. 82–83.

17. Abbreviated from "Twelve Rules for a New Academy," Gregory Battcock, *The New Art: A Critical Anthology* (New York: E. P. Dutton, 1973), pp. 168–169.

18. Wolfgang Kohler, *Gestalt Psychology: An Introduction to New Concepts in Modern Psychology* (New York: Liveright Publishing Corp., 1970), p. 173.

19. Quoted in Bruce Glaser and Lucy R. Lippard, eds., "Questions to Stella and Judd," *Art News* 65 (Sept. 1966): 55. This article is a revised version of a radio interview conducted by Glaser, "New Nihilism or New Art?" broadcast on WBAI–FM, New York, Mar. 1964. See also the reprint in Gregory Battcock, ed., *Minimal Art: A Critical Anthology* (New York: E. P. Dutton, 1968), pp. 148–164.

3. Color-Field Painting and the Washington School

1. Clement Greenberg, "After Abstract Expressionism," *Art International* 6 (Oct. 1962): 24–32.

2. Greenberg, *Barnett Newman* (New York: French & Company, 1959).

3. *Morris Louis* (New York: French & Company, 10 Apr.–2 May 1959); *Kenneth Noland: Paintings* (New York, French & Company, 14 Oct.–7 Nov. 1959).

9. Dennis Oppenheim, quoted in "Art: Back to Nature," *Time,* 29 June 1970, p. 62.

10. Peter Hutchinson, in "Art: Back to Nature," p. 65.

11. Clara Endicott Sears, *Highlights Among the Hudson River Artists* (Port Washington, N.Y.: Kennikat Press, 1968), p. 100.

12. Lawrence Alloway, *Christo* (New York: Harry N. Abrams, 1969), pp. v–xi.

13. *Christo: Wrapped Coast, One Million Square Feet* (Minneapolis: Contemporary Art Lithographers, 1969).

14. Jan van der Marck, "The Valley Curtain," *Art in America* 60 (May–June, 1972): 67.

15. Grace Glueck, "The Gap That Wouldn't Stay Closed," *New York Times,* 20 Aug. 1972, section 2, p. 19.

16. Ibid.

17. Lawrence Alloway, "Christo and the New Scale," *Art International* 12 (20 Sept. 1968): 56.

18. Frederick Hartt, *Italian Renaissance Art* (New York: Harry N. Abrams, 1969), p. 75.

19. Robert Smithson, "Entropy and the New Monuments," *Artforum* 4 (June 1966): 26–31.

20. Robert Smithson, "The Spiral Jetty," in Gyorgy Kepes, ed., *Arts of the Environment* (New York: George Braziller, 1972), p. 231; reprinted in Nancy Holt, ed., *The Writings of Robert Smithson* (New York: New York University Press, 1979), p. 115.

21. Description of Robert Smithson, *Mirror Displacement,* in *Earth Art.*

22. Robert Smithson, "Incidents of Mirror Travel in the Yucatán," *Artforum* 8 (Sept. 1969): 28–33.

23. Ibid., 33.

24. Robert Smithson, "A Sedimentation of the Mind: Earth Projects," *Artforum* 7 (Sept. 1968): 50.

25. Description of Robert Morris, *Untitled,* in *Earth Art.*

10. The Disembodied Idea

1. *When Attitudes Become Form,* Kunsthalle, Bern, 22 Mar.–27 Apr. 1969; the exhibition, in a somewhat different form, was shown at the Institute of Contemporary Art in London in Aug.–Sept. 1969.

2. See Ursula Meyer, *Conceptual Art* (New York: E. P. Dutton & Co., 1972), p. 154.

3. Ibid., p. xx.

4. Terry Atkinson, "Introduction," *Art-Language* 1 (1969); reprinted in Meyer, *Conceptual Art,* pp. 8–21, quotation p. 9.

5. Jack Burnham, "Alice's Head: Reflections on Conceptual Art," *Artforum* 8 (Feb. 1970): 37.

6. Daniel Buren, "Beware!" *Studio International* 179 (May 1970); reprinted in Meyer, *Conceptual Art,* p. 63.

7. Meyer, *Conceptual Art,* p. 65.

8. Germano Celant, *Arte Povera* (New York: Praeger, 1969), p. 11.

9. Donald Burgy, *Art Ideas for the Year 4000* (Andover, Mass.: Addison Art Gallery of American Art, 1970).

10. Meyer, *Conceptual Art,* p. 166.

11. Ibid., p. 159.

12. Ibid.

13. Ibid., p. 163.

14. Reinhardt, quoted in Meyer, p. 158.

15. Celant, *Arte Povera,* p. 58.

11. Art as Adversary Politics

1. Michael Kustow, "Is It the Role of the Artist to Change Society?", *New York Times,* 2 Aug. 1970, section 2, p. 1.

2. Ibid.

3. Dore Ashton, brochure accompanying *Edward Kienholz* (New York: Iolas Gallery, 5–23 Feb. 1963).

4. John Coplans, "Los Angeles: The Scene," *Art News* 64 (Mar. 1965): 57.

5. Sam Goodman in "no-sculpture" (New York: Gertrude Stein Gallery, Summer 1964).

6. Ibid.

7. "Prize: An Exchange of Letters Between Ajay and Reinhardt," *Art in America* 59 (Dec. 1971): 98.

8. Claes Oldenburg, statement in *Environments, Situation, Spaces* (New York: Martha Jackson Gallery, 23 May–23 June 1961); reprinted in Barbara Rose, *Claes Oldenburg* (New York: Museum of Modern Art, 1970), p. 190.

9. Gene R. Swenson, "What Is Pop Art?" *Art News* 62 (Nov. 1963): 26.

10. Gregory Battcock, "Marcuse and Anti-Art," *Arts-magazine* 43 (Summer 1969): 17–19.

11. Herbert Marcuse, "Art as a Form of Reality," in *On the Future of Art* (New York: Viking Press, 1970), p. 124.

12. Ibid., p. 125.

13. Mel Bochner, "Books," *Artforum* 11 (June 1973): 75.

14. Udo Kultermann, *Art and Life* (New York: Praeger, 1971).

15. Jerry Rubin, *Do It: Scenarios of the Revolution* (New York: Ballantine Books, 1970), p. 117.

16. Ibid., p. 132.

17. Abbie Hoffmann, *Revolution for the Hell of It* (New York: Dial Press, 1968), p. xx.

18. Gilbert and George, typescript, courtesy Sonnabend Gallery, New York. See also Robert Pincus-Witten, "New York," *Artforum* 10 (Dec. 1971): 79.

12. Post-Pop and Photorealism

1. Linda Nochlin, "Introduction," in *Realism Now* (Poughkeepsie, N.Y.: Vassar College Art Gallery, 1968).

2. Andrew Ritchie, *Abstract Painting and Sculpture in America* (New York: Museum of Modern Art, 1951), p. 68.

3. J. Patrice Marandel, "The Deductive Image," *Art International* 15 (Sept. 1971): 58–61, is an interesting exception: "Starting from a photograph, today's painter

. . . reduces the amount of information first given. . . . The result is a *deductive image.*" See also Cindy Nemser, "Representational Painting in 1971," *Arts* 46 (Dec. 1971–Jan. 1972): 41–72.

4. Tom Blackwell, in "The Photo-Realists: 12 Interviews," *Art in America* 60 (Nov.–Dec. 1972): 75.

5. William C. Seitz, "Environment U.S.A., 1957–1967," in *São Paulo 9* (Washington, D.C.: Smithsonian Institution Press, 1967), p. 56.

6. Alfred Frankenstein, *The Reality of Appearance: The Trompe l'Oeil Tradition in American Painting* (Greenwich, Conn.: New York Graphic Society, 1970), p. 6.

7. E. C. Goosens, "Introduction," *The Art of the Real* (New York: Museum of Modern Art, 1968).

8. "The Photo-Realists: 12 Interviews," p. 79.

9. Ibid., p. 85.

10. Hilton Kramer, "Stealing the Modernist Fire," *The New York Times* 26 Dec. 1971, section 2, p. 25.

11. Lawrence Alloway, "The Development of British Pop," in Lucy Lippard, ed., *Pop Art* (New York: Praeger, 1966), p. 38.

12. Frances Morley, manuscript statement for the *Documenta* exhibition, Kassel, West Germany, 30 June–8 Oct. 1972, in William C. Seitz files.

13. Ibid.

14. "The Photo-Realists: 12 Interviews," p. 80.

15. Lloyd Goodrich, *Edward Hopper* (New York: Harry N. Abrams, 1971), p. 99.

16. Daniel A. Fink, "Vermeer's Use of the Camera Obscura—A Comparative Study," *Art Bulletin* 53 (Dec. 1971): 505.

17. Van Deren Coke, *The Painter and the Photograph* (Albuquerque: University of New Mexico Press, 1964).

18. Linda Nochlin, "Introduction," *Philip Pearlstein* (Georgia Museum of Art, 20 Sept.–8 Nov. 1970); see also Nochlin, *Realism: Style and Civilization* (Middlesex, England, 1971).

19. Robert Hughes, "The Realist as Corn God," *Time* 31 Jan. 1972, p. 55.

20. Ivan Karp, "Anti-Sensibility Painting," *Artforum* 2 (Sept. 1963): 26–27; see also Karp, "Rent Is the Only Reality, or the Hotel Instead of the Hymn," *Arts* 46 (Dec. 1971–Jan. 1972): 47–51.

21. Lawrence Alloway, "Hi-way Culture: Man at the Wheel," *Arts Magazine* 41 (Feb. 1967): 28–33.

22. Douglas E. Kneeland, *New York Times,* 28 Nov. 1971, pp. 1, 60. See also J. Anthony Lukas, "As American as a McDonald's Hamburger on the Fourth of July," *New York Times Magazine,* 4 Aug. 1971, pp. 5ff.

23. Wayne Thiebaud, "A Painter's Personal View of Eroticism," *Polemic* (Winter 1966), quoted in *São Paulo 9,* p. 104.

24. "The Photo-Realists: 12 Interviews," p. 87.

25. Vincent Scully, introduction to Robert Venturi, *Complexity and Contradiction in Architecture* (New York: Museum of Modern Art, 1966), p. 11.

26. Ibid., p. 24.

27. Ibid.

28. Editor's Note: This chapter originated as a lecture by William C. Seitz at the National Gallery of Art, Washington, D.C., 9 Jan. 1972; portions appeared in Seitz, "The Real and the Artificial: Painting of the New Environment," *Art in America* 60 (Nov.–Dec. 1972): 58–72.

Epilogue

1. Guillaume Apollinaire, "On Painting," in *The Cubist Painters* (New York: George Wittenborn, Inc., 1970), p. 15.

2. Gerald Emanuel Stern, *McLuhan, McLuhan Hot and Cool* (New York: Dial Press, 1967), p. 281.

3. William C. Seitz, notes of a symposium at Brandeis University, 3 June 1963.

4. Clement Greenberg, "Counter-Avant-Garde," *Art International* 15 (May 1971): 16–90.

5. Ibid., p. 16.

6. John Coplans, "An Interview with Roy Lichtenstein," *Artforum* 2 (Oct. 1963): 31.

7. John Coplans, "Talking with Roy Lichtenstein," *Artforum* 5 (May 1967): 34–39.

Index

Koffka, Kurt, 92
Kootz, Sam, 16
Kosuth, Joseph, 158, 165–66
Kramer, Hilton, 21, 187
Kropotkin, Pëtr, 168
Kudo, Tetsumi, 183
Kuehn, Gary, 123
Kultermann, Udo, 182, 187
Kusama, Yayoi, 183
Kustow, Michael, 168, 170
Kuwayama, Tadasuke, 94

La Fresnaye, Roger-Noël-François, 202
Laderman, Gabriel, 185
Laing, Gerald, 81
Langsner, Jules, 33
Lassaw, Ibram, 117
Latham, John, 41
Lawrence, Jacob, 173
Lebel, Jean-Jacques, 182–83
Ledoux, Claude, 115
Léger, Fernand, 35, 75, 192, 202
Leslie, Alfred, 185
Leutze, Emanuel, 176
Levinson, Mon, 99
Lewitin, Landes, 22
LeWitt, Sol, 111, 158
Liberman, Alexander, 94, 122
Lichtenstein, Roy, 47, 64, 65, 68, 71, 72, 76, 81,
 109, 189, 203–4
Lind, Pi, 183
Lippard, Lucy, 155, 181
Lippincott, Don, 121, 122
Lippincott Environmental Arts, 121
Lippincott Sculpture Factory, 121
Lippold, Richard, 117
Lipton, Seymour, 117
Lissitzky, El, 94
Lloyd, Tom, 173
Long, Richard, 151, 161
Loran, Erle, 65
Lorenzetti, Ambrogio, 191
Los Angeles Artists Protest Committee, 175
Louis, Morris, 3, 16, 37, 38, 39, 91, 94, 101,
 159, 165, 170, 203
Lowry, Bates, 175
Lukin, Sven, 117
Lurie, Boris, 172

McCracken, John, 109
Mach, Ernst, 92
Mack, Heinz, 129
McLaughlin, John, 33
McLean, Richard, 193, 196, 199
McLuhan, Marshall, 4, 65, 180, 187, 201–2, 203
McShine, Kynaston, 101, 124
Magritte, René, 35, 71, 191
Mahaffey, Noel, 191
Malevich, Kasimir, 33, 35, 92, 93, 190
Mallary, Robert, 22, 31
Manessier, Alfred, 91
Manet, Edouard, 21, 165

Manzoni, Piero, 159, 160
Marandel, J. Patrice, 195
Marcuse, Herbert, 21, 86, 180
Marinetti, Filippo Tommaso, 203
Marisol, 41, 43, 47, 80, 143
Martin, Agnes, 90, 159
Marx, Karl, 168, 180
Masson, André, 16, 35
Mathieu, Georges, 15–16, 20, 60, 64, 91, 132
Matisse, Henri, 22, 33, 37, 81, 83, 187
Matta, Roberto, 35
Meadmore, Clement, 120, 121, 124
Mendelsohn, Jack, 186
Merz, Mario, 149, 160
Messer, Thomas, 181
Metzer, G., 182
Metzger, Gustave, 60
Meyer, Ursula, 159
Michaux, Henri, 91
Miller, Dorothy C., 22
Miller, Henry, 81
Minimalism, 109, 110, 111, 117, 123, 151
Miró, Joan, 8, 35
Moholy-Nagy, László, 93
Molinari, Guido, 94, 159
Mondrian, Piet, 8, 16, 35, 68, 92, 93, 94, 168,
 186, 189, 203
Monet, Claude, 8, 12, 14–15, 16–17, 37, 68, 94,
 180, 187, 189, 190, 191, 203, 204
Monroe, Marilyn, 28
Moore, Henry, 101, 115
Morandi, Giorgio, 143, 196
Morellet, François, 35
Morley, Malcolm, 185, 186, 189–91
Morrell, Marc, 176
Morris, George L. K., 35
Morris, Robert, 110–11, 121, 122–23, 129, 149,
 151, 160, 161
Moses, Grandma, 64
Motherwell, Robert, 8, 15, 38, 41, 174, 175
Motley, 199
Motonaga, Sadamasa, 56
Murakami, Saburo, 57
Murphy, Gerald, 75
Murray, Robert, 121, 123
Mussolini, Benito, 167
Myers, Forrest, 123

Nabokov, Vladimir, 76
Nauman, Bruce, 134, 149, 160
Neo-Impressionism, 92, 94, 202
Nesbitt, Lowell, 185, 186
Nevelson, Louise, 22, 121
New Realism, 61
New Tendency, 91–92, 93, 94
New Theater, 181
New York School, 7–9, 14, 16, 20, 22, 28, 31,
 91, 117, 129
New York Strikers, 176
Newman, Barnett, 3, 12, 16, 19, 20, 22, 35, 36–
 37, 38, 77, 91, 115, 117, 121, 122, 129, 168,

175, 190
Nivola, Constantino, 120
Nixon, Richard, 191, 199
Nochlin, Linda, 185
Noguchi, Isamu, 122
Noland, Kenneth, 35, 37–38, 39, 91, 94, 101,
 117, 165, 170, 203
Nolde, Emil, 167
Noll, Michael, 92
Nouveaux Réalistes group, 61
Nouvelle Tendence movement, 64

O'Doherty, Brian, 20, 21, 77, 122
Oldenburg, Claes, 47, 48, 53, 61, 81, 83, 85–86,
 120, 121, 123, 124, 158, 160, 173, 175, 177,
 183, 186, 189, 195
Olitski, Jules, 37, 39, 165
Ono, Yoko, 161
Op art, 90, 94–96, 99, 100, 101, 173, 202
Oppenheim, Dennis, 129, 134, 138, 141, 143
Oppenheim, Meret, 172
Orozco, José Clemente, 168
Orphism, 37
Oster, Gerald, 96, 99

Pani, Mario, 115
Paolozzi, Eduardo, 41, 64, 101, 124
Parrhasios, 186
Parrish, David, 198
Pascal, Claude, 60
Pearlstein, Philip, 185, 193–94
Pei, I. M., 101
Penone, Giuseppe, 151
Perrault, John, 175
Peto, 201
Pevsner, Antoine, 114
Phillips, Peter, 76, 106
Picabia, Francis, 161, 187
Picasso, Pablo, 22, 31, 35, 40, 68, 114, 121, 167,
 189, 201, 202, 203, 204
Pissarro, Camille, 191
Plato, 101, 186
Pliny, 186
Poggioli, Renato, 21
Political Art, 181
Pollock, Jackson, 9, 12, 14–16, 17, 24, 37, 38,
 47, 57, 91, 129, 186
Poons, Larry, 94
Pop art, 47, 63–89, 99, 100, 109, 113, 144, 158,
 173, 176, 177, 181, 187, 189, 190–91, 193,
 194–95, 198, 199, 201, 202, 203, 204
Porter, Cole, 64
Posada, José Guadalupe, 168
Posen, Stephen, 186, 187
Pound, Ezra, 167
Pousette-Dart, Richard, 16–17
Presley, Elvis, 64, 182
Proudhon, Pierre Joseph, 167

Radich, Steve, 176
Rainer, Yvonne, 110